SOVEREIGN ACTS

Critical Caribbean Studies

Series Editors: Yolanda Martínez-San Miguel, Michelle Stephens, and Kathleen Lopez

Focused particularly in the twentieth and twenty-first centuries, although attentive to the context of earlier eras, this series encourages interdisciplinary approaches and methods and is open to scholarship in a variety of areas, including anthropology, cultural studies, diaspora and transnational studies, environmental studies, gender and sexuality studies, history, and sociology. The series pays particular attention to the four main research clusters of Critical Caribbean Studies at Rutgers University, where the coeditors serve as members of the executive board: Caribbean Critical Studies Theory and the Disciplines; Archipelagic Studies and Creolization; Caribbean Aesthetics, Poetics, and Politics; and Caribbean Colonialities.

Giselle Anatol, *The Things That Fly in the Night: Female Vampires in Literature of the Circum-Caribbean and African Diaspora*

Alaí Reyes-Santos, *Our Caribbean Kin: Race and Nation in the Neoliberal Antilles*

Milagros Ricourt, *The Dominican Racial Imaginary: Surveying the Landscape of Race and Nation in Hispaniola*

Katherine A. Zien, *Sovereign Acts: Performing Race, Space, and Belonging in Panama and the Canal Zone*

SOVEREIGN ACTS

Performing Race, Space, and Belonging in Panama and the Canal Zone

KATHERINE A. ZIEN

RUTGERS UNIVERSITY PRESS

New Brunswick, Camden, and Newark, New Jersey, and London

Library of Congress Cataloging-in-Publication Data

Names: Zien, Katherine A., 1981- author.
Title: Sovereign acts : performing race, space, and belonging in Panama and the Canal
Zone / Katherine A. Zien.
Description: New Brunswick, New Jersey : Rutgers University Press, 2017. |
Series: Critical Caribbean studies | Includes bibliographical references and index.
Identifiers: LCCN 2016053263| ISBN 9780813584232 (hardback) | ISBN 9780813584102
(pbk.) | ISBN 9780813584249 (e-book (epub))
Subjects: LCSH: Panamanian drama—20th century—History and criticism.
| Theater—Panama—History. | Literature and society—Panama. | National
characteristics, Panamanian, in literature. | Sovereignty—Panama. | Canal Zone—
Intellectual life. | Panama Canal (Panama)—In literature. |
BISAC: HISTORY / Latin America / Central America. | ART / Art & Politics. |
SOCIAL SCIENCE / Developing Countries. | ART / Performance. | HISTORY /
Caribbean & West Indies / General. | POLITICAL SCIENCE / Colonialism & Post-
Colonialism. | SOCIAL SCIENCE / Discrimination & Race Relations.
Classification: LCC PQ7523 .Z54 2017 | DDC 862/.60997287—dc23
LC record available at https://lccn.loc.gov/2016053263

A British Cataloging-in-Publication record for this book is available from the
British Library.

∞The paper used in this publication meets the requirements of the American National
Standard for Information Sciences—Permanence of Paper for Printed Library
Materials, ANSI Z39.48–1992.

www.rutgersuniversitypress.org

Manufactured in the United States of America

CONTENTS

ILLUSTRATIONS AND TABLES

ILLUSTRATIONS

TABLES

NOTE ON TEXT

All translations from Spanish to English are mine. I accept full responsibility for any errors that may arise. Where available, the original Spanish text has been included in the endnotes section.

All efforts have been made to reach copyright holders for the illustrations in the book. If a work has been used in error, please contact the publisher.

ABBREVIATIONS

ACRONYMS

ACP	Autoridad del Canal de Panamá
ADOC	Alianza Democrática de Oposición Civilista
BCP	Bureau of Clubs and Playgrounds
COCINA	Coordinadora Civilista Nacional
CYMCL	Colored Young Men's Christian League
CZG	Canal Zone Government
DEXA	Departamento de Expresiones Artísticas
ICC	Isthmian Canal Commission
INAC	Instituto Nacional de Cultura
INTARIN	Intercambio Artístico Internacional, or International Artistic Exchange
INYC	Isthmian Negro Youth Congress
MIPPE	Ministerio de Planificación y Política Económica
MPE	Movimiento Papa Egoró
OAS	Organization of American States
PC	Panama Canal
PCC	Panama Canal Company
PCWIEA	Panama Canal West Indian Employees Association
PRD	Partido Democrático Revolucionario
SCN	Southern Command Network
SEA	Silver Employees Association
TEP	Teatro Estudiantil Panameño
TGA	Theatre Guild of Ancón
UNDP	United Nations Development Programme
UNIA	Universal Negro Improvement Association
UPWA	United Public Workers of America
USIS	United States Information Service
YMCA	Young Men's Christian Association

ARCHIVAL SOURCES

GWW George W. Westerman Papers, Schomburg Center for
Research in Black Culture

LOC Library of Congress, Canal Zone Library-Museum
Collection

NARA National Archives and Records Administration, RG 185,
Records of the Panama Canal Company

RBC Rubén Blades Papers, Loeb Library, Harvard University

SOVEREIGN ACTS

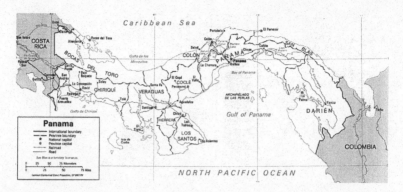

FIGURE I.1. Map of Panama. The country's "interior" is said to include the provinces of Coclé, Herrera, Veraguas, Chiriquí, and Los Santos. The Panama Canal runs between Colón and Panama City. Courtesy of the University of Texas Libraries, The University of Texas at Austin.

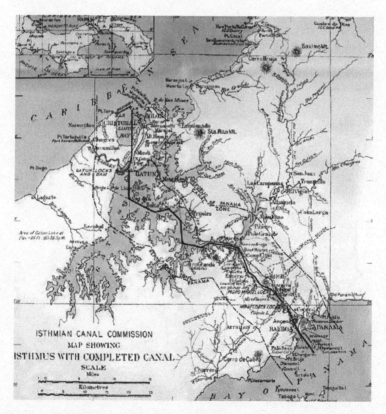

FIGURE I.2. Map of the Canal Zone, from the Isthmian Canal Commission Annual Report 1912. Panama Canal Museum Collection, Special and Area Studies Collections, George A. Smathers Libraries, University of Florida, Gainesville, Florida.

INTRODUCTION
Setting the Scene of Sovereignty

As reported in a US newspaper, people across the Panamanian isthmus "awoke in the morning [of November 4, 1903]" to find that "Panama had declared its independence on the afternoon of the 3d instant. To one and all the news came like a bolt from a clear sky."[1] The day before, a small junta of isthmian elites had executed a nearly bloodless coup, declaring Panama's independence from Colombia with the help of US warships hovering in the nearby bay.[2] A scant fifteen days after Panama's US-facilitated revolution, a treaty was hastily drawn up by US secretary of state John Hay and Philippe Bunau-Varilla, a French citizen who had himself named Panama's "Envoy Extraordinary and Minister Plenipotentiary" shortly after the revolution.[3] The resulting convention—the Hay-Bunau-Varilla Treaty, hereafter the Panama Canal Treaty—was widely lambasted as "the treaty that no Panamanian signed."[4] It was, nonetheless, ratified quickly by Panama's provisional government, under pressure from Bunau-Varilla, and by the US Congress four months later.[5] Historian John Major calls the Panama Canal Treaty "one of the most important treaties in the history of American foreign relations," granting the US government "absolute control" over the Panama Canal, an "economic and strategic crossroads of the Americas."[6] The treaty gave the US government unprecedented latitude in the newly independent and sovereign Republic of Panama (see map, Figure I.1), and in the 553-square-mile area that the treaty brought into being: the Panama Canal Zone (Figure I.2).

The Canal Zone subsequently became a US-controlled enclave that bisected the isthmus, surrounding a conduit for global commerce from whose benefits most Panamanians were excluded for nearly a century. The 1903 treaty also enabled US militarization of the Canal Zone, with deadly implications throughout Latin America and the Caribbean. In sum, the Panama Canal Treaty redefined US imperialism, diplomacy, and expansion on the isthmus, and changed the relationship of nation-state sovereignty to international law and global capital. The Roosevelt administration's actions in Panama threw politics in the United States and on the isthmus into crisis, sparking decades-long debates over the reach of US empire,

the meaning of national sovereignty, and US foreign policy in the Western Hemi-sphere.[7] As this book illuminates, the Panama Canal Zone's development and its broader ramifications emerged from dimensions of performativity and perfor-mance that enabled the treaty's redefinition of sovereignty and materialized in scenes of empire, nationalism, and race on the isthmus. *Sovereign Acts* explores the ways that embodied and aestheticized enactments and representations of sover-eignty shaped the terrain of the Canal Zone during a near-century of US occupa-tion, implicating US citizens, Panamanians, and multinational labor migrants.

While conditions surrounding the treaty's signing have been analyzed exten-sively, few studies address the nuances of the treaty's language.[8] The Panama Canal Treaty, which was written in English, employed linguistic ambiguities that transformed it from a performative utterance—language that enacts, in philos-opher J. L. Austin's conception—to a legal borderland, in which conditions of *performance* took hold.[9] The treaty's preamble acknowledged "the sovereignty of [the future Canal Zone] being actually invested in the Republic of Panama," yet its terms seemed to dictate otherwise.[10] Panama became, in the treaty, a pro-tectorate of the United States (Article I).[11] The Canal Zone was granted to the United States "in perpetuity" (Article II), and the US government was given rights to seize any lands and waters in Panama (Article VII) that it deemed "nec-essary and convenient for the construction, maintenance, operation, sanitation, and protection of said Canal" (Article II). Article III, one of the most contro-versial clauses, stated: "*The Republic of Panama grants to the United States all the rights, power, and authority* within the zone mentioned and described in Article II of this agreement and within the limits of all auxiliary lands and waters men-tioned and described in said Article II *which the United States would possess and exercise if it were the sovereign of the territory* within which said lands and waters are located *to the entire exclusion of the exercise* by the Republic of Panama of *any such sovereign rights, power or authority*."[12] Article III's "sovereignty clause" under-scored a fundamental ambiguity regarding the Panama Canal Zone's status. The phrase "which the United States would possess and exercise *if it were* the sover-eign of the territory" sparked immediate criticism by US anti-expansionists. Did this mean that the United States was sovereign in the Canal Zone, or not? What definition of sovereignty followed from such language?

I argue that the Panama Canal Treaty split sovereignty along the lines of ontol-ogy and performativity (being and doing)—and thereby made the treaty not a performative utterance, but rather what I term a *subjunctive* utterance, by virtue of the subjunctive mood expressed in Article III, paraphrased as: "The United States shall behave [as] if it were sovereign in the Canal Zone." Subjunctivity was situated at the core of the Panama Canal Treaty, making the treaty perform "as if." The subjunctive mood is part of a semantic category called *irrealis*, which marks "counterfactivity or emphatic non-factivity," and may be defined as the inability

to commit to the reality of a situation.[13] Crucially, the subjunctive is a defining mood of performance, as I address in the following pages. The treaty's use of the subjunctive mood allowed Panama to retain sovereign power (labeled "titular sovereignty" in US-Panama diplomacy) while granting the United States the ability to perform sovereign acts. The treaty thus distinguished the performance (or carrying out) of sovereignty from its ontological and even metaphysical qualities. This self-division allowed the United States to treat Panama as an independent, sovereign nation-state *and* a dependent "ward" under US trusteeship.

The *subjunctive sovereignty* set forth by the Panama Canal Treaty destabilized the treaty as a legal document and a performative utterance, and marked the terrain of the Panama Canal Zone for decades to come. In lieu of clear frameworks of sovereignty and citizenship, performances materialized the Canal Zone as a shifting mise-en-scène, opening the Zone's discursive and physical terrain to competing interpretations and claims by US and Panamanian governments, as well as assertions of belonging by local residents and labor migrants. As political theorists Joshua Chambers-Letson and Yves Winter observe, sovereignty "functions as a norm of political life that, like any norm, requires continuous affirmation through rituals and theatricality in order to sustain its prescriptive force."[14] *Sovereign Acts* addresses a near-century of rituals, theatricality, and performances in, around, and about the Panama Canal Zone. In pageants, parades, US federal holidays, blackface minstrelsy, opera concerts, popular entertainments, salsa, and nationalist theatre, artists, impresarios, administrators, activists, and audiences addressed questions of sovereignty and citizenship.

These performances, spanning the Zone's creation in 1904 to its reversion (1979–1999) into its postsovereign present, have engaged questions around citizenship and belonging, imperialism and the nation-state, labor migration, race, neoliberalism, globalization, and the meaning(s) and uses of sovereignty itself. These performances were rooted in the Zone's spectacular landscaping and architectural layout, which resembled an imperial enclave. Prominently situated US flags reinforced a scenographic display of US empire, nationalism, and colonialism. Yet these symbols signified differently to US citizens, Panamanians, and West Indian labor migrants. The Canal Zone's vexed sovereignty status influenced which bodies were allowed into, and excluded from, the Zone, and how residents and employees created identities and social networks. Workers and inhabitants in the Canal Zone were ambivalently interpellated in the legal borderland: white "Zonians" were US citizens but had no voting rights in the allegedly "authoritarian" Zone; the majority of Canal workers, recruited by the US government from the West Indies, were not citizens of the United States, the Canal Zone, or, for a considerable duration, Panama. The Zone's extensive educational, religious, and labor institutions, as well as its social and recreational facilities, were built by and imported from the United States. In lieu of a

definitive rendering of sovereignty, the Canal Zone "performed" multiple styles of sovereignty throughout its existence on the isthmus.

"THE EQUIVALENT OF SOVEREIGNTY"

Just after Panama's revolution, critics in the United States and on the isthmus decried Theodore Roosevelt's aggressive actions in Panama. One opponent, Leander T. Chamberlain, summarized critical sentiment, calling the events in Panama "a chapter of national dishonor."[15] Many pointed out the hypocrisy of the United States, a self-identified democratic republic, in trampling the sovereignty of other American republics.[16] Specifically, US critics blasted Roosevelt's disregard for Colombia's sovereignty, which the United States had pledged to uphold in the 1846 Bidlack-Mallarino Treaty but violated in 1903.[17] Responding to these critics, Roosevelt defended the sovereignty clause by noting that the United States was not claiming sovereignty, but rather "the equivalent of sovereignty," in the Canal Zone.[18] But this did not resolve the question. Rather, critics demanded to know what sovereignty's "equivalent" was, given the standard definition of sovereignty as "absolute authority over a territory occupied by a relatively fixed population and recognised as sovereign by other sovereign states."[19]

As political theorist Wendy Brown notes, sovereignty's "indispensable features include supremacy (no higher power), perpetuity over time (no term limits), decisionism (no boundedness by or submission to law), absoluteness and completeness (sovereignty cannot be probable or partial), nontransferability (sovereignty cannot be conferred without canceling itself), and specified jurisdiction (territoriality)."[20] US critic Joseph Freehoff blasted the "one-sided" treaty, which "vitally impaired" the substance of sovereignty and stained US national honor.[21] Freehoff wrote that the Panama Canal Treaty erroneously "distinguish[ed] between *de jure* and *de facto* sovereignty. The one is nominal sovereignty; the other is actual sovereignty. Nominal sovereignty may be held in suspense while actual sovereignty is being exercised by a foreign power for a consideration. Panama is at present the *de jure* sovereign of the Canal Zone. The United States is the actual sovereign. . . . *De jure* sovereignty is in suspense—it is not exercised."[22] Chambers-Letson and Winter show sovereignty to be performative in the Austinian sense, in that it "relies on recognition: sovereignty presupposes a felicitous claim, on behalf of an agent or polity, to supreme political authority."[23] Performative utterances are "verbal performances that take place within highly codified conventions," whose "power stems from the legitimacy [vested] in authorized social actors . . . (the priest, the judge)."[24] Freehoff's critique revealed the doubling of sovereignty, and he continued to deploy performance metaphors in deriding Panama as a "sham" nation, and labeling Panama's secession from Colombia an "opera bouffe revolution" and "The Vaudeville

Revolution on the Isthmus."²⁵ Freehoff's invocation of popular entertainment, intended to dismiss the isthmian coup, in fact called attention to the treaty's framing of sovereignty as performance—a quality that merits attention, apart from his intended slights.

As may be gleaned from Freehoff's entertainment metaphors, US commentators on both sides of the issue gave little credence to the fact that an independent, sovereign nation-state had been brought into being in 1903, in part through performative "language that enacts." While defending Colombia's sovereign rights, nearly all US critics underplayed or ignored the legitimacy of Panama's separation, despite the isthmus's long history of secessionist movements, sentiments, and nationalist ideologies.²⁶ Panamanian leaders, indeed, were dismayed at the reception of their nation as an "invention" of the United States. Since gaining independence from Spain in 1821, political and economic elites on the Panamanian isthmus had developed a distinct political ideology centering on liberalism, free trade, local sovereignty, and federalism. While desiring independence, these elites did not envision sovereignty solely in nation-state form; rather, they sought to balance independence with the protection offered by connection to a larger sovereign body (conceived as federalism), and local jurisdictional authority with administration of a neutral and "universal" transit route.²⁷ Groups on the isthmus had attempted to secede from the central government of Nueva Granada (Colombia) on several occasions.²⁸ While some sought self-rule, others proposed the creation of a "Hanseatic" trade entrepôt to facilitate transnational commercial flows while sustaining the local government and economy.

After the Panama Canal Treaty's ratification, many Panamanians recognized, with alarm, the colonial relationship into which they had entered. Panama's foreign minister, Francisco V. de la Espriella, condemned Bunau-Varilla's self-aggrandizing actions and lamented the Panama Canal Treaty's "manifest renunciation of sovereignty" in the Canal Zone, and potentially additional lands on the isthmus, to the US government's right of eminent domain.²⁹ In 1904, Panamanians' anger over the Canal Zone's special tariffs and postal services spurred a diplomatic crisis. Critics in Panama subsequently seized upon the treaty's performative and subjunctive language. Already riddled with semantic ambiguities in the original English, the treaty was hastily translated and published in Panama on December 15, 1903. To some observers, the translation garbled the subjunctive mood of Article III, the sovereignty clause, by translating it as: "las cuales *poseerán y ejercitarán* los Estados Unidos *como si fuesen soberanos* del territorio en dichas tierras y aguas" ("[rights] which the United States *will possess* and *will exercise as if it were sovereign*").³⁰

In 1927, the Panamanian government sought to resolve semantic and grammatical tensions by issuing a revised translation of the treaty, meant to replace the

earlier "defective" version. The revision clarified the government's interpretation of the sovereignty clause as an "implicit negative conditional," which required a construction that better highlighted the fundamental *uncertainty* of sovereignty in the Canal Zone: "[...] los derechos, poder, y autoridad que los Estados Unidos *poseerían y ejercitarían si ellos fueran soberanos*." ("[...] the rights, power, and authority that the United States *would* possess and *would* exercise *if [it] were sovereign*").[31] The conditional (*poseerían, ejercitarían*) and subjunctive mood (*si ellos fueran*), taken together, indicated Panamanians' interpretation of the treaty as authorizing subjunctivity. In Spanish, the subjunctive mood—demarcated by its distinct verbal conjugation—occupies a central role in language and enables a wide range of semantic considerations.[32] In the revised treaty translation, however, the subjunctive mood signaled the government's link between the Panama Canal Treaty's use of the subjunctive—"as if it were"—and the mood of *irrealis*. In English and Spanish alike—languages with very different manifestations of subjunctivity—the treaty's "as if" proved the unprovability of sovereignty in the Canal Zone.

TREATY-MAKING, SOVEREIGNTY, COLONIALISM

The 1904 Hay-Bunau-Varilla convention is far from the only treaty to confer subjunctive sovereignty. While a treaty would seem an ideal example of a performative utterance—as a covenant, often crafted verbally and subsequently consolidated in writing, that authorizes transactions and scripts future relations—treaties constitute textual and legal borderlands, rife with performative misfires and the opacities of the embodied encounters that motivate(d) them. Like the "fine print" that ostensibly allows for voluntary agreement and excludes those who do not sign on to its "terms and conditions," treaties function as textual props that retroactively anchor legal consent that was, in fact, often coerced or "posthegemonic."[33] If faced with genocide, colonization, and loss of land, coerced consent might be a signatory's only option—but this does not make it a decision in any real sense of the concept. The embodied exchanges and encounters that inform and issue from the conditions of treaty-making accrete "performing remains" that continue to haunt their materializations.[34] In this regard, the Panama Canal Treaty can be located within a long trajectory of European and North American treaty-making fraught with linguistic confusion and dissimulated intentions, in which colonial powers knowingly bent legal language to serve aims of conquest.

Colonial treaties emerged from trade agreements and charters, which allotted "trading companies ... sovereign rights over non-European peoples who were deprived of any sort of sovereignty."[35] The involvement of European states in treaty-making seemed to change the terms from exploitation and extraction to "order, proper governance, and humanitarianism."[36] As political theorist Taiaiake

Alfred observes, "European sovereignties in North America first legitimated themselves through treaty relationships entered into by Europeans and indigenous nations."[37] Treaties made by the Dutch, French, and British governments "all contain explicit reference to the independent nationhood of indigenous peoples."[38] Colonialism relied heavily on treaties to justify imperialist expansion within international law, even while nineteenth-century legal theorists argued that "treaties with non-Europeans were impossible."[39] The colonial encounters out of which treaties emerged did not transpire between sovereign states, but "between a sovereign European state and a non-European state that, according to the positivist jurisprudence of the time, was lacking in sovereignty."[40] Yet the treaties that buttressed the legality of empire represented their signatories as sovereign entities, capable of entering into legal relations. This paradox structured the co-constitution of colonialism and international law, showing sovereignty to be a necessary (albeit subjunctive) condition that enabled colonialism to proceed largely unfettered by moral critiques about rights violations. While treaties protected European and North American colonizers from legal sanctions, these legal amphibolies also necessitated new doctrines and norms "for the purpose of defining, identifying, and categorizing the uncivilized" and governing racial "others."[41]

Nation-state status became a determinant of a group's ability to claim sovereign rights within legal positivism. Treated and traded with as "nations" by early North American settlers—within a limited definition of nationhood provided by contemporaneous European international law—indigenous peoples were further downgraded to the status of wards, or "uncivilized" peoples outside of the law, in the nineteenth century.[42] Thomas Jefferson's denomination of the "Empire of and for Liberty" crowned the imperative to expand, mapping territories that would ultimately become states, a process set out by the Northwest Ordinance of 1787.[43] The Cherokee nation deployed its sovereign status to protest ongoing "Indian Removal" before the US Supreme Court; in *Cherokee v. Georgia* (1831), one of several key rulings on indigenous rights and sovereignty, Chief Justice John Marshall declared indigenous peoples not foreign states or nations, but "domestic dependent nations"—wards of the US federal government.[44] This shift in status effectively set the stage for the state's complicity in settler and military violence against indigenous peoples, and the US government's abolition of treaty-making with indigenous peoples in 1871. It also revealed the importance—and manipulability—of nation-state status in US foreign/domestic policy. Another crucial site of foreign/domestic blurring occurred in the US-Mexico War (1846–1848), as the US government gained half of Mexico's territory.[45]

The incorporation of the foreign into the domestic—the colonization of Mexico's sovereign territory by US settlers and then the state—was linked to

events on the Panamanian isthmus.[46] In the nineteenth century, many Latin American republics gained independence from Spain, asserted nation-state sovereignty, and developed republican structures of governance. Their political leaders crafted interpretations of "Latin" identity and regional alliances to protect their nations from US imperialism, expansionism, and marauding white vigilante filibusters.[47] When gold was discovered in the future state of California, the Panamanian isthmus proved a key site of transit, ferrying prospectors on the Panama Railroad, through the territory of a foreign sovereign nation, Nueva Granada.[48] While Nueva Granada feared that the US government sought to annex its territory, as it had large portions of Mexico, in fact US officials and the Panama Railroad Company sought control over the railroad's passageway and profits, "interoceanic commerce," not territorial annexation or colonial governance.[49] This agenda was concurrent with "strategies of empire that the United States had pursued earlier in Central America and East Asia, including the creation of treaty or free ports in which local sovereignty was curtailed or eliminated altogether in order to facilitate US economic and military interests."[50] The Panama Railroad Company's officials constructed an enclave in the port terminus of Colón to "remov[e] the transit zone from the control of the nation that surrounded it."[51] They preferred "[a] weak foreign government that left the company alone to do its business."[52] This sentiment partly presaged the Panama Canal Zone's design, as an enclave that subsumed the Panama Railroad's terrain, removed from Panama's national sovereignty and under US control.[53]

Moreover, although the United States was obliged to defend the sovereignty of Nueva Granada and the neutrality of the transit zone, many US pro-expansionists interpreted this mandate as the ability to police local political groups on the isthmus, to "maintain order" and secure US assets.[54] In 1903, the US government violated Colombian sovereignty and the neutrality of the railway, preventing the nation's soldiers from traversing the isthmus, in service of Panama's revolutionary junta. Yet these actions could still claim allegiance to the US government's aversion to territorial annexation: the United States did not desire to be sovereign in the Canal Zone, but to behave "as if" sovereign. While US critics of Panama's separation alleged a major break with previous approaches to sovereignty, many continuities may also be observed. The history of US involvement on the isthmus demonstrates that subjunctive sovereignty has long attended relations among US officials, agents of global commerce, and isthmian political leaders.

The 1903 Panama Canal Treaty located the isthmus simultaneously within the history of Latin American nation-building and post-1898 US expansionism and empire.[55] Five decades of US interest in carving a canal through the isthmus converged with a new imperial program, in which subjunctive sovereignty formed a key component. In the 1898 Treaty of Paris, the United States acquired

the Philippines, Guam, Puerto Rico, and temporary control of Cuba from Spain; while administering these colonies, the US government made leases, contracts, and quasi-treaties, creating zones of subjunctive sovereignty to serve US military and trade interests. The US government's stated goal was to enable Spain's former colonies to become autonomous, while engaging in "expansion without annexation." As Christina Duffy Burnett observes, these actions "intensified a debate . . . over whether the United States could, consistent with its Constitution, embark on a quest of global expansion and create a colonial empire to rival those then being amassed by European powers."[56] The US Supreme Court's *Insular Cases* (1901 and following) created "a new kind of US territory: a domestic territory that could be governed temporarily, and then later, if necessary, be relinquished."[57] The Panama Canal Zone formed part of this "unincorporated territory": in the Canal Zone, the simultaneous presence and absence of sovereignty produced a legal borderland, or what I term a "state of exceptionalism"—so called because the Zone's sovereignty status was symptom and product of the United States' exceptionalist imperialism.

The legal subjunctives that emerged from "expansion without annexation" required—and require—"ritual practices" to "stage and reciprocally confirm" their "sovereign statuses."[58] Performances verify the material impacts of sovereignty as a "territorially bounded political form."[59] Sovereignty takes shape before our eyes in territorial mises-en-scène, even as it is abstracted in international law. Yet the histories of the Caribbean and indigenous Western Hemisphere remind us that "sovereignty" can take many forms. Like a filmstrip out of sync with its soundtrack, communities and polities do not map neatly onto nation-states, and can productively trouble and expand the concept of the post-Westphalian nation-state, even as the latter has come to dominate the geopolitical landscape of international relations.[60] While *Sovereign Acts* focuses on sovereignty in and around the Canal Zone, we must also take into account the losses of indigenous sovereignty that nation-state sovereignty entailed on the isthmus, and past and present clashes between indigenous peoples and Panamanian nationalists.[61]

As Puerto Rico's current debt crisis makes clear, pressing questions around sovereignty and US empire persist. Puerto Rico is still ambiguously stranded between statehood and colony status, while Guantánamo's famously ambiguous status continues to leave those deemed "enemy combatants" in legal limbo. These examples, as well as ongoing settler-indigenous sovereignty clashes, attest to the need to frame sovereignty in the language of performance, subjunctivity, and "as if." Contestations over the US imperial project's reconstruction of sovereignty are far from distant or past: rather, they undergird lives, giving shape to inclusions and exclusions, defining citizenship and belonging. If the United States exercised subjunctive sovereignty in the Panama Canal Zone, Panamanian protesters responded in kind, with site-specific protests staging the Zone

"as if" it had been reverted to Panama. I discuss one such performance, the Flag-Sowing (Siembra de Banderas), at the end of the book. At times "as if" symbolic displays of Panamanian sovereignty tipped over into real violence, as in the deadly Canal Zone protests of 1964. In addition to these overt displays of the US-Panamanian sovereignty conflict, however, *Sovereign Acts* addresses myriad performances that staged alternative interpretations and implications of sovereignty for workers, residents, and soldiers.

PERFORMANCE, PERFORMATIVITY, SUBJUNCTIVITY

Sovereign Acts chronicles the ways that sovereignty has taken shape in and as legal norms and aestheticized, social, and spectacular performances. Indeed, the subjunctive mood, "as if," occurs frequently in theatre and performance. For Russian theatre theorist and practitioner Konstantin Stanislavski, "as if" (or the "Magic If") is a primary condition for enacting a role, juxtaposing the actor's emotional resources with the "given circumstances" of the character. Stanislavski tells actors to ask themselves: "What would I do *if* certain circumstances were true?"[62] The transmutation of an actor into a character incorporates "real" emotional and physical sensations, as well as illusion, pretense, and incredulity.[63] Stanislavski observes that the affects stimulated while an actor inhabits a state of subjunctivity can be, in themselves, quite real; therefore, performance has the capacity to destabilize, through affective and phenomenological processes, any sense of an ontological "real." As performance scholar-practitioner Richard Schechner affirms: "The tears Ophelia sheds for Hamlet are actual, hot, and salty, but her grief is subjunctive."[64] Subjunctivity's "as if" indexes theatre's duality: onstage, an actor can be both a physical, living human and a fictive figment (King Lear, a ghostly apparition, a nonhuman entity, or what you will).

As in the relationship between character and actor bodies, even the most all-encompassing spectacle cannot erase the materiality that contains it, and which it contains. A mise-en-scène can be "fair Verona" while exuding a concrete, phenomenal here-and-nowness. Subjunctivity lends theatre that which Colin Counsell calls its "uncomfortable" duality: the overlap of materiality (the actor's body, the apparent artificiality of props and scenery) with the symbolic, semiotized, and fictive.[65] This doubleness, at the heart of the injunction to "suspend disbelief," in fact never disappears; rather, a spectator chooses to attend to it, or not. Performances, particularly in Brechtian and postdramatic traditions, often play with this gap, expanding and collapsing the distance between fiction and "real" into a fuzzy, fluid interzone that allows for the production of new possibilities— not only the leakage of the "real" into the fictive arena, but a blurring of the two, or a reverse flow. Subjunctivity has been the vehicle of many theatrical interventions, playful and political: Bertolt Brecht, for example, brought subjunctive

elements of the rehearsal process onto the stage by "ask[ing] his actors to be in character ('is') most of the time but sometimes to stand beside their characters ('as if'), questioning the very actions they were performing."[66] Sometimes the fictive world seeks to subsume or negate the supposedly "real" one, while at other moments, the material world is designed to peek through.

The subjunctive "as if" recalls anthropologist Victor Turner's theorization of liminality as a betwixt-and-between state of hierarchical sub- and inversion. Turner locates subjunctivity at the core of liminality: the liminal is "dominated by the subjunctive mood of culture, the mood of maybe, might-be, as-if, hypothesis, fantasy, conjecture, desire."[67] In Turner's ritual process, liminality follows from schism (social separation) and leads to social reintegration, within a dialectic of structure and *communitas*.[68] Schechner takes up the linkage of liminality with subjunctivity, positioning subjunctivity as a defining feature of performances across a "broad spectrum" of ritual, cultural performance, and theatre.[69] For Schechner and Turner, the subjunctive "as if" momentarily suspends the "cognitive schemata that give sense and order to everyday life."[70] Schechner frames performance as "restored behavior," strips of action that can be isolated from a "doer" and transmitted through embodied pedagogies. Restored behavior is fundamentally "subjunctive," full of possibilities and alternatives, "as ifs." "As 'second nature,' restored behavior is always subject to revision. This 'secondness' combines negativity and subjunctivity."[71] Schechner understands subjunctivity as a kind of overriding "performance consciousness" that "activates possibility: 'this' and 'that' are both operative simultaneously. [. . .] [P]erformance consciousness is subjunctive, full of alternatives and potentiality. During rehearsals, especially, alternatives are kept alive, the work is intentionally unsettled."[72]

Subjunctivity is, for Schechner, less visibly present after the multiple alternatives explored in rehearsal have been smoothed into a streamlined "performance logic." Yet even as performances distill multifarious shards of activity and strips of restored behavior that have emerged and congealed in rehearsal, subjunctivity remains central to performance. I would argue that traces of subjunctivity are always embedded in the supposedly finished, indicative performance. From rehearsal to performance, disparate elements of the past make their way (or are thrown forward) into a future "project coming into existence."[73] Schechner states that beneath the indicative "is" of the performance text, "a more or less invariable presentation of what's been found, kept, and organized," lies an "as if," which constitutes the performance's deep structure.[74] The interpenetration of indicative and subjunctive realms makes theatre a place of semic instability, such that "even the shot that killed [Abraham] Lincoln, for a split second, must have seemed part of the show."[75] Foregrounding phenomenological practices of reception can allow for the emergence (or intrusion) of subjunctivity into even the most seamlessly sealed and cauterized performance logic.

Moving subjunctivity out of the theatre, many performance scholars and practitioners approach states of "as if" as politically liberating, making possible new and complex orientations that include both "what is" and "what could be."[76] For Turner and Schechner, subjunctivity can impose "a framework for symbolically experiencing possible ways of articulating social life."[77] Performance scholar Diana Taylor highlights "as if" and "what if" as tenors of political action that authorize (im)possible futures.[78] Theater practitioner and activist Augusto Boal goes further, making utopian subjunctivity central to social transformation. While theatre conjugates reality in the present tense, indicative mood, "in the Theatre of the Oppressed, reality is conjugated in the *Subjunctive Mood*, in two tenses: the *Past Imperfect*—'what if I were doing that?'—or the *Future*—'what if I were to do this?'"[79] Boal contends: "We have to be Subjunctive. Everything should be 'what if,' because everything can come to be. Subjunctive—that's the word! [. . .] The Subjunctive Method is the reinstatement of doubt as the seed of certainties. It is the comparison, discovery and counterposition of possibilities, not of a single certainty set against another, which we have in reserve. It is the construction of diverse models of future action for a particular given situation, enabling their evaluation and study. We should never say, 'Do this or that!' but rather, 'If we did this or that, how would it be?'"[80]

Similarly, Taylor asserts that the artist-activist's role is to embody "as ifs" and "what ifs," and thereby open "liberating and progressive pathways to social reinventions, amplifying the limits of the political imagination."[81] Taylor asks what happens when performative covenants fail, and "animatives" (mass embodied movements formed around affects) take their places.[82] Animatives do not enact or change laws, but they announce participants' emotional attachments and refusals, allowing people to live "as if." In "The Politics of Passion," Taylor describes a mock swearing-in ceremony for Mexican presidential candidate Andrés Manuel López Obrador (AMLO), who did not win the 2006 election but, in the eyes of many, should have. This inauguration intentionally "misfired" (to cite Austin's concept of a performative "misfire") because AMLO "did not have the recognized authority to enact the claim." But the misfire was not "without effect," as Austin would allege; rather, it "worked to question the authority of the 'official' decision."[83] The inauguration ceremony was explicitly *not* a performative act working to "bring about the very reality that it announce[d]," but was rather a disruptive subjunctive, which "offered another framework for envisioning a way forward by calling attention to the [actual election's] sham and imagining alternative, plausible futures."[84]

Critical race theorist Anne Anlin Cheng distinguishes performance, "with its traditional assumptions of agency and will," from performativity, the "reiteration of a norm or a set of norms," an act "not primarily theatrical" but made to seem so because "its historicity remains dissimulated," producing the subject as "originator of his/her effects."[85] Cheng asks whether "performance [can] ever

disturb performativity," thereby implying a degree of agency, and posits oscillating "moments when performance outstrips performative constraints and vice versa."[86] I would affirm that performance does not dislodge performativity's norms, but subjunctivity allows for productive acts of skewing and alienating performativity. The stage (existing within or beyond a built theatre space) affords permission to slip into, out of, and among diverse fictive worlds, troubling and dematerializing the purportedly "real" world along the way. Far from being "parasitic" upon performativity, as in Austin's dismissal, performance allows for reassessment, challenge, and deconstruction—the radical reenvisioning of a norm through a critical staging of it.[87] Through the medium of the body, and the interplay of concrete and abstract qualities, performances can cite norms disparately, purposively, and with the aim of critiquing or setting askew conventional behaviors and even performative gestures that accrete to social constructions, such as gender. In other words, subjunctivity can, if momentarily, interrupt performativity. As Taylor argues: "Political *as ifs* create a desire and demand for change; they leave traces that reanimate future scenarios."[88]

Subjunctivity has the potential to enact its politically and aesthetically distorting, scrambling, or world-making work at the locus of the spectator. The interpenetration of subjunctivity and performativity offers shifts in perspective—the possibility of transforming spectators' perceptions of that which they might take for granted as "real," or guiding audiences into the realm of utopian world-making. Taylor asserts that "there is nothing inherently passive about spectatorship"—a statement with which I agree.[89] She argues: "Political performances make dissent visible. Protests, acts of civil disobedience, strikes, marches, vigils and blockades challenge the spectator to assess the situation, think critically, and maybe even take sides."[90] Yet spectatorship is heterogeneous and unstable. Reception is fractional and perspectival, shifting, static, distracted. As performance scholar Thea Brejzek suggests, given spectators' "individualistic and dynamic" viewing practices, publics observe the world "from multiple perspectives," even if in a theatre they "for[m] one entity."[91] Theatre audiences are situated both in and outside of performance: while participating in the event, their "roles" might be to make themselves into semiotic voids, or to carry on social activities divorced from the stage action. A spectator can also separate herself by retreating into an internal theatre of thought, experience, and intertext. Spectators can extract information based on partial and transitory viewing practices, attaining diverse perspectives—an elaboration of the practice that dance scholar Susan Manning calls "cross-viewing," in which spectators access each other's viewing practices, exchange gazes, and potentially gain insight into distinct subjectivities.[92] While performances allow for heterogeneous viewpoints and ways of seeing, however, spectators may not avail themselves of a diversity of perspectives and viewing strategies. The spectator's view changes depending

on one's position, as theatre scholar Marvin Carlson observes; an individual's viewing practices are determined by economic and social hierarchies, racial and cultural factors, gender and sexuality, and a host of other considerations. Carlson provides an example of spatial hierarchizing, noting that one-point perspective on the Renaissance stage afforded the sovereign a central, optimal view. At the margins of the mise-en-scène, objects onstage were grossly distorted and dispro-portionate.[93] Spectators may not possess the opportunity for a rich view.

Just as early modern perspectival displays connected spectators' bodies with their positions relative to sovereignty, so different modes of viewing elicit dis-tinct affective and ethical connections to that which is on display. I would extend the analogy and practice of theatrical reception to the imagined and symbolic "stage" of the nation, and its public, private, and hybrid spaces. If performance can illuminate and bring into being multiple realms, then space can become "a social relation," in critical geographer Henri Lefebvre's terms.[94] Might the spec-tator's positioning in the event allow for the disclosure of sovereignty in and as performance? While knowing that a site might possess one "supreme [sover-eign] authority," we can conceive of it *scenographically*, as a stage on which mul-tiple sovereign claims are exercised simultaneously—and as an aesthetic and social milieu that "takes place," and takes up space, through critical practices of seeing and showing.[95]

Groups and individuals can embody a sense of citizenship, belonging, and inclusion—or exclusion, and that which theorists Sandro Mezzadra and Brett Neilson term "differential inclusion"—through viewing practices that "nationalize" or, alternately, exile them.[96] A distorted view, conditioned by a spectator's position as outsider or outlaw, may nonetheless afford insights not attainable from a centralized position vis-à-vis the national stage. Alterna-tives to citizenship, and shades within it, are inevitably present in these acts of reception, troubling the idealistic grounds on which theorists connect spectat-ing practices to acts of empowerment and belonging. Citizenship, after all, is tenuous and gauzy even when legally conferred, capable of being overridden by distinctions like "terrorist," "criminal," "ex-convict," and "enemy combat-ant." The permeability of citizenship, and its potential for rupture by a sov-ereign decision, force us to acknowledge not only the fluidity of the borders between citizen and noncitizen, but also the existence of other statuses beside and within citizenship: for example, the alien, the ward, and the imperial sub-ject.[97] Positioned outside of citizenship are the stateless person, migrant, refu-gee, exile, and outlaw.

Sovereignty's mise-en-scène disparately enfolds spectators into the view-ing practices of the (non)citizen subject and that which I am calling the *sub-junct*—a status between citizen and noncitizen. The *subjunct*, a syntactical term, constitutes an interstitial zone between inclusion and exclusion. A subjunct is

defined as an adverbial or propositional clause subordinate and non-integral to a sentence's main clauses; a subjunct can be included in or excluded from a sentence without altering the sentence's basic structure. Yet the subjunct shades and nuances the sentence: "He walked to school" versus "He walked quickly to school," for example. The subjunct, expressing "viewpoint, emphasis," and other shades of meaning, parallels the indeterminacy of inclusion and exclusion in a political framework.[98] The necessity of the subjunct for meaning-making is dependent on the user's judgment. Likewise, within citizenship there exist subjuncts—constituencies who possess the imprimatur of "citizen" but who are not guaranteed accompanying rights and protections. Subjuncts are citizens framed as both integral and non-integral—at times included, on other occasions shunned. The existence of subjuncts questions the very definition of inclusion by incorporating deliberation into acts of meaning-making. The subjunct can be expendable or not, depending on sovereign will.

OPERATION SOVEREIGNTY AND THE FLAG-SOWING

In Panamanians' attempts to reclaim the Canal Zone in performance, acts of site-specific protest conditioned the emergence of citizens and subjuncts in spaces that functioned scenographically to assert sovereignty, over and against its contestation. Particularly at midcentury, Panamanian nationalist activists utilized subjunctive practices to enact alternate claims to the Zone. Two key protests, "Operation Sovereignty" (Operación Soberanía, May 2, 1958) and "Operation Flag-Sowing" (Operación Siembra de Banderas, November 3, 1959), mobilized dozens of students to march into the Canal Zone and plant roughly seventy-five Panamanian flags in the soil.[99] Dancing to folkloric music and dressed in *traje típico* (traditional costumes), students and nationalists knelt and planted small flags into the soil at a key site of US dominance in the Canal Zone (see Figure I.3, which shows a similar protest). The flags contrasted with the Zone's architectural scenography of empire and imprinted the terrain with an overt marker of Panama's sovereignty claim.

Operation Sovereignty was peaceful, but its successor event, the Flag-Sowing, crossed over into violence: Canal Zone police attempted to repress the action with hoses, tear gas, and clubs, while Panamanian protesters threw rocks and defaced infrastructure. Dozens were wounded in the 1959 confrontation, which anticipated one of the most violent clashes between Panama and the United States: the 1964 Canal Zone flag protests left roughly twenty-five dead and hundreds wounded, and caused vast property damage. I will return, at the end of the book, to a discussion of Panama's annual commemoration of the Flag-Sowing, which reperforms selected facets of its site-specific engagement with the terrain of the former Canal Zone, now held by Panama. Despite

FIGURE I.3. Student demonstration against US control of the Panama Canal Zone.
May 1, 1960. (Photo by Frank Scherschel/The LIFE Picture Collection/Getty Images.)
#50563674.

the fact that the Flag-Sowing turned violent, both Operation Sovereignty and
the Flag-Sowing used metaphors of cultivation to *im*plant Panamanians' claims
of sovereignty into the Zone and *sup*plant the US flags raised at key points in
the Canal Zone. These events garnered international press attention in unprec-
edented ways, including iconic *Life* magazine images of people marching and
scaling the border with flags in hand (Figure I.4 depicts a moment in the 1964
protests).

 While US government rhetoric sought to portray relations with Panama as
friendly (as in the US Army's "Operation Friendship" project, labeled a great
success in 1960), site-specific protests in and around the Zone represented a
different picture of events and ultimately helped mobilize support for efforts
to revert the Canal Zone to Panama.[100] The protests of the 1950s and 1960s
gained the attention of global audiences in mass media transmissions, becom-
ing the most accessible reference points in a longer, more complicated geneal-
ogy of sovereign performances in and around the Panama Canal Zone, from
the Zone's creation by treaty in 1904 to its dismantling in 1999. *Sovereign Acts*
addresses a specific geographical site of sovereign contestation, yet hopefully
the questions that this book raises, and the methodologies employed, will res-
onate with tensions transpiring at other sites of contested sovereignty across
the globe. A performance-oriented investigation of isthmian sovereignty per-
mutations enables us to explore the changing ways that individuals and groups,

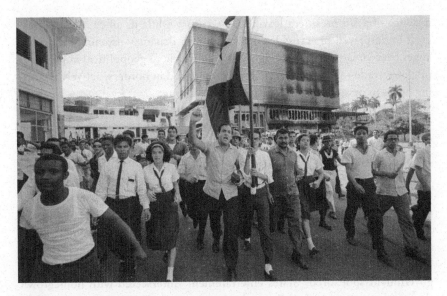

FIGURE I.4. Panamanians march in protest near the Presidential Palace during riots over the sovereignty of the Panama Canal Zone, 1964. (Photo by Michael Rougier/The LIFE Picture Collection/Getty Images.) #453616761.

citizens and noncitizens, have conceptualized and performed nation-state sovereignty, in articulation with racial categories, Third- and First-"worlding," differing modes and scopes of citizenship and belonging, concepts of nation, and imperialism and geopolitical ties. The instability of the Canal Zone, as legal territory and labor colony, spawned desires and demands to envision and articulate US and/or Panamanian territory in performance.

CHAPTER OUTLINE

Performances, as strategic resources to redefine sovereignty in the Canal Zone, were not limited to designating "national" space, as in the well-known instances above. Chapter One, "Sovereignty's Mise-en-scène: The Necessary Aesthetics of New Empire," explores political aesthetics in the Canal Zone's architecture, landscape, and the 1906 diplomatic tour of US president Theodore Roosevelt. Commencing Panama Canal construction in 1904, the US government recruited thousands of workers and confronted challenges of housing, feeding, and governing the labor force. As the Canal Zone became a permanent labor colony, discourses of "necessity" were deployed to distinguish the Zone from a European-style imperial colony, even as architects and engineers developed designs that cited Spanish, French, and British colonial structures. Construction was spurred by the 1906 visit of Roosevelt—the first

instance of a US president leaving US territory while in office. While Roosevelt underplayed his cross-border jaunts into Panama—framing his critics' anger over violations of sovereignty as an obstacle to geopolitical imperatives of global trade—he was, in fact, deeply interested in borders, actively allocating funds to develop and militarize the Canal Zone.

While the first chapter explores the built environment, Chapter Two, "Entertaining Sovereignty: The Politics of Recreation in the Panama Canal Zone," weaves a fine-grained history of Canal Zone residents' social interactions with their environs from 1904 to 1935. Boredom and high wages led to Canal workers' constant excursions into Panama. Canal officials sought to contain these pleasure-seeking border crossings with an elaborate web of entertainments for white US workers—and, to a lesser extent, for West Indians—in the Canal Zone. Drawing upon the US National Archives and Records Administration's (NARA's) records of the Panama Canal Company and the US Library of Congress's Canal Zone collection, I demonstrate how US government-sponsored "States entertainment" intersected with homegrown theatricals to create and challenge the "Americanness" of the Zonians—white US workers in the Canal Zone—and the Zone itself.

Chapter Three, "Beyond Sovereignty: Black Cosmopolitanism and Cultural Diplomacy in Concert," takes up the situation of West Indian workers and their descendants from the 1940s to the first decades of the Cold War. As the Canal downsized at midcentury, many West Indian workers were deported from the Zone and into an uncertain future in Panama. Their citizenship status in question, West Indians and their Panama-born descendants utilized classical music concerts as sites where acts of "diva citizenship" (following theorist Lauren Berlant's formulation) could irrupt into public view. I focus on the activities of West Indian Panamanian concert impresario George W. Westerman, whose papers are held at the Schomburg Center for Research in Black Culture. Westerman organized the concerts of at least a dozen Black opera singers and classical musicians, chiding Panama and the United States to recognize these artists as citizens and cultural contributors. In the concerts, Westerman portrayed West Indians as model candidates for citizenship, in parallel to African American cultural ambassadors like Marian Anderson—even as these divas were often pressed into international circulation due to racism in their home country. The example of Westerman and his divas (and divos) demonstrates the raced and gendered contradictions of subjunctive citizenship in the United States and on the isthmus.

Chapter Four, "National Theatre and Popular Sovereignty: Staging *el pueblo panameño*," is the first of two chapters to focus on Panamanian performances addressing the Canal Zone's contested sovereignty. This chapter takes up Panama's most famous and popular play, *La cucarachita mandinga* (*The Little*

Mandinga Cockroach), which appears as an innocuous musical beast fable but is in fact a potently raced, classed, and gendered anticolonial nationalist allegory. Written by Panamanian avant-gardists in 1937, the play has been staged dozens of times since; I highlight some of the best-known productions funded by Panamanian presidential regimes, the Torrijos dictatorship, and the Panama Canal Authority, to trace the ways that the play has staged critiques in evolving scripts and productions, from 1937 to 2006. During the regime of Panama's General Omar Torrijos, the play, originally a surrealist farce, became increasingly nationalist, Marxist, and anticolonial, overshadowing its earlier subtleties of staging subjunctive sovereignty.

The final chapter, "Staging Sovereignty and Memory in the Panama Canal Handover," addresses two public performances that celebrated the reversion of the Panama Canal to Panamanian sovereignty in 1999. I compare official responses by the US Panama Canal Commission and Panama City's mayoralty, which developed competing visions of the Canal's past, present, and future. Both productions took place in the former Zone, and both sought creative solutions to the question of how to stage popular sovereignty without resorting to a stereotypical ethnos and that which performance theorist Peggy Phelan calls the "trap" of "visibility." The Handover Gala was a massive pageant, staging a multicultural, conciliatory past, with a contestatory twist. The mayoralty's open-air concert by internationally renowned Panamanian artist-politician Rubén Blades traced a sonic trajectory of anticolonial liberation. Both performances were strategically choreographed through behind-the-scenes struggles over the Panama Canal handover's key meanings and implications.

Sovereign Acts concludes with a reflection on performances of sovereignty on the isthmus after 1999 and "after sovereignty." As a site of changing interpretations and ramifications of sovereignty, Panama continues to host contemporary debates about the decline (or resurgence) of nation-state sovereignty, amid globalization, transnational capital flows and financialization, new waves of migration, and transnational movements. These debates have in fact long structured lives and livelihoods on the isthmus. As Panamanian elites in the nineteenth century debated the merits of nation-state sovereignty, proposing alternatives like federalism and a "Hanseatic" mode of governance, "the US empire that [emerged] in Panama . . . was less concerned with control over territory than . . . with the control of the flow of information, people, and capital across the isthmus."[101] Drawing from the foregoing chapters, I demonstrate that understanding sovereignty in and as performance can productively intervene in analyses of sovereignty in international law, even as the geopolitical border that formerly separated the Canal Zone from Panama has transformed into a proliferation of borders, some visible and others not, which not only exclude

and include but also allow for articulation, circulation, and multiplication.[102] Still, performances of nation-state sovereignty continue to structure the former Canal Zone in ways that matter for constituents and visitors. In effect, performances can resurrect national pasts, presents, and futures on contested ground, marking sovereignty as subjunctive in ways that continue to exceed and challenge legal renderings.

1 • SOVEREIGNTY'S MISE-EN-SCÈNE

The Necessary Aesthetics of New Empire

The 1903 Panama Canal Treaty claimed both US sovereignty and its absence. In addition to sowing diplomatic conflicts between the United States and Panama, the treaty shaped the legal and physical structure of the Panama Canal Zone—a 553-square-mile strip of land that treaty makers sought both to define and to leave undefined. In this chapter, I argue that the Panama Canal Zone served as metonym and testing ground for articulations of the reach and limits of US expansionism. I frame the Canal Zone's architecture and design as performing a scenography of subjunctive sovereignty—the appearance of sovereignty lacking enshrinement in law. Both more and less than a US territorial holding—its sovereignty status left purposefully vague—the Canal Zone became a site for debates over how to define, visually and materially, US *imperial difference*. That is, the Canal Zone was made to embody both US empire and the absence of empire, since the Zone was technically designated Panamanian territory. This ambivalent status was instituted in the Canal Zone's built environment and landscape, which sought to combine grandeur and efficacy.

In the following pages, I examine the infrastructure and design of the Zone, and the conditions that brought about its transformation from temporary worksite into permanent enclave. I devote the first section to a close reading of a famous 1906 tour to Panama by US president Theodore Roosevelt (herein "TR"). This tour proved pivotal in mobilizing US public and congressional support for the Panama Canal project through the use of pictorial journalism. On tour, TR's journalistic entourage not only reported on conditions in the Zone—the purported mission of the presidential trip—but also delighted in positioning TR in the landscape as an embodied arbiter of the border, and of the lineaments of US expansion. TR's trip, reverberating in reportage, centralized embodiment: the spectacle of the white-clad, boundary-crossing presidential body. Traversing the isthmus, TR made a significant intervention by framing the Panama Canal not as "Old World"

imperialism (a constellation of ideas that TR sought to link to European monar-
chical sovereignty and colonialism), but as a beneficial political and economic
undertaking, a beacon of technological modernity that would displace archaic
geopolitical modes of conquest. Just as TR was not a "king," the Panama Canal
was not a "colony." Yet for many planners and observers, the Panama Canal Zone
came to look like a colony—a theme that I investigate in the chapter's second half.
Following TR's visit, and the flurry of building that it conditioned, questions arose
over how colonial the Canal Zone could look without becoming "Old World"
imperialism. These aesthetic questions surfaced in the Canal Zone's architecture
and landscape—a built environment that both proposed and subverted US claims
to the Canal Zone, in what might be termed "aesthetic sovereignty."[1]

On tour in Panama, TR staged that which scholar Amy Kaplan labels "New
Empire:" a style of imperialism that engaged aesthetics, engineering, and impe-
rial power to modernize empire-building processes, emphasizing its break with
past styles of imperialism.[2] New Empire, as practiced by the United States,
sought to enact "expansion without annexation" so as to uphold the idea that the
United States was not an imperial power—at least not after the fashion of Euro-
pean imperialism, with attendant restive colonial subjects and sclerotic bureau-
cracy. The United States, as "Empire for Liberty," championed expansion as a
global good, advancing intercontinental trade. In staging New Empire, TR's tour
helped publics in Panama and the United States link the Canal to post-1898 US
expansion, rather than to a longer history of relations with Colombia (in its for-
mer guise as Nueva Granada) that stretched back to the 1840s. This reorientation
of US imperialism was crucial, because it made the act of "claiming the Canal,"
which TR's opponents decried as a wholesale theft of Colombia's sovereignty on
the isthmus, into a seemingly less intrusive move that was not about territorial
conquest but rather "commercial empire," and the apparent inclusion of the isth-
mus in global markets.[3] In this reformulation, the US government's aggressive
facilitation of Panama's revolution was a necessary means to a benevolent end:
improving world communication and interchange by building the Canal.

TR's isthmian tour catalyzed construction in the Panama Canal Zone, and
a concomitant exploration of aesthetic and architectural expressions of New
Empire's values. Yet in designing the Canal Zone, architects and engineers also
recognized the colonial power of beauty and spectacle. The chapter moves from
a close reading of TR's tour to analysis of the Canal Zone's architectural design
and material construction, as both upholding and challenging discourses of
"necessity"—a term that peppers writings on the Canal Zone, and the 1903 Pan-
ama Canal Treaty that created it. Against discourses of its necessity, the Canal
Zone's material landscape showcased contradictions attending US imperial
expansion after 1898, as discussed by engineers, policy makers, and architects. An
enclave housing thousands, the Canal Zone became a test site for the conversion

of the 1903 treaty's terms into a material, embodied, and lived environment for civilians, military personnel, laborers, and families from the United States, Europe, the West Indies, and Panama, among other locales.[4] To control these populations, the US government and the Isthmian Canal Commission (ICC), the Panama Canal's administrative body from 1904 to 1914, created a "moral architecture" in the Canal Zone, crafting aesthetically pleasing architecture and landscaping, civic institutions, and salubrious entertainments.[5] Below, I probe aesthetic and representational dimensions of this "moral architecture," primarily in its built environment, while Chapter Two discusses the popular amusements and recreational activities that composed the Zone's "moral architecture"—a program to entertain workers in service of labor regulation and social control.

At the turn of the century, US pro-expansionists framed the government's actions not as a program of territorial annexation and colonial administration but as a means of liberating world trade and extending a US civilizational mandate.[6] According to these proponents, while the actions of the United States might resemble the territorial annexation of the British Empire, the US government was in fact engendering a distinct form of imperialism that would produce a different kind of rule.[7] Showcasing a strong naval fleet, US New Imperialists sought to "open" global spaces rather than close off frontiers, endorse commercial expansion without territorial annexation, and create strategic access points to international trade and military conduits.[8] A strong current of exceptionalism underlay this pro-expansionism: as the logic of exceptionalism reasoned, given the democratic formation of the United States, US empire-building could not operate along the lines of "Old World" Empire, but would be distinct, supposedly respecting the sovereignties of other nations while seeking certain kinds of access to them. Exceptionalism construed the United States "as the fulfillment of the national ideal to which other nations aspire."[9] Imperialism, then, involved discourses of self-government and autonomy for the nations that the US government occupied after 1898. In the exceptionalist formulation, US New Empire looked like imperialism but was not, while also being "not-not" imperialism, embodying a framework of double negativity developed by Richard Schechner after D. W. Winnicott.[10] Evoking performance's subjunctivity, or the liminal status of the transitional object, US imperialism resembled (and dissembled) empire—with a critical difference. The Panama Canal Zone embodied New Empire's ambivalent performance: ICC officials represented the Canal Zone as a semblance of empire without the legal framework of US sovereignty over isthmian terrain. If the Canal Zone symbolized the larger project of expansion without colonial governance, the Zone became a site for the negotiation of formations of empire's exceptionalism.

Aesthetics became a key reference point in debates over the contours of New Empire in the Canal Zone. Observers of US extraterritorial expansion assessed

whether TR's actions on the isthmus (his famous boast, "I took the Canal Zone") constituted imperialist overreach or moral mandate. Meanwhile, Canal planners and US lawmakers weighed the significance of the Canal Zone's aesthetics. These conversations, distinctly oriented, nevertheless constituted interlinked facets of a larger debate over appropriate and necessary styles of US imperialism. Pro-expansionists asserted the need for morally and aesthetically pleasing architecture in the Canal Zone. A major argument held that pleasant conditions could uplift and protect the mental and moral health of white US families living in the Zone. This through-line was reflected in the modern, beautiful construction and meticulous documentation of the Canal Zone's main structures. In their designs for housing, offices, clubhouses, storage facilities, water filtration plants, and other infrastructure, Canal Zone planners gleaned inspiration from the Canal's austere locks, whose sublime beauty was deemed by the US Fine Arts Commission in 1913 to stem from their lack of intention to be beautiful, their professed lack of ornament. As I discuss below, these locks in turn signified the power embedded in the US government's lack of titular sovereignty in the Panama Canal Zone: an efficient rule that claimed only those resources required for its maintenance, and did so with the technological beauty and grace of modern engineering.

Even as the Canal's necessary aesthetics seemed an ideal metonym for New Empire, the Zone's burgeoning infrastructure and vast bureaucracy raised concerns over imperial excess in the early twentieth century. An assessment of the Canal Zone's architectural and landscaping aesthetics, therefore, reveals the Zone to be a spectacular colony in spite of itself. Declarations of the dawn of New Empire based on technocratic functionalism clashed with the lived materiality of the Canal Zone, an enclave housing workers, soldiers, and dependents. The Zone's massive building program used materials designed to outlast Canal construction, prompting questions about the Zone's longevity. While these tensions persisted throughout the Zone's existence, its state of suspended sovereignty, engendered by the legal subjunctivity of the 1903 treaty, intensified the politics of its material consolidation between 1905 and 1951, when the Panama Canal was restructured to be self-supporting. As I trace in this chapter and the next, the Canal Zone became a shifting scenography, a site of staging (and worrying) fissures between imperial sovereignty and its absence. In what follows, I examine the Canal Zone's aesthetic and material consolidation, focusing on the justifications, in the first two decades of the Zone's development, as to why a massive construction program was "necessary" to protect the physical and moral well-being of its US citizen residents.

Language of necessity pervaded the Canal Zone's design, planning, and construction, authorized by the 1903 treaty's declaration that the Zone existed "for the protection, maintenance, and operation of the waterway."[11] The word

necessary appears at least twelve times in the treaty, and many observers, including "Panama authors" who toured the Canal Zone and wrote guidebooks, incorporated necessity into their accounts.[12] As one example of many, "Panama author" Ira Bennett noted in 1915 that "life on the Canal Zone was all that a generous government could make it, and yet it was not one iota more pleasant or more profitable than was *necessary* to make it bearable to a sufficient number to enable the canal work to go forward in a satisfactory way."[13] Bennett and others stressed the necessity of US congressional appropriations for the Zone's construction, even for components that may have otherwise been considered unnecessary—like aesthetic design and popular entertainments. Such accoutrements, observers alleged, helped to preserve and elevate the mental and moral health of the Zone's white US-citizen inhabitants. Yet what truly was "necessary," both in aesthetics and expansion? Who claimed the necessary (and unnecessary) in empire—and how was the Canal Zone's necessity as imperial outpost defended before its critics?

DEFINING AND ENACTING SOVEREIGNTY IN US NEW EMPIRE

Between 1898 and 1912, the United States shaped its approach to empire-building, statecraft, and racial nationality. While debates attending US expansion across the contiguous North American landmass had been active for at least a century, the Spanish-American War stimulated new questions about the goals and limits of US expansion, specifically around extraterritoriality.[14] By 1898, the United States amassed overseas holdings, "the unmistakable beginnings of an administrative empire."[15] Support for and opposition to expansion played significant roles in the 1900 presidential elections.[16] Rudyard Kipling composed his famous poem, "The White Man's Burden," as an admonition to US expansionism, and some in the United States heeded his warning, debating burdens of governance amid merits of empire.[17] In the wake of the calamitous Philippine-American War, TR's engineering of Panama's 1903 revolution spawned outrage, intensifying opposition to US imperialism on moral, political, racial, and economic grounds.[18] Even TR, a champion of westerly conquest, began to backpedal on his desire for territorial annexation beyond the contiguous North American landmass.[19] How would United States–led expansion define itself, as both republican and imperialist?[20] What ought US expansion to look like, in its legal, economic, territorial, racial, and aesthetic limits? What were the "optics" of New Empire?

Exceptionalism allowed proponents of expansion to foreground distinctions between US empire and its forebears.[21] New Imperialists invoked aesthetics to contrast New Empire with Old, marshaling racial, national, moral, political, and gendered traits in their comparisons. A prominent foil, deeply gendered and racialized, was Spain. New Imperialists associated the Spanish Empire with

corrupt rule and ornamental excess—symbols of the "Latin" race. The Spanish Conquest bore the "Black Legend" of brutality, as well as "indolence," despotism, inefficient ornament, feminized decadence, and an outsized bureaucracy governing recalcitrant subjects and racial "others."[22] A constant refrain during TR's 1906 visit to Panama was the United States' desire to rout Spanish influence: "The ways of Spain must go!"[23] And yet Panama had declared its independence from Spain in 1821—a fact that US press coverage of TR's tour seemed to overlook, privileging comparisons of sovereignty and empire that coalesced around the Spanish-American War and its aftermath. As citizens of Colombia, Panamanians had enjoyed political representation and rights. By reorienting Panama within a post-1898 context, the US press conveniently elided the fact that the isthmus was in fact part of a democratic republic when it separated in 1903.

Another foil invoked by Panama Canal planners was Count Ferdinand De Lesseps's failed canal project, whose excesses and inordinacies were tied to decadent pleasure-mongering of Frenchness, also racialized as "Latin."[24] Yet characterization of the "Latin" race was not solely derogatory: the racial concept had also been taken up repeatedly by post-independence creole elites in Latin America as a means of positioning emergent Latin American republics against hegemonic Anglo-Saxonism.[25] Likewise, pro-expansionists framed US New Empire as a project to free those still enslaved by Old World monarchical imperialism, to shape self-governing nation-states in the image of US democratic institutions. For pro-expansionists, US New Empire represented modernity, whereas Spain divulged an almost orientalist antiquity. To some US observers, Panamanians needed to be convinced of the superiority of New Empire: "They had loved Spain in the City of Panama." Would "they" (the Panamanian populace) similarly love the "revolutionary industry" and "general improvement of conditions, moral and material," engendered by the "pale, nervous man across the Zone line," the US citizen?[26]

The Spanish-American War produced conceptualizations of sovereignty laced with irony: while the United States went to war with Spain in 1898 on the premise of helping anticolonial forces, Spain's "liberated" colonies (the Philippines, Guam, Cuba, and Puerto Rico) soon came under US control, which looked suspiciously like imperial conquest.[27] The 1903 Panama Canal Treaty's disavowal of US sovereignty in the Canal Zone inserted ambiguity into the very definition of sovereignty. Corresponding with US Secretary of War William Taft in 1904, TR enlarged upon the sovereignty question: "We have not the slightest intention of establishing an independent colony in . . . the State of Panama, or exercising any greater government functions than are *necessary* to enable us conveniently and safely to construct, maintain and operate the canal, under the rights given us by the treaty. [. . .] In asserting the equivalent of sovereignty over the canal strip, it is our full intention that the rights which we exercise shall be exercised with all

proper care for the honor and interests of the people of Panama."²⁸ In this epis-
tolary exchange, TR made clear his aversion to the idea that the US was building
"an independent colony" in Panama and dismissed administrative colonialism as
a strategy of rule.

These statements elicit several questions, however. First, what were the "nec-
essary" conditions for canal construction, maintenance, and operation—and
who determined them? Second, what was "the equivalent of sovereignty," if not
sovereignty itself?²⁹ TR's vision of the "equivalent of sovereignty" seemed to
involve control of "the canal strip." Yet this explanation omitted mention of the
population of over 60,000 who inhabited this "strip" prior to its occupation by
the US government and would be depopulated for Canal construction.³⁰ TR also
implied a distinction between the exercise of US "rights" and the need to uphold
Panamanians' "honor and interests." Were "honor and interests" different from
"rights"? If so, what qualities differentiated these categories? TR's observations
appeared to juxtapose the US project in Panama with an interpretation of impe-
rialism based on territorial annexation, or, as TR phrased it in his corollary to the
Monroe Doctrine, "land hunger."³¹ Taken in the context of US imperial endeav-
ors after the annexation of the Philippines—namely, the Platt Amendment in
Cuba—TR's statement seemed to affirm the importance of developing strategies
of imperial difference, which would confer upon the United States the benefits
of the Canal without the burden of governance. Colonizing the Canal Zone did
not mean extracting value from land so much as stewarding an industrial land-
scape through the physical extraction of terrain from the "Big Ditch."

In effect, the Canal Zone's lack of US sovereignty eliminated problems of gover-
nance. Taft's response to TR advocated precisely this pragmatic (albeit materially
consequential) approach: "The truth is that while we have all the attributes of sov-
ereignty *necessary* in the construction, maintenance and protection of the Canal,
the very form in which these attributes are conferred in the Treaty seems to pre-
serve the titular sovereignty over the Canal Zone in the Republic of Panama, and
as we have conceded to us complete judicial and police power and control of . . .
ports . . . I can see no reason for creating a resentment on the part of the people
of the Isthmus by quarreling over that which is dear to them, but which to us is
of no real moment whatever."³² Taft's response revealed his view of sovereignty as
both legal status and material conditions. In the Canal Zone, the US government
was testing a subjunctive form of sovereignty that lingered in the "as-if"—a style
of governance bearing a resemblance to, yet not ontologically *being*, sovereignty.
Taft's logic liquidated the value of that which was so important to Panamanians,
Colombians, and US critics of the Canal undertaking: national sovereignty.

Yet how did this splitting of sovereignty impact international law and material
developments? TR's and Taft's statements opened a gap between the legal idea of
sovereignty and its performance—the latter interpreted both as representation

and as a "carrying out." Extrapolating from the subjunctive mood of "as-if" that pervaded the Canal Zone's sovereignty status, it becomes clear that US New Empire was able to represent itself as not being imperialism while at the same time performing empire—producing an imperial difference in comparison to past and present imperial powers. The absence of legal sovereignty authorized the performance of sovereignty. Historian Walter LaFeber observes that the treaty's elemental source of conflict was not, in fact, the status of Panama's residual sovereign rights in the Canal Zone, but rather "what would happen ... if ... Panamanians tried to exert those rights against the full control exercised by the United States."[33] Stated otherwise, the struggle between two powers was over the specific qualities that constituted sovereignty, as opposed to its representation, in the Panama Canal Zone.

Seemingly anomalous, the Canal Zone's state of subjunctive sovereignty is not unusual in the history of US expansion. US-Panama engagements must be positioned in relation to other spaces of suspended or subjunctive sovereignty in order to make clear the multiple dimensions of the United States' exceptionalist imperialism. A particularly apt referent is Guantánamo Bay, Cuba: the Cuban-American Treaty's 1902–1903 contracts to lease areas of Guantánamo Bay to the United States "in perpetuity" dovetailed the 1903 Panama Canal treaty's subjunctive (dis)avowal of sovereignty in significant ways.[34] As Kaplan notes regarding Guantánamo: "The [US] government's argument that the United States lacks sovereignty over the territory of Guantánamo has long *facilitated* rather than limited the actual implementation of sovereign power in the region."[35] Unlike the Canal Zone, Guantánamo became and remains "a territory held by the United States in perpetuity, over which sovereignty is indefinitely deferred."[36]

Guantánamo forms the Panama Canal Zone's speculative "shadow twin," so to speak—evoking an alternative pathway that the Canal Zone might have taken had it not been reverted to Panama in 1999. Evoking TR's commentary on the "canal strip," Kaplan argues that the US government separated Guantánamo's sovereignty from its jurisdiction, conceiving of the former as a "metaphysical" property, while the United States exerted actual control over Guantánamo base for over a century.[37] The "open-ende[d]" terms structuring US control of Guantánamo "abet a different kind of sovereignty, the executive power to dictate the violent terms of governance over the lives of the prisoners there."[38] While the Canal Zone is often depicted as a benign "other" to Guantánamo—a site of peaceful globalized trade rather than a receptacle for marginalized groups conceived as global refuse—both places have been the contemporaneous objects of a similar type of jurisdiction. The legal conditions that structured the Canal Zone and Guantánamo looked like US imperial sovereignty but were not. This double negation ("not-not" sovereignty) exemplifies the subjunctive state constituted by the co-absence of Cuban law and US sovereignty.

Constructions of subjunctive sovereignty in Panama and Cuba must be understood as further chapters in a saga of US expansionism continuous with settler colonialism and indigenous genocide in the eighteenth and nineteenth centuries. Yet many anti-imperialists made a sharp distinction between westward conquest and imperialism.[39] Even when the US government avowed no "land hunger," its acquisition of Spain's former colonies necessarily confronted questions of governance and constitutionality. The *Insular Cases* (1901–1922) helped to shore up imperial governance by providing legal justification for the amalgam of formal and informal colonialism, economic investment, territorial annexation, and military interventionism that came to characterize the United States' relations with Cuba, the Philippines, Guam, Puerto Rico, the Canal Zone, and other territories in the expanded "US-Caribbean world."[40] By "legislating an ambiguity," the *Insular Cases* enabled the US government to determine "whether, when, and which provisions of the Constitution. . . . apply overseas, and . . . what territories may be considered 'foreign to the United States in a domestic sense.'"[41] In parsing land into "foreign" and "domestic" categories, the *Insular Cases* placed unincorporated territories within the purview of US constitutional law, pushing US juridical power beyond domestic borders. On the isthmus, these debates over legal jurisdiction, imperial reach, and the aesthetics of empire converged. In what follows, I trace the junction of these strands, linking law to its material enactment and representations—to its performance.

SOVEREIGNTY ON TOUR: TR IN PANAMA, 1906

The Panama Canal and surrounding Zone marked crucial sites in a US expansionist policy based on the avoidance of "entanglements attached to race," burdens of colonial governance, and the threat of nonwhite US citizenship.[42] On tour in the Panama Canal Zone in 1906, TR fleshed out theories and practices of New Imperial sovereignty. The first US president to leave the United States while in office, TR traveled to the isthmus to survey Canal construction and convince skeptics of the waterway's viability.[43] This was not at all clear: despite the US public's sentimental attachment to the idea of a transcontinental canal, the Panama Canal's first years of construction were plagued by disorganization and workers' attrition, disease, and death.[44] These disasters lent strength to criticism of the Canal by anti-imperialists, muckraking journalists, and doubtful members of the US Congress. TR's tour was intended to rebut journalists' allegations of technological problems and human rights violations—specifically, the mistreatment of West Indian workers. His tour to Panama factored decisively in turning US public opinion in favor of the Canal.[45]

From November 15 to 17, 1906, TR toured Panama and the Canal Zone with his wife and the US Navy's surgeon general.[46] On November 15, the warship

Louisiana docked at Colón, the Panama Railroad's northern terminus, and the Roosevelts rode the train south, inspecting the Canal Zone's white townsites and nonwhite labor camps along the route, before sailing around the Bay of Panama with ICC personnel. That afternoon TR stopped at the Canal Zone's Hotel Tivoli, built shortly before his visit, and crossed the Caledonia Bridge at Ancón to make a speech alongside Panama's President Manuel Amador Guerrero at Panama City's Cathedral Plaza, marking his first official foray off US soil (if the Canal Zone could be considered such—which, in press accounts, it was).[47] Hundreds of Panamanians "garbed as Rough Riders" flanked TR's party during its procession to Cathedral Plaza.[48] After visiting Panama's presidential palace that evening, he was toasted by Panamanian elites at their Commercial Club.[49] The next day, TR resumed his tour of Canal Zone worksites and witnessed labor on the daunting Culebra Cut. At the white US townsite of Empire, he inspected single and married workers' quarters. On the final day of his tour, TR returned to Cristóbal and Colón, where Canal Zone schoolchildren paraded before him. From Colón the party boarded the *Louisiana* and set sail for Puerto Rico, spending one day there before returning to the United States.

As in his previous exploits, TR invited a press entourage to document his tour in journalistic, photographic, and filmic accounts. TR broke new ground, however, in sending the US Congress an illustrated report featuring twenty-six photographs of the Canal Zone.[50] TR's tour was framed in overtly theatrical terms: the *New York Times* stated, for example, that "The President will leave out Hamlet from the play if he does not visit Culebra while in Panama," identifying the arduous Culebra Cut as the protagonist of the Canal's "play."[51] Ralph Minger labels TR's actions in Panama "spectacular," while Julie Greene describes TR's 1906 tour to Panama as "a public relations campaign of unprecedented force, drama, and sophistication" that "refocus[ed] public opinion on the virtues of the canal project rather than on the scandals," employing TR's "talents for mythmaking and public relations as well as the prestige of the presidency."[52] "An intuitive master of public relations," TR theatrically framed the US Canal project as an altruistic mission to provide the world with a crucial trade route, in contrast to the failed canal of Count Ferdinand De Lesseps.[53]

The reporters who accompanied the US president played important roles in TR's mission to change US minds about the Canal. These reporters—from leading US periodicals such as the *New York Times* and *Harper's*—documented the tour in meticulous detail, recording nearly every movement and statement made by the presidential body. By contrast, Panama's newspapers celebrated certain events in the visit but did not capture comparable detail. This was likely due to the fact that Panamanians were, by and large, kept at a distance from TR, while US reporters accompanied him in the intimate vicissitudes of the tour—often struggling to keep up with his rapid pace. TR performed diplomacy in

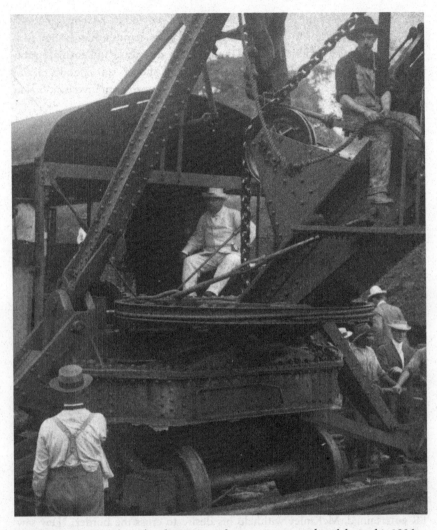

FIGURE 1.1. US president Theodore Roosevelt poses in a steam shovel during his 1906 tour of the Canal Zone. Roosevelt 560.52 1906–039. Courtesy of Houghton Library, Harvard University.

new ways and instituted a new style of imperialism—"style" invoked to indicate a personality-driven approach or signature. TR's style stressed expediency and efficacy, seeming to suggest that those who opposed the Panama Canal were opposed to progress and misunderstood the true nature of US expansion: technocratic, benevolent, flexible; driven to open and connect the world, not usurp sovereignty.

Scholars have highlighted TR's uses of performance in diplomacy and statesmanship, especially his self-representation as a virile adventurer embodying

"manly virtues" and the "strenuous life."[54] Citing previous self-transformations from East Coast elite into cowboy, rancher, and colonel mustering "Rough Riders" in the Spanish-American War, TR played the adventurer in Panama, sprinting between construction sites, leaping into a steam shovel's cab (Figure 1.1), and hopping the railroad between townships to make impromptu investigations of workers' quarters and mess halls.

On tour, TR redefined US diplomacy and employed his corporeal presence as arbiter of the Canal Zone–Panama border. He seized every opportunity to insert his hyperbolic and iconoclastic body into the itinerary. In one of many apparent deviations from the schedule laid out for him, he literally seized the reins of the tour, galloping on horseback in a digressive race through Colón's saloon district, Bottle Alley. Throughout, he appeared in a carefully chosen costume, a white duck suit signaling imperial dress, which he allowed to become progressively mud-spattered as he weathered torrential rains. Virile, masculine, and globe-trotting, he appeared unafraid to rupture the niceties of etiquette.[55] Foregrounding the Canal Zone as a symbolic site of US governance, TR's tour transplanted the 1903 treaty's terms into the Zone's material terrain. In traversing the border, the US president enacted new interpretations of sovereignty and ramifications for US imperialist expansion.

TR embodied diplomacy by breaching the physical borders of the United States in ways that his late predecessor, US president William McKinley, had presumably only imagined. While McKinley oversaw US expansionism, his imperialism differed from that of TR, as narrated by a *Harper's* vignette. Journalist Conklin Mann juxtaposed an account of TR's Panama visit with a memory of McKinley's tour of the Pacific West, highlighting a moment at which the then-US president almost crossed the US-Mexico border but "halted. Beyond he could not go, for it would have been a violation of the custom of one hundred and ten years. A step would have taken him outside the boundaries of his country. It was not for him to take that step."[56] In near-solitude, without the press cadres that TR entertained, McKinley withheld his desire to cross the border: "Few saw the incident; no one was at hand to take the picture."[57] McKinley's self-restraint, contrasted with TR's unfettered enthusiasm, seemed to highlight TR's conscious break with precedent: a history of US presidential reverence for national sovereignty. Mann's vignette of President McKinley pulling himself back from a reckless act of border-crossing obscured both the history of US territorial annexation and McKinley's assertive foreign policy. The Río Grande "border" sanctified in Mann's tale came into being through the Treaty of Guadalupe Hidalgo in 1848, which added more than 525,000 square miles to US territory, including, in part or in full, the future states of Texas, California, Nevada, Utah, New Mexico, Arizona, Colorado, and Wyoming.[58] The occluded history of annexation makes McKinley's act of restraint an ironic exercise in understatement.

McKinley's ambivalent eyeing of an unnatural US-Mexico border reso-
nated with his approach to imperialism. President from 1897 until his assas-
sination in 1901, McKinley led the United States into the Spanish-American
War and the annexation of the Philippines Yet despite McKinley's expansion-
ist foreign policies, the image of the US head of state not daring to cross the
US-Mexico border, turning back at the crucial moment, framed an ethics of
border-crossing in light of respect for national sovereignty. McKinley's near-
crossing—his temptation to impinge on Mexican sovereignty tempered by his
statesmanlike respect for diplomatic protocols—seemed to classify certain
acts of border-crossing as pejorative imperialism while legitimizing another
technology of expansion: the acquisition of territory within the continen-
tal landmass that would come to be known as the United States. McKinley's
moment of pause, metonymic of US reverence for Mexico's sovereignty, legiti-
mated the war with Spain as another act of respect for the nascent sovereign-
ties of Spain's former colonies—a just war to eradicate imperialism.[59] Framed
thusly, the United States' actions in Cuba seemed to fulfill the Monroe Doc-
trine's stated commitment to protecting Latin American nations from Euro-
pean colonizers. Comparing McKinley's tentative approach to the border
with the foreign policy of TR's and, subsequently, William Taft's presidential
administrations, Mann invoked assaultive force: TR "smashed" presidential
custom in traveling to Panama. TR's forcible performance of embodied diplo-
macy effectively structured the border between Panama and the Canal Zone.
While TR claimed to be a passive witness to Canal construction, his hyper-
charismatic presence belied his active role in framing and situating the Canal
Zone as material and symbolic emblem of US imperial style.

Aware of the status accorded him, TR nevertheless repeatedly disavowed his
self-importance. Upon arrival in Colón eighteen hours ahead of schedule, the
lack of a welcoming party "didn't feaze [sic] the President any."[60] Introducing
himself as "Mr. Roosevelt of Washington," he eschewed formalities and shook
hands with everyone present. In addition to his rogue gallop down Bottle Alley,
TR skipped a high-toned banquet in his honor to eat with Canal workers in
their cafeteria.[61] At another point, TR passed a boisterous, too-familiar civilian
whose "yell" "might have been taken as an instance of les-majeste . . . in some
other country."[62] Yet, far from offended, TR smiled "broadly" and praised the
young man's "enthusiasm." These exchanges, paralleled by his stained clothing—
permeated by the mud and detritus of Canal construction—gave an impression
of a US presidency far more egalitarian than European regimes, playing up TR's
"characteristic disregard of conventionalities."[63] His journalist companions con-
trasted TR with the figure of a "king," distinguishing the US presidency from
a monarchical sovereign ruler—a likely reference to the recurrent foil of "Old
Spain." Their accounts highlighted TR's dismissal of inherited power: unlike

kings, they noted, TR did not put on airs or distance himself from the Canal's workers, "Jamaicans" and "negroes" included.[64] TR's irreverent, antihierarchical antics indicated that US presence in the Panama Canal Zone need not emulate the oppressive form of Old World colonialism. Instead, TR's down-to-earth persona modeled the stylistic and technological possibilities of the modern project of New Empire.

BLURRED BOUNDARIES: THEODORE ROOSEVELT'S ACTS OF BORDER-CROSSING

TR's digressions and informalities found parallels in his understated acts of border-crossing. While his stated intention in traveling to the isthmus was to gather facts on the Canal's progress, his trip engendered new symbolic and material modes of diplomacy as he repeatedly crossed into Panama and spoke with and for Panamanian audiences.[65] His border-crossings, documented by his US press entourage, deviated from, undercut, and deconstructed precepts of sovereignty. While entering Panama from the Canal Zone—the latter considered US territory, as we have seen—TR dismissed the symbolic ceremonies that might accompany official acts of border-crossing. His apparent disregard for the marks of sovereignty was not intended to rupture the borders between Panama and the Canal Zone but to inculcate boundary-blurring as central to US expansion: a modern style of empire-building that foregrounded fluidities and strategic military conduits and eschewed territorial acquisition, colonial administration, and symbols of sovereign power.

While TR's companions and witnesses were highly attuned to his acts of border-crossing, the US president himself affected a lack of interest in the borders that he was traversing. TR first crossed the Canal Zone–Panama border at Caledonia Bridge, at the foot of Ancón Hill, during a drive to see Ancón's "sparkling, clean" US-built hospital.[66] As accompanying reporter William Inglis observed: "For the first time in the history of our country the President of the United States went outside of our territory. [. . .] Two hundred feet below the Tivoli Hotel a small American flag and a small Panamanian flag were waving amicably side by side in the rain. They marked the boundary between the two nations. As the President's open carriage came clattering down the hill, a thousand curious eyes were watching to see what wondrous thing would happen when the Chief Executive should first leave American soil." Inglis built up to the crossing with dramatic crescendo: "The carriage rolled nearer and nearer; it was up to the flags—past them now! And what happened?" In fact, TR and Colonel W. C. Gorgas were "so deeply immersed in their conversation" about disease control on the isthmus that neither "knew that they had crossed the boundary line." The act of border-crossing, so fleeting as to be unnoticed, revealed how

differently Rooseveltian empire conceived of sovereignty. Tracing the Panama–Canal Zone border with his body, but stripping the pomp and ceremony from border-crossing, TR downplayed the import of the Canal Zone's sovereignty status.

TR's anticlimactic border-crossings radically undermined Panama's and Colombia's heated protests over the Canal Zone's infringement of isthmian *soberanía*. The US president's nonchalance painted this vision of sovereignty as an archaic abstraction whose ideological contestation threatened material progress. It is significant that TR was praising Gorgas's elimination of yellow fever in Panama as the carriage rolled across the border: the supposedly monumental border-crossing was neatly upstaged by the material fact of US sanitation of the isthmus, a process that sent hundreds of Canal workers into Panama City and Colón with chemical sprays and cleaning equipment. Ceremonies of border demarcation were sidelined by the mention of disease control, a project whose palpable and wide-ranging benefits hardly any Panamanian dared oppose. After this crossing, Roosevelt traversed the border several more times, for impromptu digressions and official speeches in Panama. Another irreverent border-crosser, the US-owned Panama Railroad, was described as "wriggling" back and forth across national boundaries; the train was said to "shoo[t] merrily" and "sli[p]" between the Canal Zone and Panama.[67] In these accounts, the border seemed benign and even playful, less a geopolitical obstacle than a footnote in a triumphal narrative of order and improvement.

TR was not the only one to misrecognize the border: for those residing on the isthmus, the Canal Zone's border heuristics were opaque and obfuscated, and the US presidential visit did not help to clarify jurisdictional lines. The *Panama Star and Herald*—a newspaper representing Canal Zone and Panamanian views—stated, "On the Canal Zone the President will be in United States territory, but the line of demarcation between the Zone and Panama territory is to most of us [Zone residents] an obscure and almost unknown thing."[68] In a *New York Times* essay, "What the President Will See When He Gets to Panama," the border was repeatedly called "the invisible line"—that which could not be seen. Mirroring the ambiguous boundaries between Cristóbal and Colón in the north, the southern Ancón/Panama City border also "deal[t] in invisible lines." When Roosevelt stepped "across the invisible line into that historic city, Panama," the line was revealed as an abstraction to be erected and dissolved according to the ICC's exigencies. The border came into being through the material conditions that marked it: "To the south of Cristóbal is Colon. In fact, only an invisible line called 'the Zone' prevents Cristóbal and Colon from being one. . . . An interesting thing is this invisible line, for one feels it without seeing it. If the President does not wish to put his foot on foreign territory he need only mark these signs: Where the made earth suddenly gives place to mud; where the neat bungalow

becomes a lop-sided café; where a khaki-clad patrol with a carbine grins across the way at a black policeman in blue—that's the invisible line!"[69]

In this framing, the signs that mark the US side of the "invisible line" are paved roads, landfill and landscaping ("made earth"); uniform and picturesque housing; and US policemen in imperial khakis. On the other side are the mud of Colón, a "café" (a euphemism for a bar or cabaret), and a "black" policeman. Differentials of race, sanitation, and infrastructure allowed isthmian inhabitants to "feel" the border. "Feeling the border" seemed a natural and instinctive response to stimuli yet was produced by material conditions shown to be constructed. In the absence of multisensory cues betokening border difference, even TR's journalist companion trampled the fine points of territorial sovereignty, reporting erroneously that the United States possessed full sovereignty in the Canal Zone, and that Panama City and Colón lay within the Zone.[70] Despite ongoing ambiguities about the place of sovereignty in New Empire, TR's act of crossing the "invisible line" made that line momentarily material, palpable, and official. While TR professed a lack of investment in grandiose symbols, his presidential body became the key determinant of sovereign distinctions, generating the very borders that it traversed.[71]

TR's treatment of borders, in interactions with various "others" encountered on tour, sowed—and showed—contradictory impulses within New Empire. Inattentive to the conditions structuring the border, the US president seemed to represent a dismissal of borders in favor of pragmatic technologies of flow. Yet if this truly were the case, then why erect borders at all? The reason, in TR's speeches on the isthmus, was security. If, for TR, isthmian borders were not objects of ceremonial import, they were sites of militarization. Stemming in part from TR's interest in war, militarization—the installation of a permanent state of readiness for war within civil society, the organization of civilian life for the production of violence, and the "gradual encroachment of military ideas, values, and structures into the civilian domain"—became an intrinsic aspect of life in the Canal Zone.[72] Even as civilian "Zonians" distinguished themselves from the Canal Zone's military troops, militarization marked the Zone's infrastructure and administration profoundly. Security issues were not neglected on TR's tour: war emerged as a prominent concern in his speeches and behavior toward Panamanians.

Panamanians were one of three main audiences that the US presidential cavalcade encountered, the others being US engineers and "worshipping" West Indian Canal workers.[73] Perhaps because fewer than four hundred Panamanians labored in Canal construction, citizens of Panama figured in journalists' accounts as an amorphous populace on the margins of the Canal.[74] Post-independence Panama was portrayed as a feudal society pitting elites against "the teeming mob."[75] Panamanians, a faceless homogeneity, "worshipped [TR] and hated him in the same breath."[76] Responding to the threat of the "mob," the aftermath of independence,

and implied anti-US sentiment, TR's speech at Cathedral Plaza warned Panama-
nians "with a hankering for revolution" of their imminent destruction should
they oppose the United States. "Few" of the "hundreds" of Panamanian specta-
tors would "forget the flashing eyes, clenched jaws, and smashing fist on hand
that emphasized that warning."[77] This capstone speech hinted at the inverse of
TR's leveling friendliness: his investment in a disciplined, combat-ready Zone.
This interest in militarization informed TR's organization of the Canal Zone's
military governing structure: in appointing Colonel George Goethals as chief
engineer of the ICC in 1907, TR acted on his desire to have army officers fill ICC
posts, even though the politically neutral Canal was to have no role in military
conflicts, as mandated by the Hay-Pauncefote Treaty.[78]

Surrounding TR's tour, images of conflict and war indicated the militariza-
tion undergirding the seemingly peaceful Canal project. Almost all journalistic
accounts of TR's tour portrayed the Canal Zone as a battleground, employing
a language of warfare. These accounts echoed TR's own framing of Panama
Canal construction as war.[79] In speeches across the Zone, TR praised the "army"
of US Canal laborers who battled the "enemy" of mudslides, falling rocks, and
disease. The dynamite explosions that rocked the Canal construction site were
"guns of peace."[80] Although not a scene of direct military combat, the Zone was
weaponized through its dynamite, which resounded and killed (West Indian)
laborers like gunfire and bombs. While the ICC's employees were civilians, TR's
speeches conceptualized them as soldiers. He met one "tall, blue-eyed youth"
who had fought in "the war with Spain"—an encounter that linked Panama both
to TR's military exploits in the Spanish-American War and to other territories
gleaned from that conflict. TR's tenor on tour implied that violent combat would
never be far from the Canal Zone's borders. Ironically, the Panama Canal Zone
was often portrayed as a site of benign and functional imperialism—of healthy
white families and peaceful exchange, in contradistinction to US-engaged war
zones. The many "peaceful" accounts of the Canal Zone make these belligerent
framings so noteworthy: portrayals of the Zone as battlefield indirectly cited the
site's status as contested ground, on the isthmus and internationally.

Civilian and military realms were, in fact, never far apart in the Canal Zone.
The Zone's militarization was underway during Canal construction, despite the
Canal's portrayal as a civilian trade route. Defense of the Panama Canal, a topic
of debate, became a reality with the establishment of two Marine posts in 1904.[81]
After the Canal's completion, the US government earmarked an additional
twelve million dollars to fortify the Canal, and troops in the Zone increased from
797 in 1914 to 6,248 the following year.[82] The ICC (1904–1914) was housed under
the auspices of the Department of War, and the Panama Canal's administrators
were US military officials appointed by the secretary of the army. Many histo-
ries of the Panama Canal Zone have distinguished the Canal's civilian workers

from the Zone's proliferating military bases. Indeed, the civilian and military populations had strong rivalries, as historian Michael Donoghue observes.[83] Yet overriding these distinctions was a framework of militarization, which pervaded even spaces considered off-limits to US soldiers. On the ground, the aesthetics and governing structure of the Canal Zone made clear that the Zone was a militarized space, organized in accordance with US military structures, chains of command, and rule-governed vicissitudes. The enclave's aesthetics reflected not only those of the "company town"—United Fruit enclaves or petroleum concerns that historian Ronald Harpelle labels "white zones"—but also of military bases.[84] The next section explores political aesthetics in the construction and "staging" of the Canal Zone's built environment, interrogating the Zone's militarization and New Imperial formations in relation to its style.

NECESSARY AESTHETICS: DESIGNING THE CANAL ZONE, 1904–1920

US reporters accompanying TR's tour reserved their most harrowing words for descriptions of Panama's conditions prior to US intervention. Absent "improvements," the isthmus was a miasmatic swamp, a "disease-ridden death trap," rife with "steamy jungles" and squalid graveyards bearing witness to thousands dead from the failed French canal effort.[85] "Tumble-down shacks" and saloons dotted the earthquake-fissured streets of Panama City and Colón, which ran with filth like "rivers of liquefied disease."[86] In contrast to this scene, the Canal Zone's townsites of Empire and Culebra were "made-to-order, businesslike affair[s] that mar[ked] the pioneer American," their "streets and avenues . . . mathematically laid and arithmetically numbered."[87] Palm trees were planted "in lines beside cut walks, which picturesquely divide the made earth, where the art of the American seedsman is already showing."[88] The term "made earth" designated not agricultural cultivation but the literal "making" of land for aesthetic purposes: the use of landfill from Canal dredging for landscaping. This development resulted from sanitation efforts in Panama and the Zone, prompted by TR's visit. In the blitz of modernization that anticipated the presidential visit, Panama and the Canal Zone replaced yellow fever with the "fever of improvement."[89] TR's tour impelled the isthmus into "revolutionary industry . . . everywhere visible in the paving of streets, the renovation of public buildings, the installation of sanitary measures, and the general improvement of conditions, moral and material."[90] Panama, made "gay with bunting," was "determined to improve itself" with paved streets, sewers, and lighting—"urban modernization efforts" authorized and executed by the US government.[91]

Panama's and the Canal Zone's "progressive attacks" yielded long-term material transformations. TR's tour did not merely drape the borderland with bunting; in fact, the tour was pivotal in laying the ideological and material groundwork for the Canal Zone's development into a "model colony" and

"object lesson" for audiences in the United States and Latin America.[92] TR's 1906 visit shifted US public opinion in favor of the Panama Canal and enabled the ICC to secure funds and support to develop the Canal Zone into a permanent settlement. Especially after the Panama Canal Act of 1912, the Canal Zone's landscape changed from a temporary work camp based on wooden structures to a permanent enclave with the architectural and infrastructural qualities of a permanent colony. The Canal Zone's conversion from a temporary construction site into the scenography of empire was rooted in planners' desires to protect white men, women, and children in the tropics.[93] ICC officials were concerned that the jungle's humid climate and tropical sunlight would encourage "mental and moral laxity."[94] Environmental determinism motivated the development of a *cordon sanitaire* separating the Canal Zone from Panama. The ICC boasted that the Canal Zone's hygienic regime made the enclave safe for habitation by the "civilized white race," in the words of its leading medical official, Colonel Gorgas.

By the 1930s, the Canal Zone was considered an example of social engineering's triumph over tropical degeneration. Touring the Zone in 1935, Australian geographer Sir Archibald Grenfell Price marveled: "The visitor to Panama, particularly if his mind is clogged with British fallacies, is astonished to find some of the healthiest-looking white children in the world. Everywhere outside the cool, airy bungalows bareheaded, fair-haired tots . . . play even in the heat of the day. [. . . W]ith proper medical attention, sanitation, and diet children thrive on the canal."[95] As important as physical health was the maintenance of a high moral standard, to create a safe environment in the Canal Zone and to represent the US New Empire favorably to the world. Framing Canal construction as a peaceful war, TR emphasized the need for a mentally, morally, and physically fit standing army of laborers. He urged the construction of a "moral architecture" consisting of salubrious entertainments, religious institutions, and recreational activities.[96] ICC officials agreed with TR's idea "that, before starting to make a canal, the . . . conditions surrounding the *makers* should be the first consideration": "The Canal Zone needed well-built houses of pleasing uniformity and simple beauty, erected with every regard for the unhealthy climate; it required the cutting of roads through a territory which had fallen into neglect; it was *necessary* to establish a morality which would preserve the health of the men; in short, the ambition of the Canal Zone officials was to create a colony which would be ready at the word of command to execute the enormous project for which it was designed."[97] TR and Colonel Goethals, the Canal's first civil governor, appealed to the US Congress to allocate funds for the construction of this "moral architecture"—an uncontroversial request, since policy makers saw the need for moral institutions. Linked to the necessity of morality was that of beauty, of an aestheticized Canal Zone. The Zone's "moral architecture" had to be sufficiently picturesque to attract and retain white US citizens, since the attrition rate for US Canal employees had reached 50 percent by 1915.[98] In addition,

POPULAR MECHANICS

ADMINISTRATION BUILDING OF PANAMA CANAL

The Administration
Building of the Panama
Canal, Showing
the General Floor Plan

FIGURE 1.2. Plan and photograph of the newly completed Administration Building at Balboa Heights, 1915. In *Popular Mechanics*, June 1915, p. 889. Courtesy of HathiTrust.

many felt that the Canal Zone "needed . . . the imprimatur of high art . . . to fully project the American [*sic*] accomplishment" and compel further support from US Congress and the public.[99]

Tensions quickly arose over the place of beauty in the Canal Zone, however. Expressing desires for beautification and technological pragmatism, Goethals and architect Austin W. Lord clashed over the design of the Canal Zone's central icon, the Administration Building.[100] Even Goethals, the most stridently utilitarian of Canal planners, could not avoid "aestheticiz[ing] the social and technological process" of construction.[101] Architects, landscape designers, engineers, and government officials debated the Canal Zone's aesthetics; their discussions reflected ambivalence about the style and scope of US imperialism. Questions of aesthetic excess dovetailed debates about the nature and necessity of US overseas expansion.[102] Necessity linked both sides of the debate: as "necessary to Canal construction, maintenance, and operation" as imperialist expansion were the Canal Zone's burgeoning clubhouses, theatres, restaurants, hospitals, ball fields, courts, food processing plants, and gardens.[103] But who was authorized to

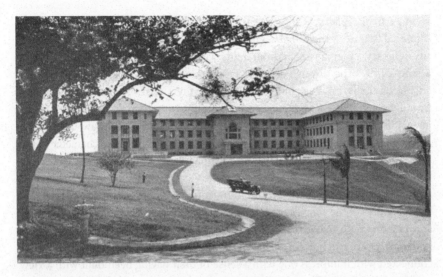

FIGURE 1.3. Photograph of the Administration Building showing landscaping and scale. In George Goethals, *Government of the Canal Zone* (1915): 16–17. Courtesy of HathiTrust Digital Library.

claim the necessary (and unnecessary) components of New Empire? How did necessity articulate with beauty—the latter fraught with excess, effeminacy, and criminality in the writings of prominent US architect Louis Sullivan, Adolf Loos after him, and others before and since?[104]

For Canal Zone planners, engineers, and architects, the conflict over aestheticizing the Canal Zone was never fully resolved. Ongoing tensions resulted in the construction of a Zone that oscillated between what Richard Guy Wilson labels the "American Renaissance"—an emulation of European Renaissance aesthetics—and a rejection of ornament, a formulation of beauty *as* necessity, a robustly anti-ornamental sentiment following Sullivan's famous decree that "form ever follows function."[105] Some of the architectural firms that Lewis Mumford cites as key designers of "American Renaissance" style in the United States—McKim, Mead and White, and Daniel Burnham—also designed colonial edifices and planned towns: Burnham in Baguio, Philippines; McKim, Mead and White (represented by Lord) in the Canal Zone.[106] Mumford documents a wave of construction in the United States evincing "imperial spectacle" modeled after the conquests and excesses of the Roman Empire—aesthetics that migrated to US extraterritorial holdings, colonies, and protectorates.[107] Yet even while the Canal Zone showcased grandiose and spectacular edifices—namely, the Administration Building designed by Lord—many other parts of the Zone became sites of contestation over the aesthetics and style of US New Empire (see Figures 1.2 and 1.3).

In particular, planners' interests in creating an American Renaissance–inspired "imperial façade" in the Canal Zone clashed with engineers' drives toward "necessity," efficacy, pragmatism, and durability. Canal planners tempered the efficacy-aesthetics dialectic through a discursive framing of the Canal Zone's beauty as arising naturally from its functionality. That the Canal's formal beauty flowed from its engineering was confirmed by the US Commission of Fine Arts, which in 1913 sent two representatives, landscape architect Frederick Law Olmsted Jr. and sculptor Daniel French, to the isthmus to assess "the artistic character of the structures of the Panama Canal."[108] The Panama Canal Act of August 24, 1912, stipulated: "Before the completion of the canal the Commission of Fine Arts may make report to the President of their recommendation regarding the artistic character of the structures of the canal, such report to be transmitted to Congress."[109] Olmsted and French's report suggested minor improvements to beautify the Canal's illumination and buoys but noted that overall, "the canal itself and all the structures connected with it impress one with a sense of their having been built with a view strictly to their utility. There is an entire absence of ornament and no evidence that the aesthetic has been considered except in a few instances." Yet the report concluded, intriguingly, that "because of this [absence of ornament] there is little to find fault with from the artist's point of view": "The canal, like the Pyramids or some imposing object in natural scenery, is impressive from its scale and simplicity and directness. One feels that anything done merely for the purpose of beautifying it would not only fail to accomplish that purpose, but would be an impertinence."[110]

To the Commission, the Panama Canal's lack of ornament made the Canal that much more aesthetically pleasing and formidable; form followed function. And as imperial form followed function, the means of imperialism were justified by empire's ends. The Commission's views echoed an anonymous commentator's thoughts on Joseph Pennell's lithographs of the Panama Canal: "There is a certain kind of art which grows out of the industrial and scientific processes. Some forms of art . . . follow utility and efficiency, and attain a beauty that is bound up in the perfect fulfillment of function."[111] Lithographer Pennell found industrial structures aesthetically spectacular, a position shared by an ensemble of modernist architects in the early and mid-twentieth century. He compared skyscrapers to European cathedrals and observed that the locks' "great arches and buttresses" were "the most decorative subject, the most stupendous motive . . . almost too great to draw."[112] Pennell's drawings of Canal construction sought to capture the work in progress, before the locks opened, at which point "half the amazing masses of masonry will be beneath the waters on one side and filled in with earth on the other, and the picturesqueness will have vanished."[113] The Canal's curvature was considered both aesthetically pleasing and "pragmatic in origin."[114] Whereas French engineers had envisioned a straight-lined canal—a model whose linearity in fact

undermined its efficacy—"American [*sic*] engineers utilized curves for practical and financial reasons." The resulting sinuous US Canal avoided "a great deal of earthwork" and extra cost.[115] Its curvilinear formation symbolized New Empire's investment not in Euclidean aesthetics but in practical, expedient designs that also proved aesthetically pleasing: the picturesque curve, its form following function, supplanting rectilinear geometry.

The Fine Arts Commission report described the sights greeting an observer upon her approach to the Canal—shapes and compositions of land, foliage, and water that the report deemed "beautiful" or "ugly." Presumably owing to the Commission's travel by boat, its report regarded the Canal not as an immobile monument but as a relational mise-en-scène oriented to motile passengers, visitors, and spectators. The Commission also surveyed the Canal Zone's major townsites—Colón/Cristobal, Gatún, Pedro Miguel, Miraflores, and Balboa.[116] Acknowledging the pragmatic goals of the ICC's military administrators, the Commission admitted that some of its suggestions for aesthetic improvement might not be "practicable." The report lent credence, however, to the idea of the Administration Building, whose construction had recently begun, by depicting this edifice as the Canal Zone's aesthetic focal point, which would unify the plan of its surrounding townsite. The Commission praised the ICC's architectural department, whose local director, Mario Schiavoni, and New York office supervised the Administration Building's construction. Further, the Commission recommended that future municipal departments in charge of developing the Canal Zone include "artistic oversight" in their public works mandate, so as to develop a holistic plan for the area.[117] The Commission affirmed aesthetics as a "necessary" component of the Canal project and posited that the Canal's beauty lay in its technological utility. Its report was accepted by Colonel Goethals, chief engineer and chairman of the ICC, who presided over the Canal Zone's development until 1916. Anecdotally depicted as a brusque man who abhorred inefficiency, Goethals nevertheless held an interest in the Canal's outward representation to the world: "Only under the Goethals regime did images become an integral part of the public relations effort."[118] Architectural design was a central component of the Canal Zone's "vast bureaucratic infrastructure"; all structures and utilities were planned and built by the ICC, the Zone's centralized administrative body.[119]

Many of the Canal Zone's townsites were designed between 1905 and 1920, in a systematic top-down process. The US government contracted architects to design structures, then the ICC's (after 1914 reformulated as the Panama Canal, or PC) engineering and building departments implemented selected blueprints, retrofitting and modifying the templates as needed while retaining aesthetic continuities. The architectural styles of townsites for gold-roll (white US citizen) workers emulated the "City Beautiful" style, while other areas incorporated a medley of Panamanian, "American Renaissance," Beaux-Arts, and French,

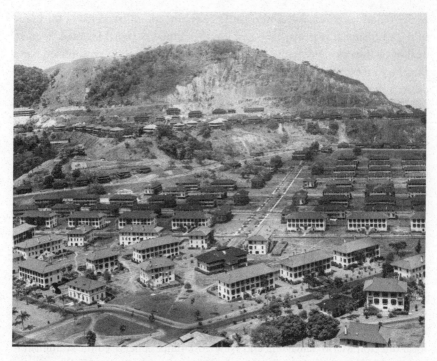

FIGURE 1.4. An image showing the Panama Canal Zone's "picturesque" settlement, June 1921. Record Group 185, Records of the Panama Canal. Entry A1–34B, General Records, 1914–60. National Archives at College Park, MD.

Spanish, and Italian architectural influences and components. This architectural eclecticism contrasted with the Zone's striking uniformity, owing to the implementation of a handful of building templates in townsites across the enclave, to create an unintentionally picturesque repetition that elicited frequent praise from visitors (see Figure 1.4 for an example of this repetitive style of building).

Mixing aesthetics and functionality, the Zone's holistic layout attained a City Beautiful form, transcending tensions between engineers and architects on the ground. These towns converted the Canal Zone into the scenography of US New Empire. Far from generic templates, the Canal Zone's buildings were designed with an eye to their locations, infused with the distinctive styles of architects Parker O. Wright, Austin W. Lord, Mario Schiavoni, William Parsons, Bertram Goodhue, and Samuel Hitt, and landscape architects Frederick Law Olmsted Jr. and his protégé William L. Phillips.[120] Interest in interweaving form and function to craft a New Imperial aesthetic was evident in Phillips's early twentieth-century landscaping interventions in the Canal Zone. Phillips added landfill, dredged from the Canal, and plantings of cultivated local flora to evoke a picturesque residential countryside, which moved with the hills' "topographically

responsive curves" and held "alluring" vistas of the surrounding hillsides, valleys, and the Canal's watershed below.[121] Houses were nestled at the lips of gently winding streets, tracing the terraces of the quarried Ancón Hill. As Susan Enscore notes, the Canal Zone's civilian architecture influenced its military buildings; US military architecture emulated Goethals's aim to contract "renowned civilian architects and landscape architects" and to ensure that "'US citizens living in the Panama Canal Zone should live in beautiful communities—communities that would contribute to the quality of life for their residents.'"[122]

The Canal Zone's architects and landscapers folded functionalism and ornament into their designs, from lock control houses and water purification plants to housing and hospitals. Wright designed the first US-built Zone structures—wooden-frame houses that incorporated aesthetic influences and existing structures left behind by the French canal. Wright's early buildings "had no powerful signatures . . . except for the ubiquitous quality of the replication of simple, formulaic functional solutions. Nevertheless . . . they created arresting ensembles in the landscape," locating inhabitants in a social order at once industrial and beautiful, oriented to labor and leisure, evoking US nationhood and its absence.[123] These designs sought to evince a semblance of small-town life. The Canal Zone was not incorporated US territory, yet ICC and PC officials endeavored to provide almost every townsite with basic civic amenities: a US post office, fire and police stations, a commissary, clubhouse, theatre, school, and church. All structures were created, operated, and staffed by US government appointees.[124] Yet this layout could not avoid a theatrical sense of staged US civic life. From the ratification of the Hay-Bunau-Varilla Treaty in 1904, the governmental structure of the Canal Zone had undergone several convulsions, beginning with a government upholding selective aspects of the US Constitution and US municipal laws, and culminating in 1908 with "autocratic rule" by an ICC chairman appointed by and accountable to the US president.[125] As a territory not formally incorporated into the United States but afforded US jurisdiction, the Canal Zone disallowed many rights and practices associated with democratic rule, such as local elected representatives, and contained uneven protections that splintered along citizenship lines.

With the end of Panama Canal construction in 1914, nonemployees of the Canal were deported from the Zone. The Panama Canal Act of August 24, 1912, authorized an executive-appointed governor, from the Army Corps of Engineers, to direct the Panama Canal and Zone in a civilian capacity (the military Canal Zone had a separate administrative structure). The ICC was dissolved by executive order and replaced with the Panama Canal (PC), still housed under the Department of War. The "care, maintenance, sanitation, operation, government, and protection of the canal and Canal Zone" were the first priorities of the Canal Zone's civil government.[126] After lengthy debate, Canal planners rejected an earlier plan to "set up a model of American government in the heart of central America as an object lesson

to the South and Central American republics."[127] Colonel Goethals noted that even the title of governor was misleading, as it seemed to connote civil rule.[128] Canal Zone officials were not accountable to internal structures of governance, such as audits and oversight, and the Canal Zone's relationship to the US federal government was attenuated and uneven. The Zone's material infrastructure, then, constituted a mise-en-scène that limned the perimeters of US civic structures but excised the substance of the state—a materialization of suspended sovereignty. As solid as they looked, many of these buildings were mobile, multifunctional structures that could be loaded on railroad cars and moved easily, like scenery. Their locations and inhabitants changed depending on the needs of the Canal administration and the US military. Clubhouses, clinics, churches, commissaries, schools, and housing would be dismantled and transported if and when the Canal required new construction and maintenance sites.

While TR had performed boundary-blurring on tour, the Canal Zone's architecture—mobile as it was—sought to channel residents' interactions and motion paths. This spatial and bodily disciplining occurred along racial, gendered, and national lines. Even as the Canal Zone's townsites' inhabitants were frequently relocated—shuttled to new townsites up and down the Panama Railroad line—the townsites remained racially segregated, with social hierarchies built into their design, planning, and implementation. Wright's plans "emphasized the social stratification that was the basis of communal life in the Canal Zone."[129] During Canal construction (1904–1914), the Zone was a work camp. Pay grades were regimented, but laborers from Europe, the United States, Latin America, South and East Asia, and the West Indies were jumbled together in space. Planners sought to separate these groups through the Zone's infrastructure. Initial social stratification included distinct quarters for married and single workers (with an incentive to marry for upgraded housing). Racial and national divisions blurred in the first years of US-led construction, placing Spanish and Italian laborers in the same mess halls as West Indians, for example. After 1908, racial divisions—Black and white, or "silver" and "gold"—hardened. At the same time, white female US citizens were encouraged to migrate to the Canal Zone in large numbers, both to join spouses and fathers and to seek husbands among the male white US worker population. In other words, the racial consolidation of the Canal Zone articulated with a desire by US government and Canal officials to populate the Zone with a white US-citizen force that would, through sexual reproduction, engender a multigenerational, long-term population on the isthmus.

As Canal planners pondered the aesthetic implications of the townsites, racialized and gendered aspects of social control penetrated to the heart of debates over Canal Zone infrastructural design. Facilities for white and nonwhite workers differed greatly: while white workers were allotted suburban-style houses—often

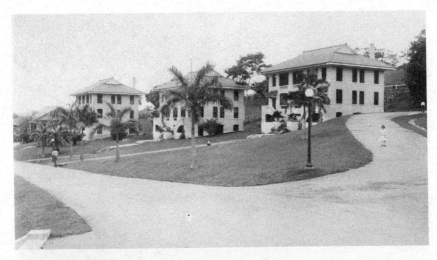

FIGURE 1.5. Balboa Heights, Two Family Concrete Quarters. November 1916. Courtesy of the National Archives and Records Administration (NARA).

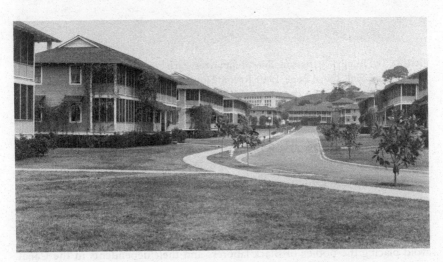

FIGURE 1.6. Four Family Quarters, Balboa, Canal Zone. January 1919. Record Group 185, Records of the Panama Canal. Entry A1–34B, General Records, 1914–60. National Archives at College Park, MD.

single-family homes or duplexes with enclosed washrooms—West Indian laborers had access to few (if any) married quarters or private spaces. Most shared massive dormitory-like structures (including one nicknamed "the Titanic") and open-air detached bathhouses (examples of white workers' housing are pictured in Figures 1.5 and 1.6, and silver-roll housing in Figures 1.7 and 1.8).

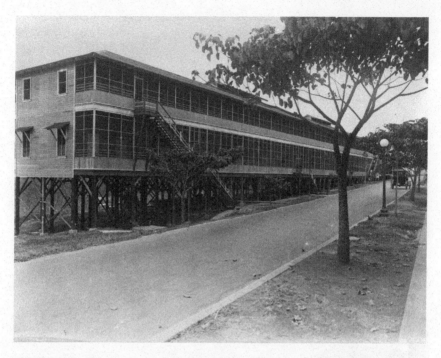

FIGURE 1.7. Family Quarters for Silver Employees. Each house accommodates 48 families. Red Tank, Canal Zone, 1920. Record Group 185, Records of the Panama Canal. Entry A1–34B, General Records, 1914–60. National Archives at College Park, MD.

In his 1913 report to the ICC, Fine Arts Commission delegate Olmsted Jr. proposed a plan of the flagship Balboa townsite that included West Indian workers but channeled them away from Balboa's central axis, which contained the Administration Building and spectacular Prado Boulevard. Olmsted's plan sought to conceal West Indians from the sightlines of US whites by situating the Black "silver-roll" townsite, the future La Boca, on the south side of Sosa Hill, an area not visible from Balboa.[130] This strategic occlusion of La Boca sought to avoid placing the bodies of Black laborers and their dependents in the Canal Zone's main square, the focal point of US empire's scenography in Panama, except as laborers. Further, Olmsted Jr. recommended the construction of a tramway line to carry Panamanian and West Indian workers from their towns directly to worksites without "interrupting" or marring Balboa's imperial spectacle. The ideal of uninterrupted whiteness was impossible, however, since Black labor—as maintenance and service work, pest control and construction—was necessary to maintain the Canal Zone's scenography.[131] Black bodies could not be excised from the landscape, try as planners might to divert these bodies from whites' recreational and social spaces.

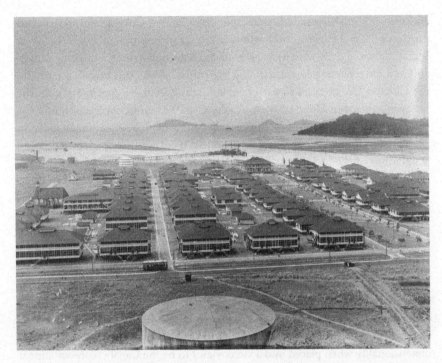

FIGURE 1.8. Quarters for silver employees, La Boca, Canal Zone. April 1, 1920. Record Group 185, Records of the Panama Canal. Entry A1–34B, General Records, 1914–60. National Archives at College Park, MD.

While Colonel Goethals did not implement all of Olmsted Jr.'s plan, under Goethals Balboa became the focal point of US military, economic, political, and social activities in the Canal Zone. The Administration Building (pictured in Figures 1.2 and 1.3) was Balboa's aesthetic keystone.[132] The structure, designed by Lord and completed in 1915, showcased the prowess of US Empire: expressing an American Renaissance style, its grounds featured an amphitheater-shaped front lawn and the Prado, an elegant, elongated promenade with magisterial steps descending to a palm-lined boulevard. The Building's inner chamber is still graced with a rotunda augmented with four murals painted for the ICC in 1914–1915 by William Van Ingen, pink Tennessee marble floors, and a stately internal courtyard buttressed with columns.[133] Van Ingen's murals—one of the largest US-authored mural groupings existing outside the United States—portray the Canal as epic and mystical object, site, and process.[134] Like lithographer Joseph Pennell, Van Ingen echoed the Fine Arts Commission's report by depicting the locks as on par with Egyptian pyramids and metropolitan skyscrapers. Van Ingen's murals aestheticized Canal construction, employing pearlescent hues and thick swirls of paint to convey

an idealized, mist-shrouded landscape. The Culebra Cut—the most arduous portion of Canal construction, where up to six thousand workers (most West Indian) labored daily with dynamite—was enshrined in one of the four panels, and in a ninety-foot frieze encircling the rotunda.[135] In Van Ingen's treatment, the Culebra Cut appears as a frontier landscape, evoking continuity with the westward thrust of Manifest Destiny; the Canal's sinuous contours mimic riverine curves, the surrounding hills a majestic canyon. The manmade incision is arrayed in the trappings of nature. Van Ingen's other three panels depict the installation of the locks: scenes laden with the hulking forms of cranes, scaffolding, and steam shovels, intercut with billowing towers of smoke. These "prosthetics of empire" composed "labor's sign": technology bled into ornament, industrialization into beautification.[136]

As it was beautified on the ground, the construction-era Canal Zone was also portrayed in popular media, including photographs, lithographs, toys, postcards, collectibles, and popular entertainments: songs, dances, films, and Broadway musicals. The 1915 Panama-Pacific International Exposition in San Francisco even featured a scale model of the Canal, and tourists came over on boats to observe Canal construction. Historians of visual culture Alexander Missal and Darcy Grimaldo Grigsby show photography and stereography (which gave the impression of tridimensionality when placed into a stereoview) to be the Canal's representational media par excellence. To this end, the ICC hired a photographer, Ernest "Red" Hallen, to document the Canal Zone's development in exhaustive detail from 1907 to 1937. Hallen "photographed every aspect of the construction and maintenance of the Panama Canal," producing more than sixteen thousand photographs over three decades.[137] His photographs sought to capture the totality of Canal building. As Goethals found, the documentation of construction, allegedly for engineering purposes, also made excellent public relations and promotional materials.

Photographs embodied debates around necessity and aesthetics in the Canal Zone: in the medium's heyday (which partly coincided with Canal construction), the photograph was considered both an inexpensive, precise form of realistic observation and a new art form, intelligible "through aesthetic categories."[138] Photographers acted as artists and laborers, employing the apparatus for purposes of technical documentation but with a "camera's gaze [that] is never neutral or objective."[139] This tension was evident in Canal Zone photography: Hallen's corpus affirms photography's oscillation between utility and aesthetics, delivering instrumental views of Canal engineering alongside images that impressed viewers with decorative, picturesque, grandiose, sublime, and quixotic qualities. Hallen also photographed street scenes in Panama, depicting US government–funded infrastructural projects with "before" and "after" scenes similar to those created by Charles Marville during the Haussmannization of Paris. Missal notes that the "visual language" of these industrial projects emerged from "the illustration of

railroads and other infrastructural projects in the American West, landscape paint-
ing and survey photography."¹⁴⁰ As such, the visual language used to describe the
Canal project dovetailed that of US imperialism, enfolding Panama into a visual
discourse of US westward expansion. Together with debates about "necessary aes-
thetics" in architecture, photography reinforced the spectacular and scenographic
qualities of the Panama Canal and its Zone, the "vistas" and angles of arrival and
departure as much objects of public viewing pleasure as of engineering practicality.

As observed in this chapter, Panama and the Canal Zone figured prominently
in debates over the form and reach of US Empire—debates that took shape in
the architectural and visual paradigms that shaped the US-occupied Canal Zone.
TR's 1906 tour served both to inculcate the borders between Panama and the
Canal Zone—primarily through the figure of the US presidential body—and
to blur those boundaries, rendering sovereignty a secondary effect of US expan-
sion. With TR's explicit authorization, the Canal Zone was built up into the
scenography of a US New Empire that sought to showcase its efficacy and neces-
sity as the source and cause of its modern aesthetics. As the Canal produced a
constant stream of representations outward, ICC officials utilized these imagis-
tic and verbal depictions to shape US and international audiences' sense of the
Canal as the United States' modern monument and strategic instrument—or
weapon—of commercial and military expansion. Yet on the ground, there
existed a direct connection between the built environment and the affective
symbols of belonging that structured the lives of the Zone's civilian and military
residents. Domestic spaces gained new meanings in the Canal Zone, since nearly
all Zone property was owned by the US government, and private property pro-
hibited.¹⁴¹ Absent civic representation, white US Zone inhabitants created other
modes of belonging and feeling national. The blurring of boundaries between
public and private space, labor and leisure, led long-term residents of the Canal
Zone—civilian workers and their families—to develop new hierarchies, histo-
ries, and sources of identity and identification. As a reporter from the *Panama
Star and Herald* newspaper would comment several decades later: "It is one
thing to write a treaty; it is much different to live with it."¹⁴²

Here I have begun an investigation of what "living with a treaty" meant in
Panama and the Canal Zone; the next chapter takes this question further,
exploring the daily lives and leisure practices of workers in the Canal Zone. In
performances, these workers and their families practiced ways of "living with"
the competing sovereignty claims that cleaved the isthmus. Performances kept
laborers entertained and quarantined from Panama's bars, brothels, and cabarets.
Yet the growth of illicit entertainments across the border testified to the limita-
tions of the Canal Zone's "healthy" moral architecture. Chapter Two engages the
proliferation of popular performances in the Zone's borderland, and intersec-
tions of performances with competing sovereignty claims on the isthmus.

2 · ENTERTAINING SOVEREIGNTY

The Politics of Recreation in
the Panama Canal Zone

During the Panama Canal's construction (spanning 1904 to 1914), tens of thousands of international workers and family members migrated to the Panamanian isthmus. To manage the Canal's multifaceted labor population, Isthmian Canal Commission (ICC) officials fostered diverse structures of social control. While the previous chapter examined the Canal Zone's architecture and infrastructure, this chapter takes up the recreational resources that Canal planners provided to keep workers contented and contained within the Zone. Initially, Canal employees started small independent clubs to stave off boredom and loneliness. White US workers began chapters of fraternal orders and secret societies in the Zone to enact recreational modalities imported from the United States and stake out cultural forms of citizenship, in the absence of rights and structures of US civic participation. Workers from the British West Indies—a group that formed the majority of Canal labor—also started clubs, lodges, religious groups, and mutual aid societies. The ICC and its successor after 1914, the Panama Canal (PC), sought to institutionalize workers' amusements, building "gold" clubhouses for whites starting in 1907 and "silver" clubhouses for nonwhites after 1914. Clubhouses were initially planned for whites only, but after several years of petitioning, West Indian workers gained their own recreational centers. For both white and nonwhite Canal employees and their dependents, the Canal Zone's clubhouses became hubs around which recreational activities and social networks would revolve into the 1940s. As I delineate below, the clubhouses—and the entertainments that transpired around and within them—helped stand in for the Canal Zone's absent political structures, linking white US citizens to the Canal Zone and providing alternative forms of community-building for West Indians and their descendants.

From 1914 to 1939, nearly every Canal Zone townsite, white and Black, possessed a clubhouse, sustained by US congressional appropriations and sales

revenues. Gold and silver clubhouses were focal points for white and nonwhite Canal employees' and dependents' social activities, economic transactions, cultural pedagogies, and daily exchanges. The Canal Zone clubhouses, as social centers, limned the contours of national belonging, racial prejudice and policing, gender divides, and discourses of "community" in the Zone. While for US whites entertainments provided a sense of belonging to the Canal Zone, West Indian labor migrants' desires for entertainments, clubhouses, theatres, and sports fields effectively troubled the Zone's cultural hegemony and performance of US sovereignty. Canal officials sought to use the clubhouse system strategically, to discipline workers' behavior, yet administrators' efforts to regulate amusements sometimes clashed with or diverged from workers' own ideas of beneficial social activities. Given the exclusion of West Indians and their Panama-born descendants from US and Panamanian citizenries, these groups attributed additional significance to the Canal Zone's silver clubhouses as sites of community formation. But after 1940, geopolitical tensions between the Canal Zone and Panama leading up to the Canal's 1951 restructuring made the clubhouses increasingly insular and commercialized, a shift that precipitated West Indians' deepening estrangement from the Zone's recreational spaces. The following chapter takes up West Indian Panamanians' quest for social spaces in Panama, outside of a Canal Zone that valued them as laboring, not leisuring, bodies.

GOVERNING LABOR AND LEISURE: CANAL ZONE
CLUBHOUSES FOR WHITE US CITIZENS

During Canal construction, white and nonwhite workers alike lamented the tedium of Canal labor. Observing the white working population, Panama travel writer Thomas Graham Grier fretted: "Along the canal where the dirt flies is the most lonesome place when the sun goes down."[1] Another writer on Panama, Ira Bennett, agreed: "Our most serious handicap is the lack of rational amusements. The people have so few diversions that they soon yearn for their homes in the States, and that condition is followed by the loss of good men from our force."[2] Workers flocked to saloons across the border, where they "drank and kept drinking largely because there was nothing else to do. This . . . made for discontent, and during the first two years over ninety per cent of the Americans returned home each year."[3] Writing to the Canal Zone's first military governor in 1904, US Secretary of War William H. Taft advised: "The one great thing that leads to dissipation and dissolute habits, is the absence of reasonable amusements and recreation and occupation during the hours when the men are not at work."[4] Some white US workers organized Canal Zone chapters of fraternal orders, which offered "the salutary restraints of home, family and public opinion."[5] Yet most workers, excluded from these small, exclusive associations, continued to

seek pleasure in Panama's flourishing nightlife—an influx that local merchants welcomed, but which Panamanian politicians decried as an affront to Panama's sovereignty and a source of inappropriate conduct.

To reduce cross-border conflicts and employee attrition, in 1905 the ICC authorized the construction of clubhouses for whites, with the goals of "increas[ing] greatly the stability and permanency of the force, and thereby enhanc[ing] its efficiency."[6] The clubhouses were intended to help anchor white US workers—and soon, white families—to the Zone within ambivalent structures of US sovereignty. Life in the Panama Canal Zone encompassed more than labor but less than citizenship, due to the Zone's subjunctive sovereignty status—its position "as if" under US jurisdiction. While migrants to the Canal Zone never became citizens of the Zone, thousands built lives and careers there, spanning multiple generations. As a Panama Canal annual report observed: "The United States Government has created here [in the Canal Zone] a unique community of workers with no responsibility of citizenship as to government, no ownership of real and but little personal property, and no encouragement (in fact, no possibility in the Canal Zone) to private enterprise of any kind."[7] The Canal Zone's subjunctive sovereignty shaped its governing structure, a system that was—in the words of its first governor, Colonel George Goethals— "autocratic," "peculiar," and "not in accord with the principles of democracy."[8] An annual report added: "It is doubtful if there is any other Federal organization in the world that embraces the variety of distinct, but . . . interrelated activities that are found in the Canal Zone."[9] The Canal Zone's government was a bricolage influenced by colonial enclaves, US municipal and state governments, United Fruit Company towns, and the US military. Conditions in the Zone were also called "socialistic" owing to the Zone's abolishment of private property.[10]

Such "peculiar" conditions, combined with whites' plentiful leisure time, shaped a social milieu in which recreational activities stood in for civic participation. Michael Donoghue observes: "While a US citizen in the States might join two or three fraternal organizations, it was quite common for Zonians [white US citizen residents of the Canal Zone] . . . to be members of twelve to fifteen different clubs."[11] The Zone's social clubs, too numerous to list in their entirety, included the Benevolent and Protective Order of Elks, the Improved Order of Red Men (whose members are pictured in Figure 2.1), the Oddfellows, Masons, Shriners, Isthmian Canal Commission Band and Orchestra, Incas, Society of the Chagres, Tivoli Club, Isthmian Historical Society, Dramatic Order of the Knights of Khorassan, Knights of Pythias, Kangaroo Court, Sojourners Lodge, and several musical, theatrical, and dance associations.[12] Citing the extraordinary number of Zonian social clubs, Richard and Mary Knapp explain that these clubs emulated structures of civil society.[13] While offering opportunities to socialize, groups like the Shriners also possessed

FIGURE 2.1. Improved Order of Red Men, "Cholo" Tribe No.5, n.d. Image courtesy of William P. McLaughlin.

internal hierarchies and elected positions, which seemed to temper the Canal Zone's lack of political representation.

In designing the clubhouses, ICC officials took note of the anchoring functions of social clubs for whites in the Zone. The ICC's 1905 annual report argued that since Canal labor was "performed in an environment entirely different from that which ordinarily prevails in the community from which the American employees come, the Government must lend its support to the creation of a substitute" for such community life.[14] Canal officials viewed clubhouses as sites of healthy entertainment that would allay workers' restlessness and dissuade them from patronizing Panama's bars and cabarets. Administrators experimented with Progressive-era embodied techniques akin to that which performance scholar Shannon Jackson terms "reformance"—embodied interventions in practices of education, health care, architecture, and socialization.[15] "Reformance" distilled corporeal practices like theatre, dance, and athletics into beneficial activities to improve mental and moral well-being. Advancing Progressivist methods of social control, ICC officials asserted that "creating a regimented and disciplined workforce required extensive intervention into employees' leisure time."[16] The ICC's experiments in reformance required institutional support, and administrators worked to secure US government funding for the Zone's clubhouses. Colonel Goethals petitioned the US Congress for funds to build and manage the clubhouse network.[17] Within a few years, annual spending on entertainment for whites in the Canal Zone rose to $2,500,000.[18] Records for subsequent years show annual contributions of $100,000 to the clubhouses by the ICC and PC, on top of clubhouses' sales revenues.[19] Justifying the expensive clubhouses, Canal planners made

FIGURE 2.2. Exterior of ICC Clubhouse at Culebra and YMCA official Floyd C. Freeman, ca. 1913. Printed in Frederic J. Haskin, *The Panama Canal* (1913): 178–179. Courtesy of Division of Rare and Manuscript Collections, Cornell University Library.

continual appeals to labor and community: clubhouses would foster cohesive communities, which would in turn produce a strong, stable white labor force.

In 1907, the Young Men's Christian Association (YMCA) assumed management of clubhouses at the gold-roll townsites of Empire, Gorgona, Culebra, and Cristóbal (Figures 2.2 and 2.3 depict the Culebra clubhouse and its administrators).[20] The YMCA managed the facilities in conjunction with a superintendent of clubhouses who reported to an ICC-appointed advisory board.[21] The guiding principles of the YMCA, which combined Christianity and Progressivism, reinforced a view of the clubhouses as necessary for workers' "moral uplift." Under YMCA management, Canal Zone clubhouses charged annual dues of twelve dollars and provided libraries, reading rooms, billiards, gymnasiums, bowling alleys, and restaurants. Also on offer were blackface minstrel shows and Chautauqua lectures; courses in "Spanish, mechanical drawing, arithmetic, shorthand, electricity, and wireless telegraphy," "chess, checker, glee, minstrel, dramatic, camera, and orchestra clubs"; and a range of other entertainments and activities.[22] The clubhouses organized charity drives, recreational outings, children's games, and US holiday festivities.[23] The Canal's 1909 annual report documented 2,140 members and an average daily combined attendance of 1,380, with aggregate income of $57,586.32. Traveling performers from the United States gave 81 entertainments for 81,225 spectators, while white Canal employees staged 104 amateur performances for 26,170 observers.

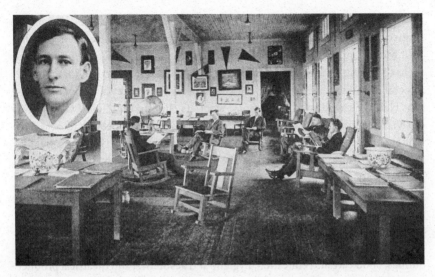

FIGURE 2.3. Interior of ICC Clubhouse at Culebra and YMCA official A. Bruce Minear, ca. 1913. Printed in Frederic J. Haskin, *The Panama Canal* (1913): 178–179. Courtesy of Division of Rare and Manuscript Collections, Cornell University Library.

CLUBHOUSES AND COMMUNITY FORMATION IN THE CANAL ZONE

While the Canal Zone's initial population consisted largely of single male laborers, after 1906 the ICC incentivized white women's immigration to the Zone, to encourage whites' long-term settlement and nurture the growth of white families.[24] Whites received a generous benefits package, including free housing and transportation to the United States, a "tropical differential" (salaries 25 percent higher than those of comparable occupations in the United States), and affordable, high-quality food and consumer products in Canal Zone commissaries. As the Zone's white population expanded into family units, the clubhouses took on new significance as centers of community life. A growing sense of the Canal Zone's whites as a community—conceived not merely in terms of US citizenship, but also as the "Zonians," a unique subculture—linked popular entertainments to the flourishing of white families on the isthmus. Donoghue notes that many Zonians consolidated a shared identity around qualities of US patriotism, white racial superiority, heteronormativity, social conservatism, and pride in their predecessors, the "Old Timers," who took part in early Canal building.[25]

For the Canal Zone's family-oriented white residents, YMCA-managed clubhouses proved insufficient. YMCA membership dues were high, and workers found YMCA rules restrictive. The YMCAs also effectively excluded women and nonwhite workers. Until 1909, only white men could be members; clubhouses were off-limits to nonwhites and non-US citizens, and closed to women

most days.[26] Before gaining clubhouse privileges in 1909, white US women formed alternative social sites and gendered spheres of affective labor. Scholar Paul Morgan notes that white women's boredom and plentiful leisure time led them to organize entertainments and shape new cultural practices that became integral to Zonian life.[27] In 1907, the US General Federation of Women's Clubs sent Helen Varick Boswell to organize women's clubs in the Zone.[28] On a previous visit, National Civic Council representative Gertrude Beeks had observed that the Zone's insularity heightened women's depression. Following Beeks's recommendations, Boswell oversaw the creation of Canal Zone branches of the Federation of Women's Clubs in each gold-roll townsite (Pedro Miguel, Ancon, Paraíso, Empire, Gorgona, Gatún, Cristóbal, and Culebra).[29] Other US women's clubs, such as the "Sorosis" network, conducted cross-border outreach, corresponding with Zonian women and inviting Panama's First Lady as "ambassadress" to New York.[30] Female social activities included lectures, philanthropy, outings, child care and education, hygiene and aesthetics, and theatrical productions. White Zonian women also created and performed in blackface minstrel shows.[31] After the Zone's Federation of Women's Clubs ended in 1913, women's religious practices, domestic duties, and staged entertainments remained important factors shaping Zonian identity.

In 1914, construction ended and the Canal opened. The ICC was dissolved, and the PC took over Canal administration. With these changes, PC officials took advantage of the Canal Zone's growing numbers of white women and children to transform the clubhouses from homosocial venues to family-oriented community centers. Clubhouses were placed under the PC's Bureau of Clubs and Playgrounds (BCP), a new administrative sector.[32] What had been gender-segregated sites privileging the entertainment (and containment) of white men were now affordable "centers for varied community activities."[33] In its 1915 annual report, the BCP emphasized the clubhouses' new mandate: "The type of activities has been adjusted so as to place greater emphasis upon the community life [...]. This change has been in conformity with the general change in the community life from that of the bachelor employee type to that of the employee with a family. Clubhouse membership ... has been made secondary to the use of privileges at fixed charges in order that this larger community use might be made of the clubhouses and equipment irrespective of clubhouse membership."[34] As the clubhouses expanded, their expenditures increased to roughly $500,000 annually in the mid-1920s.[35] These funds paid salaries and enabled amusements, from celebrations of US federal holidays to parades, mass pageants, baseball games, and community theatre.

The BCP sought to secure government funding by citing clubhouses' provision of "wholesome amusement and recreation ... under home influences": "The clubhouses serve well as stabilizers of what would otherwise be a constantly

shifting, unanchored population, drifting inevitably to the demoralizing influ-
ences of the inferior cabarets and saloons of Panama and Colon, or leaving the
service. [...] The money appropriated by Congress for the clubhouses is a nec-
essary corollary to the living conditions resulting in the Canal Zone from our
policies."[36] Continuing to uphold the clubhouses' contributions to labor pro-
ductivity, BCP officials also highlighted the clubhouses' community-building
functions, which made them "indispensable to satisfactory community life in
the Canal Zone."[37] Nearly all Canal annual reports up to 1950 included a disquisi-
tion on the benefits of clubhouses and playgrounds to the "community." The 1923
report went so far as to rename the clubhouses "community centers," while the
following year's report noted that the clubhouses "are centers for varied com-
munity activities, and . . . open to all."[38] The 1926 report called the clubhouses
"central meeting places" and stated: "The justification for [the clubhouses']
continuance is that they add materially to the morale of the organization and
to the physical and moral health of the community."[39] Discourses of community
revealed the US government's changing perceptions of the Zone, from tem-
porary worksite to permanent enclave. The rhetoric of "community" did not,
however, fix the concept in place. Rather, the meanings of "community" shifted
during the clubhouses' six decades of existence, in relation to concepts of race,
nationality, gender, sovereignty, citizenship, and cultural belonging.

WHOSE COMMUNITY? THE SILVER-ROLL CLUBHOUSES

The presence of a large body of nonwhite, non-US laborers elicited questions
of *which* bodies constituted acceptable communities in the Canal Zone. Brit-
ish West Indians were working on the isthmus before the Panama Canal, hav-
ing been recruited for the Panama Railroad (1850–1855) and the French canal
project (1882–1889), and by corporate plantations such as the United Fruit Com-
pany.[40] French canal builders had recruited an estimated 20,000 Jamaican work-
ers by 1888.[41] When the US Canal project began in 1904, the ICC also sought
West Indian labor, primarily from Barbados, Trinidad, and Martinique.[42] The
Canal Zone's total residential population regularly reached 30,000 to 40,000,
exceeding 50,000 in peak construction years and during the 1940s spike in mili-
tary and labor recruitment.[43] Of this number, historian Velma Newton estimates
that West Indians composed at least 60 percent from 1904 to 1914.[44] After 1914,
Canal annual reports and census records show West Indians outnumbering
whites four-to-one, and at times seven-to-one, in the labor force.

Although not incentivized to immigrate to the Canal Zone, many West Indian
women came over, joining male relatives and attaining employment as service
workers in the Canal Zone. As David McCullough asserts, "the entire" Panama
Canal Zone "depended on black labor": "There were . . . thousands of West Indians

down ... [at] Culebra Cut [and] at the lock sites [and] black waiters in every hotel, black stevedores, teamsters, porters, hospital orderlies, cooks, laundresses, nurse-maids, janitors, delivery boys, coachmen, icemen, garbage men, yardmen, mail clerks, police, plumbers, house painters, gravediggers."[45] Forming the backbone of Canal labor, West Indians were nonetheless prohibited from using its recreational spaces, as spectators or participants, in the Zone's early years. Canal officials considered Black and brown people inherently unproductive workers and undesirable leisuring bodies. Goethals described "Panamanians and West Indian negroes" as "non-productive, thriftless and indolent," and many Canal administrators agreed.[46] Stereotyped as tending biologically toward nonproductivity, nonwhite workers were judged in need of greater discipline, not recreational activities.[47]

As the Canal Zone became a permanent enclave, dimensions of nationality and racial difference relegated West Indians to the bottom of the Zone's social hierarchy. From the start, Canal laborers were divided into gold and silver pay-rolls, depending on factors such as occupation, citizenship, and race.[48] Before 1908, Canal labor comprised many ethnic groups, including Spanish, Italian, and Asian laborers.[49] With the advent of a rigid color line, the payrolls were overtly racialized, and West Indians were restricted to menial occupations on the silver roll.[50] By 1914 Canal Zone housing, commissaries, and social areas were racially segregated along a black-white binary.[51] In addition to meager wages, West Indians received poor resources. They paid rent for substandard housing, while white US citizens lived rent-free in modern comfort supplied by the US government.[52] The Canal Zone's silver-roll educational provisions were far inferior to those of the gold school system. Broadly speaking, while the Zone's subjunctive sover-eignty status did not adversely affect white Zonians (who retained US citizen-ship), it impacted the lives of West Indian Canal employees profoundly, leaving their citizenship status in doubt. As West Indian workers and their Panama-born children became long-term members of the Canal's workforce, these "silver peo-ple" asserted their rights to recreational resources as community-building tools in the absence of formal structures of political membership.[53]

In the first years of construction, African American, West Indian, and white US religious leaders petitioned the ICC and YMCA for West Indian workers' amusements. In 1907, the Reverend A. G. Coombs, a former Canal employee and naturalized US citizen of West Indian descent, lamented that West Indians had "nothing else to do, nor elsewhere to go" in their spare hours.[54] Coombs argued that even secondhand newspapers would alleviate West Indians' boredom.[55] The response of then-ICC chief engineer George Goethals called upon environmen-tal determinism to make the case for whites-only recreational provisions:

The original idea upon which the club houses were built . . . was that young men sent to the Isthmus are subjected to unusual temptations, being suddenly

removed from the society of their families and friends and the various elements of restraint which surround them in the States. [L]iving in a tropical climate to which they are unaccustomed and far removed from their usual mode of life, the club houses would do more to make and keep [whites] contented and satisfied than any one thing the Commission might do. [But] the colored employees . . . are living under conditions similar to those in their own countries, and are probably as well off, if not better provided for, than they are at home.[56]

Facing repeated dismissals, West Indian workers and dependents created their own social centers off-Zone and utilized Zone buildings when available. While citing the extensive recreational funding provided for whites, Newton observes: "The sense of community felt by [West Indians] resulted in a number of . . . recreational projects. This was fortunate, for the ICC was no more interested in providing these workers with recreational facilities than the French canal companies had been."[57] Social clubs, mutual aid societies, and religious institutions sought to fulfill West Indian migrants' needs. Mutual aid societies played particularly important roles, as multifaceted centers that collected life insurance, raised funds for the elderly, and supplied essential resources.[58] Both in and beyond the Canal Zone, Methodist, Wesleyan Methodist, Episcopalian, Baptist, and Catholic churches drew heterogeneous West Indian–descended audiences to cantatas, pageants, plays, and concerts. These resources helped, but major gaps remained.

Some ICC officials agreed that nonwhite workers needed US government–funded recreational provisions in the Canal Zone. A. Bruce Minear, the ICC's general secretary of clubhouses, entertained the prospect of silver-roll clubhouses. Minear suggested to Goethals and Executive Secretary Joseph Bucklin Bishop that the YMCA International Committee send African American secretaries to inspect conditions among workers of color in the Zone and establish colored YMCAs there.[59] The ICC rejected Minear's recommendations, stating: "it is unwise to begin YMCA work among them, which would unquestionably result in demands upon the Commission for assistance of various kinds."[60] Further, the ICC cited the Zone's strangely familiar racial climate: "The negro YMCA secretaries, should they also visit the Zone, would undoubtedly expect to be furnished [with] first-class accommodations on the Steamship Line, which would . . . be objectionable . . . and . . . I have no doubt that they would expect to be allowed the privilege of eating at the Commission hotels."[61]

The Commission's indifference did not stop the petitions, however. In 1908, encouraged by African American Secretary of the YMCA International Committee J. E. Moorland, Reverend D. Newton Campbell wrote: "View how [West Indians] are crowded into camps, packed into huts and quarters like sardines in a tin, practically homeless, desolate and seemingly friendless! They have no YMCA, no Epworth League, Christian Endeavor nor places of

amusement or recreation. [. . .] Left as they are to paddle their own canoe, do we wonder that the ballrooms and gambling dens are overcrowded with them? Can we blame colored youths who . . . drift away to dens of vice and sin to find a little society, pastime, or recreation?"[62] Reverend Campbell cited the "ample provisions . . . made on the Zone for the few thousand whites residing there."[63] Goethals dismissed his plea, stating: "It was not the intention to construct club houses for all employees on the isthmus, and, as the colored Americans connected with the work are so few and scattered, the Commission would not be justified in expending money on club houses for their use."[64] Here the ICC upheld nationality, not race, as a factor authorizing unequal resources. Another petitioner, West Indian dry dock worker James Harris, requested a meeting space for his "Coloured Employees Improvement Club," which would feature "Lectures, Debates, Concert Recitation, &c."[65] Harris sought permission to meet in the silver schoolhouse at Folks River. Goethals's response cited the ICC's policy of September 1907, which did not permit school buildings to be used for any purposes other than those designated. Feeling "very small of having been refused," Harris responded by invoking the promise of "the Hero President" [TR] on his visit to the Canal Zone in 1906: "that he would do anything for our improvement."[66] Following his repeated attempts to gain resources, Harris's request was ultimately denied.

Other petitions gained ground. Baptist pastor S. Moss Loveridge and the Colored Young Men's Christian League (CYMCL) each requested reading rooms and gathering places for silver-roll workers. Loveridge made points similar to Campbell's, adding that illiterate West Indian workers were forced to use Panamanian mail services, which often stole their remittances and charged exorbitant transcription fees.[67] The CYMCL's mission statement stressed "the advancement of the moral, intellectual and social conditions of the Colored young men of the Canal Zone."[68] The CYMCL envisioned women's and men's Bible lessons, intellectual and literary debates and lectures, and dances, billiards, card games, and picnics. The ICC leased land to Loveridge for a social center, and Loveridge agreed to host some of the CYMCL's activities. The issue seemed resolved. Yet Loveridge forbade dancing and cards and instead sought to run his clubhouse according to Baptist doctrine, which the "nonsectarian" CYMCL found objectionable.[69] In addition to their religious differences, Loveridge was African American and the CYMCL West Indian; the two parties held distinct views on entertainment, spirituality, and intellectual pursuits, which went unrecognized by the ICC. Talks broke down, and nonwhite workers were again left with no permanent recreational facilities in the Canal Zone.

Rev. Coombs petitioned the ICC for over two years, making repeated arguments about labor productivity: if nonwhite workers were not given recreational outlets, they would leave the Zone for "the Saloon, and other

disreputable joints, to the hurt of their strength; consequently poor health and bad labor."[70] This line of reasoning framed entertainments as key to improving work quality: "Provid[ing] decent and attractive places of amusement . . . would induce a better class of laborers, abundantly please those already in the Zone, [and] create a more satisfactory result of work . . . leading up to a decidedly better class of people as permanent dwellers and workers in the industrial life of the Zone, which anyone can see will be of no small proportion."[71] Coombs also appealed to US values: "These men . . . strongly British in thought and desire, if they are to live on American soil, must learn American ideas and customs. Not only learn them, but love them and work for them."[72] Although misguided about the Zone's sovereignty status, Coombs's arguments made an impact. In 1909 Goethals wrote to the US secretary of war to request funds for "reading and writing rooms for colored employees, to be provided with suitable amusements and conducted somewhat along the lines of the Commission club houses operated by the YMCA."[73] This appropriation would replace the ICC's practice of lending temporary sports fields and buildings to nonwhite groups, subject to confiscation.[74] Starting with the La Boca silver clubhouse in 1914, West Indians gained permanent clubhouses.[75] By May 1919, clubhouses operated in the racially segregated silver townsites of Cristóbal, La Boca, Gatún, and Paraíso, with one pending at Red Tank.[76]

Equal in number to the five gold clubhouses, the five silver-roll clubhouses were nonetheless highly inadequate to the large West Indian worker population. Despite the paucity of resources provided, the extension of BCP representation and US government funding to West Indians constituted a minor victory in light of ICC officials' continued stance that West Indian workers were not US citizens, and therefore not entitled to US government support.[77] In 1919, Paraíso silver clubhouse secretary J. E. Waller reported: "The colored people show by their actions that they appreciate such a well equipped building; many activities, for the mental, moral, physical and spiritual uplift of men, women and children are being conducted by the Secretary. [. . .] We also aim to support ourselves that we might not be a burden on the United States government or cause any anxiety on the part of the officials of the Canal Zone."[78] Secretary Waller's statement, equal parts progress report and declaration of autonomy, exemplifies his approach to the delicate cultural politics of West Indians' recreational activities in the Zone. Waller, a vocal representative for silver patrons, would become the head administrator of the silver clubhouse network. Waller stressed the need to keep the clubhouses fiscally soluble and self-supporting. He led a generation of silver clubhouse secretaries who dealt assertively with PC administrators and undertook ambitious cultural programming agendas despite limited resources. Waller used respectability politics to mediate between the Canal's nonwhite employees and the PC bureaucracy. From 1918 to the 1930s, Waller and his colleagues developed a bustling silver clubhouse

network featuring local and international entertainers, original plays, and dances and concerts that doubled as fundraisers.

The BCP's annual reports highlighted the positive effects of "colored club houses" on the West Indian "community," as "literary clubs, talks on educa- tion, health, and other subjects helpful to children as well as adults form an important part in the community welfare work."[79] The 1929 report asserted: "Community activities within the Canal Zone center in large measure around the clubhouses [as] social centers for the Canal Zone population, both white and colored."[80] BCP support for the silver clubhouses, however, was contin- gent upon the clubhouses' conformity to racialized conceptions of "commu- nity," upholding strict rules of conduct and policing Black patrons. To meet in the silver clubhouses, groups had to demonstrate to the BCP their contri- butions to West Indians' moral uplift. (No records suggest similar qualifying procedures in the gold clubhouses.) C. W. Omphroy's Olympic Athletic Club, for example, was permitted to use the silver clubhouses because it focused on "physical, intellectual, and moral uplift" through its "physical cultural Club . . . literary [and] musical programme" and lectures from "professionals and . . . gentlemen of the community."[81]

Anxieties about race and sexuality also led silver secretaries to compose "Rules for Conducting Dances in Silver Club Houses." These rules were informed by Gen- eral Secretary of Clubs and Playgrounds T. S. Booz's memo on the "dance prob- lem": "Such suggestive dances as the Strike or Hoochiecoochie—or any dance where dancing is done in close bodily contact tends to incite the sex impulses [and] for that reason there should be written rules conspicuously posted in the halls of each Clubhouse insisting that all dancing be done in open positions." Although the note could ostensibly have been addressed to all clubhouses, there was no mention of a "dance problem" in gold clubs, suggesting that silver clubs may have been policed more actively. The silver secretaries agreed to "appoint a Com- mittee or a Floor Manager whose especial duty would be to prevent any suggestive or improper dancing. This action Mr. Booz said he considered necessary because of the fact that the Clubhouses are expected to assist in helping to elevate the moral tone of the community."[82] The secretaries developed behavioral guidelines:

1. A man uses his right arm to guide his partner, with his hand resting lightly on her back just above the waist and she looks more attractive if her hand rests gracefully on his arm or shoulder.
2. Any dancing which exaggerates any part of the body movements unduly is not suitable for these dances.
3. Open position, and proper movement of bodies must be maintained by both men and women while dancing.

4. Men are not expected to smoke nor keep their hats on while dancing.
5. Persons who violate these regulations will be excluded from clubhouses (or handed over to Police Dept., or both).[83]

In policing social dance patrons, silver secretaries complied with BCP mandates and deployed a discourse of respectability to legitimize their recreational activities. The disciplining of bodily comportment formed part of silver secretaries' strategies to negotiate administrative power, racial, sexual, and gendered identity, and social marginality.[84] Silver secretaries "cleaned out" the "bad underworld element who have no respect for themselves," who "frequented the clubhouses and conducted themselves in such a way that the best element of people looked upon the clubhouse as a place of ill repute."[85] Nothing was said about whether this "bad element" originated in the Canal Zone or Panama. Secretary Waller only noted, after one purge: "We can now boast of the fact that . . . the very best element of Cristóbal and Colon, in fact of the Isthmus, take pleasure in visiting the Cristóbal Silver Clubhouse."[86]

Despite the silver clubhouses' self-policing measures, West Indians were the subject of constant false and damaging rumors, pamphlets, and op-eds, like one entitled "The Jamaicans Are Ready to Revolt" (1933).[87] Racial paranoia and xenophobic violence against West Indians were pervasive in Panama, as historian Kaysha Corinealdi shows.[88] Amid these hostile conditions, silver secretaries Waller, Neely, Eagleston, and Collins worked to make their clubhouses into centers of social, educational, economic, and political activity for West Indian–descended people. Waller helped to formulate a long-term development plan for the clubhouses, comprising religious, educational, and "recreative" activities and sports, as well as community outreach at schools and churches, and with US military servicemen of color. The clubhouses sought to sustain themselves through soda fountains, motion pictures, playgrounds, dances, bowling, room rental fees, billiards and pool, and library fines. Secretaries frequently hosted inter-clubhouse activities like monthly sports tournaments for which resources were pooled.[89] At the clubhouses, West Indian community leaders supplemented an otherwise inadequate silver educational curriculum with night courses, as several annual reports noted: "At the colored clubhouses a special effort was made to offer helpful educational attractions and to foster interest in classes covering health, social, commercial, industrial, and other self-help features, both for adults and for children."[90] Labeled "self-help," these services in fact filled gaps in the PC's silver curriculum, which focused on vocational skills in contrast to the high-quality education provided for US whites.[91]

SILVER-ROLL CLUBHOUSES AS SITES OF CONTENTION

Once West Indian workers obtained clubhouses, conflicts arose over their uses. Many West Indian social networks transcended the Canal Zone–Panama border, prompting questions about which bodies could enter the Zone for recreational purposes. Shortages of Zone silver housing, particularly for families, forced many to live in adjacent Panamanian neighborhoods like Guachapalí and Marañon.[92] Given fluctuating residential and labor conditions, West Indian social clubs might include Canal employees residing in the Zone, Canal employees living off-Zone, and nonemployees connected to the Zone through friends and relatives. PC policy "restrict[ed] the use of the Clubhouses to forms of amusement and recreation. The Clubhouses cannot be used by fraternal societies, or lodges, or labor organisations" and were "reserved for the uses of employees."[93] This policy met with a storm of petitions from West Indian clubs, lodges, and organizations. In response, the PC stepped up its policing of West Indian social gatherings.[94] While an array of West Indian groups requested access to silver clubhouses, only select groups deemed nonthreatening to the Canal, like the Atlantic Girl Reserves, were permitted to utilize them as meeting venues. Labor unions were particularly prone to BCP scrutiny. Unrecognized by Canal officials, West Indian labor organizations like the Colón Federal Labor Union were active since 1916, and likely before.[95] Two labor groups were prominent: Samuel Whyte's Silver Employees Association (SEA), founded in 1917; and a union established by Barbadian teacher William Stoute, affiliated with the white US United Brotherhood of Maintenance of Way Employees and Railway Shop Laborers, and Marcus Garvey's Universal Negro Improvement Association (UNIA).[96]

Canal Zone governor Chester Harding viewed Stoute's union as a threat. Stoute's union had been meeting at the Cristóbal silver clubhouse with the clubhouse secretary's approval until Canal officials forcibly ended the practice and informed Stoute that he would have to request permission from the general secretary of clubhouses, T. S. Booz. Stoute's April 1919 petition stated: "We prefer to hold our meetings in the Canal Zone as it affords the Police Dept. the opportunity to know at first hand what we are doing, and precludes the idea that we are secretly and maliciously plotting against the government."[97] This comment acknowledged that police spies monitored Zone activities yet stated a preference for the spy-ridden Zone to holding meetings in Panama, since the Canal Zone governor often summoned the Panamanian police to disband gatherings, sometimes violently.[98] Stoute also observed "that there has never been any misbehavior at meetings held in the silver clubhouses under the auspices of the United Brotherhood."[99] He attempted a tactical dance of power: if the Canal would allow his organization to meet in the clubhouses, he would freely show his hand. Stoute's argument failed to convince Booz, who vetoed the petition on

the grounds that the United Brotherhood was focused neither on education nor amusement.[100] In response, Stoute offered to teach free courses in arithmetic and geometry at the meetings.[101] This idea was rejected six days later with the reply that the clubhouses were confined strictly to "amusement and recreation."

Other United Brotherhood branches—the Victory Lodge (Paraíso) and Liberty Lodge (Red Tank)—were also ejected from the silver clubhouses. Waller wrote to Canal Zone governor Harding in protest, noting that the union's conduct was exemplary, and its activities never conflicted with normal scheduling. The removal of the Victory Lodge negatively impacted Waller's Paraíso clubhouse, which lost clientele and income as the men "forthwith cease[d] to patronize" it.[102] Members of the 400-strong Liberty Lodge also protested to Harding.[103] In response, Harding invoked the policy of making Zone clubhouses available "for the use of the entire community" of Canal employees, rather than for "outside agitators."[104] Other administrators echoed this argument: if permission to meet were granted to all groups, then the clubhouses would be overtaxed and depleted of their value as community-binding centers. Invocations of "community" portrayed labor organizers as outsiders, but in fact these organizers were themselves members of the community.

Stoute's union was banned from meeting in the Canal Zone, but the PC would have benefited from keeping it within earshot. Six months after the ban, the union executed one of the largest and best-organized labor disruptions on the isthmus. On February 24, 1920, up to 16,000 workers—primarily West Indians—went on strike. The Panama Canal reeled from the absence of 80 percent of its workforce, and Harding ejected strikers and their families from the Zone, yet the strike continued for nine days, at which point its leaders were deported.[105] After the strike, West Indian organizing was largely curtailed until the 1940s. Yet the PC allowed Samuel Whyte to keep his union running and meet in the silver clubhouses. Whyte's SEA (1917–1919) reemerged in 1924 under a new name, the Panama Canal West Indian Employees Association (PCWIEA).[106] Petitioning the BCP, Whyte leveraged the threat of Panamanian influence on West Indian workers meeting off-Zone and noted that the PCWIEA was not only a union but also a "communal agency [with] musical, literary, and dramatic exercises," and a source of philanthropy.[107] On the condition that it did not host nonemployee speakers, the BCP permitted the PCWIEA to meet in the Zone—an acknowledgment of its minimal threat to the establishment.[108] Whyte's union was widely considered ineffective; Canal officials used it to supervise West Indian labor activity that might "breed discontent."[109] Whyte's and Stoute's negotiations with the BCP, PC, and Canal Zone police offer insights into the clubhouses' strategic roles in West Indian–US relations. Given West Indians' lack of political or bargaining power, their struggles for power manifested in the Zone's recreational structures.

DEFINING "AMERICA" IN THE CANAL ZONE:
TRAVELING STATES ENTERTAINMENT

While Canal officials permitted the silver clubhouses to host indepen-
dent entertainers, West Indian clubhouses were not allotted an explicit US
government–sponsored program of entertainment, as were US whites. From
the first years of Canal construction, the ICC sought to create entertainments
for whites that were infused with US nationalism, fostering cultural affilia-
tions between Zonians and the country of their citizenship. Through perfor-
mance's embodied, spatially delimited techniques of display, audiences could
come to identify with a large and amorphous collective: the United States.[110]
Between 1904 and 1914, offers poured in from US lyceum and theatre com-
panies to send magicians, acrobats, phrenologists, Jubilee singers, chalk talk
artists, impersonators, and ladies' orchestras to the Canal Zone.[111] The YMCA
created a special process for bringing US performers (called "States enter-
tainment") to the Zone: the ICC paid entertainers' travel, lodging, and per
diem expenses and offered artists a small fee, in exchange for eight free perfor-
mances (two at each gold clubhouse). The YMCA also organized tours of the
isthmus for States entertainers. While the arrangement caused artists to miss
two weeks of domestic performing due to the voyage to Panama, many, like
Shipp's Circus, found the terms amenable and returned for a second or third
engagement. Some further exploited their time in Panama by incorporating
isthmian themes and anecdotes into their domestic US repertoire.[112] Capital-
izing on the Canal's watershed moment, for example, the Redpath Lyceum
Bureau sent States entertainers to the Zone and introduced exoticized acts like
the "Panama Singers" to the US circuit.[113] Many acts traveled to the West Indies
and Cuba before or after performing in Panama, while others added Panama to
tours of Ecuador, Chile, Brazil, and Argentina. As such, the tours mapped new
routes of transnational performance, with Panama as a hub.

The ICC sought to contract States entertainers whose racial, gendered, and
classed profiles evinced "moral character."[114] These "wholesome" performances
would, it was believed, help reinforce national identity and cultural belonging.
YMCA officials patterned their project after a "lyceum model," citing US lecture
practices like lyceum and Chautauqua, which focused on community-building
and "moral uplift."[115] Charlotte Canning notes that the content, demographics,
and routes of lyceum reflected facets of US democracy; through performance,
the ICC sought to link itself to a still-emergent sense of the United States as
national cultural and political entity.[116] The YMCA also sponsored more frankly
theatrical acts, like vaudeville, circus, musical comedy, and traveling dramatic
troupes, but its New York office pre-vetted Zone-bound theatricals for moral
cleanliness and quality control. Moreover, YMCA officials followed trends in

US popular entertainment, seeking to include Zonians in US audiences.[117] The first States entertainers—drawn from Chautauqua and lyceum circuits, touring theatre, and vaudeville networks—included the Ernest Gamble Concert Party, Edwin R. Weeks Company, Lyric and Lotus Glee Clubs, Frank Robson, William Jennings Bryan, Apollo Concert Company, Thomas McClary, and Gay Zenola MacLaren, as well as several university glee clubs.[118]

These performers were received positively by white Canal employees, who attended States entertainments in large numbers. In 1913, for example, nearly 30,000 people turned out for visiting international artists, while local entertainments and film screenings drew total audiences of roughly 97,000.[119] Imported US films formed a centerpiece of Canal Zone clubhouse entertainment: as early as 1908, the YMCAs distributed films to clubhouses, then to Panama's movie theatres, through the Cinema Pan-Americano, accompanying films with live vaudeville when possible.[120] While connecting Panama to hemispheric touring performances, the States entertainment and US films linked Panama and the Canal Zone in new ways. Like films, theatrical entertainments that traveled to the clubhouses almost always played in Panama too. In 1921, for example, the PC's contract stipulated that any entertainer appearing in the Canal Zone had to perform at two or more additional venues outside of the clubhouses, including army and navy YMCAs and theatres in Panama City and Colón. These film and performance distribution networks marked early incursions of US cultural production that shaped Panamanian cultural practices, instilling a US cultural hegemony that drew criticism from some Panamanian artists and audiences. I take up Panamanian responses to these iterations of US cultural dominance in Chapter Four.

When the ICC became the PC in 1914, the States entertainment policy came under renewed scrutiny. The BCP sought to adapt to white families' long-term needs by expanding local offerings while continuing to contract States entertainment. The PC's Washington, DC, office now managed entertainment selection, employing booking agents to scout performers with the YMCA's help.[121] YMCA secretary F.M.M. Richardson likened the Canal Zone to Wilmerding, Pennsylvania, "in general make up [sic]" and wrote to Wilmerding's YMCA for entertainment recommendations, convinced that "what has taken at Wilmerding would take on the Zone."[122] The first entertainments after the administrative change were consistent with those before: an array of singing quartets, lyceum, vaudeville, humorous lecturers, and short playlets. In 1915 Richardson hired talent agent Clyde Smith to scout plays, vaudeville, variety acts, and musical concerts calibrated to the Canal Zone's special conditions.[123] Between 1915 and 1916, five vaudeville groups signed contracts of engagement at the five gold clubhouses, army and navy YMCAs, and two theatres in Panama.[124] Entertainers would perform the first five engagements in the Canal Zone free of charge, after which tickets could be sold for at least fifteen paid engagements in the Canal

Zone and Panama. In return, the BCP would pay them an agreed amount and cover all costs.

Already in 1915 the PC was suffering financial losses from hosting entertainers on a salary basis, and Richardson reverted to the cost-effective "lyceum type . . . used on the Zone for six to seven years past."[125] Meanwhile, BCP officials saved money by booking international entertainers brought to the isthmus by Panamanian impresarios. When performing at the Teatro Nacional in Panama City, the Teatro Variedades in Colón, and Teatros Cecilia and América, artists often made a side trip to the Canal Zone, stopping at Balboa and Cristóbal gold clubs and army and navy YMCAs. The clubhouses helped with publicity and received a small commission. These lucrative performances included classical music, opera, "eccentric" dancing, circus acts, magicians, acrobats, and large ensembles.[126] In 1919, the outlook for traveling entertainment seemed promising, despite the Canal's postconstruction reductions in force.[127] In March 1919 the PC sent requests for "first class entertainments" to more than a dozen influential US entertainment bureaus and practitioners, including well-known US producer David Belasco.[128] Later that year, Executive Secretary of Clubhouses C. A. McIlvaine laid out the PC's entertainment goals in a forceful memo:

> There is a large number of intelligent and well educated Americans on the Isthmus who need entertainment of a better class than is available at present. . . . [We need] a system [whereby US] entertainers will be furnished to us regularly, and that these entertainments should be of a character to give the community an intellectual and esthetic treat. [. . .] What I desire to see inaugurated is a service of entertainments consisting of . . . first-class musical troupes, first-class lecturers, and small stock or vaudeville companies. I desire that . . . we receive one month a troupe of good musicians, the second month a good lecturer, and the third month a small stock company or vaudeville troupe giving clean performances; and then this cycle being completed, repeated. [. . .] We need good music, good lectures on interesting topics—travel and matters of current interest in the world of thought; in short, something that will supply a better class of entertainment than anything we have locally.[129]

McIlvaine's ideas were the catalysts of a new entertainment policy. The PC would draw up contracts in-house, providing transportation, commissary, housing and medical benefits—the opportunity to experience Zonian life—in exchange for at least five performances at Canal Zone clubhouses, plus performances at US Army bases and in Panama City and Colón. McIlvaine also sought to create a semipermanent circuit with dual booking agents in Washington and the Canal Zone, and a permanent orchestra in the Zone.[130] The 1920 lineup reflected McIlvaine's objectives, as the PC contracted "local talent, and . . . singers, magicians,

telepathist, Japanese troupe, and the marimba band, which were booked while passing through Panama."[131]

Despite McIlvaine's optimism, the PC was having difficulty procuring entertainers. In August 1920, the PC's Washington office contacted *Billboard* magazine editors Hermann Fisher and Fred High about attracting Chautauqua lecturers and commercial performers to the Canal Zone.[132] Noting a general downturn in touring entertainment, Fisher urged the Canal to form its own dramatic stock troupe. Calculating a stable audience population of at least 12,700 in the Canal Zone, Fisher saw no reason why the Zone should not foster a resident company. Yet despite the Zone's critical mass of patrons, entertaining white families continued to be a money-losing venture. Starting in late May 1921, the PC began canceling its engagements with performers contracted up to two years in advance.[133] At first officials sought to retain solo acts while discontinuing larger, costlier entertainment. Eventually the BCP conceded that even its sponsorship of monologists and lecturers was unfeasible.[134] The traveling entertainment policy was discontinued in favor of an arrangement whereby groups traveling to the Canal Zone of their own accord could perform in the clubhouses, allotting the BCP a percentage of their intake to cover publicity and operations costs (one such entertainer is depicted in Figure 2.4).[135]

The failure of the gold-roll entertainment policy was puzzling to some administrators. After all, the Canal Zone did not lack for a captive audience. Thousands of military and civilian US citizens lived there, and the Zone possessed no competing private industry. Some clubhouse secretaries attributed the failure to the Washington office's disconnect from Canal employees. According to the Ancón gold clubhouse secretary, Washington had the "wrong idea as to what is wanted here": "We do want high class entertainment, but an entire evening of purely classical music would only get by in larger communities where there are enough there that would enjoy it. People do know and appreciate good things here. If we have a black face comedian he must be *good* in his line, or a singer, or dancers . . . they must all be good in their specialty. [. . .] It does not follow that because our employees in general do not care for an evening of all high class music that they will enjoy poor or trashy acts."[136] High-class fare was "more suitable for an audience of artists and critics than for our employees, the great majority of whom belong to the workingman class, with tastes and desires accordingly."[137] In response to such class-oriented claims, the Washington office turned to contracting "persons who can give short, snappy sets, humorous selections, impersonations, light and popular music, etc., [who] are more satisfactory to the local audiences and will certainly be less expensive to the Canal."[138]

Yet the disconnect was not solely due to differing tastes. In the United States, the shift from small-time entertainment to "oligopolies," the postwar scarcity of performers, and the Canal's declining stature in the US public imaginary after

CANAL ZONE CLUBHOUSES 95-E-7

ALAIDA ZAZA

IN

CLASSIC DANCES AND ART POSES

SACRED DANCE OF INDIA

In Costume,

POSES PLASTIQUE -

(Imitation of Art Statues)

HINDOO SNAKE DANCE.

In Connection with the

Moving Pictures.

BALBOA	PEDRO MIGUEL	ANCON
Thursday, March 12	Friday, March 13	Saturday, March 14
7:45 P. M.	8:15 P. M.	7:45 P. M.
with Jack Hoxie in	with Mae Murray in	with Conrad Nagel in
"WESTERN WALLOP."	"FASHION ROW."	"NAME THE MAN."

PRICES: Children 20 cts. -- Adults 40 cents.

FIGURE 2.4. Flyer, Alaida Zaza Classic Dances and Art Poses, Performance in Canal Zone Clubhouses, March 12–14, 1925. 95-E-7. Record Group 185, Records of the Panama Canal. Entry A1–34B, General Records, 1914–60. National Archives at College Park, MD.

1914 diminished artists' incentives to travel to the Zone, even with a government subsidy. Chautauqua and lyceum circuits declined in the 1920s, as erstwhile rural populations urbanized.[139] Those who predicted that the Canal Zone would support a constant stream of local and international entertainment also overlooked the Zone's complex internal dynamics. Unlike Chautauqua's small-town itinerary, the Zone was not a settled rural nucleus. Nor was it an ideal stop on the vaudeville circuit (as a Western industrial city might be). Zonians were well paid but did not correspond to a specific class position or map neatly onto a US rural/urban dichotomy. The Zone was simultaneously more cosmopolitan than rural US towns and a hierarchized, militarized enclosure. Because of the Zone's range of socioeconomic and regional positions, white US workers formed networks and hierarchies based on factors endogenous to the Zone, such as occupation, seniority, and housing type and location. Moreover, while Zonians possessed limited entertainment options, they continued to enjoy relative freedom of movement across the border in the early twentieth century. White US workers who crossed the border were subjected to far less policing in Panama than were border-crossing West Indians and Panamanians. Because white US citizens could cross the border with ease, they flouted the PC's efforts to contain them. Even Zonians who stayed tethered to the Canal Zone preferred their own social clubs to government-sponsored entertainments. Rather than absorbing national cultural identity from imported US entertainments, US citizens in the Canal Zone derived cultural and social identities from their many club affiliations, which were both connected to the United States and imbued with the local culture of the Zone.

Nevertheless, despite financial losses, BCP officials continued trying to implement McIlvaine's entertainment policy. General Secretary of Clubs and Playgrounds Booz explained why: "If one of the objectives of this Bureau is to keep employees on their side of the line to maintain morale, sobriety, regularity to work and contentment by recreation, we should use some of the methods used by cabarets [in Panama] to interest employees. They bring singers, dancers and musicians down there at considerable expenses. Employees get tired of hearing local singers only, who appear at lodges, churches, social affairs frequently, and desire a change. If we do not furnish it they go, in numbers, where such entertainments can be found." Booz continued defending the productivity of entertainments: "It has been stated, 'It don't pay.' Well, if an employee goes down town [into Panama], gets drunk, has a [hangover] . . . the canal loses the money. If this same employee can be entertained, kept at home and sober, his efficiency at par, such effort has actually earned the Canal money."[140] While Booz and other PC officials assumed that entertainments would keep employees in the Zone, transcending the border's pull, Zonians formulated their own styles of cultural belonging through recreational activities, which were predicated on the Zone's separation from both Panama and the United States.

A TALE OF TWO COMMUNITIES: SILVER AND GOLD CLUBHOUSES

In the 1920s and 1930s, the failure of the States entertainment policy and a downturn in funding led the BCP to embark on a cost-saving initiative for silver and gold clubhouses alike: the "Community Night." Inspired by the clubhouses' Amateur Nights, which featured local acts and "Old Timer" nostalgia, Community Nights were implemented to stimulate "fellowship in the community" through monthly live performances created by townsite residents.[141] Partly sponsored by Cinema Pan-Americano, Community Nights included movies screened free of charge if (but only if) the PC judged the accompanying live performances to be of sufficient length and quality.[142] The secretaries were required to file reports on their Community Nights so that the BCP could learn how to improve social cohesion in the Zone. Gold and silver reports recorded similar levels of attendance (usually three hundred to five hundred children and adult attendees) but very different outcomes. Both silver and gold Community Nights centered around storytelling, and movies were a major draw for silver and gold patrons alike.[143] In the gold townsites, many Community Nights had patriotic themes, celebrating US federal holidays.[144] Gold Community Nights also featured children's performances, comedy, dance (eccentric dance, clog dance, and Apache dance), magicians, farces, boxing, girls' singing, violin solos, drills, recitations, "dramatizations," and blackface minstrelsy in performances and "Community Singing" programs.[145] In contrast to gold clubs' prevalence of vaudeville and variety acts, silver "Community Nights" featured talks on education and well-being, with little to no vaudeville.[146] Silver Community Nights were often called "Educational Shows" and organized by teachers.[147] These Educational Shows foregrounded elocution and recitation, in extemporaneous speeches and debates on "community welfare" topics, and often included intellectual competitions.[148]

In silver clubhouses, independent groups like the Young People's Progressive Club, Samuel Whyte, the silver Boy Scouts, and the UNIA used Community Nights to discuss labor rights, racial consciousness, and political issues.[149] Many silver Community Nights ended with group singing of the Negro National Hymn.[150] While silver Community Nights centered largely on West Indian life, records show some participation by "the Spanish element" (a possible reference to Spanish or Latin American workers).[151] Community Nights thrived in the silver clubhouses, drawing hundreds of attendees, until the 1930s.[152] While circumscribed, they served pedagogical aims and afforded West Indians the ability to socialize in the Zone, where, despite their social marginalization, they were afforded basic protections against mob violence. In contrast, gold Community Nights waned, and gold secretaries were often forced to reject PC funds due to low interest. The Gatún gold secretary noted that his

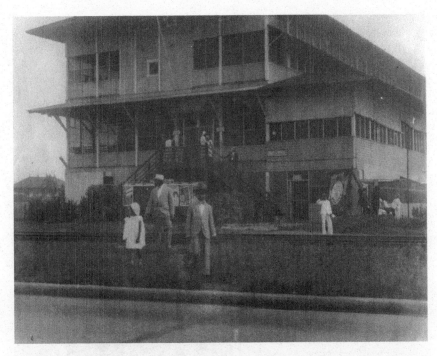

FIGURE 2.5. West Indian Canal employees and dependents standing in front of a silver-roll clubhouse, ca. 1918–1934. 1581–83.95-A. Record Group 185, Records of the Panama Canal. Entry A1–34B, General Records, 1914–60. National Archives at College Park, MD.

patrons were "becoming indifferent towards furnishing the required number of local talent entertainers in connection with Community Nights."[153] Secretaries' reports do not explain these different outcomes, but it seems plausible that whites' many recreational options made gold Community Nights less popular, while silver Community nights offered an outlet for Black and brown laborers and families who enjoyed far fewer recreational options.

WEST INDIANS' FLOURISHING CROSS-BORDER AMUSEMENTS

In addition to the Community Nights, in the 1920s and 1930s West Indians' social networks began to proliferate on both sides of the Panama–Canal Zone border. A description of an "elite . . . Carnation Ball" in the *Panama Tribune*, a West Indian newspaper, gave one example in an emerging roster of parties, balls, teas, Athenaeum clubs, and gatherings "which brought out the cream de la cream [*sic*]."[154] One of the few photographs of West Indian workers at leisure, showing people posing in fine dress in front of a silver clubhouse, affirms this sense of growing cosmopolitanism and social dynamism (Figure 2.5).

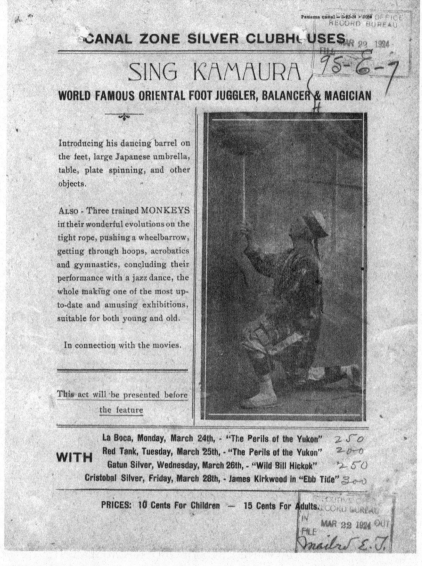

FIGURE 2.6. Flyer for Magician Sing Kamakura's performances in the Canal Zone Gold Clubhouses, March 10–15, 1924. 95-E-7. Record Group 185, Records of the Panama Canal. Entry A1–34B, General Records, 1914–60. National Archives at College Park, MD.

Unsegregated venues in Panama, like the Teatro Variedades and Teatro América, were becoming West Indian social hubs. West Indian–descended playwrights Milton Garvey and Joseph Raymond presented original plays, including "Neta, the Scarlet Woman" and "Heritage of Youth" in Panama.[155] Vaudeville shows and dances at silver clubhouses supported a West Indian–influenced

CANAL ZONE CLUBHOUSES

Panama canal — 3-8-24 — 100+

SING. KAMAURA 95-E-7

WORLD FAMOUS ORIENTAL FOOT JUGGLER, BALANCER & MAGICIAN

Introducing his dancing barrel on the feet, large Japanese umbrella, table, plate spinning, and other objects.

ALSO - Three trained MONKEYS in their wonderful evolutions on the tight rope, pushing a wheelbarrow, getting through hoops, acrobatics and gymnastics, concluding their performance with a jazz dance, the whole making one of the most up-to-date and amusing exhibitions, suitable for both young and old.

This act will be presented before the feature with the exeption of Balboa, where it will appear between first and second show.

Patrons to first show will please remain seated until after this act.

With — Rudolph Valentino in "THE YOUNG RAJAH" a spectacular love–drama from novel "Amos Judd." A Hindu Prince smuggled out of India, reared amidst the peaceful surroundings of New England village, sent to a big American University, then returning to take up his duties as a gentleman farmer, only to find himself thrust from a simple life into glittering palaces of India, teeming with revolt.

A series of unexpected happenings bring things out happily.

CRISTOBAL, Monday, March 10th. - - GATUN, Tuesday. March 11th.
PEDRO MIGUEL, Wednesday, March 12th.
BALBOA, Friday, March 14th. -- ANCON, Saturday, March 15th.

REGULAR PRICES: 10 CENTS AND 20 CENTS.

FIGURE 2.7. Flyer for Magician Sing Kamakura's performances in the Canal Zone Silver Clubhouses, March 24–28, 1924. 95-E-7. Record Group 185, Records of the Panama Canal. Entry A1–34B, General Records, 1914–60. National Archives at College Park, MD.

music scene.[156] The Isthmian Syncopators, a popular West Indian band, played both in the Canal Zone and at the Teatro América's "Temple of Jazz."[157] The Syncopators, the Seven Dominoes, and Shortly Welch and his Harmony Boys performed in silver and gold clubhouses.[158] So popular were West Indian–descended musical groups that in 1929 a group of Panamanian musicians petitioned

Panama's President Florencio Harmodio Arosemena to ban the employment of West Indian musicians.[159] International artists and speakers also traveled to the isthmus to entertain West Indian audiences. Although the BCP did not explicitly provide this service for silver employees, the flyers shown in Figures 2.6 and 2.7 reveal that at least some traveling entertainers, like the Orientalist magician "Sing Kamakura," performed at both gold and silver clubhouses.[160]

Additionally, several artists, including the Miami Follies Colored Troupe and the Maud Forbes and Brothers Dramatic Company, journeyed from the United States to perform at silver clubhouses.[161] Proceeds from these events contributed to the support of retired silver Canal workers, who were denied pensions by the PC.[162] Marcus Garvey was another frequent visitor to the isthmus: Panama had 49 UNIA branches in the mid-1920s.[163] Garvey visited West Indian Canal and United Fruit banana plantation workers in Panama on at least three occasions, in 1911, 1919, and 1927.[164] In 1929, Amy Ashwood Garvey, a Pan-Africanist playwright (and Garvey's ex-wife) who had grown up in Panama, tried to bring a theatrical troupe to the silver clubhouses.[165] Later she returned as the producer of a concert given by Sam Manning, a well-known West Indian comedian and calypsonian.[166] Manning and Syd Perrin played at silver clubhouses and two theatres in Panama. The *Panama Tribune* reported that the two "gained the approval of capacity crowds."[167] Manning also took the opportunity to write a column for the *Panama Tribune* on the need for Afro-Caribbean unity in Panama.

Creating social and recreational institutions in and beyond the Zone, West Indian Panamanians positioned their rights to cultural expression and participation as vital to individual and collective well-being, given the political and legal constraints that they faced. While the PC felt that the silver roll's "fifty or sixty dollars per month are enough for a colored man to live on," the *Panama Tribune* voiced its disagreement:[168] "The difference between the salaries of the white and colored employees of the Panama Canal is the difference between a living wage and a cultural wage. The former barely enables the worker to exist while the latter affords opportunities for the acquirement of that culture, refinement and leisure which are the birthrights of the civilized man."[169] Intriguingly, West Indians' burgeoning cross-border networks were heavily influenced by US culture, as made manifest in the Canal Zone. The Zone's gold and silver townsites were suffused with US cultural influences, from US films and school curricula to US holidays and the national anthem. Both white and nonwhite workers were exposed to these influences and products. These features made US citizens feel as if they were at home—that is, in their home country—and caused them (at times) to view the Zone as an extension of the United States. For West Indians, the results were more complex: immersion in the Zone's landscape of Jim Crow segregation and blackface minstrelsy bred identification with African American racial and social justice struggles (which I take up in the next chapter). Yet West Indians

also clashed with African American silver clubhouse secretaries. While lauding African American racial and political achievements, West Indians chafed against the color line and the clubhouses' erasure of diasporic differences. After Waller and other silver secretaries of his generation retired, tensions flared between their replacements and clubhouse patrons. Claiming that African American clubhouse secretaries did not understand the cultural and social needs of their Caribbean constituencies, some patrons urged the PC to hire West Indians as secretaries.[170]

Several 1927 editorials in the *Panama Star and Herald* emphasized the centrality of the silver clubhouses to community cohesion and urged West Indian representation. Silver clubhouses were deemed "necessary to the social and physical requirements of our people," host to a "large amount of business," "serving good purposes," and "frequented and patronized by all, old and young, big and little."[171] One letter to the editor noted that the new African American silver secretaries "are entirely ignorant of West Indian psychology" and "should [not] be placed in charge of the recreational and social activities of the hard-working employees who by force of necessity seek amusements in these clubhouses."[172] Voicing fondness for former African American secretaries, the author identified the real problem as low BCP wages for Black employees. A respondent tried to defend the secretaries but did not deny that frictions existed.[173] These and other examples illustrate the ways that West Indian Panamanians continually negotiated ties to African American people—intellectuals, entrepreneurs, community leaders, and civil rights activists—and ideas of blackness emanating from the United States, via the isthmus.

CONCLUSION: FROM COMMUNITY TO COMMERCE

In the absence of political structures or forms of civil society, recreational pursuits shaped life for white and nonwhite workers and families in the Canal Zone. White US families flourished, their leisure practices and recreational outlets taking on semblances of civic participation, even as they created a new community both US-identified and independent: the Zonians. For West Indians, by contrast, the Canal Zone's subjunctive sovereignty compounded an already ambiguous citizenship status, even for those born in Panama. After Canal construction, the United States incentivized West Indians' self-deportation, yet many stayed on the isthmus, incurring Panamanian xenophobia and racism. Recreational resources encouraged the emergence of alternative sites of community formation, even given hostilities on both sides of the border. In the 1930s, diplomatic conflicts with Panama, and the Canal's lessening importance to the US public, increased the Canal Zone's insularity. Panamanian diplomacy led to legal changes, such as the Alfaro-Hull Treaty (1939), which excised Article 136

(declaring Panama a US protectorate) from Panama's Constitution. Not only did the US government relinquish the right to intervene militarily in the Republic of Panama, but the treaty increased separation between Panama and the Canal Zone by mandating "restrictions on the use of the facilities of Canal Zone clubhouses and hospitals."[174] Nonemployees of the Canal were banned from Zone clubhouses and recreational sites after 1933—a change that did not affect Zonians but severely impacted West Indians' cross-border social networks and silver clubhouse sustainability.[175]

Geopolitics converged with austerity measures to widen the gap between gold and silver clubhouses. While popular amusements were initially considered community-building tools, moral necessities, and public goods (and hence worthy of US government funding), the Zone's gold and silver clubhouses were commercialized in the 1930s and made to pay for themselves. In January 1936, the BCP split into two subdivisions, "clubs" and "playgrounds." The 1936 split made way for the dissolution of the clubhouses' US government–funding structure. Gold and silver clubhouses were made to be self-sustaining through clubhouse revenues (sales of movie and performance tickets and food), while playgrounds were subsidized by US government funds.[176] Yet the PC annual reports continued to frame clubhouses as community centers. The 1937 annual report stated: "As private industry is not permitted in the Canal Zone, the Government is under the obligation of operating restaurants, motion-picture theaters, and other activities for which there is a community demand."[177] The insertion of "demand" after "community" hinted at the slippage from a community of citizens to one of consumers, whose demand dictated the clubhouses' supply.

In 1940, clubs were separated completely from playgrounds: playgrounds were relocated within the Schools division, while the Bureau of Clubs and Playgrounds (BCP) was renamed the Panama Canal Clubhouses.[178] While the US government continued to fund playgrounds and schools, clubhouses were considered "auxiliary services to the Canal." As auxiliary services, clubhouses were removed from the Zone's roster of civil services. In 1951, the Panama Canal administration underwent a US government–mandated reorganization. The PC dissolved, and the Panama Railroad, renamed the Panama Canal Company (PCC), assumed all Canal-related responsibilities. The Zone's governmental functions, including schools, fire and police, and immigration, were housed under a new entity, the Canal Zone Government (CZG). The Zone's clubhouses remained an "auxiliary operation" of the PCC, unaffiliated with the Zone's civil administration.

These changes had distinct outcomes for white and nonwhite employee populations. Entertainments for white US citizens underwent improvements in infrastructure and resources that incentivized whites' confinement to the orderly, pristine Zone enclave.[179] Even after the US Congress ceased its support in 1951,

the white clubhouses' revenues and PCC largesse proved more than sufficient to sustain the clubhouses. They became "service centers, affording minimum necessary service in the various civilian towns of the Canal Zone."[180] While excised from the annual reports of 1953 and thereafter, the term "community" did not disappear; clubhouses were housed under the Supply and Community Service Bureau. However, the clubhouses centered on service transactions, becoming commercial oases in the supposedly enterprise-free Zone. The clubhouses (now "service centers") "provid[ed] certain essential sales and recreational facilities for employees of the [Panama Canal] Company/Government organization, their dependents and guests."[181] Historian Michael Donoghue links postwar entertainments—"an array of modern, more upscale clubhouses with adjoining movie theaters, bowling alleys, athletic fields, basketball courts, and swimming pools"—to Zonians' "retrea[t] into the Zone."[182] After World War II, the Zonians "rarely penetrated more than a few blocks from the boundary line" with Panama.[183]

While whites' service centers were enriched, West Indian social life in the Zone withered. In the 1940s, West Indian workers protested the inadequacies of their clubhouses, which were increasingly given over to commercial uses. The Isthmian Negro Youth Congress (INYC), a West Indian organization, wrote PC Executive Secretary of Clubhouses Frank Wang lamenting the deleterious effects of the clubhouses' "strict commercial policy."[184] For West Indians, the silver clubhouses' conversion distanced the clubhouses from the populations they were intended to serve and diminished their roles as community-building sites. As management vacancies arose, the *Panama Tribune* and INYC advocated the appointment of West Indians, but unlike in the silver schools, few were given administrative posts as clubhouse secretaries.[185] When the PC discontinued some recreational facilities in 1946, the INYC declared those resources "sorely missed," their absence "impos[ing] considerable hardship upon our social and cultural development."[186] Among West Indian employees, "the consensus of opinion . . . is that the clubhouse has deviated from its former wholesome policy of social service to the community, and has embarked on a policy of undue commercialism."[187] When the La Boca silver clubhouse was renovated in 1944, the repairs reduced capacity and exacerbated structural flaws in the theatre, forcing the cancelation of community-based performances. The INYC argued: "From its inception the Panama Canal Clubhouse has meant more to the people who used its facilities than just a movie hall, or restaurant . . . we believe that the Canal Zone Government intended that the clubhouses should be operated with the view of catering to the social needs of the community, the government being well aware of the material benefits to be accrued from a well-regulated social center in any community."[188] Querying whether the clubhouses were "dedicated to social services, as . . . in the past," or "no more than a profit-making enterprise," the INYC petitioned Wang for improved spaces and resources—requests that were not granted.[189]

As may be gleaned from the above discussion of the politics of white and nonwhite recreation in the Canal Zone, leisure practices and social interactions played crucial roles in shaping communities, even as Canal officials strategically employed discourses of "community" to control the Zone's populations through recreational provisions. Cultural belonging became a central part of Zonian socializing, often construed in opposition to, or in tension with, the Canal Zone's subjunctive sovereignty. Zonian practices helped suture US ideologies and imagery to the material structures of the Zone. West Indians and their Panama-born children, on the other hand, were not allowed to be "at leisure" in the Canal Zone or Panama, given the Zone's Jim Crow segregation and racism, and Panama's convulsions of anti–West Indian sentiment. For a brief but critical period, the silver clubhouses established after 1914 formed a partial haven for West Indian workers, friends, and relatives living on both sides of the border, even while the clubhouses were fraught with internal instabilities.

When gold and silver clubhouses were made to become self-sustaining, this transition changed each group's interactions with the clubhouses. The shift from community to commerce proved damaging for West Indians while strengthening Zonians' isolation and intragroup cohesion. The demise of West Indian clubhouses went hand-in-hand with the reduction and depopulation of West Indian schools, housing, and entire silver townsites. In the lead-up to the 1951 reorganization, fiscal austerity forced many West Indians into Panama for education, housing, and political, cultural, and social life.[190] There they encountered a citizenship vacuum: their island ties had waned, and the British government "liquidated its responsibilities to the West Indian community after the [Second World] war."[191] Despite the uncertainty of their status, many sought to integrate into Panama, while others left for the United States at midcentury. As I chronicle in the next chapter, West Indians' forced integration into Panama shaped new modes of being and community formation, building upon their cross-border social networks. Performances came into play in new and important ways in reorienting West Indians to Panama and the Canal Zone.

3 · BEYOND SOVEREIGNTY

Black Cosmopolitanism and Cultural Diplomacy in Concert

On June 19, 1951, Marian Anderson performed for one night in Panama, the last stop on a two-month tour of Latin America and the Caribbean.[1] Arriving in Panama City on the 18th, Anderson and her accompanist, Franz Rupp, were received at the US Embassy by interim chargé d'affaires Murray Wise and members of the US diplomatic corps. Anderson's sold-out concert at the Teatro Central the next evening was immensely successful. At the close of her program of opera, art song, and spirituals, Anderson acquiesced to audience demand and gave two encores, several curtain calls, and three final encores. Then she improvised a bit of diplomatic choreography, descending the glittering stage and striding into the auditorium—where Panama's and the Canal Zone's top officials were seated—to shake hands with Panamanian president Alcibiades Arosemena and his wife.[2] This humble, friendly act caused a swell of applause and further endeared her to an already adoring audience. Panama's West Indian newspaper, the *Panama Tribune*, stated: "Visibly overcome by her appealing gesture of goodwill, President Arosemena told Miss Anderson: 'I would that I could do for Panama politically what you are doing for the world spiritually.'"[3] The exchange affirmed Anderson's talent at transmitting cultural and spiritual uplift to publics across the globe.

In Panama, however, Anderson was not acting in the official capacity of goodwill ambassador. Despite her warm welcome by government officials across the isthmus—including Panama's presidential cabinet, members of Panama's National Assembly, Canal Zone military and civil authorities, and regional diplomats—Anderson's visit was arranged neither by the US government nor by Panama. In fact, one private firm held "exclusive" management rights to Anderson's isthmian visit: Westerman Concerts (Conciertos Westerman), a small, idiosyncratic concert promotion agency founded by West Indian Panamanian impresario George W. Westerman. Westerman's interculturally and geopolitically

TABLE 3.1. Westerman Concerts' events

Artist / headline performer (nationality)	Dates of visit	Sponsoring agency
Aubrey Pankey (USA)	December 29, 1942–January 5, 1943	INYC, *Panama Tribune*, and Herbert De Castro (representing the Daniel Society)
Hazel Lawson and Florizelle Wilson (Jamaican)	April 11–May 7, 1944	INYC
Todd Duncan (USA)	May 2–4, 1945	INYC and Sociedad Pro-Arte Musical de Panamá
Portia White (Canada)	ca. January 28, 1946	INYC, Panama Conservatory
Intercultural Program (Panama)	September 29–October 6, 1946	INYC
June McMechen (USA)	March 28–April 2, 1949	Westerman Concerts
Camilla Williams (USA)	June 27–28, 1949	Westerman Concerts
Emily Butcher (Panama)	September 28–October 4, 1949	Westerman Concerts
Hazel Scott (USA)	December 6–15, 1949	Westerman Concerts and Society of Good Fellowship
Dorothy Maynor (USA)	March 12–13, 1950	Westerman Concerts
Carol Brice (USA)	August 3, 1950	Westerman Concerts
Marian Anderson (USA)	June 19, 1951	Westerman Concerts and Daniel Society
Ellabelle Davis (USA)	October 26–29, 1951	Westerman Concerts
Philippa Duke Schuyler (USA)	August 7–12, 1952	Westerman Concerts
William Warfield (USA)	November 9–11, 1953	Westerman Concerts
Davis-Breen *Porgy and Bess* (USA)	October 5–7, 1955	Westerman Concerts

Source: GWW, Schomburg

motivated concert promotion work, and his use of concerts as a means of inter-
vening in Panama's racial climate, are this chapter's foci. Westerman Concerts'
sponsorship of Anderson's concert did not transpire ex nihilo but was part of
a larger, long-term project: for more than a dozen years, Westerman was a cul-
tural organizer on the isthmus, convinced that interculturalism and performance
held the keys to undoing racism, xenophobia, and anti–West Indian sentiment
in Panama and the Canal Zone. Prior to Anderson's visit, Westerman organized
concerts by Black opera singers June McMechen and Camilla Williams. From
1942 to 1955, Westerman would sponsor, in full or in part, the concert tours to
Panama of at least eighteen Black classical artists and the 1955 Davis-Breen pro-
duction of *Porgy and Bess*.[4] (See Table 3.1 for a list of all of Westerman's events.)
Westerman considered himself an activist; in his day, he was lauded as one of
the foremost community organizers on the isthmus, and many Panamanians
continue to honor his legacy of political and scholarly engagement. Historian
Michael Conniff recalls Westerman as a "newspaperman, diplomat, and intellec-
tual leader of first-generation Panamanians of West Indian descent"; Westerman
played a pivotal role in defining West Indian "integrationism" into Panama.[5] Yet
in these homages, his cultural and aesthetic interventions are often elided.

Performance proved an integral component of Westerman's activist arsenal.
He curated his selection of artists with meticulous care. The "Westerman art-
ists," as I refer to them herein, shared many traits: all performed mixed programs
comprising art song, classical Western repertoire, and Negro spirituals; all were
international touring celebrities; and all were Black. The majority were African
American women; gender and nationality figured centrally in Westerman's cam-
paign for racial uplift. Westerman promoted each concert with nearly identical
methods, drawing upon his journalism expertise to manage all aspects of their
publicity, so as to transmit specific messages to audiences on the isthmus. Local
publics, cued by his expansive multimedia educational campaign, came together
in unsegregated venues in Colón and Panama City to witness these artists later-
ally—as a series of mobile Black figures whose international celebrity revealed
interpretations and strategies of "doing citizenship" in relation to race, gender,
nation, empire, and global politics. Westerman hoped that these artists, and the
events that their visits conditioned, would focus local and international atten-
tion on the isthmus's social and political problems—especially the plight of
West Indian descendants, who were treated as pariahs in both the Canal Zone
and Panama. In what follows, I examine this agenda and the outcomes that his
concerts inspired.

While privately sponsored, Marian Anderson's performance elicited a strong
governmental response from Panama and the Canal Zone, which was precisely
what Westerman sought. One of his primary goals was to expose the paradox
of national exclusion of Black excellence on the isthmus. Westerman designed

his concerts to "shadow" the US government's official cultural diplomacy efforts, which also brought renowned performers to Panama. While mimicking US cultural diplomacy, Westerman diverged critically in his singular, deliberate focus on racial and social conditions. In bringing Black artists to Panama, Westerman did not use diplomacy as a showcase for US antiracism, but rather employed this trope to spur Panama and the Canal Zone into behaving as democratic, antiracist polities. His concerts staged an implicit critique of the Canal Zone's racial inequality and queried the role and responsibilities of the US government, given its self-identification as de facto sovereign power in the Zone. In Panama, the concerts and their accompanying events functioned as sites of rehearsing democracy, or acting democratic, through intimate and public encounters with Black goodwill ambassadors. Westerman hoped that the acts of democracy staged by Panama and Canal Zone governments in receiving these artists would stick—that performances of liberalism and racial equality would remain after the artists had traveled on.

The Westerman artists' visits accorded with philosopher Jacques Rancière's formulation of emancipation as "equality *in actu*"—the practice and verification of equality, rather than its sole claiming.[6] Equality *in actu* means that the political subject must behave as though there is room for her—practicing and verifying an as-yet-unregistered equal status, and in this act exposing both the desire for that status and its effective absence. Theorist Lauren Berlant discusses a similar process in her theorization of "diva citizenship," "grandiose public dramatic performances of injured subjectivity" that show remarkable self-restraint, predicated on a "national fantasy of corporeal dignity."[7] These moments of diva citizenship—"when a person stages a dramatic coup in a public sphere in which she does not have privilege"—are designed to be "heroic act[s] of pedagogy, in which the subordinated person feels compelled to recognize the privileged ones, to believe in their capacity to learn and change; to trust their desire not to be inhuman."[8] Yet within acts of practicing, verifying, and diva citizenship lurks a subjunctive quality: "as-if." To cite this book's central themes of subjunctivity and sovereignty, the concerts formed *subjunctive* sites. While performing a utopian conditional ("as-if"), the Westerman concerts also exposed fault lines and cracks in the twin façades of Panama and the Canal Zone, entities whose discourses of liberalism, pro-democracy, and antiracism were contradicted by the materialities of deeply entrenched racial and social inequality, prejudice, and exclusion of Panama-born people of West Indian descent.

Berlant notes that diva citizenship cannot create legal change but can produce an affective recognition of inequality through spectacular performance. This caveat centralizes the subjunctive in the performance of citizenship. Indeed, Westerman utilized the concerts as moments of diva citizenship to expose West Indian Panamanians' marginalization through the figures of traveling Black

artists, so as to shift the tenor of race relations and national belonging on the isthmus. Yet these Black divas (and divos) were themselves entangled in paradoxes of racialized marginality/celebrity in the United States and abroad, which threatened to disrupt their uses as models for ideal citizenship. The Westerman artists' diva citizenship functioned, in fact, to stage the limitations of the category of "citizen" for those whose lives conform more to the figure of the *subjunct*. Working from the "as-if" of subjunctivity, I develop the *subjunct* as a figure drawing attention to the shortcomings within citizenship for marginalized peoples. Like an adverb in a sentence, which can be removed without changing the sentence's intrinsic properties, the subjunct embodies and performs qualities of both citizenship and noncitizenship at once, capable of being included or excluded by the sovereign power's will. The figure of the subjunct haunted Westerman's uses of concerts as sites of enacting diva citizenship: even while he sought to elevate Black divas as models for an idealized form of West Indian Panamanian citizenship—conceived in relation to an idealized Western modern liberal nation-state—those very divas, as I illustrate below, tested the limitations of citizenship as national membership, calling into question its raced and gendered grounds, within the project of liberal nation-building from World War II to the Cold War.

THE SILVER PEOPLE: WEST INDIAN DESCENDANTS IN PANAMA

Recruited for Canal labor, West Indians were encouraged to self-deport after the Canal's completion in 1914. Yet many remained in Panama, facing racism, xenophobia, and subjugation. Throughout Canal construction, West Indians earned lower wages than whites, on a racially segregated pay scale ("the gold and silver rolls"), and the purchasing power of the "silver rolls" steadily declined. West Indian descendants found themselves pushed into Panama, which did not want them, in the early and mid-twentieth century. This shift intensified a focus on West Indian integration. Yet Black Anglophone people were viewed as incongruous with Panama's national self-image, a blackness-disavowing mestizo category that Conniff calls "Latin Panamanian."[9] As George Westerman observed: "the colored people on the Isthmus of Panama find themselves hemmed in on the Canal Zone by racial bigots who operate a high-geared machinery of discrimination and segregation, and in Panama by dogmas which are scientifically absurd but which have become a powerful and dangerous instrument of power politics."[10] As the West Indian Panamanian community grew, the threat of being "stateless people" loomed. On October 23, 1926, Panama's National Assembly passed Law 13, prohibiting immigration to Panama by Chinese, Japanese, Syrians, Turks, Indo-Orientals, Dravidians, and Anglophone Blacks from the Antilles and "Guayanas."[11] Labeling Blacks "undesirables," some Assembly members proposed a census

and extra tax for "aliens."[12] Law 6 (1926) required that 75 percent of a business's employees be Panamanian.[13] These measures sought to "free the Panamanian workman from the ruinous competition of the Antillean Negro."[14] While some parts of Law 13 were subsequently repealed, the Assembly passed a constitutional amendment two years later to withhold citizenship from future children of "prohibited foreigners" until their twenty-first birthday. Those born after 1928 "were cast into a nationality limbo."[15]

These conditions institutionalized West Indian descendants' discrepant relationship to the Panamanian nation-state, shot through with racial politics. In Panama, blackness was viewed as virtually synonymous with foreignness. On November 3, 1940, the National Assembly voted to change Panama's Constitution, identifying "prohibited immigrants" as "the black race whose first language is not *castellano*, the yellow race, and races originating from India, Asia Minor, and North Africa" (Article 23). West Indian Panamanians, called criollos, were the largest foreign-born group, totaling over 50,000 at midcentury.[16] Article 12 of the proposed Constitution denied citizenship to those born in Panama whose parent(s) were Anglophone Blacks. This clause retroactively stripped citizenship from tens of thousands of West Indian Panamanians—a drastic measure, and one of many anti-criollo acts effected by the presidency of Arnulfo Arias, a polemical figure elected (on the first of several occasions) in 1940. In response to the proposed 1941 Constitution, Westerman formed the interracial National Civic League (Liga Cívica Nacional) with West Indian Panamanian attorney Pedro N. Rhodes to circulate petitions and publicly protest the xenophobic content.[17] The National Civic League gained prominence as an activist organization, and its pressure contributed to the reversal of the offending articles in 1947. Yet West Indian descendants' citizenship status and civil rights were not unequivocally upheld until the 1960 Bazán Amendment, followed by the 1972 Constitution.[18]

Even after criollos' citizenship was legalized, Panama's climate of pervasive racism spurred the National Civic League to lobby for the 1956 Huertematte Law, which prohibited and fined racial discrimination in hiring and business transactions. Westerman's pamphlet "Toward a Better Understanding" (1946) contextualized West Indian Panamanians' denationalization in relation to global events like war—"the dire catastrophe which man's inhumanity to man brought to the world twice within the span of a single generation"—and racism: "the status quo which makes men of white skin prosper to the disadvantage of black, or yellow to flourish at the expense of brown."[19] Westerman reproached "the governments of the United States, Great Britain, and Panama . . . [which] failed, neglected, or did not care to consider the West Indian worker as a human factor."[20] This statement resonates with Wendy Brown's observation that "the intersection of law and exception . . . generates a body of labor outside the law, labor that is neither organized nor protected, and that increases the number of usable and disposable subjects who are not citizens."[21]

The Canal Zone disavowed West Indians' long-term presence, yet complex ties remained. Owing to the Zone's subjunctive sovereignty status, West Indian descendants who grew up there did not attain US citizenship. The Zone was sometimes included in US federal legislation, sometimes not. During the war, the US government made the Canal a crucial military outpost while ignoring its unequal rights and labor conditions. In the 1940s the Panama Canal (PC) began austerity and downsizing measures that acutely impacted West Indian Panamanian workers, forcing them out of Canal Zone silver-roll housing, schools, and clubhouses and shutting down entire townsites.[22] The United Public Workers of America (UPWA) labor union, Paul Robeson, W.E.B. Du Bois, and the NAACP became involved, reporting on the Zone's racial prejudice to US president Franklin Delano Roosevelt when Canal officials ignored the US president's executive order on fair employment practices for defense industries (1941).[23] In Westerman's view, Canal administrators were not deaf to criollos' pleas, but they were hamstrung by a vocal population of white Zonians who deployed their US citizenship to put pressure on Zone officials. Whether or not the blame lay with Canal officials or Zonians, the *Panama Tribune* abounded with grievances against the latter, labeled a "white labor oligarchy."[24]

Given Jim Crow segregation in the Canal Zone, many West Indian Panamanians found points of identification with African American artists, intellectuals, political leaders, and civil rights activists. The relegation of African-descended people in the United States to second-class citizenship resonated with West Indian Panamanians, who similarly viewed themselves as a people longing for but denied the rights of full citizenship.[25] Moreover, despite ill treatment by Zonians, many West Indian descendants felt vicarious US patriotism. Westerman and other criollos were deeply inspired by the US "goodwill ambassadors" who entertained the Zone's 67,000 stationed US troops during the Second World War. Westerman's belief in the United States as a beacon of liberty surfaces in a 1942 edition of his weekly column, "The Passing Review," at the height of US military presence on the isthmus. He wrote of the *Booker T. Washington*, the first "Liberty Ship" (part of the US Merchant Marine) "to be named for a Negro."[26] The 10,500-ton *Booker T.* not only "[bore] the name of a distinguished American whose color has been brutishly regarded as a badge of inferiority and whose race has been unfairly burdened with most of the encumbrances known in the world," but the crew and shipbuilders constituted a "mélange of racial extractions," including "Chinese, Filipino, Mexican, Negro, and Caucasian workers." The ship was captained by Hugh Mulzac, a British West Indian–born skipper and former master of the *Yarmouth*, part of Marcus Garvey's Black Star Line.

With a Black captain at the helm, this multiracial ship "composed of seamen from practically all the United Nations" would sail the world "to end imperialism, racial and national discrimination."[27] The multinational, multiracial crew

"volunteered for service . . . so that all the strength of their respective nations, united as a whole, might be vitalized through a functioning democracy." For Westerman and his readers, the harmonious *Booker T.* was a floating microcosm of a new world order, in which multiracial groups could unite for common cause, guided by a Black captain whose former internationalism (embodied in his association with Garveyism) was now tempered to nationalist, pro-US (seemingly synonymous with pro-democracy and antifascist) ends. The narrative of a Black captain leading a multiracial community through international waters to deliver war supplies from factory to battlefield painted a vivid picture for West Indian Panamanians, representing the United States as harbinger of democracy to the world. Westerman strongly felt that "US interracial good-will," not Garveyism, would engender world peace and equality.

World War II helped West Indian Panamanians somewhat by stimulating Panama Canal traffic, business, and jobs.[28] The war also elevated Panama as a crucial nexus of US militarism and Pan-Americanism, reversing decades of dwindling international interest in the Canal.[29] For West Indian Panamanians, the war brought a new sense of Panama's importance as a crucible for intercultural exchange and liberalism. As noted by Westerman's colleague Linda Samuels, "right here in Panama . . . many groups of diversified cultural backgrounds live in very close proximity. If the groups who occupy this narrow strip of land are to live in harmony, there must be some way of breaking down the unwarranted barriers of prejudice and unfriendliness which exist merely because of a state of ignorance concerning the peculiarities of various cultural groups."[30] West Indian Panamanian leaders saw in this challenge an opportunity to position their community as a vital and strategic mediating influence. As bilingual Canal employees and Panamanian citizens, West Indian Panamanians could bridge the deepening geopolitical conflict between Panama and the Canal Zone. Criollos could help Panama gain treaty concessions and negotiate Panama's cooperation with the Canal Zone. To serve in these ways, in Westerman's view, criollos had to integrate wholeheartedly into Panama—learning Spanish and Panamanian history and framing themselves as suitable citizens—while also continuing to link themselves to the US project in the Zone.

ANTIRACISM, ANTIFASCISM, AND THE ROLE OF ART

For Westerman, as for many international observers of the day, the means to solving problems like those plaguing the isthmus were chiefly psychological. People needed to become (or be made) receptive to a "feeling of human understanding" that would allow for common sympathy and cooperation in service of "justice, liberty, freedom, and true human independence."[31] In the campaign to "change hearts and minds," Westerman, in keeping with mainstream

attitudes, focused on media, the arts, and cultural production. Film and photography, popular music, literature, radio, theatre, dance, plastic arts, and the emerging medium of television were thought to hold tremendous power to shape their consumers' ideologies and identities. Today cultural works and aesthetic production occupy minimal roles in international relations, but during and after World War II, culture was viewed as a powerful weapon and tool for fostering psychic structures.[32] President Eisenhower created the President's Special Emergency Fund (1954) and the Cultural Presentations Program (1956) to build international "sympathy" for the United States through art.[33] UNESCO's Constitution opened with a call to shape "the minds of men [sic]" to foster "the defenses of peace."[34] During and after the war, cultural creators and consumers asked which media were useful and benign ways of attaining "a better understanding" and shaping open-minded, democratic psyches. As media historian Fred Turner shows, Frankfurt School theorization of the "culture industry" was somewhat oversimplified by US theorists when Theodor Adorno and others came to the United States as refugees in the 1940s.[35] Popular and mass media like jazz and cinema were, in this interpretation, viewed as dangerous, seductive, and corrupting. Classical music, by contrast, was construed as intrinsically apolitical and "autonomous," an ideal conduit for shaping exchange in cultural diplomacy.[36]

Westerman's 1942 project, "Fifty Outstanding Afro-Americans," revealed his interest in the power of images to communicate racial uplift. For this project, he filled the Canal Zone's silver-roll La Boca library with signed portraits of influential African Americans, from W. C. Handy and Carter G. Woodson to Alain Locke, Langston Hughes, and Walter White.[37] Westerman followed the project by organizing, with Linda Samuels, an interactive, participatory installation, the "Exhibit on the Races of Mankind," that embodied Turner's concept of the "democratic surround."[38] Westerman's and Samuels's efforts predated the 1955 "Family of Man" exhibit at the Modern Art Museum in New York by nearly a decade.[39] "The Family of Man" would go on to travel internationally as part of US cultural diplomacy. "The Races of Mankind" also traveled, as an installation of images, artifacts, and texts prepared by the Cranbrook Institute of Science and circulated by the Race Relations Division of the American Missionary Association.[40] When Westerman and Samuels brought the exhibit to Panama in 1946, Samuels accompanied the installation with a public lecture, broadcast on the radio and published. Her lecture stressed the lack of scientific basis for racial difference, with topics like "What is the Modern Concept of Race," "Races Cannot be Classified by Blood Type," "No Race is Ape-Like," and "The Jews Are Not a Race." All told, "The Races of Mankind" sought to counter stereotypes and create a new account of human equality.

Writing on Samuels's lecture, Westerman argued that Black people, "interested in the encouragement of scientific thinking about all people . . . should

help to create opportunities for accurate observation of race and culture, and thus provide others with evidence for drawing their conclusions."[41] Black people were ideal antiracist educators because "the Negro is perhaps the greatest victim of attitudes and prejudices based on assumptions that are largely without foundation"—denied "justice and humanity."[42] Because of the suffering, both past and ongoing, that they endured, people of African descent were poised to lead the new society that would emerge after the war's defeat of Nazism, fascism, and Japanese imperialism. This idea resonates with Westerman's *Booker T.* anecdote: the ship as metonymic incubator of a new racial order. Of crucial importance to the allegory, a Black captain steers the ship, engendering a new racial (if masculine) chain of command that would, in Westerman's view, "put to shame those prejudice ridden individuals who claim that peace and harmony cannot reign between white and black unless the former is the controlling influence."[43] West Indian Panamanians, like many others, viewed the Allies' fight against Nazism as a fight against racism. The horrors of the Holocaust did substantial (if still partial) pedagogical work to force a large-scale reassessment of racial categories and well-worn prejudices. Historian Michel-Rolph Trouillot locates in postwar racial liberalism the moment of material implementation of Western Enlightenment values of the "human."[44] While inconsistencies remained, a concept of human equality predicated on "mutual understanding" began to take root in mainstream discourse. The view that all people are fundamentally the same seems far from ideal when considered from our contemporary moment. Yet during and after the war, the idea of the "Family of Man"—that all humans were equal, and differences must be actively overcome to reveal this equality—was a response to the racial taxonomies that informed Nazism, and to which many people in the United States, Europe, and Latin America also subscribed.

Direct exposure to those considered "different" could shape democratic psyches, demonstrating that race was only "skin-deep." Ultimately, Westerman decided that the best way to transmit pedagogies of interculturalism and forge "mutual understanding" was live performance. Writing to Eslanda Robeson to request a visit from her husband Paul in 1945, Westerman gave an argument that he would repeat in inviting Black artists to the isthmus:

> We have seen him on the screen; listened to him over the radio; read about him; drawn encouragement from his leadership; and we have a true experience of that spiritual kinship that exists between him and us. But we are anxious to *know him in person* and to borrow from him something of the great vision that he has for the glorious future of the Negro race. [. . .] We need to be inspired by the *physical touch* of great Negroes whose public career stands as a beacon to the youths of all nations. We need to have visit with us here Negroes whose achievements . . . will

deal a lethal blow to bigotry and racial prejudice of which there is an abundance in this country.[45]

In emphasizing the touch of "great Negroes," Westerman stressed an affective longing for physical connection that materialized Black presence as ontological aid to an intercultural, antiracist pedagogy.

THE ISTHMIAN NEGRO YOUTH CONGRESS (INYC)

In the spirit of performance as antiracist pedagogy, Westerman cofounded the Isthmian Negro Youth Congress (INYC) on August 22, 1942.[46] The INYC emerged as a haven for "Isthmian Negro youth," responding to the challenges facing criollos. The organization's motto was "Progress Through Education," and the group had over a thousand members. Based in the silver-roll Canal Zone, the INYC labored to improve silver education and create spaces of social and cultural production and exchange. Until his resignation from the INYC's Executive Committee in 1946, Westerman served as executive treasurer, director of the Intercultural Committee, and lead editor of the *INYC Bulletin*.[47] These activities informed his subsequent concert impresario work. The INYC sponsored and interacted with Black artists and goodwill ambassadors. The first artist to perform for the INYC was African American opera singer Aubrey Pankey, who gave a week of concerts on the isthmus starting in late December 1942. Pankey was "the first singer of his race to have made an official tour of South America under the sponsorship of Nelson Rockefeller's Office of Inter-American Coordination."[48] He visited Panama as part of sixty concerts in ten Latin American countries. Pankey likely performed a "mixed program" comprising both 'high art' (classical music and art song) and Negro spirituals. As observed by musicologist Danielle Fosler-Lussier, the mixed program was favored among touring artists during World War II, and it recurs frequently in records of isthmian cultural diplomacy at the time.[49]

The INYC did not plan the visit but hosted a reception where Pankey spoke of his "experiences with people of difference races." He concluded: "My only hope is that I perform in such a manner that I succeed in aiding some other Negro to get a chance." A reviewer observed that "these words . . . express eloquently the spirit that moves the Good-will Ambassador sent by one American Republic on a cultural junket to other sister republics in this Hemisphere."[50] Pankey's visit was celebrated in the *INYC Bulletin* issue on "the Negro in Music," and further events followed, featuring local musical groups like the Atlantic Orchestra, the Cleff Melodaires, and the Gatún Glee Galaxy. But Westerman, Roy Best, LeRoy Hogan, and other INYC officers were captivated by the prospect of bringing international Black celebrities to the isthmus. From April 11 to May 12, 1944, the INYC sponsored the visit of Jamaican musicians Hazel Lawson and Florizelle

Wilson.[51] The classical violinist and pianist gave several concerts at the Caribe and Encanto Theatres in Panama City and Colón, and in Canal Zone clubhouses and hospitals. In one performance at the Zone's La Boca Clubhouse, the Jamaican musicians' classical repertoire segued into a mixed program, as West Indian Panamanian musicians including Emily Butcher and Eric Graham added Negro spirituals and folksongs. Local press outlets lauded the performances as well-attended, "cosmopolitan" events.[52]

Lawson and Wilson's visit—the INYC's first attempt to sponsor "goodwill ambassadors"—was deemed a smashing success. It was followed by a performance of African American composer William Grant Still's *Afro-American Symphony*, by Panama's National Symphony. Westerman, friendly with the Stills, wrote to request Still's music, explaining: "The Panama Symphony is very cosmopolitan in make-up, its members . . . drawn from the Panamanian population, as well as from the Army, Navy, and civilian personnel on the Canal Zone, and its programs attract large numbers of music-lovers. . . . A program featuring Dr. Still's symphony would [popularize] the work of a great American composer, at the same time that it would . . . furnish a new viewpoint to many Panamanians and Americans on the Isthmus regarding the cultural and artistic heights to which a Negro can attain."[53] In citing cosmopolitanism, Westerman noted his actual goal: to bring US and Panamanian audiences together physically in appreciation of Black excellence.

In the same spirit, the INYC cosponsored renowned African American baritone Todd Duncan and accompanist William Allen on May 2, 1945. Duncan was lauded as a "soloist . . . screen star, and concert artist of the Hayes-Robeson tradition," who had debuted Porgy in *Porgy and Bess*.[54] As with Pankey's visit, INYC could not afford full sponsorship of Duncan and Allen, and shared costs with the US Sixth Air Force Personnel Office's "We Bring You Music" concert series and INTARIN (Intercambio Artístico Internacional, or International Artistic Exchange), a Pan-Americanist agency led by Mexico-based musicologist Myron Schaeffer. Duncan inaugurated the 1945–1946 season of INTARIN's isthmian partner, the Sociedad Pro-Arte Musical de Panamá. This society, affiliated with the US "Community Concert Association," sought to embody the cosmopolitan, Pan-American face of the "Good Neighbor" on isthmian soil, counting among its members Panama's president Adolfo De la Guardia and US general George H. Brett, US Navy rear admiral Howard F. Kingman, and Canal Zone governor J. C. Mehaffey.

While evincing US patriotism, the wartime tours of Aubrey Pankey and Todd Duncan also showcased Pan-American friendliness. West Indian Panamanians were keenly attentive to goodwill ambassadors' propensity to transform conditions on the ground, particularly in matters of race. Race relations formed a pivotal site for inter-American geopolitical tensions, which emerged in Latin

American reception of the goodwill ambassadors' tours. The tours engaged the "Good Neighbor" project to sow hemispheric community among "American republics"—seemingly construing these republics on an equal footing. But US hegemony in the region was undeniable, and new frictions and power discrepancies arose during and after the Second World War. Amid these regional tensions, the Duncan/Allen tour became a lightning rod when the artists "caused Venezuela to legislate against racial discrimination."[55] An unnamed criollo reporter wrote in the *INYC Bulletin* that Duncan "attained artistic heights and made political history. What diplomacy and statesmanship have failed to accomplish was achieved by the distinguished recitalist."[56] Almost every place Duncan and Allen performed, they faced racism in hotels, restaurants, and theatres, which sparked responses by their host countries. Duncan encountered discrimination at a hotel in Guatemala, and in Venezuela he was impacted by a law that prohibited non-white persons from entering the country, in place since 1932. While "in Guatemala and Venezuela the dragon of racial prejudice . . . thrust its poisonous fangs of racial discrimination in the direction of the internationally famous Negro," Duncan "slew the horrible monster and left it to be buried by the anti-democrats who had nurtured it."[57]

Both countries were at pains to rectify the exposure of racism. Guatemala's chief of police fined the offending party and delivered a public apology. In Venezuela, Duncan's visit spawned "a furor in the Senate and a bill presented by Dr. Manuel Rodríguez Cárdenas was unanimously passed making racial or religious discrimination a penal offense." Cárdenas stated, however, "that the sporadic instances of racial discrimination are the direct product of an ever-increasing Yankee influence"—a view popular in Panama as well. A Venezuelan newspaper echoed this, accusing the United States of exporting "race prejudice" to Venezuela along with "Wrigley chewing gum."[58] Pan-Americanism became deconsolidated at the site of race relations, in the interactions of Black goodwill ambassadors with diverse publics. "The United States, the country of Duncan's birth, did not escape its heavy responsibility for the spread of racial intolerance to Latin America."[59] The unnamed criollo reporter concluded with condemnation of the United States: "May Duncan's big country likewise hasten to apply to its practices of racial discrimination the corrective measures adopted by two of her smaller sister republics." Duncan, Allen, Pankey, and others showed the power of "good-will tours" to "expose the cultural prowess of the Negro to more sincere appreciation on the part of Latin America."[60] During and after the 1940s, observers in Panama, taking cues from Brazilian writers like Silvio Julio and Gilberto Freyre, framed antiblackness as a US export to Latin America.[61] Scholars have shown this to be simplistic: Panamanian racism, while manifesting less systematically than the Canal Zone's Jim Crow color line, was and remains pervasive.[62] Yet the INYC, knowing this, also saw a productive place for West Indian

descendants' active intervention in inter-American racial juxtaposition. The INYC watched with interest the goodwill ambassadors' destabilizing and transformative effects on tour: in encounters with diverse groups ranging from "regular concert-goers" to the US armed forces, the performers came into meaningful contact with cosmopolitanism, pan-Americanism, cultural diplomacy, and state action in response to racism.

Westerman was particularly attuned to the ripple effects of Black artists' tours. He seized the reins of future INYC sponsorship, choreographing anti-racist political manifestations and acts. A memorable turning point occurred during the visit of Afro-Canadian singer Portia White. Westerman was alerted to White's visit by "Professor del Val of Panama Conservatory," who sought his support in sponsoring White. Westerman "pointed out [del Val's] error in having entered [sic] such an arrangement without having first consulted any member of the Isthmian colored community." He and colleague Herbert Thomas worried that "Professor del Val intended only to profiteer at the expense of our community by promoting a Negro singer," and they threatened to boycott White's performances unless "members of the Negro community were invited to share in the venture and see that Miss White was given all the considerations that other artists have been extended in Panama."[63]

During White's visit, Westerman engaged the singer in political matters. On top of her performance on January 28, 1946, Westerman brought White to a session of Panama's Constituent [National] Assembly. White also received a courtesy call from Panama's president Enrique Jiménez. Reviewing White's visit, Westerman contextualized these events within a "liberal trend of affairs in this country," mentioning "Panama's third constitution, said to be one of the most liberal in the Western hemisphere," drafted a month later.[64] He sought to instill and derive a connection between the visit of an international Black celebrity and Panama's "liberal trend of affairs." In the same account to the editor of *Metronome* magazine, Westerman requested an isthmian visit by "one of the leading Negro bands of North America," which "would further enhance the prestige of our people here and make for the strengthening of Inter-American relations." Westerman requested Duke Ellington, Louis Armstrong, Cab Calloway, Lionel Hampton, Count Basie, Earl Hines, and several other famous African American artists; their visits "to this Latin American Republic," he stressed, "could be viewed in the light of a good-will mission."[65] This 1946 correspondence demonstrates that Westerman was not solely interested in sponsoring classical singers and musicians—at least not initially. However, as leader of Westerman Concerts, he would focus solely on classical artists.

GEORGE WESTERMAN, CONCERT IMPRESARIO: 1949–1955

After parting ways with the INYC, Westerman sought to undertake sole management of internationally renowned Black artists' concerts in Panama.[66] From 1949 to 1955, he sponsored the concerts of lyric soprano June McMechen, soprano Camilla Williams, Panamanian pianist Emily Butcher, jazz pianist Hazel Scott, lyric soprano Dorothy Maynor, contraltos Carol Brice and Marian Anderson, soprano Ellabelle Davis, pianist Philippa Duke Schuyler, baritone William Warfield, and the Davis-Breen traveling production of *Porgy and Bess*. All but Butcher were US citizens (although Scott was born in Trinidad); most were engaged on privately sponsored tours. Diverging from the local impresarios described by Fosler-Lussier, Westerman demanded sole sponsorship of his chosen artists during their time in Panama. As impresario, Westerman invited US Embassy delegations to the concerts and allowed the artists to attend Embassy functions, but he largely excluded the US Embassy from cosponsorship. In Westerman's carefully orchestrated events, US Embassy staff were positioned as grateful recipients of his benevolence rather than collaborators.

The goals of Westerman Concerts differed from INYC cultural programming in several ways. First, Westerman was clear that he sought to manage his artists' concerts in Panama, and would not sponsor concerts in the Canal Zone.[67] In part this was because Zone entertainments were organized by the Panama Canal's Bureau of Clubs and Playgrounds (BCP), but the distinction also framed Westerman Concerts as a national project, training its focus on Panama. Canal Zone audiences were welcome to attend the concerts, and many did. Another difference was Westerman's overt and singular focus on Black uplift and excellence. As he wrote to Hazel Scott's US manager:

> Westerman Concerts was organized to sponsor outstanding Negro artists. However, the sponsorship of Negro artists in this community is more than a promotional venture. . . . The native Panamanian has a very poor conception of the cultural and artistic worth of the non-Latin Negro. [. . .] [E]fforts have been put forth by members of our group to correct this unfavorable impression. There is evidence . . . that a wholesome appreciation for the Negro is notably enlarged with every performance of a celebrated Negro personality on the Isthmus. This means that steady progress is being made in race-relations and that our concerts are featuring artists who render the service of Good-will Ambassadors of their country and the Negro race in particular.[68]

If we compare Westerman to one of his frequent business partners, the differences in focus and methods become evident. Powerful Jamaican impresario couple Dorothy and Stephen O. D. Hill brought many famous artists to the

Caribbean at this time, as part of a postwar "Celebrity Concert Series."[69] The Hills corresponded and collaborated frequently with Westerman, seeking to share costs. Commercially motivated impresarios, the Hills had no coherent political agenda aside from box office gains, and they partnered with US Embassy staff and the Canal Zone government to bring an array of "highbrow" and popular artists—including African American artists like jazz performer Cab Calloway, renowned dancer Carmen de Lavallade, and opera singer Lawrence Winters. Hill also repeatedly tried to interest Westerman in "white artists" like US opera singer Lawrence Tibbett and "marvellous Hindu Dancers," which Westerman declined.[70] Hill viewed Panama as a lucrative entertainment stopover, with the US military buildup of World War II and Panama's dense midcentury leisure-scape of cruise ships, casinos, clubs, cabarets, and bars.

While collaborating with Hill, Westerman made clear his disinterest in monetary gain and commercial entertainment and foregrounded his agenda of promoting Black artists who performed rarefied repertoires. Nevertheless, Westerman accepted several of Hill's offers, and his meager personal finances suffered from low audience turnout for artists like Ellabelle Davis, who were talented, as Westerman explained to Hill, but had little name recognition in Panama.[71] Westerman's precarious financial state and focused goals led him to reject many of Hill's offers to send artists including Katherine Dunham, Muriel Rahn and Kenneth Spencer, Ginette Neveu, and the DePaur Infantry Chorus.[72] Knowing that his target audiences in Panama and the Canal Zone were fiscally constrained and could not spend freely on entertainments, Westerman focused on cultivating spectatorship for Black classical artists. He was fastidious about promoting his artists, and created an extensive publicity campaign around each one. He also took measures like negotiating with Hazel Scott's US manager for reduced ticket prices in the face of an impending reduction in force of 10,000 Canal workers and resulting West Indian Panamanian unemployment.[73]

Spatial constraints prevent a full chronicle of all of the Westerman artists' visits to Panama. Below I present highlights and ramifications of selected artists' performances. Figures 3.1 to 3.4 show selected Westerman Concerts program covers and flyers, in chronological order of the artists' visits to the isthmus.

June McMechen was the first artist contracted by Westerman, in spring 1949. Despite misgivings about Panama's political and economic instability, Westerman organized three concerts for McMechen: two with Panama's National Symphony Orchestra at the National Theatre, and another at the Jewish Welfare Board Armed Services Center, apparently the last concert Westerman organized in the Canal Zone. McMechen's programs, like those of all Westerman artists except Hazel Scott, included classical music (Mozart arias), modernist US compositions (namely, *Porgy and Bess*), and a final section of Negro spirituals.[74] For the concerts, Westerman experimented with a publicity scheme that he would

subsequently repeat: he invited top officials in Panama and the Canal Zone, such as US ambassador Monnett Davis, and sent press releases to newspapers and radio stations across the isthmus. In tune with the news cycle, he released articles, adapted from international newspapers and United States Information Service (USIS) publications, to Panama's many Anglophone and Hispanophone periodicals. These included the *Star and Herald/Estrella de Panamá*; *Panama American/Panamá América*; *The Nation/La Nación*, *The Courier*, *La Hora*, *El Mundo Gráfico*, *El País*, and his own *Panama Tribune*. These press releases and publicity dossiers generated further columns by Canal Zone, "Latin Panamanian," and West Indian Panamanian journalists. Westerman sent invitations and free tickets to diplomats, high-ranking US Army and Navy officers, Canal Zone government officials, and Panamanian politicians and intellectuals. Although the Westerman artists were largely US citizens, he always dedicated their concerts to Panamanian government officials.

McMechen's visit accomplished several cultural-political coups: first, the symphony's performance indicated that "Panama has placed the supreme benediction on this visiting artist who has been received officially and acclaimed generally in official government and diplomatic circles."[75] In addition to national praise, Westerman garnered a new victory: desegregation of the US ambassador's residence. Westerman wrote that McMechen "was entertained at the Embassy residence of Ambassador Monnett B. Davis and Mrs. Davis; the first time in history that such a function was sponsored."[76] The Black artist's visit spurred a reception hosted by US Ambassador Davis with a mixture of Latin Panamanian, West Indian Panamanian, and US citizens. Among those present were Canal Zone governor Francis Newcomer, Panama Canal executive secretary Eugene Lombard, and Panama's foreign relations minister Ignacio Molino Jr., education minister Ernesto Mendez, and government and justice minister Jose Daniel Crespo.[77] Criollos present included pianist Emily Butcher, Westerman, Archdeacon Arthur Francis Nightengale, and journalist Jack Jamieson.[78]

Ambassador Davis lauded McMechen as a fellow "American" and "goodwill ambassador."[79] But West Indian Panamanians, and the African American press, foregrounded the fact that McMechen was Black, and this was the first time the ambassador had invited a mixed-race group into his home. The event was picked up in the African American press, as "June McMechen Re-Writes US History in Panama: Zone Wilts under Magic Spell of Vocal Excellency."[80] The *Washington Afro-American* stated: "For the first time in the memory of the present generation, Panamanians of African descent mingled on terms of social equality with diplomats at a social affair under the aegis of the U.S. Ambassador to this strategic military base, which has seen segregation introduced at the instigation of the U.S. Government." The newspaper conflated the US Embassy with the Canal

Zone, but the point held: a US government official had, if momentarily, desegregated a diplomatic site.

Jack Jamieson—a witty and incisive commentator on isthmian social relations—wrote in the *Panama Tribune* that McMechen had "[broken] down the racial barrier . . . allowing us entrance into the sacred . . . preserves of the American Embassy."[81] Jamieson praised this act as "an indication of practical democracy" and stated that "the peoples of the world are fast coming to the realization that for world peace and security there must be greater fraternizing of the human race on the common ground of mutual understanding and reciprocal courtesy." In a longer unpublished draft of his article, Jamieson wrote: "From the high estate of divinity . . . to members of the Fourth Estate . . . the free intermingling of guests, including PanCanal's Governor Newcomer was indicative of what we have dreamed the democratic life to be."[82] For Jamieson, the guests' free movement, "conversing and questioning," created the groundwork for "a deeper and broader understanding of one another's sympathies and aspirations." McMechen's traveling body, performing goodwill, proved more transformative than her voice. Her concerts began a trajectory that Westerman continued, building on McMechen's political and performative momentum.

A few months later Westerman brought soprano Camilla Williams and her accompanist Borislav Bazala to the isthmus. Williams was tremendously accomplished, a two-time winner of the Marian Anderson Award and a "nationally famous figure" in the United States.[83] She had made history three years earlier as the first Black woman to sing the role of Cio Cio San in Puccini's *Madame Butterfly* with the New York City Opera.[84] She was also the first Black woman offered a full-time contract with a major US opera company.[85] Her many achievements, attained with the help of benefactors and industry greats, made her a living "democratic enterprise."[86] Westerman foregrounded Williams's pioneering acts and reached out to an even broader array of US Embassy, Canal Zone, and Panamanian officials, US Army and Air Force officers, and Latin American ambassadors. He also added a concert in Colón, acknowledging audiences on Panama's Atlantic side. His fliers framed Williams as part of an elite group of "famous Negro singers, beloved of the music world," including "Marian Anderson, Roland Hayes, Dorothy Maynor, Paul Robeson, Todd Duncan."[87]

Following Williams, Westerman promoted Emily Butcher, framing Butcher as an international celebrity and a model citizen of Panama, "the Home Town Girl Who Made Good."[88] Butcher had earned advanced degrees at Columbia University but returned to the isthmus after graduation to oversee music curricula in the Zone. Her philosophy echoed core tenets of cultural diplomacy: she viewed music as a gateway to mutual understanding and improved intercultural relations due to its seeming lack of political ideology.[89] Butcher's concerts

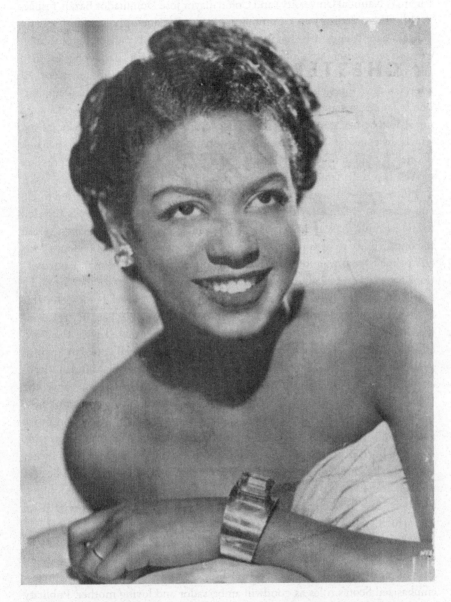

FIGURE 3.1. Portrait of pianist Hazel Scott from concert program cover, 1949. Manuscripts, Archives, and Rare Books Division, Schomburg Center for Research in Black Culture, The New York Public Library, Astor, Lenox, and Tilden Foundations. 56706345.

in Panama City and Colón were dedicated to Octavio Méndez Pereira (rector of Panama's National University) and Colón mayor José Dominador Bazán, respectively.[90] These dedications communicated West Indians' appreciation for Latin Panamanian "friends" like Bazán. Multiple press accounts praised Butcher as an exemplary representative of her "race" or her "people," a "dark-complexioned girl" who had risen to "a permanent civil service position on the Canal Zone at a top US rate" through "talent developed over years of hard study and application."[91] Jamieson stated, "whatever honors have come to the young woman, are not shared by her alone, but by every conscientious member of the group from which she sprang."[92] Butcher's concerts were poorly attended, owing to her lack of celebrity, but declared aesthetically stunning, producing a positive impression of West Indian Panamanians' achievements.

Butcher was followed by a very different artist: Hazel Scott, married to US congressman Adam Clayton Powell Jr. (see Figure 3.1). The Powells traveled to the isthmus for a political visit in December 1949, and Westerman seized the opportunity to organize Scott's concert after several years of trying.[93] Powell's primary goal was to gather information on the Canal Zone's labor relations for the House Labor and Education Committee, in particular around a new local-rate (i.e., silver-roll) retirement pension bill.[94] Powell connected this issue to racial discrimination, adding information on US-Panama relations that he likely gleaned from research that Westerman shared with the Powells.[95] In addition to touring the isthmus with Scott, Powell spoke in Spanish at Panama's National Assembly, calling "for Panamanian and American leaders to 'stand together and beat back those individuals in Panama or in the United States who practice hatred. [. . .] Let us show to the world that here in Panama people of two nations and many races can live together in peace and equality.'"[96] Powell's political activities did not upstage his glamorous wife. Trinidad-born Scott, stage and screen star, performed three concerts in her famously dazzling, jazzy style. Her talents included "swinging the classics . . . musical comedy . . . boogie-woogie (including original compositions), blues, and bebop."[97] This repertoire excluded spirituals in favor of improvisational jazz, which Westerman rarely promoted.[98]

At the Teatro Lux, Scott wore a shimmering, low-cut silver gown and jewelry—a dramatic departure from the modest, matronly, and body-concealing style of other female Westerman artists. Westerman's press booklet nonetheless emphasized Scott's roles as goodwill ambassador and loving mother. Publicity materials highlighted her work with US soldiers during the Second World War.[99] In addition to being a model of domesticity—fishing, cooking, horseback riding, and playing with her son Skipper on her White Plains, NY estate—Scott was also a civil rights pioneer.[100] Banned from performing in Washington, DC in 1947 by the Daughters of the American Revolution (the same group that

protested Marian Anderson), she and her husband broke racial barriers at "all of the important Washington social events," marking (for example) "the first time that an American Negro had been invited to a major Embassy reception."[101] These portrayals countered depictions of Scott as a louche nightclub singer, the highest-paid Black performer at the Café Society.[102] Westerman lauded the visit as "history in the making."[103]

Hazel Scott contrasted markedly with Westerman's subsequent artist, Dorothy Maynor—a deeply religious expert in the study and performance of spirituals. Westerman had been trying to book Maynor since 1947, as Maynor embodied traits that Westerman valued highly in an artist-diplomat.[104] Daughter of a Methodist minister and "the first woman ever to sing in the Washington Cathedral," Maynor was committed to faith and community outreach.[105] She was mentored by Nathaniel Dett at the Hampton Institute before joining Princeton's Westminster Choir School. Maynor was a tireless goodwill ambassador and humanitarian who felt that the "universal language" of music, particularly Negro spirituals, could "create a bond of understanding between peoples of all races and creeds," and "help the Negro achieve the important place in American life to which his talents and contributions entitle him."[106]

For Maynor's visit, Westerman capitalized on her interest in charitable outreach, crowding her schedule with radio interviews, a visit to a local-rate teen club, sightseeing in the Canal, a Panama Methodist Church service, and a solo performance during mass at the Santa Ana Roman Catholic Church.[107] While her concert at the Lux did not sell out, the community outreach appearances of the "cherub-faced diva" helped Westerman to "further better relations among the peoples of Panama" in ways that differed from those of previous artists' visits.[108] During her concert, she included a Jamaican folksong, "Linstead Market," and a "Creole song called 'Jan'"—Anglophone Caribbean themes that resonated strongly with West Indian Panamanians.[109] Westerman again lost money but was ecstatic, telling Maynor's manager of his pride in sponsoring a gracious, warm, and "sparkling" goodwill ambassador, with "the finest esthetic sensibility of any artist to perform on the Isthmus of Panama in many years. [. . .] [U]nanimous is the view that she made a sound, serious, and significant effort to advance the cause of good-will on the Isthmus."[110] Maynor reinvigorated Westerman's faith in US cultural diplomacy: "Through culture and esthetic feeling the United States will yet exert a beneficent influence on the destiny of the world, and the artistry of its citizens like Dorothy Maynor, carries abroad the nation's ideals of liberty and justice."[111]

The next highlight after Maynor was Marian Anderson's concert, discussed at the chapter's outset, which marked the apex of Westerman's project (Figure 3.2).[112] Like Maynor, Anderson embodied spiritual depth, benevolence, aesthetic refinement, and world-transforming cultural ambassadorship. Anderson, a

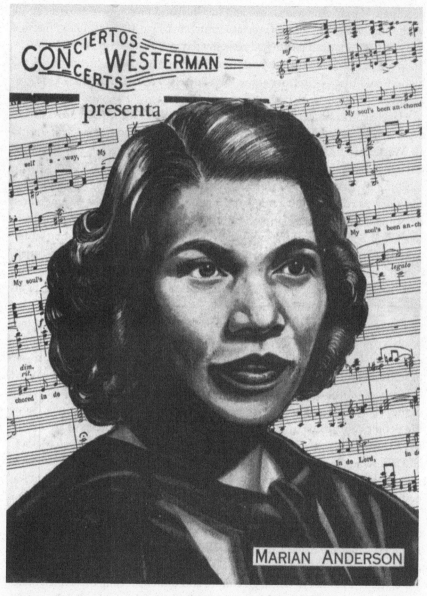

FIGURE 3.2. Portrait of singer Marian Anderson from concert program cover, ca. 1951.
Manuscripts, Archives, and Rare Books Division, Schomburg Center for Research in
Black Culture, The New York Public Library, Astor, Lenox, and Tilden Foundations.
56706325.

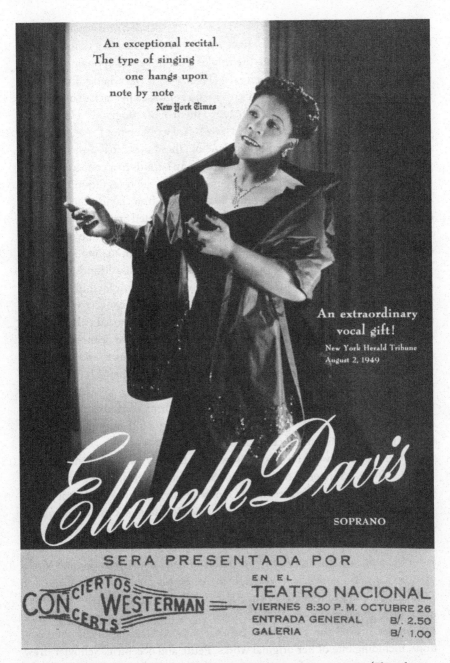

FIGURE 3.3. Concert handbill depicting soprano Ellabelle Davis, ca. 1949. (Photo by Yvonne Le Roux/Manuscripts, Archives, and Rare Books Division, Schomburg Center for Research in Black Culture, The New York Public Library, Astor, Lenox, and Tilden Foundations.) #56706327.

consummate artist-diplomat and world-renowned celebrity, proved a hard act to follow. Westerman decided to contract another pathbreaker: soprano Ellabelle Davis, the first Black diva to sing the role of Aida in Verdi's eponymous opera (with Mexico's Ópera Nacional, in 1946) (Figure 3.3).[113] Davis had a distinct sensibility as a classically trained opera singer who confessed her lack of experience with Negro spirituals, although she included them in her program.[114] Having performed extensively in Latin America, Davis stated a preference for audiences in Buenos Aires, Mexico City, and Rio de Janeiro. These sites offered ways to navigate around "the kind of difficult channels that are hazards to a concert career in the United States."[115] Implicit in Davis's comment was the recognition that Latin American operagoers did not prevent Black artists from taking the stage for racial reasons, as happened all too frequently in the United States. Davis embodied aspects of both high cosmopolite and goodwill ambassador. She performed in Europe, at the Hague, in Sweden, Italy, and Austria, from 1948 to 1949.[116] She came to Panama from Jamaica, where her performance raised funds for earthquake relief.[117] Westerman emphasized her goodwill ambassadorship by having her perform free of charge in Colón.[118] While Davis's Colón concert appeared to result from a local councilman's protest that Westerman ignored Atlantic audiences, Westerman had in fact planned to have Davis sing "two or three numbers at a plaza in the City of Colón on November 1 or 2, as a gesture to the republic of Panama which celebrates its independence day on November 3."[119] Westerman had also wanted Marian Anderson to perform a free public concert, a request that her manager declined. This correspondence affirms Westerman's interest in choreographing his artists' goodwill ambassadorship so that audiences would suture the concerts to official cultural diplomacy.[120]

Westerman followed Davis's visit with a friendly favor, hosting pianist Philippa Duke Schuyler at the behest of Schuyler's parents, George and Josephine.[121] Black conservative firebrand George Schuyler, New York editor of the *Pittsburgh Courier*, was a close acquaintance of Westerman's mentor, *Panama Tribune* editor Sidney A. Young. Philippa, aged twenty during her isthmian visit, was a gifted pianist-composer and a child prodigy.[122] Her goodwill ambassador bona fides included World War II performances for US troops and Voice of America radio concerts.[123] Westerman devised a public service event for Schuyler: helping to inaugurate the Casa del Periodista (Journalist's House) in Panama, in reference to her father's work.[124] Panama's president Alcibiades Arosemena hosted the event, and Schuyler played three classical compositions, including one of her original works. Petite and eccentric, Schuyler drew widespread praise in press accounts that dodged questions about her racial composition. One exception was Eleodoro Ventocilla's review in the *Estrella de Panamá*, which called her "an example for the racists and the apostles of racial discrimination who believe that the color of skin brings privileges and superior

Concierto del Cincuentenario

WILLIAM

WARFIELD

═══ BARITONO ═══

FIGURE 3.4. Portrait of baritone William Warfield from concert program cover, ca. 1953. Manuscripts, Archives, and Rare Books Division, Schomburg Center for Research in Black Culture, The New York Public Library, Astor, Lenox, and Tilden Foundations. 56706327.

capacities."[125] Ventocilla, noted music critic, lauded the "author of this grand and unforgettable feast for the spirit ... George Westerman, the dynamic and intelligent representative of Westerman Concerts, who allowed us to listen to Marian Anderson and to the highest figures of her race and her line."[126]

On this, as on past concerts, Westerman suffered losses; concert promotion proved increasingly unsustainable. In 1956, after coordinating the concert of baritone William Warfield and the Davis-Breen *Porgy and Bess*, Westerman changed tacks and entered Panama's diplomatic corps, pursuing a profession that continued his intercultural goals and ending his impresario work.[127] One of the last artists (and one of the few men) promoted by Westerman, William Warfield was a well-regarded artist-diplomat in 1953, when Westerman featured him in Panama's fiftieth anniversary marking independence from Colombia (Figure 3.4). Warfield's concert in Panama City was dedicated to Panama's chief of police Bolívar Vallarino and included classical music, US compositions (from folksongs to Aaron Copland's modernist works), and a lengthy final section of Negro spirituals. In Colón, Warfield's performance was dedicated to Mayor Bazán and the director of the Abel Bravo school, Victor Dosman.[128] Westerman sustained his biggest losses yet, roughly $1,800.[129] Yet audiences continued to communicate their appreciation, echoing the praise of H. L. Rose, *Panama Star and Herald* critic, four years earlier:

> If popular opinion were undecisive [*sic*] ... as to its potentialities as an instrument for the cultural elevation of the isthmian community, the Westerman Concerts agency, under the dynamic direction of our friend and local impresario, George W. Westerman, has ... not only completely justified its existence ... but has loomed high as a power to be reckoned with in the local field of concert promotion. The high standards established by Westerman Concerts in its endeavor to present the very best available to the local public, have recommended it very strongly to the ultra-discriminating and hypercritical elements in our midst and have ... earned for it a place of unique distinction among the high social and cultural institutions of the nation.[130]

RAMIFICATIONS OF THE WESTERMAN ARTISTS' CONCERTS

The Westerman artists' visits to Panama garnered multiple outcomes. Westerman, for one, was welcomed into Panama's elite sector and firmly included in the nation. Yet an expanded assessment of critical reception in Panama reveals other implications of the artists' acts of gendered and classed Black movement through national space and time. Westerman sought to make his artists into models of Black citizenship, positioning them in ways that made public the isthmus's racial and national tensions. Given the centrality of racialization to the Panama

concerts, the Westerman artists' bodies, voices, and on- and offstage behavior became imbued with political agendas occupying different scales of magnitude: transnational concerns made local, and local relationships seeking international attention. While the Westerman artists did not voice political views, Westerman choreographed them into a political mise-en-scène that I call "civil rights spectacles." Civil rights spectacles like McMechen's desegregation of the US ambassador's home sought to practice and verify emancipatory change, translating the artists' struggles against racialized oppression into isthmian contexts. Such spectacles, however momentary, rehearsed the state's response to racial difference.

Ironically, by "acting like a state," Westerman signaled the inverse: he was not a state representative, or even a state-sanctioned actor. West Indian descendants' citizenship status was still in doubt; Westerman was not, in the eyes of some, a proper citizen of Panama. At a time when criollos' liminal status placed them on the cusp of being "nonstate actors," the civil rights spectacles seemed to counter these brutal conditions, reweaving West Indian descendants into the nation-state that was actively excluding them. The concerts reminded the state, in a flourish of "diva" virtuosity, that its excluded quasi-citizens deserved inclusion as citizens. Many sympathetic audiences (among them powerful leaders on the isthmus) framed Westerman as delivering a national good and proving the worthiness of his "race." These efforts paid off in the 1950s and thereafter, as criollos received formal citizenship rights, and Westerman became Panama's diplomatic representative—a sign of his national inclusion. Yet what of the Westerman artists' struggles within US citizenship, as subjuncts, whose own national inclusion was highly unstable? While it is clear that Black, white, and mestizo audiences alike came away from the concerts with great appreciation for the artists' talents, doubts arise as to whether audiences translated these talents into ideas of citizenship, as Westerman hoped. Westerman sought to focus on isthmian relations, excluding another possible interpretation of the artists as exiles who built international careers to circumnavigate the racism that prevented many of them from attaining positions of prominence in their home country, the United States.

Westerman intended his civil rights spectacles to link cultural diplomacy techniques to representations of Black excellence. The artists stood at the center of these spectacles, as the empirical evidence sought by an antiracist pedagogy, to dismantle unscientific stereotypes. Yet as postcolonial theorist Homi Bhabha contends, stereotypes are capable neither of decisive verifiability nor disproof, even while seeming to pivot on the possibility of evidentiary revelation. "Stereotype . . . is a form of knowledge and identification that vacillates between what is always 'in place,' already known, and something that must be anxiously repeated."[131] No amount of evidence can prove or contradict a stereotype—yet the stereotype holds out this tantalizing possibility. Westerman sought to dislodge stereotypes associated with Blackness in the mainstream imaginary, with

the "Exhibit on the Races of Mankind" and "Fifty Outstanding Afro-Americans." But stereotypes defy these efforts, always existing "in *excess* of what can be empirically proved or logically construed."[132] The artists were framed as Black antiracist educators by example, but "scientific antiracism" also reproduced anxieties around the very provability of such traits, especially around questions of national inclusion.

Discourses of individualism also permeated Westerman's framing of the artists as living evidence of Black excellence. Westerman foregrounded the soloists as triumphant individuals, even though their solo performances in Panama had practical root causes: a singer (or singer and accompanist) proved less costly to transport than large ensembles. Westerman's focus on individualism also exhibited strong links to his anti-Communism.[133] Promoting the artists as empowered individuals, Westerman sought to prove that sole actors could transcend unjust conditions and achieve national inclusion; they did not need the apparatus of a political movement or syndicate to uplift themselves. Audiences in Panama received the artists as an impressive collection of boundary-breaking pioneers, not a collective movement to sow structural change. The artists' discovery narratives and rags-to-riches stories asserted the feasibility of upward social mobility in a Western capitalist society. Intrinsic to these heroic narratives, however, were unperturbed cores of individuality. The personalized narratives provided little insight into racial and national contexts in the United States, even as Westerman positioned the artists at the center of racial and national questions on the isthmus. Isthmian audiences extrapolated, however, and drew upon their understandings of US racism in interpreting the artists' visits.

The individualized Westerman artists conveyed Black corporeal sovereignty: their self-contained bodies were immune to the contagion of collectivism, even when traveling behind the Iron Curtain. Here gender figured crucially. It is unclear why Westerman largely contracted women; perhaps more Black women than men were performing on the international concert circuit, or this may have been Westerman's conscious choice. The artists' gendered bodies, which might have been construed as sexually provocative—as the Black female body was and is often hypersexualized in representation—were carefully offset by their mannerisms, dress, and (mostly white) male accompanists, who were all but ignored as innocuous chaperones. In press accounts of their isthmian concerts, Anderson and other married female singers were desexualized and addressed as "Miss," construed as benign, matronly figures.[134] With the exception of Scott, the artists wore modest clothing—formless sheaths that occluded their bodies, to minimize perceived threats of Black female sexuality. As performance scholar Daphne Brooks observes, "the black female body" is "scripted by dominant paradigms to have 'no movement in a field of signification'" and therefore to "countenance a 'powerful stillness.'"[135]

This stillness was palpable in the Westerman artists' near-absence of move-ment during performance, and in their offstage interactions.

Despite their spectacular accomplishments, the Westerman artists were por-trayed as demure, humble, and modest. Press images mostly featured their faces, rarely their torsos. Their performances of affective and corporeal self-negation seemed designed to rein in their boundary-breaking, border-crossing moves.[136] Aligned with Cold War stereotypes of "woman as domestic safekeeper," the artists were often depicted as "homebodies" who liked to cook, sew, and tend hearth on their rural or suburban estates.[137] Yet these portrayals were ironic, given that they were rarely "at home." Their functions of shoring up the US nation-state were complicated by their evocations of a "never-at-home"-ness.[138] They joined the international concert circuit for multiple reasons, but over-whelmingly because of the comparatively favorable treatment and reception of audiences, venues, and companies outside of the United States. On the whole, classical Black artists had few opportunities to work with professional US opera companies, and many turned to international audiences for steady employment. Black popular entertainers—in vaudeville, commercial theatre, and minstrelsy-derived genres—were in demand, but the field of classical music was effectively closed to Black artists, even at midcentury.[139] The artists' international travels compounded already tense and tenuous ties to their home country's artistic institutions.

On tour, the artists were lauded as celebrities and US "nationals," made to perform as more "national" than they could be at home. An example arises in the life story of Roland Hayes, a pathbreaking Black performer on the international concert circuit who inspired many Westerman artists. After living abroad, Hayes returned to the town of Rome, Georgia, where he was brutally beaten, and his family harassed, by the local white police in 1942. The incident aroused inter-national outrage, leading Langston Hughes to write: "America is a land where the best of all democracies has been achieved for some people—but in Georgia, Roland Hayes, the world-famous singer, is beaten for being Colored and nobody is jailed—nor can Mr. Hayes vote in the State where he was born."[140] This racial aggression, like the many obstacles that the Westerman artists faced, further ingrained their subjunct status—as if citizens, but materially not able to access the rights of titular citizenship. Such unfulfilled rights arguably increased many Black artists' ambivalence toward the United States. While Westerman worked to frame these stories positively—as agential triumphs over racism—Panama-nian audiences and critics could not and did not ignore the narratives' racial implications.

Arguably, too, the artists' pairings destabilized a straightforward reading of their ideal citizenship. Downplayed in the press, the singer and accompanist pairs—Marian Anderson and Franz Rupp, Ellabelle Davis and Kelly Wyatt,

Camilla Williams and Borislav Bazala, Dorothy Maynor and Ludwig Bergmann, Carol Brice and her brother—mimicked the form of the heterosexual couple while not (ostensibly) being sexual couplings.[141] All of the lineaments of propriety prevented a mainstream interpretation of the traveling pairs as romantic couples. Their seeming unfitness for reproduction marked them as temporary visitors and queer pairings. Yet this status dialed up the contrast between the mobile, interracial, (supposedly) nonsexual duos, and the ideal citizen couple— since citizens are often envisaged in the symbology of the settling heterosexual couple primed to reproduce future citizens. The Westerman artists and accompanists were not trying to become citizens of Panama, of course. They were in movement, on the road, not planning to linger or to seek asylum. As guests, they could call upon structures of hospitality and portray racial inclusivity in civil rights spectacles on the isthmus. Yet their temporariness may have inadvertently highlighted the fact that these Black visitors couldn't stay in Panama for long. Jamieson noted as much in his interview with Marian Anderson. Jamieson, citing Panama's restrictions against US Black immigration, pointedly sought to make Anderson respond to the discriminatory policy by asking her, "Do people in the United States know much about Panama?" By this, he meant something distinct: "We were careful to avoid the word 'Negroes,' as we felt sure the lady would 'get' the meaning. And she did too!"[142] Anderson replied: "People in the States know very little about Panama. I do wish they would learn more about this wonderful little country and its magnificent people." Jamieson followed in print: "Panama as a free and democratic country with an admixture of racial strains should not . . . raise barriers of immigration against one ethnic group of Americans while throwing her gates wide open . . . to another group of US citizens." This "other group" that Jamieson indicated in his critique of racism and xenophobia on the isthmus was white Zonians. Yet Anderson's behavior—like that of all Westerman artists—was designed to minimize any threats that might arise from the fact of Black female mobility. The artists had few ready responses for the political and social frictions provoked by their civil rights spectacles—nor could they have been expected to respond adequately. The desires that their presence elicited on the isthmus were incommensurate with their mobile bodies, enmeshed in costumes of feminized domesticity, racial and class uplift, and disavowal of corporeality: the duties of the Black female artist-diplomat.

Press accounts of the Panama concerts render visible contrasts between Westerman's framing of the artists as self-contained, individualized model citizens and their own transnational lives. The artists' mobility linked them (intentionally or not) to other styles of supranational Black movement—including exile, internationalism, diaspora, and Black flight.[143] Certainly, Westerman was invested in Black internationalism as a practice of modernity, albeit one that he aligned with Western Enlightenment concepts like the post-Westphalian (more

accurately post–World War II) sovereign nation-state.[144] In the Americas, the idea of the sovereign nation-state, which Westerman supported as a beacon of anticolonialism, contains intrinsic pitfalls, subordinating internal racialized and subaltern groups, particularly those who do not conform to coercive citizenship norms—conditions that scholars Walter Mignolo, Anibal Quijano, and others would term coloniality.[145] Theorist Paul Gilroy's assessment of the Black Atlantic as "counterculture of modernity" gestures to coloniality as modernity's "dark side"; the oppression of Black peoples indicates the persistence of racial stratification at the core of Enlightenment modernity, and the nation-state represents a signal means of excluding blackness.

The Westerman artists did not directly challenge the coloniality of Western modernity: rather, they embodied a subjunctive relation to sovereignty that political scientist Michael Hanchard terms "Afro-Modernity."[146] Foregrounding the "constitutive role" of racism in the development of the nation-state, Hanchard traces "Afro-Modernity" in transnational, interlinked movements of Black uplift that do not oppose Western modernity but, instead, critique and reconfigure modernity along specifically Black lines.[147] Afro-Modernity has often entailed rerouting Black networks around the nation-state, in "supranational formulation[s]" of imagined communities, as African descendants' responses to Western oppression.[148] Rather than claiming territory and practicing a kind of counter-sovereignty, these "alternative political and cultural networks" voice "explicit critique of the uneven application" of Enlightenment discourses and "processes of modernization by the West, along with those discourses' attendant notions of sovereignty and citizenship."[149] Modernity thus becomes a lived practice, in which Black people "utilize the very mechanisms of their subordination for their liberation."[150]

In keeping with the goals of Afro-Modernity, the Westerman artists did not disavow Western Enlightenment cultural mores. The so-named "apolitical" status of classical music seemed to foreclose the possibility of ideological expressivity. Yet the artists' citation of classical registers, in Euro-American opera and art song, provoked debates about the relationship of race to this canon. Critics in North and Latin America made the artists' voices into sites of difference, claiming to perceive racially distinct vocal qualities. In the *New York Times*, for example, music critic Olin Downes wrote that Ellabelle Davis's voice "could only be the voice of a gifted singer of her race. No white artist would or could produce such tone, with its harmonics . . . of 'cellos and reeds, and its very intelligent projection."[151] These sentiments echoed in Carol Brice's publicity, and that which Nina Sun Eidsheim denotes as Marian Anderson's "sonic blackness."[152] Racialization of the voice was a topic of discussion during the Harlem Renaissance and thereafter; even tenor Roland Hayes was concerned that his voice was "too white."[153]

The artists' culmination of their programs with Negro spirituals intensified critics' disjunctive readings of race and Western modernity. The singing of spirituals as art song, popularized by Hayes and Paul Robeson, activated debates over delivery, style, and "high/low" aesthetics. Some critics, like Carl Van Vechten, advanced a "polemical binary between the imitative, over-civilized refinement and unschooled, 'natural' authenticity," predicated on "a perilous aesthetic of racial essentialism."[154] Panamanian journalists often invoked the Westerman artists' racialization through the lens of the spirituals. For these audiences, spirituals seemed to communicate an authenticating, sensual, metaphysical aura or *mística* that rendered palpable Black "suffering" and embodied "all of the misery of a race."[155] Anderson in particular was construed as a "symbol," containing "all of the pain of her race" in "her cry of sonorous miracle."[156] Listening to Anderson's performance of spirituals, one critic felt it a "pity that her . . . ancestors hadn't known that these tender songs would be elaborated by someone of their race, with such unbreakable faith, with conviction and charm."[157] Spirituals do not only treat pain and suffering, as Grant Olwage observes: many encompass hope, "ecstatic" joy, and humor.[158] In concert, they were often structured into a narrative, from "sorrow songs" to hopeful melodies, or arranged to highlight distinct attitudes. Du Bois separated spirituals into three stages (African, Afro-American, and "blending with the songs heard in the foster land")—a progression that also informed the organization of spiritual sections in classical concerts.[159]

Whether or not the Westerman artists structured their concerts this way, however, Panama's press did not take up the issue. Rather, critics received Negro spirituals as uniform expressions of racialized suffering and Black authenticity. Many critics heard spirituals as sonic and affective conduits of antiracist pedagogy and windows into the experiences of an oppressed group. Such interpretations accord with sociologist Jon Cruz's discussion of abolitionists' uses of spirituals to evoke whites' "ethnosympathy," as well as Harlem Renaissance uses of spirituals to stimulate racial integration through feeling.[160] Although spirituals could be framed as high-culture art song, or included in the US national musical canon, many concertgoers in Panama received them as vocalizations of escape, echoes of the plight of Black people in the United States.[161] The spirituals' sonic intimations of Black flight, and the artists' international travels in anticitizen "queer couplings," clashed with Westerman Concerts' work to project ideal citizenship onto the artists, and, by proxy, onto West Indian descendants in Panama.

Westerman avoided framing the artists as *subjuncts*—as US citizens, nominally, but whose raced and gendered marginalization exposed the limitations and uneven coverage of citizenship. Instead, Westerman pitched them as global cosmopolitans. He wrote: "The magnificent art of Marian Anderson doesn't belong to a race, a nation, or a hemisphere. It belongs to the entire Universe and we, Panamanians, feel proud and happy to be able to share the emotion of life

that all people feel when under the magical influence of the American First Lady of Song."[162] West Indian Panamanian journalist A. Bell admonished those who would view Marian Anderson primarily as a "Negro," when in fact, she "belongs to the *world*, as long as the world will accept her as a contributor of inspiration and spiritual upliftment."[163] Anderson was "an example of beautiful womanhood, a remarkable representative of her racial group, [and] a credit to humanity."[164] When questioned about US racism, few artists offered direct critiques. Yet their visits uncovered fissures in national sovereignty confronted by international Black movement(s), and techniques through which Western liberal nation-states ambivalently included Black people. At once celebrities and representatives of a marginalized group, they symbolized, for some audiences in Panama, the difficulties of translating the Black body into (US) citizen.[165] This ambivalence within citizenship suggested, ominously, that once West Indian descendants became Panamanian citizens, they might encounter similar obstacles. Seen from this angle, Westerman's "civil rights spectacles" and efforts to spark "diva citizenship" were not enough to inculcate inclusion. As much as they seemed to shore up concepts of "nation," the artists' lives threw into radical question the substance of citizenship.

The Westerman artists embodied and envoiced "expressions of and commentaries upon ambivalences generated by modernity."[166] They touched down at the corners of the Afro-Modern project, only to set off for other ports of call. At their most utopian, their transiting bodies gestured to critical theorist Rinaldo Walcott's concept of "black global nonsovereign movemen[t]"—a "pure decolonial project" evading nation-state sovereignty, constraints of citizenship and politics of identity "in favor of a mobile 'politics of thought.'"[167] By contrast, Westerman viewed developmental decolonization and the liberal Western nation-state (in its trajectory toward sovereignty) as the only ways out of racism and colonialism.[168] As evidenced in his *Booker T. Washington* anecdote, Westerman advocated a harmonious multiracial ship of state, rather than a Garveyite Afro-Modern politics of transnational blackness. His concerts were grounded in the faith that racists would reverse their views if presented with convincing counterexamples. He believed in the power of law to be just, even as he faced persuasive evidence to the contrary.[169] In his diplomatic career, he upheld sovereignty and independence as the only solutions to peace and progress.

CONCLUSION: SHIFTING GROUNDS OF RACE AND BELONGING IN PANAMA

In 1965, Westerman chronicled Marian Anderson's cultural diplomacy, defining Anderson's true talent as her ability "to establish ties of common interest uniting nations, creating new values, and preparing people for better understanding."[170]

Linking song to "the fine art of diplomacy," Anderson expressed her belief in "the ideals of human freedom, justice for all, and an elective democratic process."[171] Westerman's invocation of these ideals was a strong statement one year after violent US-Panama conflicts had riven the isthmus.[172] The 1964 Canal Zone flag protests expressed Panamanians' frustrations with the Zone's US occupation and the dominance of a European-descended oligarchy whose democratic institutions were a façade. As pressure built against Panama's oligarchy, Westerman supported Arnulfo Arias's 1968 presidential campaign, even though Arias (promulgator of the 1941 Constitution) was rightly considered the enemy of West Indian descendants.[173] Not long after taking office, Arias was pushed out in a coup, and General Omar Torrijos Herrera took power, commencing over two decades of dictatorship. When Westerman protested the dictatorship, his newspaper, the *Panama Tribune*, was closed in 1973. One can only imagine the gulf between Westerman's faith in democracy, liberalism, and the sovereign nation-state and US-Panama relations after 1964.

Ultimately, for criollos Westerman's model of Black uplift proved constrictive, overdetermined by African American civil rights modes, New Negro Black respectability politics, and faith in liberalism's inclusivity. Thousands of criollos obtained Panamanian citizenship and suffrage in the 1950s, and Westerman sought to mobilize their votes in support of Latin Panamanian political campaigns.[174] Yet "gradual political inclusion" for criollos was accompanied "ironically [by] . . . economic exclusion and . . . emigration en masse to the United States."[175] Many left Panama, and those who stayed sought ties to international Communism, radical Black movements, and the Torrijos dictatorship. Westerman clashed with members of the increasingly self-identified "Afro-Panamanian" community, who supported Torrijos and felt more included in the nation-state than they had previously been.[176] As the next two chapters reveal, Afro-Panamanians' incorporation into Panama took shape outside of a politics of Black respectability and challenged US power on the isthmus. In Chapter Four, I investigate *La cucarachita mandinga*, a Panamanian anticolonial nationalist play that engaged satirically with racial, regional, gendered, and classed inflections of *panameñidad* (Panamanianness) and sovereignty. In the final chapter I explore how the Panama Canal's handover, and the performances that accompanied it, sought to reinterpret Panama's past, present, and future for national unification, decolonization, and a performative (re)enactment of the nation-state as autonomous from its longtime occupier.

4 · NATIONAL THEATRE AND POPULAR SOVEREIGNTY

Staging *el pueblo panameño*

Shortly after Panama's 1903 revolution, US Secretary of War William Taft labeled the country an "Opera Bouffe republic and nation."[1] Others, like critic Joseph Freehoff, followed suit, burlesquing Panama as a comic opera. In response, many Panamanian artists sought to represent the depth and heights of their nation in painting, poetry, sculpture, and architecture that emulated European 'highbrow' aesthetics. Yet the artwork that would galvanize Panama's nationalist pride for more than seventy years was itself an opéra bouffe—a farcical children's operetta starring an impoverished, racialized female cockroach. With carnivalesque humor, folk music and dance, and colorful masks and costumes, *La Cucarachita Mandinga* (*The Little Mandinga Cockroach*) has been one of Panama's most popular and beloved theatrical works, gracing large and small stages continually since its 1937 premiere. *La Cucarachita Mandinga* depicts Panama's history of colonial domination through the allegory of the Mandinga Cockroach (hereafter called Cockroach). The story at the play's core is not unique to Panama but is, rather, a popular fable across Latin America and the Caribbean (showing up in Cuba, Brazil, and Puerto Rico, among other places). Stumbling across a coin, Cockroach is pursued by rapacious animal suitors—a Bull, Pig, Duck, and others—representing Western colonial powers. While the suitors attempt to seduce her and steal her wealth, she dodges their advances. Protesting the incursions of the US-occupied Canal Zone, *La Cucarachita Mandinga* portrays the United States as the latest in a line of exploitative imperial powers. The play offsets its polemics with levity, however, by intermixing folkloric tropes and avant-garde formal experimentation, tying off the farce with a felicitous deus ex machina twist.

The play had an immensely successful debut, which came during swells of Panamanian anti-US sentiment and aesthetic experimentation in service of nationalism. The 1937 script and performance captured Panamanian artists'

interest in "ruralism" and "folklorism," intellectual movements that germinated in Panama in the 1920s and 1930s. Grounded in ethnographic pastoralism, ruralism and folklorism sought to "present the peasant as 'the base of our nationalism'" over and against the encroachments of foreign immigration and US hegemony.[2] Audiences connected with the mix of Panamanian folklore and avant-garde flourishes, viewing the play as an encapsulation of the contradictions of modernity on the isthmus that nonetheless celebrated Panamanian nationalism. In script, score, and mise-en-scène, La Cucarachita Mandinga stages a parable of space and power, folding the nation into theatrical space. The play is set in a fantastical rendition of an area known as the "interior," a region considered the source of Panama's "folk." (See Figure I.1, specifically provinces west of the Canal.) The script and libretto, authored by playwright Rogelio Sinán (the pen name of Bernardo Domínguez Alba), and score, by composer Gonzalo Brenes Candanedo, simultaneously affirm and unsettle the folkloric setting. The resulting work converts the interior into an ambivalent metonym for Panama, revealing the nation's permeation by the Canal Zone and all that it represents.

Oscillating between contemporary milieux and a supernatural Aesopian realm, the multilayered mise-en-scène destabilizes the interior as "national space." In similar fashion, Cockroach and her Mosquito and Cricket neighbors play ambivalently at citizenship, depicting both idealized Panamanian peasants and semiotically capacious animal-cartoon allegories. Their characters verge on the anthropomorphic while exhibiting extra-human traits, infused with qualities of race, class, gender, and sexuality. Compounding these characterizations is Sinán's portrayal of the protagonist Cockroach as both rooted in the interior and descended from the Mandinka people of West Africa. The play's interlock of Panamanian nationalism with African diasporic movement challenges dominant discourses of Panama's "folk" as geographically stable and isolated from the urban ports' cosmopolitan mixing. Yet this challenge to Panamanian nationalism is further complicated by the play's farcical treatment of its anticolonial narrative. Even as the suitors' attempted rape of Cockroach parallels the Panama Canal's geopolitical penetration of the isthmus, Cockroach's plight straddles comedy and terror, inciting audience laughter.

After its 1937 debut, La Cucarachita Mandinga ascended to Panama's "national stage." In subsequent years, government-sponsored productions often and eagerly took up the challenge of staging its whimsical take on colonialism. Spectacular "mega-productions," funded by Panama's governing powers in 1953, 1965, 1976, and 2006, dramatized past and present divides between Panama and the Canal Zone, rallying audiences to national political campaigns that challenged US power. These populist productions translated the play's spatial dynamics into nationalist rubrics, exploring multiple staging possibilities presented by its heterotopic mise-en-scène and antirealist characters. With each remounting,

production teams made adjustments and revisions, articulating Panama's changing orientation to foreign powers and global politics. Their casting choices reveal anxieties of race, class, gender, and sexuality underlying ideologies of national belonging. This chapter interrogates adaptations of script, score, setting, and character that have shaped *La Cucarachita Mandinga*'s multifaceted and ambivalent representations of Panamanian sovereignty over seventy years. Changes and continuities in the play's staging have rendered the play a collection of intertexts, exposing the shifting discursive terrain of Panamanian theatre, between nationhood and sovereignty.

TROUBLING FOLKLORE: *LA CUCARACHITA MANDINGA*, 1937

La Cucarachita Mandinga debuted on December 6, 1937, at Panama's National Theatre.[3] Elevating folk music and dance to "highbrow" cultural forms, the play engaged capriciously with Renaissance and neoclassical aesthetics and poetics, as well as the nineteenth-century European-influenced genres of comedy and melodrama that continued to fill Latin American theatres. The authors' sly modernist treatment of folklore garnered widespread praise, including from Panama's secretary of education.[4] Reviewers feted Sinán and Brenes, along with the rest of the production team, as "the new generation" of artists, "a . . . revelation of our culture that has awakened [interest] in all sectors of Panama's population and society."[5] Some Panamanian artists in this generation, like Brenes, looked to the rural interior, west of the Canal Zone, for sources of national cultural identity. Poised against a tide of foreign (and nonwhite) influence, the interior's *típico* (traditional) clothing, food, music, and dance marked Panamanianness, linking geography to racialized traits of (non)belonging.[6] The play premiered amid rising Panamanian nationalism, four years after the nationalist group Acción Comunal had staged a coup and taken over Panama's government. Anti-Black xenophobia was pervasive: elite politicians, artists, and intellectuals feared the effects of cultural and racial mixing and blamed foreigners, especially Afro-Caribbean labor migrants, for Panama's problems. As Octavio Méndez Pereira, founder of Panama's national university, lamented: "Our status as the bridge of the world has instilled in us . . . the psychology of a transitory people, shallow, unworried, without a sense of traditions, of constancy, or any conception of nationalism."[7]

La Cucarachita Mandinga's folklore reassured elites who mourned their country's "pulverization," and the loss of a sense of national identity from the Panama Canal's waves of globalized trade and immigration, that the nation had a consolidated *ethnos* upon which to draw in crafting a unified identity.[8] Above all, reviewers and audiences lauded Brenes's score, which paid homage to "popular interior song."[9] The score featured *puntos, mejoranas, tamboritos,* and *cumbias,* and copious *música típica* (traditional music), also called *típico* or *pindín*.[10] This

"potpourri of national folklore" derived from Brenes's ethnomusicological field-work at Las Tablas and the Festival of the Mejorana; another source was Narciso Garay's seminal volume of Panamanian folk music, *Tradiciones y cantares* (*Traditions and Songs*).[11] The orchestra's inventory included "traditional" and "national-ized" species of "whistles, accordions, guitars, drums, and maracas"—a mixture of percussive and melodic instruments that showcased Brenes's meticulous research in musical folklore.[12] Praising the score's combination of high art and popular folklore, one reviewer declared that no previous artwork had so success-fully appropriated and popularized "our music."[13] The play's folklorism extended to its plot, a popular fable that many audience members viewed, erroneously, as autochthonous to Panama.[14]

The play's narrative follows thusly: while sweeping her rural cottage, Cock-roach finds a coin, with which she buys ribbons to go courting. Her accessories attract animal suitors, who compete to win her hand and carry off her riches with overtures ranging from flirtation to coercion. The Cockroach spurns each suitor because of his frighteningly "loud noises at night," an allusion to snoring and an erotic innuendo.[15] Finally, she agrees to marry Ratón Pérez (hereafter, "Mouse"), who falls into a pot of soup and drowns. When he revives, en route to his funeral, tragedy yields to a happy conclusion in the wedding of Cockroach and Mouse. Ostensibly a congenial staging of a folk tale, *La Cucarachita Mand-inga* in fact includes a critique of the nationalist impulses undergirding ruralism and folklorism. Rather than idealizing the "folk," the script toys with folklore's relationship to Panama's fissured national boundaries and colonial history. At its outset, for example, the play represents the interior as both charming scen-ery and a space from which Cockroach must escape. Opening with Cockroach weeping disconsolately and lamenting her poverty in the song "Sweep, Broom, Sweep," the mournful soundscape contrasts with bucolic scenery to evoke the irony of the interior as a site elevated by folklorists but suffering from stagna-tion and economic depression. Though a chorus of neighbors urges Cockroach to move away, she demurs: the interior offers no room for movement, and her only hope rests with a wealthy suitor. The song's lyrics emphasize the plight of the isolated residents of the interior, portraying rural Panama not as a stable and self-contained region but as alienated from the Canal's resources and promise of economic mobility.[16] Reviewer Federico Tuñon applauded the play's adornment of a well-known "great-grandfather's tale" with modernist touches like "[a] cho-rus of crickets, radios, loudspeakers, siren whistles, and automobiles," which lent the "little rural story an urban tone."[17] In the play, the urban metropole cannot stay out of the interior: cosmopolitan influences persistently permeate the rural mise-en-scène, through musical modernism and allusions to racial mixture and migration.[18]

Both Brenes and Sinán were interested in this interpenetration of urban, cos-mopolitan modernity with folkloric tropes, but each artist approached the task of destabilizing folklore differently. Examining the production's components

elucidates each collaborator's distinct aesthetic and political investments. Brenes's synthetic score interwove European music, like Wagnerian leitmotifs (evidencing his musical training in Germany), with Panamanian folk music and dance.[19] The score formed an early phase of his lifelong project to create "musical nationalism." And Sinán's script revealed rural life to be more mixed and mobile than pristine and idyllic. After their collaboration for *La Cucarachita Mandinga*, Sinán and Brenes became pivotal figures in Panama's cultural landscape while taking divergent paths. While Brenes, an ethnomusicologist and composer, ultimately returned to his natal province of Chiriquí, Sinán achieved distinction as a cultural administrator in Panama City and earned the title of "Panama's literary father." In his poetry, drama, and short fiction, Sinán explored surrealist techniques and racial and sexual themes.[20] Sinán was also interested in comparative intercultural mythopoetics, serving as Panama's consul in India in 1938.[21]

While Brenes's score engaged Panamanians' folkloric yearnings, Sinán's script undercut representations of nationhood. In playful counterpoint to the score's musical folklorism, the script depicted a turbulent interior, disrupted by the bombardments of military conflict—an allusion to the First World War. The narrator, a public address system, alerted insect villagers to don gas masks and take cover during airstrikes.[22] The mise-en-scène was also interpenetrated by surrealist and futurist imagery, conveying Sinán's avant-garde stylistic influences.[23] Populating the interior were characters who transgressed the boundaries of animal, human, cartoon, and allegory. Contrasting with the interior's humble insects (mosquitoes, crickets, and Cockroach), the animal suitors were explicitly modeled after Disney characters. These cartoonish suitors entertained audiences while pointing up the cultural hegemony of Disney and Hollywood in Panama.[24] "Blue-blooded" Tío Toro (Uncle Bull), a bullfighter, represented Spain.[25] Tío Sapo (Uncle Toad) drowned himself in a swamp, evoking the disastrous French canal project. Described as "black" and British, Tío Caballo (Uncle Horse) referred in less than pleasant terms to West Indian labor migrants. Tío Pato (Uncle Duck), a drunken sailor, alluded both to Donald Duck and to the US military personnel who crossed from the Canal Zone into Panama nightly for pleasure and debauchery. Ratón Pérez (Mouse), who shared initials with the Republic of Panama, was a glamorous and appetitive "relative of Mickey Mouse," a burlesqued Don Juan Tenorio.[26] Clad in the *típico* costume of a Panamanian peasant, Mouse entered the rural scene from New York in an airplane, a mechanical symbol of modernity. Mouse's aerial entrance signified the intrusion of urban cosmopolitanism into the rural interior—yet his peasant clothing revealed his intermediate status, between urban modernity and rural purity. Audiences most enjoyed the satire of Tío Puerco (Uncle Pig), who drove onstage "from Chicago" in a Ford Model T. Stuttering in Spanglish, the fat Uncle Pig symbolized the "ugly American" and "the perfect bourgeois who, emitting the airs of a great

man, is convinced of his unmitigated triumph in love."[27] Uncle Pig's noxious behavior was amplified by his "luxurious plaid pants" and "a giant flower in his buttonhole, a frock coat and shining watch chain, a fine cane, and. . . . a large belly distended with pride."[28] This corporeally excessive and vocally grotesque portrayal satisfied spectators' desires for satirical representations of Zonians, US citizens inhabiting the Canal Zone.

While the suitors mimicked Disney cartoons, Sinán adapted Cockroach partly from Kafka, a nod to his interest in experimental and antirealist literature. Sinán's Cockroach was also unmistakably African. Inventing the character's gene-alogy in an essay accompanying the script, Sinán traced Cockroach's origins to the "Mandinga/Mandinka people of the Upper Senegal and Upper Niger . . . the Banmaras, the Malinkés, and the Soninkés."[29] His revisionist history diasporized the nationality of the fable, charting its journey to Panama, Cuba, Puerto Rico, Costa Rica, and other Caribbean sites through the storytelling practices of female African slaves.[30] Transcriptions of oral narratives by Costa Rican social-ist feminist Carmen Lyra ostensibly formed the immediate source for Sinán's Mandinga Cockroach.[31] Lyra situated her rendition of the Cockroach story in the Afro-Costa Rican littoral, adding *negras* (Black women) and coastal accents. By contrast, Sinán set his play in Panama's interior, a site symbolically central to the nation, and thus added to the fable's reputation as a "national" story. Yet while relocating his narrative to the interior, Sinán did not change the Cock-roach's name to Martina or Doña Baratinha, as in other iterations of the fable. He purposefully retained "Mandinga" and explored the term's connotations across Latin America. Sinán's etymological research revealed both representational and abstract connotations beyond the signification of African heritage.[32]

Along with Cuban ethnologist Fernando Ortiz and Venezuelan scholar Ángel Rosenblat, Sinán noted seemingly incommensurate qualities of "mandinga," ranging from intelligence, beauty, decadence, and artisanship to grotesque and evil traits.[33] In Cuba, *Mandinga* meant clumsy, demons, bad spirits, and the devil; in Costa Rica, an effeminate male; a "rebel" in Venezuela; and enchantment and witchcraft in Argentina. Rosenblat states that to "have [a] *mandinga* in your body" meant that you were bewitched (in Brazil) or untrustworthy (Río de la Plata); parents throughout Latin America scolded misbehaving children that "the *mandinga* [devil] will take you away!"[34] Sinán's characterization of Cock-roach also drew upon links between *mandinga* and the figure of the *cimarrón*, a resistant or revolutionary fugitive slave. In Cuban novelist Alejo Carpentier's account: "Every *mandinga* . . . concealed a potential *cimarrón* [maroon, or fugi-tive slave]. To say 'mandinga' was to say disobedient, rebellious, devil. That's why [they] fetched such low prices in the slave markets. They all dreamed of fleeing to the hills."[35] A frequently occurring literary and cultural trope, the *cimarrón* is both emblem of and historical participant in antislavery resistance.[36] Imbued

with the *cimarrón's* defiance, Sinán's Cockroach inspired both admiration and trepidation, leading one Panamanian theatre reviewer to characterize her thusly: "The Cucarachita, gracious and coquettish . . . Mandinga and devil . . . a diabolical woman."[37]

These diverse connotations of *mandinga* critiqued racialized tensions within Panamanian mestizo (mixed-race) nationalism. As Jill Lane notes, "mestizaje (racial mixing) throughout the Americas provided grounds for emergent American nations to articulate their difference from Europe, while gaining control . . . over the relation between race and national belonging."[38] Mestizo nationalism and racial democracy shaped a new Latin American citizen body, supplanting European-influenced theories that placed racial categories in a fixed hierarchy, with whiteness at the top.[39] In Panama as elsewhere, theories of mestizo nationalism and racial democracy framed *mestizaje* as a means of creating strong, racially hybrid citizens.[40] Advocates of racial democracy also claimed that their societies lacked racial divisions because of *mestizaje's* hybridizing effect.[41] Yet despite its semblance of inclusivity, *mestizaje* in fact upheld whitening, considered desirable for nation-building.[42] Many scholars who championed the mestizo citizen as "the apotheosis of human development" also believed in "genetically inherited characteristics . . . inconsistent with a nonracist approach."[43] In Panama, governing elites deployed *mestizaje* and racial democracy in service of nationalism, portraying mixed-race citizens as assimilable into the national populace.[44] A sense that Panama lacked autochthonous racism also distinguished Panamanian nationhood from the cultural and social influence of the United States. Claiming Panama as a racial democracy free of racism, Panamanians disparaged the Canal Zone's Jim Crow segregation and US-imported "color line." Yet *mestizaje* masked elites' desires to dilute the citizenry's blackness, as literature scholar Sonja Watson asserts. In Panama the specification of racial blackness (as opposed to brown- or mixed-ness) often implied foreignness, as in Panama's large West Indian–descended population.[45]

Clashing with the *mestizaje's* assimilationist inclination, Sinán's characterization of Cockroach showed her African roots to be undeniably present and her blackness indissoluble. Cockroach's Mandinka heritage oriented her toward Africa—a characterization at odds with mestizo nationalism and out of place in Panama's interior. Given that Sinán was considered "white" in Panama, his characterization of the Mandinga Cockroach suggests links with Panama's "negristic" literary movement, then at its height.[46] In poetry and prose, Panamanian *negrista* writers like Víctor Franceschi and Demetrio Korsi depicted Black bodies with simplistic and pejorative stereotypes—the sensual, voluptuous *zamba* (Afro-indigenous woman), for instance. *Negrista* writers also employed Black characters as thinly veiled critiques of US imperialism, blaming the US-sponsored Canal project for flooding Panama with West Indian labor migrants

and for indoctrinating Panamanians with foreign racial prejudices. While this context forms an important reference and infused Sinán's other writings, *La Cucarachita Mandinga* does not align with all aspects of *negrismo*. Sinán's literature offers plentiful *negrista* depictions of Black characters as simplistic, sensual, and brutish, but *La Cucarachita Mandinga* represents the African Cockroach in a more positive light. The play's nonconformity to *negrismo* is partly due to its collaborative production: supplementing Sinán's script and Brenes's score, many other artists actively resignified Cockroach's character, adding their interpretations to the piece, as I demonstrate below. In its textual and performance iterations, *La Cucarachita Mandinga* depicts Cockroach as a dignified heroine and national symbol, roles that far outstrip the simplistic caricatures of *negrista* literature. Indeed, as archival evidence demonstrates, Cockroach's malleable character stretched the bounds of *negrismo* and challenged mestizo nationalism, as production teams explored various implications of her racialized, gendered, and sexual critiques of imperialism. Further, her extra-human qualities offered an escape from racial debates: her fantastical insecthood both freed her from human bodily constraints and liberated production teams from the need to give her character humanlike features. Cockroach's multiple irreconcilable subject positions would repeatedly (and playfully) elide the grasp of racialization even while at times seeming to reinforce a visual racial hierarchy.

In productions after 1937, Cockroach's nationalist symbolism became paramount in her staging, and as a result she was often given human features. Production teams wishing to strengthen audience allegiance to national sovereignty confronted a challenge: how to align Cockroach's Africanness with Panamanian nationalism? In this challenge lies one of the play's sources of power: its protagonist's incongruous racialization. Not an African migrant, she is autochthonous to the interior, a citizen of the New World, as indicated by her deep familiarity with traditional folk customs. Sinán labeled her "Afro-indigenous"—yet an Afro-indigenous symbol of Panamanian nationhood proved too controversial for many mainstream production teams. Another response to the racial-national query was to label Cockroach a *mulata*, a mixed-race woman of Black and white ancestry.[47] While the 1937 script implies that her character is a *mulata*, the revised 1976 script explicitly racializes her as a *mulata*. A *mulata* Cockroach may seem like a concession to mestizo nationalism, but in fact this racial status holds revolutionary potential, as Sinán recognized when overtly calling Cockroach a *mulata* in his revised script. A *mulata* Cockroach "disrupts the ordered, masculine political and national body based on a paradigm of *mestizaje* that attempts to naturalize a stable, harmonious image of the nation in its racial relations."[48]

Although nations are often gendered female, rarely do they self-represent as *mulatas*.[49] The *mulata*, produced and visibly marked by interracial sex, is a destabilizing force, "a precarious and tenuous multiplicity [and] the site of troubling

sexual and racial difference."[50] Although she appears frequently in Latin American and Caribbean popular culture, the *mulata* has "'no place' in the society that employs her as a symbol."[51] A disordered figure, the *mulata* Cockroach embodied Panamanians' feelings of being out of place in their country. This out-of-place sensation stemmed from Panamanians' material and symbolic displacement from the Canal Zone—itself a displacement of matter, in the terrain that the US government excised from Panama's mountains to carve the waterway. The Cockroach's characterization as a *mulata* enacts dual alterity: she is both a marginalized figure within Panama and a metonym for the country as refracted through the suitors' Western gaze. Frances Aparicio contends that such *mulata* symbolism "is ... deployed interculturally to ethnify and feminize Third World cultures. Within the boundaries of the nation, the female is constituted as Other; in ... transnational cultural transactions the (Caribbean or Latin American) nation itself becomes feminized by an imperial, colonizing gaze."[52] Representing Panama's objectification by Westerners for Panamanian audiences, the play satirizes practices of othering and demonstrates these audiences' awareness of their nation's demeaning representation as a subjugated woman of color. The play also inverts the trope of the sensual, promiscuous, and sexually available *mulata* by having its protagonist repel her white male aggressors. *La Cucarachita Mandinga* therefore converts a seemingly abject Cockroach into a strong and forceful protagonist. This shift echoes Mary Russo's recuperation of the female grotesque as a resistant, insurgent body. Multiply abjected as a *mandinga/mulata* female/insect, the Cockroach inhabits a Bakhtinian "grotesque body"—hypersexualized, queer, "freak," and "stunted."[53] Russo and Alicia Arrizón reclaim the grotesque body, however, as a site of revolt against patriarchal Euro–North American epistemological and colonial violence.[54] Through her display of "disordered" traits—sexual excess, racial mixture, and social marginalization—the grotesque female transforms abjection into potentially radical transgression. Asserting herself as a grotesque female insect, Cockroach challenges would-be rapists and colonizers.

The question remains: how did Cockroach's character translate to the stage? A lack of early production and reception information precludes firm answers. Apart from Sinán's essay, no critical commentary addressed the racial aspects of the 1937 performance. Performance reviews of *La Cucarachita Mandinga* omit information about Cockroach's characterization: these reviews, vocal about nearly every other element of the performance, are silent on racial matters. Their silence speaks of an elision of the conversation that Sinán sought to catalyze. The paucity of the production's photographic record compounds the difficulty of determining Cockroach's racial performance in 1937. Actress Ana Elida Díaz, who played the role of Cockroach, may well be embodying the persona of a mixed-race female; little evidence exists in the play's many reviews to suggest that Cockroach's African roots were represented in a purposeful or meaningful way onstage.[55]

While it is difficult to know how the racialized traits of the Cockroach presented themselves onstage (if they did at all) in 1937, it is clear that elite audiences' racial anxieties surrounded the production. An anecdote illuminates these tensions: when National Institute director Octavio Méndez Pereira first heard drums resounding in the halls of the Institute during Sinán and Brenes's rehearsals of the play, he recoiled with "discomfort and non-acceptance."[56] Implicit in the reaction was Pereira's fear of the corrupting influence of the Africanized drums, and their presence in the National Theatre. Given this context, Sinán's script and Brenes's score arguably sought to provoke questions about race mixture in the representation of Panama's "folk"; Cockroach's African surname called attention to the rootedness, even indigeneity, of blackness in the nation-state. Likewise, interracial sex—correlated in the script with interspecies reproduction—materializes as a representational possibility in performance, potentially increasing audiences' anxieties.

The play centers on a marriage plot to lift Cockroach out of poverty, and both Cockroach and Mouse are—in contrast to the fully masked suitors—anthropomorphized, showing only the merest hint of animal features. In hazy production photographs, Cockroach appears onstage as a human, with only the slightest hint of "Cockroach"—feelers—embellishing her costume. The characterization of Mouse, "the only suitor without a mask," suggested a male Panamanian peasant rather than an animal.[57] Similarly humanlike portrayals of Cockroach and Mouse appear in subsequent stagings, even as the other animal suitors become more fantastical and exaggerated, their faces and bodies obscured beneath masks. The anthropomorphized representations of Cockroach and Mouse give an allegorical cast to their union, implying that their reproduction will spawn Panama's citizenry. The choice to anthropomorphize the pair while animalizing the rest of the cast created a disjunction between the play's supposed fantasy world and the material, social, and racial implications of Cockroach and Mouse's pairing.

While possibly overlooking the multiple meanings of "mandinga," audiences were thrilled by the production, which elicited laughter and adulation. This laughter was not, I suggest, wholly comfortable; rather, laughter can be the cause (and result) of crossing a boundary or confronting a source of unease. Productions' ostensible characterization of Cockroach as a Panamanian woman of African origin pushed audiences to consider the centrality of African diasporic migration to the (re)production of Panama's citizenry. By making an African-descended Cockroach a symbol of Panama, and situating this character in the interior—the primary site of national identity formation—Sinán implied that Panamanians, even supposedly racially "pure" residents of the interior, might possess African ancestry. As such, La Cucarachita Mandinga challenged dominant representations of Panama's "folk" and unsettled Panamanian nationalism. In the following sections, I trace stagings of the play after 1937, as subsequent production teams grappled with these folkloric, socioeconomic racial, gendered, and sexual polemics.

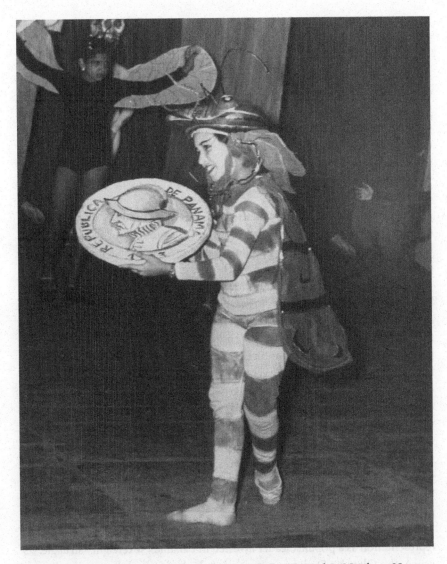

FIGURE 4.1. Josefina Nicoletti as Cockroach in the ballet *Cucarachita Mandinga*, November 1953. Courtesy of Josefina Nicoletti's personal archives.

BECOMING A NATIONAL SYMBOL: *LA CUCARACHITA MANDINGA* ONSTAGE, 1953–1965

La Cucarachita Mandinga's popularization produced two major remountings, in 1953 and 1965. These large-scale productions reimagined the play's script, score, and staging on a mass scale. Panamanian presidents José Antonio Remón Cantera (1952–1955) and Marco A. Robles (1964–1968) sponsored the play to criticize the

United States without harming diplomatic ties. With official diplomacy between the United States and Panama restricted to "delicate, respectful" exchanges—an affect out of sync with strengthening Panamanian protests against the Zone— Panamanian presidents supported the play as an artistic expression of sentiments unsayable in diplomatic terms.[58] The massive productions drew audiences in the thousands, making the play a propaganda tool inflected by contemporaneous political and social developments. Later administrative bodies—including the dictatorship of General Omar Torrijos Herrera (1976) and the Panama Canal Authority (2006)—would follow Remón's and Robles's leads, using the play to galvanize Panamanian audiences to specific objectives. While raising *La Cucarachita Mandinga*'s profile—making it into a canonical work of Panamanian literature and performance—each production enacted dramaturgical modifications to address the play's anticolonial nationalist argument and racialized, gendered, classed, and sexual tropes. The 1953 and 1965 productions formed influential bridges from the play's debut to its uptake by Panamanian leaders in 1976 and 2006.

President Remón's 1953 production employed professional artists and highbrow aesthetics to repudiate stereotypical representations of Panama as an opéra bouffe nation. The production team adapted the play into a ballet featuring stylized imagery and formal choreography, yielding a vastly different performance from the 1937 production. The only thing childlike about the ballet was its young performers; every other aspect was designed, arranged, and choreographed by Panama's leading artists.[59] Fusing populist and elite forms, the play featured a large ensemble from Panama's National School of Dance, with a score arranged for the National Symphony. A young Josefina Nicoletti, who would go on to be one of Panama's foremost ballet instructors, played Cockroach.[60] As captured in production photographs (Figures 4.1 and 4.2), the reimagined costumes portrayed abstract animal forms and indigenous ritual headdresses and half-masks, imbuing the production with a modernist, primitivist sensibility.[61]

Consciously elitist, the ballet nevertheless aligned with Remón's selfrepresentation as a populist leader invested in Panama's sovereignty struggle. Its venue, the Olympic Stadium, countered its high art sensibility, and audiences numbered 10,000 over seven nights.[62] After a stint in Panama City, the production toured to the interior.[63] The intranational tour resonated with the Remón administration's stated interest in incorporating all Panamanian provinces, including the rural interior, into the national polity and economy.[64] Further, the ballet lent nationalist pride to Remón's quest for treaty reform. Adopting the slogan "neither millions nor alms: we want justice," Remón entered treaty talks with US President Dwight D. Eisenhower soon after taking office.[65] This slogan prioritized sovereignty over financial reparations; the ballet affirmed a sense that Panamanian national patrimony was "not for sale." Yet while *La Cucarachita*

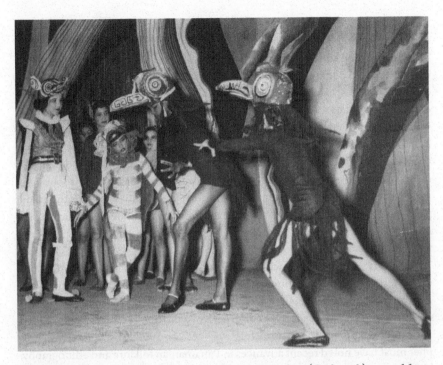

FIGURE 4.2. Unidentified dancers surround Josefina Nicoletti (Cockroach), second from left in front, in the November 1953 ballet *Cucarachita Mandinga*. Courtesy of Josefina Nicoletti Personal Archives.

Mandinga helped to rally Panamanians behind Remón, the resulting treaty failed to make gains for Panama in the struggle for sovereignty in the Canal Zone.

The next major staging of *La Cucarachita Mandinga* occurred as nationalism and anti-US sentiment exploded into geopolitical conflict in the mid-1960s. The heavily advertised production took place almost two years after the so-called "riots" of early January 1964, which fissured the Canal Zone with clashes between US and Panamanian citizens and resulted in roughly two dozen deaths.[66] The play, dedicated to the Robles administration's favorite charity, opened in October 1965, attracting massive audiences and stimulating popular support for renewed treaty revisions with US president Lyndon B. Johnson.[67] Robles's production stimulated nostalgia for the 1937 play and its folklorism by returning Sinán and Brenes to the production team as director and chorus master, respectively. While highlighting the play's use of folklore to affirm a coherent national identity, the 1965 production sought to distinguish itself from the premiere through a more rigorous focus on the study of folklore in Panama.

Like the 1953 ballet, the 1965 production interwove aesthetics and politics. At the time, Sinán, cultural administrator and professor at the University of

Panama, presided over the university's boom in nationalist artistic production and was a central figure in Panama's state-sponsored artistic establishment. In addition to Sinán and Brenes, many other members of the production team were state-appointed cultural administrators: choreographer Blanca Korsi de Ripoll directed Panama's National Dance School.[68] The resulting massive, costly production took place at the Colegio Javier auditorium, Panama's most capacious venue. In addition to its ensemble of more than one hundred children, the cast included artists from the National Dance School and a twenty-five-member orchestra from the National Music School, supplemented by a large children's choir.[69] After thirty performances for general audiences and public schools, the play toured to Colón and the interior through 1966.[70] Over twenty thousand people allegedly attended the performances.[71] Critics lauded *La Cucarachita Mandinga* as "a genuinely Panamanian theatre," and the play gained a national visibility unparalleled in prior stagings.[72]

As in 1937, the 1965 production foregrounded folklore in music, dance, and costumes.[73] Yet the production team differed on how to represent Cockroach's African roots. While Sinán forcefully proclaimed Cockroach to be "Afro-indigenous" (*afro-indígena*) in an editorial, Korsi de Ripoll's choreography elided African elements of Panamanian folklore.[74] An avid folklorist, the choreographer must have noted recent advances in Panamanian folklore and ethnography, but her essay accompanying the production, an otherwise exhaustive chronicle of folkloric food, clothing, dance, and musical customs, omitted discussion of African heritage in Panama.[75] In particular, Korsi de Ripoll gave only brief mention to a recent text, *Drum and Guitar* (*Tambor y socavón*), which was transforming Panamanian folklore studies by focusing on the African origins of popular music and dance. Modeled on Cuban ethnologist Fernando Ortiz's renowned *Cuban Counterpoint: Tobacco and Sugar* (*Contrapunteo cubano del tabaco y el azúcar*), *Drum and Guitar* traced Panamanian folklore's "transculturation," whereby Africanized folk practices were "whitened" and taken up as canonical national forms.[76] The book's authors, folklorists Manuel and Dora Zárate, documented the contributions of African-descended populations to Panama's folk dance and music. Unlike previous folklorists, the Zárates praised the drum (*tambor*) as intrinsic to Panamanian culture. The book's title contrasted the drum with the *socavón*, a four-stringed guitar exemplifying Spanish (and thus Europeanized and "white") influences.[77] The Zárates separated their text into two parts, comprising dances based on the drum (*tamborito, cumbia, bullerengue,* and *bunde*) and the *socavón* (*punto, mejorana*), respectively. Drawing on research by West Indian Panamanian scholar Armando Fortune, the Zárates contended that the emancipation of the slaves had also "liberated the drum" to achieve its rightful place in Panama's national folkloric canon.[78] The drums, "the patrimony of all Panamanians," "prov[ed] the effectiveness of transculturation[:] no other

country on the continent, of predominant peninsular stock, possesses a black-originated dance, with predominantly black characteristics, as its national folk dance."[79]

As the above quote demonstrates, while validating the contributions of African forms and instruments *Tambor y socavón* also reiterated problematic dualisms between African and "whitened" folklore.[80] The Zárates celebrated drums as fundamental to Panama's folklore but created a racialized and geographically specific hierarchy of folk dance and song, locating the most refined and civilized forms in the "whitened" interior, specifically in the town of Los Santos.[81] If Panamanian folk dance showed "different stages of transculturation" depending on one's geographic location, then the whitest forms were found in Los Santos.[82] The "blackest" dances, by contrast, hailed from the Darién and the northern coast. In urban areas, these forms mixed to make "brown" dances and songs. Notwithstanding these limitations, *Tambor y socavón* advanced connections between Africanness and folklore, and the 1965 staging of *La Cucarachita Mandinga* followed suit, acknowledging Cockroach's African heritage in reviews. Yet the production seemed more interested in the contemporary political context than the racial complexities of Cockroach. One reviewer proclaimed: "*Despite* the fact that Sinán ... has demonstrated the African origins of the 'Cucarachita Mandinga' ... [he] has rooted his farce in the most profound Isthmian soil, nourishing it with our wisdom and ... the highest symbols of our history."[83] Critics quarantined "our [Panamanian] history" from African origins: first and foremost, the play represented "the many surprising peaks of our Republic, motivated by the flux and reflux of the Interoceanic Route" and Panama's assault by "the ambitions of this or that imperialism."[84] Other than the costume designer's choice to anthropomorphize Cockroach and Mouse and exaggerate the suitors, the archival record provides little indication of the racialized coordinates of the performance given by high school student Luz Graciela Krauss, who played Cockroach.

The 1965 production's use of folklore was tightly sutured to Panamanian national identity. Choreographer Blanca Korsi de Ripoll called attention to the need for more rigorous folklore studies in Panama's institutions of higher education.[85] Yet, partly due to the paucity of archival resources, it is unclear whether the Zárates' book, published in 1962, influenced the production. While the Zárates and Sinán asserted the centrality of African descendants to Panamanian folk culture, the production team seemed at best uncertain as to how this research might translate into performance. The Zárates' research took hold in later productions, manifesting in radically divergent ways in 1976 and 2006. While the 1976 production upturned nearly every element of the play, reorienting the production's focus toward disco and Broadway musical theatre aesthetics, its successor in 2006 made concerted efforts to apply the Zárates' ethnographic and musicological research to the score and choreography, as I examine below.

MANDINGA NATION: *LA CUCARACHITA MANDINGA* IN 1976

Grandiose though the 1953 and 1965 productions were, they paled in comparison to the scope of *La Cucarachita Mandinga*'s spectacular remounting in 1976. The 1976 production's splendor was largely due to its sponsorship by General Omar Torrijos Herrera, who came to power in a 1968 military coup.[86] Part of Torrijos's overhaul of Panamanian artistic, cultural, and educational institutions, *La Cucarachita Mandinga* rallied audiences to the dictatorship's social and economic projects. Specifically, the production sought to galvanize favorable votes in a national referendum, held in 1977, to authorize the Panama Canal's handover to Panamanian sovereignty.[87] The 1976 production encapsulated the precarious state of US-Panama relations, suspended between the hope of a decolonial future and the threat of continued conflict between Panama and the United States.

The play's opening on June 25, 1976 was timed to coincide with the end of the Sesquicentennial Anniversary Congress of the Bolivarian Nations, which gathered representatives from Peru, Venezuela, Ecuador, Bolivia, and Colombia in Panama to commemorate the 1826 Bolivarian Congress and strengthen regional solidarity against US imperialism.[88] The 1976 production ran for twenty performances in the Javier auditorium and National Stadium before touring to public schools and the interior. Its sponsors—the University of Panama, National Bank, and National Lottery—contributed approximately $70,000 to "the cultural event of the year," one of the most lavish theatrical productions in Panama's history.[89] Employing Panama's top performing and visual artists, the 1976 production emulated Broadway-style musical theatre, forgoing the folkloric considerations that had characterized its predecessor.[90] Composer Toby Muñoz updated Brenes's score, quickening the songs' tempos, replacing drums with synthesizers, and adding an irreverent disco ball to match new choreography that commingled folk dance with ballet, pantomime, and disco struts. In keeping with past costuming choices, the suitors' faces were obscured by masks, with the exception of Mouse, who was semi-anthropomorphized along with Cockroach. (The 1976 production's Mouse and Cockroach are shown in Figure 4.3.)

Journalists documented the production's festive, carnivalesque air; witnesses reported that the expansive venue was packed with spectators and vendors.[91] Director Miguel Moreno and producer Aurea "Baby" Torrijos—General Torrijos's sister and an arts educator—confected a discotheque mise-en-scène.[92] Moreno, a longtime theatre practitioner and founder of the Teatro Estudiantil Panameño (TEP), was the third director to join the project; Baby Torrijos's first choice, Bruce Quinn, met with public outcry due to Quinn's status as a "Pana-Zonian" or "Panagringo."[93] Nationalist critics felt that Quinn's hybrid identity—his Panamanian mother and "Zonian" (US citizen) father—made him insufficiently Panamanian to helm the performance. Ejected from the 1976

FIGURE 4.3. Dabaiba Conté (Cockroach) and unidentified actor as Mouse (1976).
Source: Panamá América, June 27, 1976.

production, Quinn would direct its 2006 successor, drawing upon his ostracism from the 1976 production to shape the 2006 production's message of inclusivity. Quinn's replacement by Moreno confirmed *La Cucarachita Mandinga*'s importance to Torrijos's cultural mandate. To a greater degree than any other Panamanian leader, Torrijos supported and funded artistic and cultural production.[94] He established the University of Panama's Department of Artistic Expressions (DEXA) and the National Institute of Culture (INAC), which promoted Panamanian literature, theatre, visual arts, music, and dance.[95] As director of DEXA, Baby Torrijos was an instrumental figure in Panama's fine arts boom from 1968 to 1981.[96] She focused on theatre and performance, seeking to increase popular appreciation for the arts, diversify Panama's art scene racially and socioeconomically, and incubate a professional artistic community. One of her primary goals was to make the arts less racist and classist. With community outreach groups for adults and children, including the children's acting club Felices Niños Artistas, she shaped a populist, multiracial *La Cucarachita Mandinga*.

Along with its revitalized score and mise-en-scène, the 1976 production featured a dramatically altered script. Sinán clarified the play's "zoomorphic symbolism," revising the script in collaboration with Moreno and Agustín del Rosario.[97] According to Moreno, these revisions intensified Cockroach's plight for audiences.[98] One reviewer, writing for a government-owned newspaper, avowed that the revised script transformed the play into "a morally instructive piece, identified with the socioeconomic and political progress now underway in

Panama."[99] While the 1937 script was a subtle farce, the 1976 revisions made the plot into a didactic parable of Panama's history of exploitation and struggle for full sovereignty and economic independence.[100] The 1976 script hewed closely to the Torrijos dictatorship's rhetoric, which aligned Panama's quest to reclaim the Canal Zone with decolonization of the Global South. The revised script featured militant critiques of the racial, gendered, and sexualized qualities of past and present Western political and economic imperialism. Sparing no one, the script's polemic even included a reconceptualized Uncle Toad, whose character, "the vile Isthmian toad of chicanery and lies . . . a bribe-taking, *sapeando* (snitching)" politician, denounced Panama's corrupt elites.[101]

The 1976 text and production referred to Panama's rural/urban divide, but without folkloric niceties: instead, they revealed the interior as an impoverished place. Aguilar Ponce's scenery segregated "the city and its concrete structures on one side" of the stage, "the country and its simplicity . . . on the other."[102] Rather than prettifying the Cockroach's country cottage, the revised script castigated rural poverty. New stage directions had the play open with a multilevel backdrop of "*casitas brujas*," or auto-constructed shanties: "At the top of the hill, a church. In the first penumbra, multicolored lights give the illusion of an enormous Christmas manger, but when the lights come up we realize that the scene portrays a small, poor farmhouse. It should be an attractive *mise-en-scène* that simultaneously produces the sensation of absolute misery."[103] Before the audience's eyes, the scene shifted, stripping the picturesque tableau to reveal rural immiseration. This opening mise-en-scène evinced a changed attitude toward the interior: more than previous administrations, the Torrijos dictatorship sought to resolve Panama's widening geographic income gap, which concentrated poverty in rural areas. The scene gestured to the dictatorship's goal to redistribute Panama Canal revenues for rural development and infrastructural projects.[104]

The 1976 production emphasized development over the interior's folkloric value; development discourses saturated the new script. For example, when Cockroach finds her coin, one neighbor disparages the coin as worthless. Another rejoins that the coin is made of *cobre colorado*—copper from Panama's Cerro Colorado mine—and is therefore "the symbol of riches that Cockroach ignored and that she now ought to use, exploit, and '*usufructuar*.'"[105] By dramatizing the concept of "usufruct"—the temporary right to use property and resources belonging to another—the play converted dialogue into dialectic, demonstrating in the neighbors' arguments facets of the debate over Panama's self-decolonization that would ideally result in a new, radicalized Cockroach—and audience. Panama and the United States frequently clashed over the use and ownership of the Canal Zone's resources in the twentieth century, as usufruct came to replace sovereignty, and the new script advocated radical autonomy rather than a relation of usufruct. Echoing this decisive stance, a third

neighbor affirmed that Cockroach must use her copper "to govern herself, gain self-knowledge, and liberate herself from foreign oppression."[106]

In referencing Cerro Colorado's copper, the Cockroach's neighbors have invoked one of Torrijos's flagship projects, meant to provide Panama with revenues from nationalized mining. Theories and discourses of development are further voiced and tested as the villagers debate how Cockroach should spend her coin. One criticizes her "egotistical" purchase of ribbons until the play's narrator (now host of "Radio-TV Mandinga") admonishes that ribbons are crucial components of tape recorders, movie cameras, typewriters, and other tools of modernity that "symbolize progress."[107] Continuing the focus on development, Cockroach reemerges in glamorous formal dress in Act Two, as "the scenery revolves" to show that the shanties have become new buildings, "with signs that say: school, factory, hospital, library, high school, theatre, book store, culture, university."[108] By Act Three, the tableau of "progress" is complete: "Dazzling lights illuminate a new world of skyscrapers, chimneys, and long poles hung with many wires conducting electrical power."[109] The scenery once again guides audiences toward the bright future that awaits an autonomous Panama.

While Cockroach's character still symbolizes Panama, she is not the coy and naïve flirt of 1937, but a self-aware, defiant woman of color. Recognizing her entrapment within interlocking systems of oppression, she weds not for love but for financial security. Her search for a mate becomes an overt analogy for Panama's quest for economic stability through the formation of unequal partnerships with Western governments—a mission that the new script shows to be futile. Cockroach is still melancholic at the play's opening, with an intensified sadness born of loneliness and poverty: she is cynical about her prospects and desires revolution. Speaking in forceful manifestos, she lectures her insect neighbors on Panama's history of colonization and internalized subjugation. Early in Act One, for example, she critiques religion, reproaching her neighbors for their blind adherence to Catholicism and disavowing the set's centerpiece, a large colonial church such as one might find in a rural Panamanian town. Cockroach asserts that they cannot passively pray for their lives to improve but must actively work to better themselves: "We . . . must put our things in order, analyze, investigate, attain consciousness of who we are, and what we want to be."[110] The new Cockroach knows no easy escape from the harsh reality of Panama's precarious economic position vis-à-vis its past and present oppressors; the only paths to liberation are economic and political self-sufficiency.

In both text and production, Cockroach's racial depiction also changes. While the 1937 script did not racialize Cockroach beyond her "mandinga" surname, the 1976 script edges closer to asserting Cockroach's racial identity. Characterized as an *"india"* (indigenous woman) by the Bull and a *"mulatita"* (little *mulata*) by the Horse, she obliquely self-identifies as brown-skinned (*morena*).[111] Sinán also reaffirmed the African roots of the tale and its eponym by including parts of his 1937

essay, "Divagaciones," in a preface to the 1976 script entitled "the African origins of the Cucarachita Mandinga."[112] Yet despite increased attention to the Cockroach's Africanness, the production highlighted mestizo nationalism by employing a light-skinned actress in the role of Cockroach.[113] The phenotypic "whiteness" of the 1976 production's lead actress Dabaiba Conté led reviewer Edilia Camargo to remark: "The only thing 'mandinga' about Cockroach is her surname."[114] Camargo further noted: "Cockroach appears paradoxically 'clean,'" void of the "repugnant projections" that Sinán built into the text.[115]

Interviews reveal that Cockroach's casting was motivated by the agendas of the production's underwriters, who stressed that Cockroach must symbolize Panama—as if her metonymic properties would be incompatible with brown skin. Critic Pedro Mérida evoked the desire to separate African roots from Panamanian actualities: "The Cucarachita Mandinga is PANAMA."[116] Given her goal to nurture a racially diverse artistic community, and the dictatorship's interest in racial inclusivity and distributive justice for Black and brown Panamanians, Baby Torrijos recognized the incongruity of a light-skinned Cockroach. She noted that her desire to costume Cockroach "unconventionally" (in African diasporic dress) was also rebuffed, as others in the production team urged her to use a classic *pollera* skirt.[117] Baby Torrijos recounted that she sought to increase diversity by recruiting prominent West Indian Panamanian ethnomusicologist, actor, music professor, and calypsonian Leslie George and his multiracial Chorus of the Americas to join the production.[118] George's chorus received highly positive reviews and furthered the Torrijos dictatorship's alliances with West Indian Panamanian artists.[119] The 1976 production created a visibly multiracial representation—a goal not overtly present in 1937, 1953, or 1965—but the play continued to reinforce the centrality of perceived whiteness to the project of Panamanian mestizo nationalism. Although blackness was not absent from the 1976 production, it was relegated to the peripheries, embodied in the ensemble.

If Cockroach's racial performance remained in line with previous stagings, the violence of her animal suitors was greatly amplified. In both scripts, Cockroach admits that she is "frightened" of the suitors. In 1976, however, her fear is a justified concern about violent and sexually abusive white men. Sinán called the suitors "conquerors" in 1937, making plain the link between sexual and imperial conquest.[120] In the 1976 script, though, the suitors, including Mouse, are far more sinister, opportunistic, and aggressive. They also allegorize specific moments in Panama's history, such as the Spanish conquest of the New World, English piracy, the failed French canal project, and US imperialism during the Panama Canal's construction. Uncle Bull—now an amalgamation of Conquistador and Grand Inquisitor—is a hyperbolic embodiment of cruelty: "The great bull of the Conquest! Voracious adventurer, he comes to enrich himself with the Cucarachita Mandinga's gold. He hails from the Spanish bullfight . . . brutal, savage, and fierce!

His greed will blaze a trail of blood and destruction. Cruel and ambitious, he will trample human lives to make himself rich. . . . We hope that the Cucarachita Mandinga is a good bullfighter and can free herself of his horns."[121] The others are similarly overt symbols of domination. In 1937 Uncle Horse was a jockey; in 1976 he represents English pirates Francis Drake and Henry Morgan, who sacked the town of Portobelo in the sixteenth and seventeenth centuries.[122] Rather than prancing shyly as in 1937, Horse steals Cockroach's gold earrings while teasing out a tale of her journey to the Portobelo Fair, with new dialogue that alludes to English piracy.

Diplomatic and military facets of US imperialism find their embodiments in the Pig and Duck. The 1976 script preserves 1937's comical Uncle Pig, "the Little Pig with the Big Pirouette," who "throws his weight" around the Western Hemisphere.[123] Whereas in 1937 Pig was a fat, stuttering businessman in a loud suit, in 1976 he is a mélange of cowboy and Teddy Roosevelt, an emblem of the 1903 Hay-Bunau-Varilla treaty, stuttering Roosevelt's famous line, "I took Panama." Members of the Mosquito clan ask Pig about the "big stick" that he brandishes—another reference to Roosevelt—and he responds with a threatening sexual innuendo: "When visiting women, never forget your big stick."[124] Alluding further to the 1903 treaty, Pig asks Cockroach if she will marry him "in per-per-per-perpetuity," as he squeals and showers her with dollar bills. She asserts: "You stutter like a machine gun, and I hope that you won't use one."[125] As he is chased offstage, the mosquitoes slyly change the date on his 1913 Ford to read, in English, "Remember 1903."[126] Uncle Duck, Pig's counterpart, is an inebriated US Marine, "who invade[s] . . . the Caribbean frequently." When Duck feigns firing a machine gun at the female characters, they scatter, voicing fears of rape, and Cockroach asks him archly, "How are you going to *invade* us at night?"[127]

The suitors' violence threatens to make Cockroach a sexually and racially malleable placeholder—the object of layered oppressions spanning centuries. Yet in fighting them off she asserts a specific racial identity: that of a "brown" (*morena*) woman. Rather than asking each suitor the same question, as in the 1937 script, she tailors her refusals to each contender's desires. Confronting Bull, she inquires how he will "behave in the Conquest," invoking the duality of that term. Her rebuff of Horse speaks to her seizure of control: "I don't like discriminators who underestimate the brown races. I believe that you are one of these. What interests you is my fortune. What attracts you is the shine of silver and gold. You disdain me but seek to enrich yourself at my coast. Show me that you will be impartial. I want to know if, instead of whinnying with greed, you will be a noble lover. How will you act at night?"[128] As Cockroach takes back her character from the suitors, so Panama reappropriates its national identity. The script replaces generality with specificity, countering the suitors' savagery with sharpened vengeance. Whereas in 1937 all suitors were yanked offstage with a giant vaudevillian hook, now each is dispatched with historical specificity. The Spanish Bull is chased off by a *militar bolivariano* (a

soldier in Simón Bolívar's army and a nod to the Bolivarian Congress attending the 1976 production); the drunken Duck falls to a Panamanian National Guard; and a *negro mandingo* (male Mandinka) shoots a cannon at the English pirate Horse.[129]

While in 1937 the play's polemics were offset by a fairytale marriage plot, in 1976 even Mouse is a colonizer. Marriage becomes a false path that will not resolve Cockroach's or Panama's problems. In 1937, Cockroach fell in love with Mouse, and the chorus accompanied her courtship with the refrain, "it's time for love." But the 1976 script omits mention of romance. Formerly a genteel figure, Mouse is now lascivious, making no attempt to conceal his sexual advances toward Cockroach's neighbor on the eve of his wedding.[130] Whereas Mouse's sweet tooth landed him in the soup in 1937, in 1976 his Don Juanism upsets his union with Cockroach. Mouse's fraudulence exposes the marriage plot as wrongheaded. As a reviewer demanded, following the marriage allegory: "Cockroach desires to 'liberate herself,' but . . . with whom are we going to get engaged? And how can we marry, is that really a solution?"[131] Furthering the argument that Panama must seek a different path to economic and political liberation, the play concludes with the narrator soberly exhorting the audience that "We cannot forget to work, / Only that way will we achieve progress, / And progress will liberate us. / With true riches and culture, we will continue growing. / Let's go now, peace be with you . . . this story, *señores*, has come to an end."[132] This lyrical incantation suggests that Panama's future demands a rethinking of the parable, pushing the limits of the farce as Cockroach finds the strength to reject parasitical opportunists who exploit her with amorous guises. The wildly popular 1976 production confirmed *La Cucarachita Mandinga* as a fixture of officially sanctioned nationalist cultural production in Panama. The production raised awareness of the nation's colonial history, despite mixed critical reception, and its performances bolstered the regime's reputation and political platforms.[133]

Theatrical populism supported Torrijos's larger project of elevating Panama's sovereignty struggle to the world stage, which he accomplished through masterful displays of social dramaturgy. In a "pilgrimage" to meet with world leaders, Torrijos "search[ed] for a stage [*escenario*] and auditorium [*auditorio*] on a global scale for his truth, that of his Homeland" to raise awareness of the sovereignty crisis.[134] Similar concerns motivated Torrijos's sponsorship of the United Nations Security Council in Panama (March 15–21, 1973), to draw international and UN attention to Panama's sovereignty struggle.[135] Taking diplomats on a tour of the isthmus, Torrijos pointed out contrasts between Panama and the Canal Zone— development and infrastructural gaps that encapsulated cross-border disparities. Torrijos's iconic assertion, "I don't want to enter 'History'—I want to enter the Canal Zone," did similar work, telescoping rhetorical abstractions of sovereignty into physical terrain to affirm the political value of geographic place.[136] His desire to "enter the Canal Zone" evoked historiographic "entries" as secondary effects to

material access to the Zone. The conversion of the Panama/Canal Zone border into an anticolonial spectacle also situated Panama's sovereignty crisis within Latin American critiques of US military and economic incursions in the region. Interconnecting material and symbolic spaces, *La Cucarachita Mandinga* contributed to a dramaturgical understanding of Panama's grievances, aligned to global debates over "Third World" dependency, development, and decolonization. Torrijos's dramaturgical manipulations spoke deeply to both Panamanian audiences and international observers. *La Cucarachita Mandinga* helped to rally Panamanians to the Canal's handover process, which would commence shortly after the performances with the national referendum. Needing to convince the majority of Panamanians to support the handover, Torrijos employed spectacular and dramaturgical techniques in his campaign for the Canal Zone's reversion, asserting before the international community and Panamanian audiences alike that the handover's time had come.

REMOUNTING THE BORDER: *LA CUCARACHITA MANDINGA*, 2006

The February 2006 remounting of *La Cucarachita Mandinga*, staged six years after the Canal Zone's handover, displayed a measure of continuity with Torrijos's performances thirty years prior. The 2006 production utilized the 1976 script and employed populist techniques to rally Panamanian voters, once again, to a national referendum, this time on the Panama Canal's expansion. Departing from a model of government support, this production's sponsor was the Panama Canal Authority (ACP), the Panamanian agency that manages the Canal. While maintaining the dialogue's anticolonial dialectics, the 2006 production made substantial changes to the score, choreography, and mise-en-scène, showcasing new approaches to representing the folkloric interior. The result was a kind of alienation effect in reverse: staging resolution rather than provocation, the 2006 production seemed to show that Panama's reclamation of the Canal Zone had neutralized or eliminated many of the play's central concerns. Taking place in a transformed political context, the 2006 production dramatized the pleasures of temporal, spatial, and social distancing. This production made the play into an archive, reviewing the ideologies and affects that had undergirded Panama's erstwhile sovereignty struggle, now celebrated as "past."

Materializing Torrijos's promissory rhetoric, the 2006 production took place in the former Canal Zone (now named the Canal Area, *el área canalera*). For many audience members, the play's location remains charged with memories of conflict, recalling protests staged by Panamanian activists in 1958, 1959, and 1964 that breached the Canal Zone's borders. Yet despite its evocation of Torrijos's polemical convergence of material and symbolic space, the 2006 production was not confrontational. Rather, the play assessed the geopolitical effects of

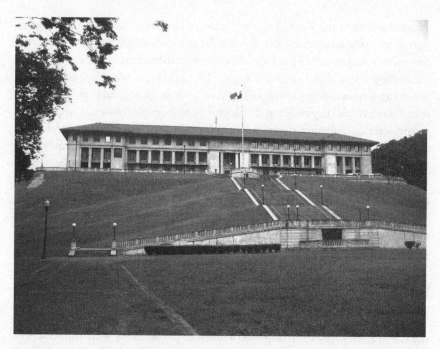

FIGURE 4.4. The Administration Building and Escalinatas/Prado. Photo by the author (2008).

the Canal's handover in 1999. Seeking to "open" the former Zone to its inheritors symbolically and materially, the two-day run took place in front of the Administration Building, the former center of US civilian power on the isthmus, now converted to ACP headquarters. Even after 1999, this area retains the appearance of an imperial enclave; its immaculately landscaped grounds look almost the same as in 1914, the year of the Administration Building's completion.[137] The building's grandiose Italianate Neo-Renaissance architecture perches atop a hill that cascades to the Prado, a long, palm-lined boulevard. (Figures 4.4 and 4.5 depict the Administration Building and Prado.) At the base of the hill stands a memorial to US colonel George Goethals, lead engineer during Panama Canal construction and the Canal Zone's first civil governor. The steps and surrounding hill became the production's open-air auditorium, and the cast performed on a raised stage in front of the Goethals Memorial.

Although ten to fifteen thousand audience members occupied the site during the performances, they did so with little intention of protesting.[138] In choosing this staging ground, the 2006 production team sought to counter Panamanians' feelings of exclusion and disenfranchisement from the former Zone and convey a sense that the Canal Area was now accessible to its citizens, since the territory now belonged to Panama. In 1999, this area had served as the setting of

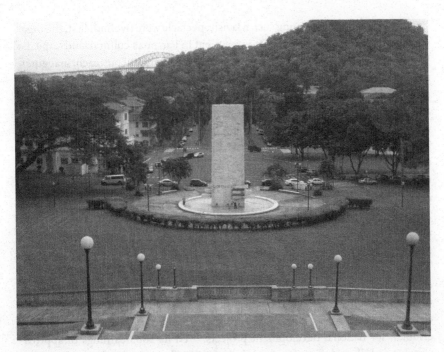

FIGURE 4.5. Memorial to Col. George Goethals, viewed from Escalinatas/Prado. Photo by the author (2008).

ceremonies commemorating the handover, welcoming thousands of Panamanians into the former Zone—a spatial-affective relationship that the 2006 production actively cited. The scenography also linked the Canal Area to Panama by setting the Cockroach's village in Panamá Viejo, one of Panama's iconic landmarks and a UNESCO World Heritage Site, rather than in the interior. The set's centerpiece mimicked the sixteenth-century ruins of the colonial capital, grounding the production in Panama's material landscape rather than evoking a fantasy idyll. Performed in a locale where nonwhite, non-US citizen bodies were not allowed to stroll or relax for many decades, *La Cucarachita Mandinga* seemed to symbolize the integration of the Canal Area as national space. During the twentieth century, the Canal Zone was often treated as a ludic space by its white US citizen residents. These "Zonians," having plentiful leisure time, pursued sports, held pageants and parades, made theatre, and otherwise enjoyed the Canal Zone, while Panamanians were largely denied entry to the Zone unless they had a specific purpose for being there. The 2006 performance reframed the Canal Area as a space of leisure and recreation for Panamanians, encouraging a shared sense of political resolution and territorial ownership.

All aspects of the production—including sound, lighting, scenery, and costumes—were of high quality: the ACP "spared no expense" in mounting the

show.[139] Its reasons for creating such a lavish spectacle were twofold: first, the organization sought to demonstrate its investment in Panama's cultural landscape. *La Cucarachita Mandinga* formed part of the ACP's community outreach, inaugurating the cultural programming initiative, "Cultural Summer Nights," which promoted Panamanian performing arts.[140] The ACP's community relations director, Ana María de Troitiño, explained in promotional materials that the ACP's work was "not just opening locks, charging tolls, and dredging" the Panama Canal but also included "stimulating artistic performances for the good of the community."[141] Another force motivating the production was the ACP's referendum, in October 2006, to widen the Panama Canal.[142] This nationwide vote consciously echoed Torrijos's referendum to approve the handover treaties in October 1977. As in 1977, the vote was by no means secure; many Panamanians saw expansion as a risky, costly undertaking.[143] The ACP, in sponsoring *La Cucarachita Mandinga*, sought to activate the affective powers of nostalgia felt by many Panamanians for Torrijos. Evoking Torrijos's leadership through a staging of *La Cucarachita Mandinga* helped to cement the ACP's place in Panama as an administrative organ of the state. Yet it is not a public organization, but a hybrid public/private entity—a corporation that gives a portion of its annual revenues to the Panamanian government for national development projects.[144] Of its 2008 earnings of approximately two billion dollars, for example, the ACP's direct financial contribution to the government is reported to have amounted to roughly $700.8 million, with an additional $13.6 million in indirect contributions.[145]

With a large budget, the ACP contracted Bruce Quinn to direct, in recognition of Quinn's many decades of theatre practice in Panama and the Canal Zone. Quinn's selection generated controversy, though considerably less than in 1976, especially after Quinn received the endorsement of Rogelio Sinán's surviving daughter.[146] Quinn had previously directed a small but well-received production of *La Cucarachita Mandinga*, but in 2006 he converted the play into high-watt spectacle. While opting to use the 1976 script, he modified many aspects of the staging.[147] Holding casting calls for ACP employees and their children, Quinn also brought his longtime collaborators—choreographer Ana Melissa Pino, costume designer Charles Brannan, musical director Dino Nugent, and technical director Juan Carlos Adames—on board.[148] This time, the creative team expressly incorporated references to the African roots of Panamanian folklore. Nugent, a West Indian Panamanian composer with extensive training in jazz and classical composition, reconceptualized the score to showcase African-influenced rhythms and instruments. His orchestration included the musical genres of "funk, reggae, jazz, *paso-doble*, Panamanian *cumbia*, *atravesa'o*, and *bullerengue*."[149] Many of these genres were documented by the Zárates in *Tambor y socavón*. Nugent also accelerated tempos and added bass guitar and drums to melodies like "Toro, Torito" and "Sapo del Naranjal" from Brenes's score. He preserved

the minor key of Cockroach's opening song but translated it into a fast-paced, syncopated jazz rhythm. Nugent also changed the score's performance approach by hiring Panamanian musicians Chispa, Wichy, Luís Carlos, Reynaldo, Bonilla, and Maricúz to perform live, downstage and in full view of the audience.[150] The high-profile band mixed Panamanian *típico* (or *pindín*) and mainstream Western instruments, while on the set's upper level, four female characters crooned into standing microphones in the style of Motown backup singers.[151]

Like Nugent's score, *La Cucarachita Mandinga*'s dance numbers incorporated African-influenced movements and forms. Pino's choreography swayed and swung from reels and circle dances into *baile típico*, salsa- and merengue-style partner dance, kicking up Broadway-esque chorus lines along the way. *Cumbia*, the only circle dance in Panama's official canon, featured extensively.[152] The choreography's focal point, however, was the *punto santeño* (the *punto* from Los Santos), danced by Cockroach and Mouse in formal *típico* dress, according to custom. This *punto*, hailing from the interior, is one of the most representative Panamanian folkloric dances and often performed at festivals. In their racial-geographical folk hierarchy, the Zárates labeled the *punto santeño* "refined" and "whitened." To dance the *punto*, Cockroach and Mouse wore spotless white *pollera* dress and *montuno* shirt, transforming from peasants into a conjugal pair. The presence of the *punto* danced Cockroach and Mouse into their marital union and denoted the Zárates' apotheosis of Panamanian folk dance, counterbalancing the score's African diasporic music. This refined *punto* from Los Santos affirmed the folkloric interior as central to the play's imaginary in 2006, despite the set's rerouting of folklore away from the Western provinces and to Old Panama.

The production's jumble of geographic markers found its parallel in racial ambivalence. While actors articulated the script's racial references—Uncle Horse enthusiastically dubbed the Cockroach a *"mulatita"* (little *mulata*) while kissing her neck, for example—the production once again elided the discussion of Africanness that Sinán hoped to ignite decades earlier, escaping to the realm of extra-human fantasy. Although the production employed a multiracial cast, the juxtaposition of multiracial bodies and formal *típico* dress staged Panama's interior as an implicitly "whitened" space. Elevating the fable to national symbolism, the 2006 production—like many before it—largely avoided a discussion of African diaspora migration in favor of a focus on the *punto* from Los Santos, an encapsulation of the "whitened" interior and Panamanian nationalism's yearning for folk fantasy. Yet the multiracial cast's positioning onstage engendered an intriguing racialized configuration—an effect perhaps unintended, but nonetheless powerfully evocative. Vicky Greco, playing Cockroach, appeared prominently beside ensemble member Cheryl Cubilla, who echoed her gestures precisely during many numbers. The synchronized coupling of Greco and Cubilla was projected to audiences on massive screens flanking the stage. The

simultaneous doubling and splitting of Cockroach into two synchronized roles heightened the performance's aesthetics of racial difference. Consciously or not, the pair's mirrored movements created a choreography of racial haunting, performing the absent presence of the *mandinga* (or afro-indigenous woman) in Cubilla's character while avoiding an overt presentation of Cockroach's Africanness in favor of a "whitened" personification of Panama.

In *La Cucarachita Mandinga*'s production history, racial performances are repeatedly tethered to assertions of sovereignty. In each "mega-performance," the actors and creative team laid claim to racial categories as a means of delineating Panamanian national identity. Yet the slippages among these performances and characterizations of the protagonist—as "whitened," folkloric, Africanized, *mulata*, human, insect, abstract symbol, and beyond—reveal artists' and audiences' anxieties and disagreements about Cockroach's and Panama's racial composition. Stagings of race reveal the complexity of racial performances, mutable and polysemic, and the multiplicity of audience reception across cultural and social contexts.[153] Both onstage and in everyday life, a light-skinned actress can inhabit the roles of "brown" (*morena*) or mixed-race (*mestiza*) personae, since *mestizaje* represents "race" as a spectrum, not a binary. Some audience members interpreted Greco's Cockroach as a *mulata*, while others saw an insect, pushing the character beyond human boundaries. Cockroach's intrinsic mutability allowed for such capacious readings. Perhaps by performing Cockroach in these ways, the productions staged a society beyond racial dyads, the utopian dream of racial democracy and *mestizaje*. Lost in a mestizo nationalist representation, however, were Cockroach's "Mandinka" roots, and all that this identity marker entailed: the African diasporic movements and histories of slavery and oppression that shadowed the character's arrival in Panama, as the fable passed from speaker to listener, transmitted by Black female storytellers in Sinán's apocryphal origins story. Also elided were the African roots of interior folklore, and the rebellious, devilish, radical connotations of *mandinga*. Similarly, if the 2006 production staged resolution, it masked many Panamanians' lingering anxieties after the handover—of ongoing economic disparities, privatization of the Canal Area, and racialized inequities blanketed over by narratives of *mestizaje* and nationalism.

CONCLUSION: CLAIMING STAGES, STAGING CLAIMS

Nearly eight decades after the premiere of *La Cucarachita Mandinga*, many Panamanians consider the play "immortal," and Cockroach a figure "whom we all know."[154] The play permeates Panama's public life; its characters and references appear in public school curricula, on television, radio, and in the news.[155] Yet the play's ubiquity masks irreconcilable tensions. Despite its light tone, *La Cucarachita Mandinga* stages Panama's history of slavery, colonization, and

marginalization, engaging polemics of national identity, classed and raced sub-jectivities, and sexual violence. While the scripts tended toward an Afrocentric, or at least Afro-sympathetic, worldview, many productions emphasized antico-lonial nationalism over racial and sexual themes. Production teams reconfigured Cockroach and Mouse as an idealized couple, giving insect and rodent human bodies and heteronormative interactions. In so doing, these stagings minimized the script's insistence on Africanness as shaping citizen bodies, folk culture, and symbols of Panamanianness arising from spaces other than an idealized interior. The play's power to encapsulate Panama's sovereignty struggle surprised its cre-ators: Gonzalo Brenes stated that neither he nor Sinán had anticipated that their collaboration would yield such a significant and enduring representation of Pan-amanian identity.[156] Yoking the play to Panama's anticolonial narrative of national formation smoothed its subtle ironies into resolution in 2006, leading Panama-nian scholar Delia Cortés to doubt whether La Cucarachita Mandinga could still "make trouble" after the Canal's handover.[157] Had the play's driving force shifted to congratulatory self-satisfaction? Was the sovereignty struggle "past," and with it, the play's resonance?

Asking questions like these also gestures to an important point of disequi-librium: that of the relationship between nationalism and sovereignty. Over decades of remounting, La Cucarachita Mandinga had become thoroughly yoked to Panama's struggle for control of the Canal Zone, which was made into a nationalist campaign. Yet nationalism and sovereignty differ. While national-ism takes the nation as given, sovereignty "matters" the nation, arguing for its material construction and bordering with speech claims that are also acts. Sov-ereignty is an intersubjective, performative process involving speaking (claim-ing authority) and authorized hearing (assessing claims), and theatre's act of claiming space onstage would seem to provide an apt means of representing these nation-making processes. Yet the symbolic claims made upon a theatrical stage can perhaps be too easily assimilated into nationalism, which already owns what it claims: the idea of the "nation." A performative process of making and remaking the nation, reordering boundaries and redefining its relationship to the state, sovereignty is "a set of practices" that are "contingent," "struggled over," and actively engaged in questions of constructing claims to nation- and statehood.[158] Sovereignty "is contested because it is continually negotiated on the ground."[159]

As sovereignty is a construction that "shows its seams," so La Cucarachita Mandinga's insistence on farcical ambivalence concurs less with nationalism than with sovereignty-as-process, and particularly the subjunctive sovereignty that marked Panama's creation in 1903. Through the polysemic excess of Cock-roach and her disruption of the rural mise-en-scène, La Cucarachita Mandinga symbolizes Panama's sovereignty struggle while—at least initially—critically

undercutting linkages of sovereignty to nationalism and seeking to overturn folkloric "givens." With its cacophonous, chaotic portrayals of the interior, and its Mandinka Cockroach, the 1937 script sought to interrupt and poke fun at, as much as uphold, the nation. *La Cucarachita Mandinga* manifests sovereignty as a process interlaced with revision and reversal. The play—a children's farce laden with sexual violence, starring a "repugnant" (but beautiful) Cockroach as a symbol of Panama—enacts geopolitical ruptures alongside economic marginalization and leaves the nation unresolved. And this irresolution—encompassing ironies and acts of doubling back—compels audiences' recurrent pleasure. Panamanian politicians made the play into a nationalist work, to demonstrate the strength and roots of Panamanian aesthetic patrimony; directors and producers sought to synchronize the play's narrative with mestizo nationalism, Panama's anticolonial trajectory, and the folkloric interior.

Streamlining Cockroach's symbolism, theatre artists delimited her character. The reclamation of sovereignty would render the nation whole, in the government's estimate, and site-specific theatre could represent this reunification. Yet each iteration grappled with ambivalence: not all characters fit within the theatrical and political stagecraft, leading production teams to highlight and omit selective elements. Even the 2006 production overflowed its container: the racial and anticolonial vectors involved in the performance's "homecoming" to the post-imperial Canal Area refused to stay within the bounds of a conciliatory narrative of resolution. In Panamanian theatre director Edwin Cedeño's view, the play continues to confront "hard truths" of "nationality and identity and the quest for power through what appear to be children's games"; frolic and fun, dance and song tease out racial and gendered critiques of colonialism.[160] The play unsettles folklorism and stages a nation in the process of being made—through colonial encounters, diasporic movements, and racial mixing as much as through treasured folk customs. Desires to restage the play reveal yearnings to (re)enact the nation, while the play's space continually exceeds national space. As such, the play threatens to "make trouble" as long as there is trouble to be made: *La Cucarachita Mandinga* evades mestizo nationalism's grip, provoking divergent interpretations and lingering questions. Despite repeated efforts to instrumentalize it for nationalist causes, the play's incendiary power refuses to be neutralized, and its irrepressible protagonist—the insurgent *mandinga/mulata*, a reconfigured *cimarrón*, both African and Panamanian—slips away again, cackling from the anticolonial margins.

5 • STAGING SOVEREIGNTY AND MEMORY IN THE PANAMA CANAL HANDOVER

In 1999, the US government transferred the last of its territory and holdings in the Panama Canal Zone to Panamanian sovereignty. The turn of the millennium marked the end of a process initiated by the ratification of the Torrijos-Carter Treaties (the Panama Canal Treaty and Neutrality Treaty) in April 1978. A massive handover clock in the Canal Zone counted down the minutes to the reversion.[1] Panamanians awaited, with excitement and fear, the handover's legal closure. The official reversion ceremony, which took place on December 31, 1999, enacted sovereignty in a felicitous performative utterance that philosopher J. L. Austin would likely have endorsed (Figure 5.1 depicts the ceremony's gathered audience). Panama's president Mireya Moscoso received the Canal from former US president Jimmy Carter, as authorized witnesses, including several Latin American heads of state and King Juan Carlos of Spain, validated the transfer.[2] The change in sovereignty elicited many questions beyond those that the handover's performative gesture could resolve. Lingering questions included: How would Canal management change under Panamanian sovereignty? Would the US government and US military truly depart the isthmus? What did sovereignty in the Canal Zone mean for Panama's working-class citizens? Could Panamanians rewrite the histories of the Canal and Zone— spaces that had long been considered off-limits—as "national histories"? For many, hopes of making the former Canal Zone more inclusive already seemed sabotaged by the Zone's burgeoning privatization.

Amid these uncertainties, an overarching question of continuity versus rupture emerged in the reversion. The transformation of the US-occupied, militarized Canal Zone to a Panamanian, civilian "Canal Area" exemplified

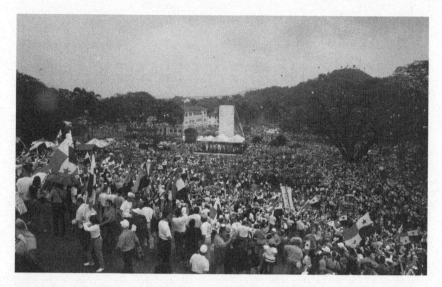

FIGURE 5.1. The Panama Canal Handover ceremony, December 31, 1999. Photo Courtesy of the Panama Canal Authority (ACP).

ideas of persistence and change contained in what I call "(post)colonial surrogation."[3] (Post)colonial surrogation takes up performance scholar Joseph Roach's concept of "surrogation," the process by which "culture reproduces and re-creates itself": "In the life of a community, the process of surrogation . . . continues as actual or perceived vacancies occur in the network of relations that constitutes the social fabric. Into the cavities created by loss or other forms of departure . . . survivors attempt to fit satisfactory alternates."[4] Surrogation's connection to sovereignty is central to Roach's analysis; one of his main metaphors is the duality of the king's "body natural" and "body politic."[5] The sovereign figurehead may die in flesh while being represented and replaced by effigy, actor, and heir, allowing the state to live on. "The King is dead; long live the King." Yet how does the performance of sovereign surrogation operate in the disseminated "body politic" of the nation-state's aspiration toward liberal democracy? How can representation stage the "symbolic diffusion" of the sovereign king "into a body of laws"?[6]

The concept of "(post)colonial surrogation" sheds light on a dialectic of change and continuity that resonated in the Canal handover's "decolonization"—a strange designation given Panama's long-standing possession of "titular sovereignty" in the former Zone. As the US government and US military vacated institutional roles and trained Panamanian successors, people in Panama queried the grounds of possibility for (post)colonial surrogation in the reverted lands. While some stepped into the roles left by the United States, many

others looked askance at the act of reversion itself, thinking it almost a parody of decolonization: a sovereign power, the United States, granting sovereignty to another sovereign power over a territory that the former had partially claimed ("sovereign-not-sovereign") for almost a century. The effect was akin to a trespasser allowing someone entry into her own house. Many Panamanians, nevertheless, persisted in framing the handover as enacting "decolonization." But what did this mean for Panama and its citizens?

Unresolved questions around sovereignty, decolonization, history, and surrogation spurred at least fifty events commemorating the handover in 1999. Among other activities, the United Nations and Organization of American States (OAS) held special sessions and sponsored cultural festivities and sports competitions; the Afro-Antillean Museum expanded its annual "Conozca su Canal" (Know Your Canal) week; and a commemorative Flag Sowing (Siembra de Banderas) was held in the former Zone on April 14, 1999.[7] These events helped to frame the handover as a rich and meaningful aperture through which Panamanians— even those minimally impacted by it—could critically (re)view intersections of colonialism and sovereignty, international trade and national borders. Performing artists also took active roles in creating aesthetic and social entry points into reenvisioning sovereignty on the isthmus.

This chapter details the production histories of two large-scale commemorative performances. First, from August 13 to 15, 1999, the Panama Canal Commission (hereafter called the Commission) sponsored the Eighty-Fifth Anniversary Gala of the Panama Canal (hereafter, the Handover Gala), free of charge and open to the public, in the former Zone. Six months later, to accompany the official transfer ceremony, Panama City mayor Juan Carlos Navarro sponsored a massive open-air concert, Patria Entera (translating to "fatherland made whole" or "whole fatherland/homeland"), also in the former Zone.[8] Patria Entera was headlined by internationally renowned Panamanian salsa artist and politician Rubén Blades, who steered the production process. The Handover Gala and Patria Entera sought to frame questions attending the handover, narrate the isthmus's past and present, and articulate possible post-handover futures. Both performances approached these questions through an oscillating interplay of subjunctivity and performativity, in which subjunctivity's "as if" proved a crucial means of supplementing (and interrupting) the performativity of the handover's official legal ceremony. While the official transfer enacted legal change, the subjunctive enactments made palpable and spectacular Panamanians' collective inheritance. Both performances employed large creative teams, including Latin Panamanians, former Zonians, present and past Canal employees, West Indian descendants, and representatives of several indigenous groups. While striving to represent the multifaceted transition, the performances also sought to initiate new ways of thinking, feeling, hearing, and visualizing sovereignty, mapping abstract concepts of governance, liberty,

and decolonization onto the physical site of the former Zone. In portraying possible futures for the Canal within a unified isthmus, each performance foregrounded selective identities and events, within national, regional, and global registers.

While utilizing distinct techniques, the Handover Gala and Patria Entera nonetheless shared a desire to guide audiences on a collective journey through imagined and material space and time. Both performances took place at, or very near, the former Zone's central locus of imperial aesthetics, the Administration Building—a mise-en-scène possessing symbolic benefits and drawbacks. In endowing the Canal Zone with a protagonic role—bodying forth the Zone as an actor in their scenarios of recuperation—both performances confronted two challenges. The first was to transform the Zone's mise-en-scène from exclusionary (its historical valences of white US privilege) to inclusive space. The second challenge was to find a means or form of staging "the sovereign people" in the site. Creators of both events were aware of, and sought to avoid, pitfalls of representing "the people" as a generalized ethnos, in the racially chauvinistic, ethnoscopic ways that nationalism can devolve into populist "folk" imagery. Yet both production teams wanted to represent Panamanians as a collective, embodying ideas of popular sovereignty. The task of representing "the people" in a theatrical format that Panama's diverse audiences could accept forced each production to find novel solutions to the problem that Peggy Phelan calls the "trap [of] visibility" in staging the paradox of a sovereign demos.[9]

CONTEXT: THE HANDOVER PERIOD, 1979–1999

The US government returned the former Canal Zone, piecemeal, to Panama from 1979 to 1999. The civilian Canal Zone was dissolved, and its assets transferred, in October 1979.[10] By 1991, roughly 61.1 percent of the Zone's 147,399 hectares had been reverted; core military installations followed after 1994, with a few remaining bases under US control until 1999.[11] At the end of the handover, all military installations became the property of Panama's government, and the binational Commission, which had taken over from the US Panama Canal Company (PCC) in 1979, ceded power to the Canal's new Panamanian managing body, the Panama Canal Authority (ACP).[12] By 1999 Canal employees were mostly Panamanian, with only two hundred US citizens remaining in the workforce.[13] Onlookers in and outside of Panama were impressed by how smoothly the transfer proceeded, considering the geopolitical turmoil that surrounded the handover period.[14] Specifically, Panama's military dictatorship (1968–1989) had intensified under General Manuel Antonio Noriega, who came to power following General Omar Torrijos's sudden death in 1981. Noriega violently repressed Panamanian civilians and taunted US military personnel on the isthmus while trafficking in drugs and arms on the CIA payroll.[15] On December 20, 1989, the

US government retaliated, invading Panama to oust Noriega, in violation of the Torrijos-Carter Treaties and United Nations and OAS charters.[16] The US invasion, Operation Just Cause, killed at least 700 to 1,000 civilian Panamanians, most poor people of color, and wrought massive property damage with advanced weaponry and bombs.[17] Noriega's dictatorship, and the invasion that ousted him, sowed major instability in Panama.[18] Many Panamanians felt betrayed by the United States, taking the invasion as an indication that the United States would not honor the Torrijos-Carter Treaties.[19] Yet late sociologist Raúl Leis and other commentators noted that some in Panama welcomed the invasion, exacerbating a political schism around issues of US influence and interventionism.[20] Musician and composer Rómulo Castro characterized Panamanians' ambivalence as "sí, pero no" ("yes, but no") or "quiero que te vayas, pero no te vayas" ("I want you to leave, but don't leave").[21]

Following the events of Operation Just Cause (1989), Panama was "a country in ruins, internationally isolated, with a massive foreign debt, high levels of unemployment [and] poverty, the concentration of wealth in a few hands, and occupied by the US army."[22] Problems needing immediate attention in the Zone included military waste, unexploded ordnance, and chemical contamination.[23] Political instability gave US and Panamanian observers reservations about Panama's readiness to assume control of the Canal. Panamanians felt skeptical as to whether the United States would honor its promise to cede its military holdings; many thought that the United States would retain at least some bases in Panama. In the decade after 1989, conditions did not stabilize. The threat of continued US military occupation after the handover reemerged when, in 1998, leaked correspondence revealed negotiations between Panamanian president Ernesto Pérez Balladares and the US government to retain military bases, exacerbating public mistrust of both governments.[24] The US military had proposed retaining bases and building a "multilateral anti-drug enforcement center."[25] This plan was anathema to many Panamanians, who wanted an end to the militarization of the isthmus.[26]

Political and economic instability led to mixed feelings about the transfer of power. While some Panamanians cheered the imminent departure of the United States, others predicted that the handover would worsen conditions on the isthmus.[27] Still others were concerned about the fates of the reverted areas. By 1999, Panama had inherited "some four billion dollars' worth of property, including beachfronts, virgin rain forests, airstrips, ports, housing subdivisions, military bases, and, of course, the Canal itself."[28] After 1979, the civilian Zone's suburban-style neighborhoods, which formerly housed Zonians and military families, were sold to private investors at a premium.[29] Several of my interviewees, including Rubén Blades and Rómulo Castro, lamented the escalating fragmentation of the Canal Area into mini-enclaves and gated communities for the foreign and

local rich.[30] Indeed, during the handover Blades and Castro had taken part in debates on alternative uses for reverted lands, especially the former US military bases.[31] The handover was also emotionally difficult for those who had built lives and livelihoods around the Canal. White Zonians and West Indian Panamanian employees of the PCC faced a diminishing sense of belonging. Many Zonians left for the United States.[32] Former PCC and Commission employees feared reduced benefits under the ACP and doubted the Canal's future success without the United States.[33] In sum, 1999 did not mark an unambiguous transition for either the United States or Panama, despite efforts to make it seem that way. Both the Handover Gala and Patria Entera honored some of these ambiguities, while simplifying other complexities attending the handover.

BORDERING ON RECONCILIATION: THE PANAMA CANAL COMMISSION'S HANDOVER GALA

The Commission's Handover Gala, like its sponsoring body, sought to form a bridge between those who had formerly felt welcome in the Canal Zone and the Zone's new "owners." The Commission produced the Gala both to celebrate the Canal's reversion and to provide a sense of closure for the Zone's former residents. Performers, audiences, and contributing artists all viewed the event as an opportunity to remember or frame the Canal in specific ways. This multiplicity proved a tenuous balancing act and posed numerous questions about how the Gala would appease its stakeholders. By titling the event the "Eighty-Fifth Anniversary Celebration" and staging it in August—the month that the Canal opened in 1914—the Commission consciously placed the Handover Gala within a lineage of commemorations of the Canal's inauguration, including twenty-fifth, fiftieth, and seventy-fifth anniversaries celebrated, with pomp and ceremony, at the very site where the Gala would be performed.[34] This anniversary-themed title, among other facets, indicated the Handover Gala's desire to emphasize continuities in the Canal's history. Although the Gala was organized by both Zonians and Panamanians, the event was overlaid with a sense of nostalgia for the former traditions of the PCC and Canal Zone, and a desire for these mores to carry over into the Canal's future under Panamanian sovereignty, or at least to enter positively into memories and histories of the former Zone, amid the negative memories attending the site.

The performance took place in the amphitheater created by the sweeping stairs of the Escalinatas (called the Prado by Zonians), which connected the Goethals Memorial to the grandiose and imposing Administration Building, on the Canal's Pacific Side (see Figure 4.4). This area, the PCC's former headquarters, would house future ACP offices. The Administration Building was a controversial venue choice: Rómulo Castro notes that this area is considered the locus classicus of the "imperial architecture with which the Canal was born."[35]

Many Panamanians still reflexively call the Canal Area the "Zone." Even though most of the territory was reverted by 1999, a significant number of Panamanians experienced this place—which Torrijos had called Panama's "fifth border" (*quinta frontera*)—as more closed than open.[36] Many were old enough to remember when an eight-foot-high, barbed wire–topped fence was erected in 1959 to separate parts of the Canal Zone from Panama following violent clashes that year.[37] Some parts of the fence, which Panamanians nicknamed the "Berlin Wall," remain in place. Others recalled the US Canal Zone Police who patrolled the perimeter of the Zone until their disbandment in 1982.[38] Yet parts of the former civilian Zone were opened to Panamanians since 1979, and younger people enjoyed playing in the green expanses of sports fields, whose pristine landscaping contrasted with Panama City's dense urban development. The Commission and the ACP Board of Governors had sponsored a preparatory concert at the site in June 1999.[39] The Handover Gala's production team chose the site to emphasize the Zone's aspects of leisure, recreation, and beauty. Assistant Producer Gale Cellucci attempted to make the area look "less undemocratic" by separating audiences with plastic mesh rather than cyclone fencing.[40] This detail indicates the production team's efforts to make accessible a place whose spatial aesthetics retained potent symbolism for US and Panamanian citizens alike.

Helming the Handover Gala as artistic director was dual Zonian-Panamanian citizen Bruce Quinn. Quinn's multigenerational family history on the isthmus, and his extensive theatre work in the Canal Zone and Panama, made him an ideal candidate. His father's family emigrated from the United States to the Canal Zone in 1907, becoming "Old Timers" (predecessors to the Zonians) who received Roosevelt Medals for their long Canal service.[41] Quinn's father married a Panamanian woman, making their family dual citizens. Quinn grew up in the Zone in the 1950s and 1960s, participating in theatre as a student at Balboa High School before studying architecture and scenic design in the United States. Despite his Zonian lineage, Quinn did not confine himself to the Zone. Returning to Panama from US military service in 1962, he facilitated the racial integration of the PCC's employee pool and mediated labor disputes as assistant to the personnel director. He also returned to theatre, producing and directing at the Canal Zone College (renamed the Panama Canal College in 1977) and the Theatre Guild of Ancón (TGA), an Anglophone "little theatre" founded in 1950 by Panamanian elites. Because the PCC viewed theatre activities as fostering positive connections between Panama and the Canal Zone—an agenda that the US State Department increasingly encouraged at midcentury—Quinn was able to procure funding to supplement the TGA's membership base.[42]

At the TGA, Quinn met Carlos Williams, a Panamanian Canal employee with whom he began collaborating on annual theatrical productions for the Canal Zone's branch of the United Fund, a charitable nonprofit (now the United

Way of America). Participation in these productions, at the 600-seat Balboa The-
atre, was initially restricted to Canal employees and US military personnel, with
Army and Air Force bands supplying music. Beginning in 1964, Quinn changed
this practice by hiring Panamanian artists. His first production, *Oklahoma!*, fea-
tured Panama's National Ballet dancing the famous dream sequence. The per-
formance took place just after the Canal Zone flag protests, but the National
Ballet participated despite ruptured diplomatic relations.[43] The United Fund
continued to host joint US-Panamanian productions for decades, even at the
height of anti-US sentiment in Panama. According to Sarah Knapp, who lived
in the Canal Zone in the 1960s and thereafter, at the United Fund shows "every-
one came together . . . servicemen and women from the bases, Zonians, and
Panamanians."[44]

In 1972, Quinn began directing for the Teatro en Círculo, a theatre company
in Panama. His directing career in Panama gained momentum, and he began
collaborating with the Department of Artistic Expressions (DEXA) at the Uni-
versity of Panama. Quinn's love of US musical theatre converged with DEXA
director Baby Torrijos's interest in musicals as mass entertainment. The two pre-
sented *Man of La Mancha* in Spanish, which "was different from anything [Pana-
manian audiences] had ever seen."[45] In our interview, Baby Torrijos stated that
this play—the first opportunity for working-class Panamanians to see musical
theatre—attracted such large audiences that people were "hanging . . . from the
rafters" of Panama's National Theatre.[46] Quinn feels that his hybrid Panamanian-
US identity has yielded more positive connections than hindrances. By his own
admission, he was never quite "Zonian" enough for the Canal Zone, and his
broken Spanish and physiognomic whiteness make him seem like a "Yankee" to
many Panamanians. Yet his dual status has enabled many US-Panamanian inter-
sections and theatrical collaborations.

In the mid-1990s, Quinn expanded the reach of his theatre practice in Pan-
ama, starting a creative partnership with West Indian Panamanian composer
and musician Dino Nugent. For years, Quinn and Nugent's production team
mounted at least three large-scale productions per year at the National Theatre,
Atlapa Convention Center, and other large-scale venues in Panama. In 1997
Quinn paused his practice of remounting Broadway musicals to create and direct
a production based on Rubén Blades's 1979 salsa album *Maestra Vida*, with added
dialogue and staging techniques to highlight the theatrical elements of Blades's
"salsa opera."[47] This production became immensely popular in Panama, solidi-
fying Quinn's professional relationships with Panamanian actors and musicians.
Linking theatre with renowned artist Blades, *Maestra Vida* affirmed Quinn's
commitments to theatre and Panama for those who had previously questioned
his Panamanianness (*panameñidad*). When the Canal Zone dissolved and many
Zonians moved to the United States, Quinn remained in Panama, where he and

Nugent continue to produce theatre with a devoted following of Panamanian musicians and performers whom Quinn affectionately calls the "Dream Team."

In early 1999, the Commission selected Quinn to be artistic director of the Handover Gala and "handed [him] a blank check," with the sole guideline that the Gala should mark the anniversary and the handover.[48] Reportedly costing around three hundred thousand dollars, the Gala was one of the most expensive and ambitious theatrical events in Panama's history.[49] Local media announced that the Gala "will pay tribute to all of those who shared the vision of an Inter-American channel through the isthmus, to the builders of the canal, and to the future Panamanian administration of the waterway."[50] Panama Canal Public Relations Manager Mercedes Morris García stated: "With this Gala, in the year of [the canal's] transfer, we have sought to commemorate the contributions of sweat, blood, vision, and hope by thousands of people who made this great work of engineering possible while also charting its future."[51] Quinn, musical director Nugent, and Panamanian art historian Orlando Hernández Ying formed the crux of the Handover Gala production team. Hernández, Nugent, and Quinn chose participants and organized central themes; Nugent composed the score and conducted Panama's National Orchestra; and Hernández served as production assistant and authored the script, incorporating historical context and educational information into the narrative. Hernández told me that, despite the many questions that swirled around the handover, and the activities sponsored by outside bodies, neither the US nor Panamanian government had created an official educational program to accompany the reversion. Many Panamanians were largely unacquainted with the Canal's history, environmental impact, technical operations, and economic relationship to the Panamanian government. The Gala aimed to rectify this lack through a semi-educational framework.

Quinn recruited Gala actors with an eye both to talent and personal connections to the Canal. He was adamant that the Gala not replicate the former Zonian performance "amateur nights," which spawned the Community Nights discussed in Chapter Two. Yet in auditions, Quinn also asked: "What is your connection to the Canal within your family?"[52] He noted that this question stimulated many conversations about the Canal's history and its ties to participants' "parents, grandparents, [and] great-grandparents," which shaped the Gala actors' perspectives of the handover's significance.[53] Quinn also sought to link the Gala to the Canal's history by having the production team visit the Commission's logistical and technical departments. Nugent felt that in-depth tours of the Canal strengthened his investment in the project, motivating him to reflect upon the migration of his great-grandparents from Jamaica to Panama.[54] Quinn wanted the Gala to showcase "the contributions of people who came to offer their support in the construction of this waterway, like the French, Spanish, [South Asians], Italians, Greeks, North Americans, among others."[55] He initially

planned a pageant of ethnic groups involved with the canal's construction. Hernández felt, however, that the Gala's aesthetic and representational structure should foreground present-day Panamanian identity, a mixed-race *panameñidad* that did not distinguish among ethnic and racial origins.

This goal, to represent an integrated mestizo citizenry, resonated with many Afro-Panamanians' long-standing quests to integrate into Panama, as discussed in Chapter Three. Hernández, who told me that he has Asian, African, and Latin American ancestors, wanted to emphasize the shared qualities of Panamanians and avoid an essentializing multicultural discourse that reduced differences to stereotypes.[56] He felt that Panamanians were "tired of that old story . . . of migrations and how different groups have shaped the country and made it what it is . . . because it gives too much credit to foreigners . . . now Panamanians are Panamanians, and they might have Asian origins or a West Indian background, but now everyone is Panamanian."[57] Moreover, he felt that a focus on disparate ethnic groups would magnify the Canal's past, detracting from the opportunity to centralize its present and future. In composing the script, Hernández emphasized the racial and cultural diversity of Panamanians at the turn of the millennium, so as to stimulate reflection on ramifications of the government's newfound authority over the Canal.

Ultimately, in part due to Zonians' and Panamanians' overwhelming interest in participating as performers, the Handover Gala took the form of a musical and performance revue, a collection of sketches and vignettes linked by two narrators, Panamanian actors José Carranza and Lissette Condassin, who contextualized each segment with educational information. The production included approximately two hundred Panamanian and US performers and spanned several hours, culminating with the song "Patria," performed by Rubén Blades.[58] The event drew audiences in the thousands; invited guests included the presidents of Colombia and Costa Rica, official representatives from Mexico and Venezuela, and the OAS secretary general.[59] The Gala split its narrative between two focal points: first, Panama as international trade conduit serving global capitalism; and second, the country as concrete locale with unique populations, histories, and dynamics. This schismatic focus makes sense, given that the Canal's national benefit lies precisely in its international services. Tensions between local sustainability and international trade have threaded through Panama's history long before independence from Colombia in 1903. In the mid-nineteenth century, Panamanian elites sought to make the isthmus a Hanseatic trade emporium, to enrich the isthmus while facilitating capital flows. As historian Aims McGuinness shows, isthmian trade has often had disastrous consequences for local lives and livelihoods, even as high volumes of capital and goods have flowed to global destinations, via the Panama Railroad and Canal.[60] Whereas some segments of the Gala highlighted the isthmus's local conditions and day-to-day life,

many others upheld Panama's motto, *pro mundi beneficio* ("for the benefit of the world"), foregrounding the Canal as global good.[61] The Canal's slogan under US administration, "the land divided, the world united," was repeatedly invoked during the Gala. In keeping with the theme of universal benefit, narrator Carranza stated that the handover "will be a celebration as much for Panamanians as for all of humanity."[62]

Panamanian scholar Gregorio A. Urriola Candanedo, writing on the eve of the handover, viewed public discourses of the Canal's global benefits as ignoring local impacts in favor of a worldview (*cosmovisión*) oriented to wealthy trading partners. Urriola urged Panamanians to divert their gaze from "the world" to the local context of underdevelopment and socioeconomic stratification on the isthmus, which directly implicated the canal's resources and revenues.[63] Likewise, several Gala participants wanted the performance to serve as a moment of reckoning for Panamanians, provoking debates around the historical juncture and allowing audiences to critically assess the future of Panama's control of the Canal. Castro, Hernández, Nugent, and singer/actor Luís Arteaga were concerned about the handover's focus on transnational capital, at the expense of improving the lives of Panamanian citizens. In the Gala, they helped to advance counter-arguments against globalization, revealing discursive constructions of "world" as synonymous with global capital and blind to Panama's heterogeneous, African-descended, indigenous, and working-class populations. These Panamanian artists utilized the Gala's embodied narrativization of the Panama Canal as an opportunity to challenge discourses of universalism and reterritorialize the Canal within local and national contexts.

HANDOVER GALA: PRODUCTION DETAILS

Flanked by massive screens, the Handover Gala's raised stage featured moving scenery built by Commission employees to resemble the Canal's locks.[64] The Gala opened with a spectacular homage to Panama's pre-Columbian past: as the orchestra played the opening theme, dozens of dancers representing indigenous peoples emerged onstage, carrying flaming chalices and sporting loincloths and gold ornaments, the latter a reference to Mesoamerican *huacas*. This choreography seemed poised to evoke the multicultural pageant that Quinn had desired, but such ethno-pageantry was offset by the New Millennium chorus, which entered from the wings, taking positions on bleachers behind two replicas of "mules" (small trains that guide ships through the Canal) placed far upstage, framing the simulated locks on either side. Following the opening spectacle, narrator José Carranza introduced the Gala as a "journey through time and space in memory of the thousands of people who gave their youth, and even their lives, to achieve the dream of dividing the earth to unite the world."[65]

Subsequent sequences hewed to the display of disparate ethnic origins rather than a unified *panameñidad*: Carranza and Condassin gave statistics on Italian, Greek, Spanish, and West Indian immigration during Panama's "North American" era (1904–1999), supplementing musical performances representing each national group.[66] North American influence was represented in pieces including an excerpt from Agnes de Mille's ballet *Rodeo*, a jazz dance number, and "Summertime," from the folk opera *Porgy and Bess*, sung by West Indian Panamanian soprano Cynthia Franklin Brown. Brown, a US citizen, was part of the West Indian Panamanian diaspora in New York. The late singer's Gala participation was significant, given that she was one of the few Afro-Panamanian artists promoted by concert impresario George Westerman, whose activities I detailed in Chapter Three, and Westerman had helped to bring *Porgy and Bess* to the isthmus in 1955.[67] In the Gala's second half, Brown sang "O Patria Mia" from Giuseppe Verdi's 1871 opera *Aida*, which resonated on multiple levels: ostensibly sung for the opening of Ferdinand de Lesseps's Suez Canal, the opera also inaugurated Panama's National Theatre in 1908.[68] Moreover, the role of *Aida*, an enslaved woman of color, has been interpreted by notable Black female opera singers (including Ellabelle Davis, another Westerman artist).[69] Brown's performance, and her mentorship by Westerman, alluded to the history of Black classical artists' travels to Panama. Her song selections cut across West Indian, African American, and European "high art" musical influence, much as Westerman's concerts had.

In another significant segment, a contemporary dance piece movingly portrayed the contributions of West Indian labor migrants. The piece was adapted by choreographer Patricia Galindo de Orillac and composer Dino Nugent from Melva Lowe de Goodin's play, *De/From Barbados a/to Panamá*.[70] With corporeal repertoires drawn from ballet and modern dance, the work gracefully represented the play's narrative, which ranged from the departure of West Indian men for Panama, to West Indian workers' deaths during Canal construction (a frequent occurrence), dalliances with prostitutes, and marriages among Afro-Caribbean migrants in Panama—a microcosm of West Indian descendants' settlement on the isthmus. As dancers embodied the narrative in fluid group formations and solos, the screens displayed construction-era footage of West Indian workers collecting "silver roll" pay, strolling in Panama City and Colón, and laboring in the dangerous Culebra Cut. Many participants of West Indian descent, including lead dancer Ela Spalding, found the piece a welcome opportunity to explore personal and family histories of migration through dance.[71]

Representatives of the Zonian community, including Sarah Knapp and Bruce Quinn's sister, Patricia Quinn, returned to Panama to perform in the Gala. Born in the Zone, both women established acting careers in the United States. Both delivered performances evoking nostalgic desire for the paradisiacal Zone.

Patricia Quinn recited a poem, "Hail Panama," written by Zonian "poet laureate" John Stanley Gilbert, who had composed a large body of poetry about the Canal Zone in the early twentieth century. Wearing period dress, Knapp portrayed the figure of the "early Zonian." Her song, "Always Summer," painted an idyllic portrait of the Zone as a place of eternal pleasure and escape.[72] These two Zonian vignettes sought to connect with and channel the grief of those who lamented the loss of their treasured Canal Zone. They also showed audience members who did not inhabit this experience that the Zone had been a joyful place for its former inhabitants.[73]

The final segment of the Handover Gala represented current conditions of *panameñidad*. Singer-songwriter (*cantautor*) Rómulo Castro contributed three original compositions to the Handover Gala: "La Herencia del Pela'o," "La Rosa de los Vientos," and "Parte de la Historia," the last written with Nugent (a frequent collaborator) expressly for the Gala. While each song showcased distinct tones, instrumentation, and lyrical content, together they formed a cycle that encouraged critical reflection on the historical moment of the reversion. Castro developed his syncretic repertoire with his band Tuira (named for a river near Panama), which rose to national and regional prominence in the 1990s. Tuira integrates North American, Latin American, Caribbean, and African diasporic genres, including calypso, salsa, rock, jazz, samba, Panamanian *baile típico* (or *pindín*), and *canción protesta* (protest music).[74] Castro's repertoire is also influenced by the Cuban genre of *nueva trova*, as elaborated by *cantautores* Silvio Rodríguez and Pablo Milanés.[75] Descended from Panamanian and Cuban immigrants and Spanish Civil War refugees, Castro grew up in Cuba before moving to Panama at the age of eighteen, during Torrijos's campaign to reclaim the Canal. Yet Castro distinguishes his musical approach as *canción propuesta*—music of "proposal" rather than protest. Many of his compositions seek to historicize a societal problem while provoking listeners to action. Castro studied music in Cuba in 1984 before returning to Panama on the eve of the 1989 US invasion. Meeting likeminded artists and activists at the University of Panama, he became committed to creating political music dedicated to the "rescue of Panama's national identity and right to the Canal Zone."[76]

Castro's first song, "La Herencia del Pela'o" ("The Kid's Inheritance"), incorporated a panoply of Panamanian folk styles, foregrounding the accordion and three-drum (*pujador*, *repicador*, and *caja*) structure of *pindín* (also called *música típica* or *típico*). The song is narrated by a father addressing his son ("pelado," shortened to "pela'o" or "pela'ito," Panamanian slang for boy, "pelada," "pela'a" and "pela'ita" for girl) with advice for the future. The father's narrative ambles through Panama's linguistic, cultural, and geographic terrain, including all nine provinces, and highlighting the Darién, Costa Arriba, Colón, the interior (Azuero; Coclé; Penonomé), and Bocas del Toro. Along the way, the song indexes an

array of intimately localized cultural symbols, customs, and landmarks, such as *bunde* and *bullerengue* musical and dance forms; the Cristo Negro (Black Christ) in the town of Portobelo; the *bailes congos* (festive rituals of Afro-descendants along the Costa Arriba); *guari-guari*, a mélange of English and Spanish spoken by Bocas del Toro residents; and Kuna and Ngäbe-Buglé indigenous languages. Traversing the vast and dynamic reach of Panama, the song indicates facets that exceed the scope of the nation-state. Its refrain, studded with dropped consonants in the argot of the everyday, declares: "When you grow up, my son, when I die, I won't leave you much money, since I spent it on chimeras; I'll leave this land for you to love."[77] In the Gala, "La Herencia del Pela'o" established the conceptual frame of territorial inheritance and the generational transfer of knowledge and cultural practices.

Castro's second composition, "La Rosa de los Vientos" ("The Compass Rose"), also appears on Tuira's 1997 album *Herencia*.[78] In contrast to the baroque arrangements and syncretic forms of "La Herencia del Pela'o," this song featured a comparatively spare setup of lead singer on acoustic guitar and backup chorus, its title a reference to the maritime navigation tool.[79] Where "La Herencia del Pela'o" centered on generational instruction, "La Rosa de los Vientos" signaled weary resilience in the face of a catastrophic loss that has confused the compass and thrown the world into disorder. Singing in the Gala, the browbeaten song leader proclaimed his resignation, garnering the chorus's counterbalancing reassurance that "each man carries within him the traces of his time."[80]

As in other compositions by Castro, the dialogic lyrics and dialectical call-and-response format embedded the individual within historical structures of feeling; the collective chorus assuaged the leader's fears and doubts.[81] The song queried placelessness and exile, trauma and brutality, asking: "Who said that laughter had to emigrate?"[82] Indicting inequality in a flourish of apostrophe, the leader demanded: "Can you deny a name and drain a ghetto, raving that the North Pole is in the South?"[83] Locating himself in neither (Global) North nor South, he traced his nationality to the place "where the compass rose is born"—navigating his body/compass through choppy social and political seas, toward a better future.[84] The song offered tenuous hope, doubling the body/compass as corporeal symbol of a migrant's movement through storms, "*el vendaval* . . . political and military violence embedded in a long history of expropriation of regional goods."[85] The body/ compass metaphor also cited the many streams of migration composing Panama's populace and rendering it a location out of place, disorienting distinctions of North and South on the isthmus, whose discourses of modernity confront centuries of imperialism and capitalism, unleashing continual storms upon poor people. Like the first song, "La Rosa de los Vientos" incorporated the *saloma*, a distinctly Panamanian sonic register. The *saloma* is a well-loved sound in Panamanian music and daily life—a forceful cry that calls campesinos together in the rural interior.

The final song in the cycle, "Parte de la Historia" ("Part of History"), was the Gala's penultimate segment, preceding the closing anthem, "Patria." An elaborate salsa, "Parte de la Historia" featured a robust horn section, piano, cowbell, bass, congas, and timbales. The song's jazzy, syncopated rhythm evoked Panama's nexus of North and Latin American jazz. The song's use of salsa connoted transnational travel and cultural syncretism: emerging from Cuban *son* and utilizing its clave rhythm, salsa is also a Puerto Rican diasporic and Nuyorican form.[86] Intrinsically hybrid, salsa is the multicultural product of Cuban and Puerto Rican musical migrations and cross-class, interracial exchanges within the United States, attaining commercial success at midcentury but existing long beforehand in working-class venues.[87] Nugent and Castro cast the political potentialities of Canal reversion in a salsa form, pointing to the compositions and performances of Willie Colón, Rubén Blades, Tite Curet Alonso, and other socially engaged salsa artists. In the 1970s, the albums of these artists were recirculating to fan bases in Latin America after gaining international acclaim.[88]

Unlike overtly politicized *nueva trova*, much mainstream salsa is commercialized *salsa romántica*. Yet salsa's popular, working-class, mixed-race origins hold political dimensions. Cultural theorist Frances Aparicio identifies salsa as shaping raced, classed, and gendered identities, in intersecting local, national, and global contexts, and notes that salsa's emergence in marginalized urban poor and working-class communities of color has made it a music of resistance, interpreting the lived realities of its creators and audiences.[89] Scholar Ángel G. Quintero Rivera labels salsa a mixed-race music (*música mulata*), enabling political, social, and civic participation as a collectively authored, dialogic, and improvisatory form.[90] Aligned with jazz, salsa's collaborative creation allows for the contributions of multiple artists and delineates new participatory roles for musicians and audiences. Breaking with the orthodoxy of a Westernized instrumental hierarchy, the salsa *conjunto* places percussive instruments in the foreground.[91] Rivera also discusses the democratizing effects of improvisatory music on its listeners, especially in live performance.[92] While his constructions reify the binary of "West and rest," Rivera's observations aptly assess the political implications of salsa's dialogic format, particularly in its call-and-response *montuno* section. In this section, occurring toward a song's end, the leader can engage the chorus in dialogue, reiterate a song's central themes, riff on them in a *soneo*, or develop new exchanges with chorus and audience.

The *montuno* break in "Parte de la Historia" functioned to provoke. The chorus represented the masses and the song leader the instigator, attempting to rouse the collectivity to action. The leader opened the song by contemplating the millennial turn and the transformation taking place in Panama. In a patronizing tone, he admonished the chorus (and, by proxy, the audience) that "there will be no more protection nor spontaneity; now it will be your fault . . . and your chance."[93] The refrain continued the previous song's metaphor of maritime

travel, yet "Parte de la Historia" did not describe a disoriented compass buffeted by sociopolitical strife but rather a self-sufficient, empowered vessel—both a ship passing through the Canal's locks and Panama's "ship of state." The leader exhorted the chorus and audience to "navigate your own ship; weather the storm; avoid pirates and cliffs; you'll arrive at safe harbor."[94] Applying direct address and collectivizing the audience, he stated: "It depends on you, my people (*mi raza*), and no one will help you; you'll either be part of 'History,' or you'll be history."[95] In this pull-yourself-up-by-your-bootstraps lecture, the leader warned listeners to cease being passive bystanders "who ha[ve] only watched things happen" and to take control of their historical trajectory against the inexorable march of an anonymizing, leveling "history."[96] Citing (tenuously) Marxian historical materialism, the verses suggested that one must either be an agent of historical change or be passively enacted upon—a conceit that reproduced unilateral development discourse, figuring Panamanians as perennial spectators on the sidelines of history rather than actors in its central arena.

In response to these provoking words, the chorus dragged its feet, responding to the leader with an elongated, hesitant rejoinder of "well . . . but . . ." ("bueno, pues"). As in "La Herencia del Pela'o," the leader-chorus relationship was paternalistic, but in "Parte de la Historia" the chorus was configured as a reluctant child and the leader a cajoling father, replacing the United States in the patriarchal role. In the breakdown's improvisational dialogue, the chorus continued to hesitate while the leader agitated: "[let's make] a Panama with solidarity . . . for our children and grandchildren. You are the Generation of 2000, but you don't want to deal with the mess. [. . .] Don't make excuses, don't throw in the towel, this show (*función*) is all yours, the theatre is your home. The future has arrived, it's at your side; Ascanio [Arosemena] proclaimed it: *bandera, bandera!*"[97] Ascanio Arosemena was the first of several Panamanian students and civilians killed during the 1964 Canal Zone flag protests and is recalled in Panama as a "martyr." The "Generation of 2000" was intended to echo the "Generation of 1958," Panama's nationalist youth movement, which organized the initial protests that spurred public support for the handover. And *bandera* (flag) implied both the material flag and its attendant allusions to national sovereignty. The song ultimately enacted a conversion narrative, as the chorus came around to the leader's unstinting view. At the end, the melody, clave percussion, and drums (congas and *timbales*) of salsa gave way to a new rhythm, escalating in pace and intensity. Nugent utilized two *típico* rhythmic structures for the song's final measures: first, an *atravesa'o* rhythm in a 6/8 time signature, followed by the *tamborito*, a classic Panamanian rhythm. The salsa segued into the percussive palette of Panamanian *típico* music (the *pujador*, *repicador*, and *caja* drums and *churuca*), and the melody faded amid spare, forceful drumming. These rhythms provided a visceral

closure to the song, foregrounding drums to emphasize the legacy of African-descended peoples in the musical formation of Panama and Latin America.

In our interview, Castro attributed the tone of "Parte de la Historia" to a remark by a colleague in 1989 that "the United States has been our best pretext for remaining mediocre, for not doing anything ourselves."[98] Castro told me that he viewed 1999 not as the culmination of the Canal's handover (as other segments of the Gala portrayed it) but as the first phase in a process of reclaiming the Canal and responsibly integrating the former Zone into the nation. He observed: "All of these riches that reverted to Panama [were supposed to be] for the benefit of all Panamanians, and things did not work out that way. So we didn't fulfill our duty."[99] While some challenges had been met—administering the Canal, increasing its productivity, converting its revenues into sources of national wealth—others, like redistributing the ACP's revenues, remained poorly implemented.[100] When I inquired about the song's reception in Panama, Castro stated that "Panamanians did not like hearing" its critique, especially near the end of an event designated as celebratory. Yet he felt that it was important to explore, amid expressions of joy, some of the hopes, frustrations, and disappointments that remained to be considered.

Taken together, Castro's three songs charted a journey. The first enacted generational transfer, displaying a Panamanian father's knowledge of his local terrain for his child inheriting the isthmus. The second ruminated on recent political and economic crises and revealed a society in flux. The final song commanded audiences to seize the reins of history and chart a new course. Following Ana Patrícia Rodríguez's reflection upon the mode of address employed in "La Rosa de los Vientos," I note that each song had a different addressee: whereas "La Herencia del Pela'o" spoke to a child, "La Rosa de los Vientos" interrogated the structural violence of dictatorship, poverty, and forced migration in Central America.[101] Finally, "Parte de la Historia" interpellated the audience, hailing spectators as complicit participants in the actions unfolding in their temporary auditorium, the Panama Canal Area. Invoking the term *función* (performance and event) in the phrase "la función es toda tuya" ("the show is all yours"), the song leader referred both to the Handover Gala and to the performance of authority that Panamanians now exerted, the role into which they must "grow," to follow the developmentalist metaphor. Likewise, "the theatre is your home" interlinked the frame of performance with history, public and private space. Problematic as were these subject-positions, the three-song cycle as a whole provided a counterbalance, intervening in the Handover Gala's overarching narrative and shifting its focus from "the world" to the isthmus's localized present and future. While the Gala attended to the Canal's past as a triumphalist narrative of cultural integration and the US government's engineering victory over nature, the post-handover future seemed less clear-cut. By placing Castro's songs in the

final section, Quinn, Nugent, and Hernández made the event more contestatory than conciliatory. Evoking emotional unity and dissonant rupture, the Gala did not resolve the dilemmas at the handover's core. Rather, formal disaggregation worked to juxtapose cultural and racial specificity with national homogeneity, allowing artists and audiences to interrogate the opportunities and risks posed by the reversion of property, land, and resources to Panama.[102]

HOMELAND MADE WHOLE: RUBÉN BLADES'S PATRIA ENTERA CONCERT

In contrast to the disaggregated Handover Gala, Rubén Blades's Patria Entera concert wove a coherent overarching narrative, merging international and local musical valences into a political performance that touched on Panama's past, present, and decolonial future. While the Gala allowed multiple conflicting narratives to emerge, Patria Entera aimed for holism. Patria Entera's overarching message was not the utopia of an interconnected, borderless world, but of Latin American decolonization and liberation. In part, the political momentum underpinning Blades's concert's utopic vision of Panama's freedom from US occupation grew out of the chaos and rebuilding efforts of the post-Noriega era. Noriega's devastating ouster invigorated Panamanians' frustration with the status quo and stimulated public desires for electoral democracy and new political actors—a call that Blades sought to answer in cofounding the political party Movimiento Papa Egoró (MPE) with Rómulo Castro, Raúl Leis, and others.[103] During *peña* sessions at Castro's Panama City performance space, El Zaguán, Blades began to formulate the party and his presidential campaign.[104] The concert that he gave to mark the handover also situated Blades in a doubled identity, as performing politician and political performer. As an artist, Blades was long known for his socially engaged, overtly politicized, thematically and formally innovative salsa and world music; as politician, Blades had a rockier road to travel in gaining constituents' trust. In the aftermath of his failed presidential bid, Patria Entera engaged the dualities of his relationship to Panamanians as audiences and body politic.

Blades's interest in political music was conditioned by his upbringing in Panama. Born in San Felipe, a working-class urban area in Panama City and the setting of many of his songs, Blades grew up surrounded by music.[105] A polymath, he attended high school at Panama's prestigious National Institute and performed in bands like Papi Arosemena's Conjunto Latino, Los Salvajes del Ritmo, and Bush y Sus Magníficos in the 1960s while studying law at the University of Panama.[106] His initial musical influences were the North American genres that pervaded Panama in concerts (including tours by Black US artists like the Nicholas Brothers) and US military base Fort Clayton's SCN (Southern Command

Network), the first television station to broadcast the Beatles and Elvis in Latin America. Like others with whom I spoke, Blades recalled emulating US artists like Frankie Lymon:[107] "In Panama . . . we grew up loving the US—but I mean, loving the US like our dear friend. Everything US was for us a source of admiration, to the point that on the fourth of July, Panamanians went to the Canal Zone, picked up US flags, and applauded the troops going by, ate the hotdogs and . . . even declared . . . a national holiday."[108]

While nominally involved with Panama's nationalist Generation of 1958, Blades remained socially supple, performing in *West Side Story* at Balboa High School in 1968 with TGA friends Bruce Quinn and Carlos Williams.[109] Yet the Canal Zone protests deeply impacted his understanding of US presence in Panama: "500 wounded and 21 [sic] dead—that . . . was the most shocking thing you can imagine. [. . .] And it was so ugly, it made all of us in my generation . . . revise [our] position. And then I started paying more attention, and I saw the [segregation], and I thought about the American Indian, and then I had to say, 'What happened here?'"[110] After this period, Blades started to identify less with North American cultural influences and gained interest in Latin American and Latina/o music, politics, and history. In 1967, at the age of nineteen, he composed the song "9 de Enero" to honor the Panamanian "martyrs" of the Canal Zone flag protests. While critics in and outside of Panama have represented Blades as an international or US-associated artist, I concur with scholar Ana Patrícia Rodríguez's assessment of Blades's political and social consciousness as rooted in isthmian geopolitics. As he stated regarding the former Zone:

> The Canal Zone broke Panama in two: there were two states here. Some would say, "no, Panama was sovereign," but it was not. First, if I got arrested in the Canal Zone, I would be judged by a US tribunal in English, and whatever law was applied to this territory or dependency . . . that's what I would be subject to. [. . .] If I wanted to cross [the Canal], and a mounted policeman said, "no, you can't," I could not. It's not just that we couldn't go to the commissary or the clubhouse; it's about going through your own country. [. . .] As ridiculous as having a Russian enclave in the middle of Manhattan; you wouldn't accept it.[111]

Despite his growing critique of the United States, Blades's family moved to Miami, Florida in 1973 due to conflict with the Torrijos dictatorship. After graduating from the University of Panama, he joined them one year later. He had met musicians in New York while the Torrijos regime shuttered the University of Panama in 1969, and on return to the United States he left Miami for New York, found work at Fania Records, and began collaborating with salsa artists including Raymond Barretto, Héctor Lavoe, and Willie Colón.

Associating Blades with *nueva canción* (a genre that arose in the 1960s, thematically and melodically linked to *nueva trova*), José Davíd Saldívar argues that "from his earliest songs Blades has shown a predilection for radically experimenting with the traditional salsa form and content."[112] Even in his early career, he ventured away from *salsa romántica* tropes and incorporated political and social issues, as well as literary themes and techniques influenced by his readings of Franz Kafka, Bertolt Brecht, and Kurt Weill, and Gabriel García Márquez. For example, Blades's song "Pedro Navaja" refers to elite and popular culture, its anecdote of a pimp and prostitute rerouted from *Threepenny Opera*'s "Mack the Knife" to an urban Latin American streetscape. Blades has described salsa as an "international urban folklore, reflecting the sentiments of a Latin America in search of its unification and identity."[113] Many of his best-known compositions and performances treat blackness, slavery, colonialism, racial and social injustice and alterity, and African diasporic spiritual syncretism (selected examples being his early song "Juan González," "María Lionza," and "Canto Abacuá"). Other songs make explicit reference to salsa as urban, working-class, mixed-race popular music, depicting festive or tragic (or tragicomic) street scenes (examples include "Juan Pachanga," "Ligia Elena," "Amor y Control," "Decisiones," "Pablo Pueblo," "Adán García"). Blades honors his Afro-Antillean ancestry and St. Lucian paternal grandfather in songs like "Madame Kalalú" (1981) and "West Indian Man" (1992). Calypso, reggae, rock, jazz, soul, funk, disco, and North and Latin American folk and protest music suffuse Blades's repertoire, in addition to interventions in the "world music" genre (his 2002 album *Mundo*, for example).

Blades developed these combinatory, exploratory aesthetics in exchanges with Cuban, Puerto Rican, Panamanian, and North American artists. Noting the "intersection between his Afro-Cuban musical formation . . . and his 'magical' sociopoetic idiom," theorist José Davíd Saldívar labels Blades a "hybrid composer . . . open to two worlds and . . . formed within his local and global Borderlands."[114] Saldívar argues that "the hybrid thus becomes, through the lived-in simultaneity of the Americas, the ground for political analysis and social change." Blades's multiple vantage points enact temporal and geographic decentralization, positioning him in "a place of hybridity and *betweenness* in [a] global Borderlands composed of historically connected postcolonial spaces."[115] In other words, the cosmopolitan content of Blades's salsa does not disengage the grassroots and political contexts that Blades is documenting. Documentation is Blades's goal, not embellishment: finding "beauty in the grotesque," he seeks to "express reality as it is, without hiding anything" and "present a problem but not provide the solution. I have led a life of observation and had interchanges with all types of people. My subject matter demonstrates that lives that develop in obscurity end the same way."[116] Blades's autobiographical, "sociological" style

of storytelling has attracted a diverse public comprising cross-class, multiracial, bigender, and multigenerational listeners and concertgoers.

Soon after releasing the anti-US song "Tiburón" with Willie Colón in 1981, Blades became the first Latin American artist to sign with a major label, releasing *Buscando América* on Elektra Records in 1984.[117] This album, deemed part of his "crossover" success, moved away from the *conjunto* style and toward genre-mixing. While living in the United States, Blades and his collaborators explored links between Latina/o marginalization and Latin American political oppression, creating a "critical crossover" in addition to commercial success. Expanding on the idea of the "critical crossover," I argue that Blades enacted multiple crossovers—into the North American mainstream music industry and back to Panama, transposing his political performance style with that of a performing politician while retaining the interconnections afforded by both of these personae.[118] *Buscando América's* critical crossover foregrounded political songs like "Desapariciones" (dedicated to the Madres de la Plaza de Mayo in Argentina) and "El Padre Antonio y el Monaguillo Andrés" (hereafter called "Padre Antonio").

These songs expressed anti-US and antidictatorship messages, touching on conflicts across the Americas. The songs linked the US government's anti-Communist military interventions—many coordinated from the Panama Canal Zone—to proxy wars, coups d'état, dictatorial regimes, and neoliberalism in the Western hemisphere. "Padre Antonio," one of Blades's most important songs, recounts the assassination of a popular village priest and an altar boy. The song refers to the 1980 killing of Bishop Óscar Arnulfo Romero by an El Salvadoran death squad linked to the US-operated School of the Americas (then located at US military base Fort Gulick, on the Atlantic side of the Canal Zone). Panamanians also related the song to the 1971 kidnapping and murder of Panamanian priest Father Héctor Gallego by the Torrijos regime. With careful attention to detail, "Padre Antonio" balances a message of hope—"you can kill the person, but you can't kill the idea"—with a narrative technique that invites audiences into a tragic scene through visual cues rather than melodrama. The understated imagery of the everyday that grounds the song's narrative paradoxically heightens the intensity of the crisis when the assassination comes into focus. Details—for example, that the soccer-loving altar boy died without ever meeting his hero, Pelé—unspool, accreting into wrenching evidence of lived grief in minutiae and quotidian recollections instead of grand tableaux. In later work, Blades honed this engagement with broad concepts, like social justice and antiwar protest, through an image-laden storytelling style that builds an accumulation of details to body forth a larger schematic.

In the late 1980s, Blades was working toward a master's degree in international law at Harvard and performing with his band Seis del Solar, later renamed Son

del Solar. The 1989 invasion of Panama, carrying echoes of 1964, permeated his US-based career. Blades recalled talking on the telephone with his father, who was in Panama, as "22,000 troops invaded Panama in the largest American military intervention since Vietnam."[119] The invasion and ensuing political crisis prompted Blades to form Movimiento Papa Egoró (MPE) in late 1991, which registered as a political party the following year.[120] MPE was independent from but influenced by the National Civic Crusade (called the Civilistas), a consortium of civil society and business organizations that protested Noriega's dictatorship beginning in 1987.[121] The Civilistas emerged from (or "co-opted," as Orlando Pérez writes) the Coordinadora Civilista Nacional (COCINA), which protested the dictatorship in the early 1980s.[122] In 1988, Blades released the song "Patria," encouraging the Civilistas to adopt it as an anti-Noriega rallying anthem.[123] The group did not take up the song, despite its nationalist themes and overtly anti-dictatorship lyrics.[124] Blades viewed this as a sign that "the Civilistas did not value this as an act of collaboration with the resistance."[125] Further, Blades felt that many Panamanians questioned his investment in the anti-Noriega movement and discounted his music as a valid form of activism.

These factors motivated the cofounding of MPE as an alternative to Panama's two predominating political parties, the PRD (Partido Revolucionario Democrático, the party of Torrijos and Noriega) and the Arnulfistas, named after Panama's former president Arnulfo Arias, promulgator of the xenophobic 1941 constitution.[126] The MPE was transnational in scope, including high-profile supporters in the United States. In Panama, the MPE attracted cross-class supporters from the disaffected former ranks of the PRD and Civilistas, including anthropologist Raúl Leis, Rómulo Castro, Fernando Manfredo Jr., and Ricardo J. Bermudez.[127] The heterogeneous (and often internally divisive) MPE base included "the guy who lives in Curundú [a low-income area] and the guy who lives in Paitilla [a wealthy neighborhood]."[128] In 1992, after convening grassroots town hall sessions on Panama's post-handover future, the MPE released a position paper, titled "Una Sola Casa" ("One Single House"), which presented the party's platforms, proposed economic and political reforms, and social policy initiatives.[129] The white paper advocated governmental decentralization and economic transparency, enhanced civil and human rights protections, strengthened cultural and educational policies, and ecological safeguards. Yet the MPE avoided labeling itself politically "left," instead offering an inclusive alternative to Panama's two-party system. Born "without [mediation] by the military or banking elite," the MPE sought to avoid the binary of "all nationalism and no democracy [PRD] versus all democracy and no nationalism [Civilistas]."[130]

The position paper cited Panama's "emergency": ballooning foreign debt and unemployment, a 55.5 percent poverty rate, and widespread political

disenchantment.[131] Noriega's rule and the US invasion had left Panama "a disintegrated country," traumatized, violent, disarticulated, and riven with racial, class, gender, sexual, and anti-indigenous discrimination.[132] Yet the paper also labeled the situation an "economic, political, moral, and social crisis," focusing on the etymology of "crisis" as "decision," and sensing, in the widespread disenchantment with the political status quo, an opportunity for dramatic social transformation toward real democracy, in which poor people's voices would be heard.[133] Addressing the implications of globalization, MPE stated: "Our national slogan, 'Pro Mundi Beneficio,' is understood by our movement to be 'Pro Panama.' Panama first—our interests out in front."[134] This "nation-first" platform sought to link all nine provinces in the country's "integral economic development," instead of concentrating wealth in Panama City's financial metropolis. The MPE proposed the construction of an auxiliary service center in the former Zone to develop infrastructure on former US military bases and retrain the labor sectors that had benefited from the military's presence.[135] The party "registered, in surveys across the nation . . . opposition to the privatization of strategic national goods" in the reverted areas.[136] Proposals for reverted lands "should not be limited to economic factors. We need to consider the cultural possibilities of recreation and environmental conservation . . . we cannot forget the social function that the reverted areas should fulfill."[137]

Many were drawn to Blades's presidential campaign and the MPE's platforms, which, in the words of artist Ela Spalding, might "have made Panama one of the best places to live."[138] Although Blades did not win the 1994 election, he garnered third place among seven candidates, superseded by frontrunner Ernesto Pérez Balladares, nicknamed "The Bull" (PRD), and Mireya Moscoso, Arnulfo Arias's widow, who became president in 1999.[139] Despite the PRD's association with dictatorship, and Panamanians' general mistrust of Balladares, PRD leaders sought to convert the party's image into one of civilian, democratic reform.[140] Although it had broad-based support, Blades's MPE dissolved after the 1994 election. In early 1999 Blades endorsed PRD presidential candidate Martín Torrijos, son of the late General Omar Torrijos.[141] This endorsement, several months before the May elections that placed Moscoso in power, perplexed and angered MPE followers. What, if anything, was the motive behind Blades's endorsement of General Torrijos's son? Had the 1994 campaign been a chimerical flirtation with Panamanian voters?[142] Was the party finished, or would Blades revive it to run for president in the future? These questions dogged Blades during the Patria Entera concert on December 31, 1999.[143] The MPE's remaining representatives released an official statement that the concert would not pursue "political goals other than national unity, peace, optimism, and healthy diversion," although Blades's unapologetically political music "serves to confront realities."[144]

PATRIA ENTERA: DECEMBER 31, 1999

While Blades's party faltered under the weight of its ambitions to overhaul Panamanian politics, the MPE fostered new artistic relationships, resulting in Blades's locally created, collaborative albums *La Rosa de los Vientos* (1996) and *Tiempos* (1999). These albums attended to Panama's landscape, cultural composition, and musical forms, including the *típico* music of accordionist Osvaldo Ayala (the 1996 album contained Ayala's songs "Eres Mi Canción" and "Mi Favorita," which he performed in the Patria Entera concert). Rómulo Castro also played a major role in the partnership. After producing *La Rosa de los Vientos* on Castro's label, Kiwi Records, Blades worked with the Costa Rican band Editus on *Tiempos*, for which Castro contributed several compositions dedicated to Panama: "El Puente del Mundo," "Tú y Mi Ciudad," and "Encrucijada."[145] Paying tribute to these years of local collaboration, Blades featured Castro's compositions in Patria Entera, his first official performance in Panama since his electoral defeat five years earlier.[146] Patria Entera began just after the official acts of transfer, at Fastlich Field in the former Zone, the Administration Building looming behind the stage. The arena-style event, open to the public free of charge, was named "for the fact that at noon on the 31st of December the Canal will pass to Panamanian hands, converting the country into a 'whole Patria,' with full sovereignty over all its national territory."[147] Blades followed Patria Entera with an exclusive, paid-entry "Gala of the Millennium" for 2,500 elite attendees on Isla Flamenco, near the former US Fort Amador, for which he received a fee of $30,000.[148]

Sponsored by Panama City's mayoralty, Patria Entera celebrated "the transfer of the Panama Canal and the full reversion of lands occupied by the US government for 96 years."[149] More than 20,000 people attended the concert, with up to 400,000 watching it on national and international television broadcasts, Internet transmissions, and giant projections along Panama City's central commercial thoroughfare, Vía España.[150] The newspaper *Panamá América* reported that "eighty per cent of Rubén Blades's repertoire will be based on his old songs, which have brought him such glory . . . especially 'Patria,' which might be said to be the [national] hymn of the moment, in an environment where Panamanian flags will surely be flying."[151] Panama City mayor Juan Carlos Navarro opened the concert with a speech "congratulat[ing] Panamanians on the historic recuperation of the canal, a national triumph that unites all and permits the country to enter the new century as a 'whole fatherland,' with the hope of national development and progress" and "highlight[ing] that all Panamanians should work together with commitment."[152] The concert's first acts were well-known Panamanian "national artists" Sammy y Sandra Sandoval and Manuel de Jesús Abrego. Then Editus and Blades took the stage for approximately three hours of performance,

TABLE 5.1. Rubén Blades's Patria Entera concert set list, December 31, 1999

Song title	Album title	Release year	Notes
1. "Pablo Pueblo"	*Metiendo Mano*	1977	
2. "Decisiones"	*Buscando América*	1984	
3. "Juan Pachanga"	*Bohemio y Poeta*	1977, 1979	
4. "Camaleón"	*Caminando*	1991	
5. "Todos Vuelven"	*Buscando América*	1984	
6. "Amor y Control"	*Amor y Control*	1992	
7. "Caminando"	*Caminando*	1991	
8. "Ligia Elena"	*Canciones del Solar de los Aburridos*	1981	
9. "Padre Antonio"	*Buscando América*	1984	
10. "Puente del Mundo"	*Tiempos*	1999	Composed by Rómulo Castro
11. "Eres Mi Canción"	*La Rosa de los Vientos*	1996	Performed with and composed by Osvaldo Ayala
12. "Mi Favorita"	*La Rosa de los Vientos*	1996	Performed with and composed by Osvaldo Ayala
13. "Muévete"	*Escenas*	1985	Composed by Los Van Van
14. "Ojos"	*Siembra*	1978	
15. "Plástico"	*Siembra*	1978	
16. "Pedro Navaja"	*Siembra*	1978	
17a. "9 de Enero"	—	ca. 1967	
17b. "Tiburón"	*Canciones del Solar de los Aburridos*	1981	
17c. "20 de Diciembre"	*Tiempos*	1999	
18. "Patria"	*Antecedente*	1988	

Source: Canal 11 footage of Patria Entera concert, 1999.

with appearances by Osvaldo Ayala.[153] Blades covered over two decades of his music, along with a penultimate medley merging "9 de Enero," "Tiburón," and "20 de Diciembre," before culminating with "Patria" (see Table 5.1 for song list).[154]

Judging from footage of audience response captured in the concert's televised broadcast, the playlist of Patria Entera was familiar to most in the crowd. Throughout the interactive concert, Blades's amplified onstage performance was accompanied by the constant, audible hum of audience members singing along. Blades frequently paused and yielded to the audience, which sang back or embellished his verses and refrains. After each song, audience members called out new requests. A few Papa Egoró signs floated in the crowd, remnants of the 1994 MPE campaign, but they were dwarfed by oversized Panamanian flags that traced large arcs in the air amid a shivering forest of smaller flags. Although several audience members whom I interviewed felt skeptical of Blades as politician or disappointed by his PRD endorsement, they were still able to invest emotionally in Blades's music. Panamanians had mostly watched Blades's rise to fame from afar, and many criticized his internationalized persona, which made him seem inaccessible and oblivious of local issues during his presidential campaign. But positive, enthusiastic audience response during Patria Entera indicated that Blades was able to transmute his international star-text into that of a "national artist," successfully connecting with audiences in performance as a local representative of the Canal's handover.[155]

Blades effected this transition from international celebrity to "national" artist through progressive shifts in costuming, persona, biography, and sonic referents. His decision to open his concert with "Pablo Pueblo" helped to ground his persona in Panama straightaway. One of his first major hits, "Pablo Pueblo" treats the daily frustrations of a relatable average person, midway between human and symbol ("pueblo" meaning "the people" and "the folk," as well as "town"). As captured in concert footage, during "Pablo Pueblo" Blades inserted *soneos* (improvised declarations) calling out Panama City's working-class neighborhoods of Chorrillo, Calle Segunda, and Carrasquilla, the last his childhood home. This marked the first of many instances in which Blades employed the *soneo* to intervene in and localize his repertoire, highlighting spatial and temporal specificities that resonated with audience members. In these improvisational moments, Blades interwove his personal biography with the nation's history. He chronicled his life as a young boy from the *solar* and student at the National Institute and the University of Panama. At other moments, like the end of "Todos Vuelven," he extemporized connections to significant historical Panamanians (including historian Ricaurte Soler, Ascanio Arosemena, and composer Roque Cordero) and present-day icons (Alexis Batista, Davis "Junior" Peralta, Eusebio Pedroza,

Carlos López Guevara, Adolfo Ahumada), representing Panama abroad, in sports (Batista, Peralta, Pedroza), and in US-Panama relations (López Guevara, Ahumada).

Patria Entera also incorporated songs framed as "national" repertoire ("Eres Mi Canción," "Mi Favorita," "Puente del Mundo") and performed by "national artists." Blades inserted a *saloma* into songs like the salsa "Juan Pachanga" to situate his compositions within a distinctly Panamanian register. Finally, he offered a constant stream of commentary on "this historic day," emphasizing the country's unification with frequent exhortations of "una sola casa," "una sola bandera" ("one house," "one flag"), and "¡Viva Panamá!" Blades's extemporaneous outbursts grounded the concert in the handover's historicity, while the audience's view of the Administration Building positioned the stage in the former Zone, mixing symbolism and materiality and providing space for audiences' conversion from spectators to co-participants in the unification of the country's geography and polity.[156] During "Amor y Control," which treats parent-child relationships, Blades improvised a comparison to the Panamanian "family, united and in one house." He shouted, "We need 'love and control,' people!" to bursts of audience cheering and applause.[157] The theme of unity was reiterated and intensified in "Ligia Elena" and "Muévete!" (the latter adapted from Cuban band Los Van Van), songs that address racism. In the first song, the title character elopes with a Black trumpet player, disappointing her family. The second song carries an explicit antiracist message. Blades used this moment to mention his recent appointment as one of six United Nations Anti-Racism Ambassadors, and his intention to be more than "a paper ambassador."[158] During "Ligia Elena," he linked antiracism to Panama's reunification: "Whites, Blacks, Asians . . . we are all united as one people! Without racism! What matters is a person's character, down with racism," and so on.[159]

Blades continually extrapolated from his songs to conditions on the isthmus. During "Padre Antonio," he linked the Canal's reversion to ongoing struggles for social justice across Latin America and the Caribbean. "Padre Antonio" has often been adopted as a social justice anthem, but here Blades concretized its connection to Panama's history by invoking Ascanio Arosemena and Ricaurte Soler, making the church bells (*campanas*) that ring after Padre Antonio's assassination into "campanas panameñas" signaling "nuestra libertad" ("Panamanian bells" signaling "our freedom"). Blades also sang "suena el canal . . . limpiado de la pena" ("sound the Canal . . . washed clean of shame/sorrow")—equating the waterway with the bells' intonations of resilience and regeneration.

Local histories were further expounded in "Eres Mi Canción" ("You Are My Song") and "Puente del Mundo" ("Bridge of the World"), two songs showcasing

Panamanian folklore. In the first song, Blades introduced canonical Panamanian *pindín* accordionist Osvaldo Ayala as "an important 'national artist' (*artista nacional*)." Blades asserted: "We're showcasing not only international artists but also *artistas de patio*." This statement implicitly juxtaposed his cosmopolitan persona with Ayala as local folk artist, the "patio" as formative site of (rural, *santeño*, campesino, *típico*) Panamanian folk identity, and the source of the nation's mythological ethnos.[160] By contrast, Rómulo Castro's "Puente del Mundo" traced the geographic and historical expanse of the isthmus in similar fashion to "La Herencia del Pela'o." The song chronicled Panama's history of foreign invasions and aggressions, including the 1856 "Tajada de Sandía" massacre.[161] In addition to featuring *salomas*, the song incorporated indigenous vocabulary to depict a populace "Ngöbe-Buglé, Emberá, Chocó, white, Black, and Kuna." During the song's *montuno* break, Blades cited vignettes like "the city of Colón after a downpour," which elicited audience identification (Panama's rainy season spans nine months of the year). "Puente del Mundo" integrated folk, rock, and jazz, and featured a plethora of instruments, including guitar, violin, piano, and cymbals, to build a multifaceted sonic portrait of Panama as a place of hybrid identities in motion, exceeding categorization and refusing stasis. Patria Entera's televised broadcast complemented the performance with scenes from daily life and familiar locales for Panamanian audiences, aerial views of the Canal Area, and images of representatives of diverse groups. As he sang, Blades progressively donned symbols of *panameñidad*, including a necklace with a Panamanian flag. Finally, he exchanged his sunglasses and signature black porkpie hat—symbols of his cosmopolitan "jazz" sensibility—for a *típico* straw hat, signifying his affiliation with the folk culture of the interior.

Just before the concert's conclusion, Blades ran through a rapid progression of songs considered his most provocative repertoire. These songs, "9 de enero," "Tiburón," and "20 de diciembre" ("January 9," "Shark," "December 20"), marked a departure from what had come before. All of these songs have spawned controversy for their overt anti-US sentiment. "Tiburón" characterizes the United States as a shark patrolling the ocean and eating "shrimp" (i.e., small countries like Panama, El Salvador, and Puerto Rico); "9 de enero" recalls the 1964 flag protests; "20 de diciembre" the 1989 invasion. Blades presented the songs in the order of their composition, playing straight through with no pauses. Abandoning his instrument-laden band, he performed with only drums and vocals. This spare, minimalist presentation isolated the medley and channeled audience attention to Blades's focused narration of Panama's trajectory of US intervention and imperialism. After this brief but potent rupture of the festive frame, Blades readopted the band's full instrumentation and segued into "Patria," closing the concert with a sense of resolution. For "Patria," Blades was joined onstage by many of those whose names he had spoken during the concert, including

scholar Carlos López Guevara, Canal treaty negotiators Adolfo Ahumada and Omar Jaén, basketball player Davis Peralta, jockey Alexis Batista, boxer Eusebio Pedroza, and pianist and composer Danilo Pérez.[162] Also present onstage were several women in formal *polleras* (Panamanian *típico* dress) and representatives of Afro-Antillean, Kuna, Emberá, and Ngäbe-Buglé ethnic and indigenous groups, as if embodying the multicultural theme of "Puente del Mundo." As Blades sang his "second national anthem," the broadcast showed scenes including Panamanian Olympic athletes, historical footage of the Zone, and the Coca-Cola Café, a familiar landmark in Panama City's Santa Ana neighborhood.

The lyrics and melody of "Patria" exemplify Blades's inductive storytelling style, which builds from ephemeral details to a general conclusion. Here, the conclusion is nationalism, the symbolic binding agent of the "imagined community."[163] As noted at the outset, "the nation" is impossible to visualize. Benedict Anderson gives the example of the Tomb of the Unknown Soldier as a consummate symbol of the nation, in that its empty signifier, or open cipher, is sufficiently general to unite a diaphanous, heterogeneous polity in popular sovereignty—the modern secular nation-state as the absence of a centralized sovereign figurehead.[164] Yet "Patria" seeks to stage nationalism differently—as an attribute of the everyday, without solemn ceremony, and in highly concrete images.

"Patria" uses salsa's clave rhythm and instrumentation, with their implications of popular reception and social dance. The infectious melody is a conduit for a progression of relatable images, which invite listeners' identification, recognition, and emotional attachment. The song opens unpretentiously and intimately, with light drumming and the narrator's scatting, almost as if humming to himself. In the narrator's anecdote, he is approached by a young boy who asks him what the word "patria" means. The narrator wants to provide a definition but is unable to do so due to a sudden, paralyzing wave of emotion. He resorts to condensed images to represent the "many beautiful things" elicited by the term, like "that old tree, talked about in that old poem;" "the affection that you feel for your grandmother after her death"; and "the walls of the *barrio*, of its brown-skinned hope . . . all that you carry in your spirit, when you move away."[165] The narrator continues relating impressionistic snapshots: "*Patria* is a feeling, in the gaze of an old man . . . the laugh of a newborn sister." Although the lyrics also include well-trammeled nationalist tropes ("martyrs" and "flags"), these are intertwined with images of the everyday: people, places, and objects glimpsed on the street. The effect is to render abstract symbols as fleeting visions, layered between drumbeats and the call of the trumpet (a "nationalist" instrument of patriotism and militarism indeed). Here, though, the trumpet appears in the salsa horn section. Like "Padre Antonio," "Patria" places visual details in the foreground as material indexes of abstract sentiment. As concretely visual as these images can be,

they are also sufficiently general to apply to a variety of situations, producing a paradoxical sense of concrete abstraction that mimics the working of nationalism itself.

CONCLUSION: STAGING SOVEREIGNTY AND INCLUSION

In 1999, Panamanian social and governmental institutions filled the public sphere with activities related to the Canal's handover. Among these, the Handover Gala and Patria Entera utilized performance practices to transform Panamanian audiences into an embodied (if momentary) populace. The performances sought to script participants' bodies into discourses of national belonging and map sovereignty onto the former Zone's spaces. They also sought to symbolically "open" the reverted lands to audiences and publics. Positioning audiences within the former Zone, both events interlayered symbolism and materiality: subjunctivity's "as if" converged with the reality of reversion and the norm of sovereignty, buttressed by, and reinforcing in turn, the performative transfer. Panamanian audiences' physical presence in the former Zone enabled them to perform, perhaps momentarily, the roles of the Canal's inheritors and guardians. While both performances sought to make the Canal Area more inclusive and narrate the isthmus's past, present, and future, each utilized distinct methods. The Gala opted for a disaggregated format, including spectacular pageantry, fictional representations, and interrogations of Panamanians' contemporary lived experiences. Some direct address was employed, but most scenes invited viewing in the style of conventional realist theatre—a passive audience and reconstructed fourth wall. Nostalgia and fantasy were central components of the Gala, which portrayed mythic Mesoamerican indigenous peoples, early "Zonians," and construction-era West Indian labor migrants. These historical characters were enacted by performers like Ela Spalding and Sarah Knapp, who felt linked to the roles by their own biographies. Combining historicity and symbolism, then, the Gala sought to raise audiences' awareness of their place in the transfer of power while ensconcing them in fictive entertainment and pedagogical interludes. Direct participation was limited—audience members could not, for example, enter the stage and interact with performers—but spectators could gaze around them and reflect upon the "spatiality" of the former Zone.[166]

In contrast to the Gala's interlock of fact and fantasy, Patria Entera sought to (re)present familiar repertoire by well-known Panamanian musical artists. The frame was resolutely realist and biographical. Evoking configurations of urban life in the Americas, lead performer Rubén Blades guided audiences through a narrative of Panama's place in a regional geopolitical history and traced a trajectory of the nation's transition from occupation to liberation, from colonization to "full" sovereignty. While the Handover Gala delved into a deep past, the

timeline of Patria Entera was tailored to the span of a human life. Patria Entera traced Blades's personal past, entwining his childhood, adolescence, and adulthood with US interventions and geopolitical conflicts in the Americas from the mid-to-late twentieth century. The concert combined international and local referents: Blades jockeyed between personae of Panamanian and cosmopolitan, political performer and performing politician, linking his international repertoire to those of *artistas nacionales* and *artistas de patio* like Osvaldo Ayala. With improvisatory commentary and extensive direct address, Blades positioned his social justice–themed music as a medium for sonic representations of *(afro)latinidad, panameñidad,* masculinity, marginalization, decolonization, resilience, hope, and empowerment across the Western hemisphere. Both events, nonetheless, concluded with masculine generational transfer: in the Handover Gala, the father-son dialogues of "La Herencia del Pela'o" and "Parte de la Historia"; in Patria Entera, the narrator's attempt to explain the meaning of "fatherland" to a child.

Both performances confronted two questions: first, how to displace the former Zone's deep-seated history of exclusion; and second, how to stage the "sovereign people" in ways that would resonate with artists and audiences and, hopefully, stimulate participants' desires for continued involvement with the Canal's future, post-handover. The two performances strove to build upon, and ultimately displace, hegemonic iterations of the Canal Zone as a paradisiacal space restricted to Zonians, in favor of a postmillennial, postcolonial sovereign utopia, recuperated by and for Panama's citizens. The events' organizers both reiterated and challenged long-standing discursive constructions of the Panama Canal Zone as a white "paradise" or "utopia."[167] The Canal Zone was characterized throughout US occupation as a "lush green enclave of middle-class prosperity surrounded by [Panama's] teeming poverty," "an idyllic playground," and "Shangri-La."[168] Late Panamanian architect Eduardo Tejeira Davis notes: "What many people find attractive about the architectural landscape and urban legacy of the Canal Zone . . . is a product of Panamanians' nostalgia: faced with the chaos of Panama City today, the Canal Zone seems a paradise of order, tranquility, and ampleness. [. . .] [T]he monumental and residential ensembles of the Canal Zone were purposely developed with their backs turned to Panama City and Colón—and according to highly controlled conditions that cannot be repeated in an environment where private ownership of land prevails."[169]

Historian Alan McPherson reveals Panamanians' views that Zonians "held all the desirable, racially-segregated jobs in this well-tended tropical paradise. In the eyes of watchful Panamanians, [Zonians] embodied US empire in all its greed, racism, and paternalism."[170] Although this is an oversimplification, in 1999 discourses of paradise, utopia, and Eden continued to circulate around the Canal Zone. Many of my interviewees voiced these sentiments when describing the

past and present Canal Zone/Area. Nugent described the Zone as a "utopian environment: everything was perfect, clean. You had everything you needed. Playgrounds for the kids, you don't pay light or rent. [. . .] The scenery, environment were totally different. The housing, versus what we had on our side . . . it was really bizarre."[171] Hernández recalled the Zone as "a little utopic town" where "everything [was] in pristine order."[172] These ideas surfaced over and over, in my interviews with Zonians and non-Zonians alike.

Given that many Panamanians defined the Canal Zone's utopia in relation to their own senses of alterity and estrangement, both the Handover Gala and Patria Entera aimed to unify audiences into a (momentary) body politic through what performance scholar Jill Dolan would describe as "utopian performatives." Utopian performatives are "received moments of [Brechtian] *gestus*, [in which] pictures of social relations become not only intellectually clear but felt and lived by spectators as well as actors."[173] As Dolan observes, citing the work of fellow theorist Elin Diamond, utopian performatives are axes at which Austinian performative utterances "materializ[e] as performance in that risky and dangerous negotiation between a doing (a reiteration of norms) and a thing done (discursive conventions that frame our interpretations) . . . [giving] access to cultural meanings and critique."[174] I would qualify this statement by noting that, since reception is always heterogeneous, these moments allow for the *possibility* of access to meaning-making and critique. Utopian performatives implicate performativity and subjunctivity in an unpredictable, oscillating dance: the norm is made to press up against the possibility of seeing "as-if." The subjunctive futurity of performance can allow not only for a critique of the inadequacies of the present but also, possibly, illuminate something not presently known. For the Gala and Patria Entera production teams, strategic deployments of mise-en-scène, embodiment, and narrative engendered new ways to inhabit the Canal Area, in leisure and joy, rather than labor and disaffection.

The events' creators also felt that the social and political (re)construction of Panamanians as a polity, aligned with their physical gathering in the former Zone, was imperative to the production of new conceptualizations of the Canal's relationship to Panama. Performance provided a way to project new conceptions of nationality, racial and cultural diversity, socioeconomic equity, and political participation onto the collected (and ideally collective) audience body. Joseph Roach argues for the centrality of performance practices, or "restored behavior," in performance scholar Richard Schechner's words, as conduits of social memory, mediating between past and present, physical and symbolic bodies, and the individual and the collective. Roach asks: "On a scale of organization any larger than that of the village, how is a deep sense of common culture to be instilled?"[175] Citing anthropologist Paul Connerton's classic study, *How Societies Remember*, Roach contends that a "people" is "formed by viewing representations of actions

that might or might not at any moment be substituted for their own through the restoration of behavior."[176] Connerton observes that commemorative ceremonies inculcate shared social memory through their use of performativity—the bodily deployment of discursive and representational citations that Connerton links to "habit."[177] As Connerton notes, even commemorations of a new historical chapter or regime change must account for the fact that "all beginnings contain an element of recollection"—a maxim that the Gala and Patria Entera both engaged.[178]

Roach and Connerton both link performance to kingly sovereignty. As Connerton notes, the ritual execution of Louis XVI "was not the murder of a ruler but the revocation of a ruling principle . . . according to which the dynastic realm was the only imaginable political system."[179] Executing the king meant killing the representative body of sovereignty's political theology. In similar ways, the site-specific commemorations in the former Canal Zone sought to ritually and corporeally transform a regime of sovereignty, from militarization and foreign occupation to decolonial autonomy and national reunification. In these handover commemorations, representations of changing sovereignty were not concentrated in a sovereign head of state, but displaced into the audience as a collective embodiment of popular sovereignty—those who gathered in the former Zone performing "incorporating practices" that socially constructed their bodies as citizen bodies.[180] These incorporating practices involved narrations of a collective past—"memory [as] sedimented, or amassed, in the body"—and projections of possible post-handover futures.[181]

Staging the "sovereign people" on the isthmus posed multiple challenges, however. Roach qualifies his optimism about the power of performance to make audiences into a public with the assertion that "the threat of surrogation also raises questions about the fictional status of [a people's] identity and their community."[182] The commemorations' fictions of an inclusive, even utopian Canal Area could not avoid certain realities. As the performances put forth visions of the isthmus's political future, forces of global capital, private property ownership, and foreign resettlement were steadily fissuring sovereignty's symbolic and material fabric. Both events downplayed, or ignored outright, changes underway since 1979 to radically reshape the Canal Area's political and economic landscape. As architect Eduardo Tejeira Davis notes, under US rule the Canal Zone's abolition of private property created a unified, coherent territorial aesthetics and a centralized governing structure. After 1979, amid the handover's many positive aspects—decentralization of the former Zone, rise of Panamanian leadership, demilitarization—the Canal Area was aggressively privatized, its spaces fragmented into an incoherent array of micro-enclaves and miniature "Zones." In 1999, Panamanians stood to inherit an idea, an abstract symbol of nationhood, while conditions on the ground produced little material evidence to support

the idea that "rescued sovereignty" would benefit average citizens. The former geopolitical Panama–Canal Zone border fractured into a thousand proliferating micro-borders engendered by private capital, as the Zone was resettled by wealthy local and foreign interests.

In addition to this material challenge, democratic sovereignty poses irreconcilable paradoxes, at the registers of history and theory. Political theorist Wendy Brown examines the "waning" power of the sovereign nation-state in late modernity, beset by "unprecedented flows of economic, moral, political, and theological power across national boundaries."[183] The history of the isthmus throws into doubt whether the "nation-state" has ever, in fact, been coherent and impermeable, and whether these transnational flows truly are "unprecedented." In Panama, commercial flows have, for centuries, rendered national sovereignty spectral at best. Brown also cites the role of the United States, "the world's oldest continuous democracy," in its "overtly imperial conduct, during the Cold War and also in its aftermath . . . the legitimating aim of which, universal democracy, has paradoxically entailed both domestic subversions of democracy and disregard for other nation-state sovereignties."[184] Such behavior makes the US act of "giving back" the Canal seem hypocritical, after nearly a hundred years of "occupation without annexation." There are at least two ineluctable paradoxes at the core of sovereignty on the isthmus: first, the geopolitical history of the US government as subjunctively sovereign in the Canal Zone; and second, the central catachresis of sovereign democracy, which has flummoxed political theorists for centuries.[185] As Brown states, "it is nearly impossible to reconcile the classical features of sovereignty—power that is not only foundational and unimpeachable, but enduring and indivisible, magisterial and awe-inducing, decisive and supralegal—with the requisites of rule by the *demos*."[186] She continues: "Insofar as the people authorize the suspension of their own legislative power in granting prerogative power to the executive, they suspend their sovereignty in the name of their own protection or need. But a sovereign that suspends its sovereignty is no sovereign."[187]

The task of representing the sovereign demos is complex, if not impossible. These two incoherencies explain, in part, why the Handover Gala and Patria Entera ultimately found respective solutions in a disaggregated format and the participatory, dialectical, and border-breaching sounds of salsa music. Rather than attempting to represent "the sovereign people" through visuality and embodiment, both performances sought routes around the visibility trap. A disaggregated format allowed the Gala to weave fact and fantasy in framing "the sovereign people" of the isthmus, over an extended spatiotemporal trajectory. This format did not force "the people" into a category; the possibility remained for Panamanians to take away a message of "the people" as both multicultural mosaic and assimilative product of mestizaje, because the contradictory

positions put forth by the Gala's individual segments were allowed to coexist within a flexible frame. The event enabled audiences to practice heterogeneous viewing and selectively interpret the historical and symbolic information that it staged. In Patria Entera, by contrast, salsa's dialogical relationships allowed Rubén Blades to create a space privileging participatory sonic transmission. Sound, bodiless and uncontained, can traverse borders in diaphanous aerial flight.[188] Sonic iterations of sovereignty supersede spatial materiality and connect multiple generations over time, engendering new ways of representing and unifying "the people."

Ultimately, both events recognized the persistence and proliferation of borders within the (post)colonial surrogation of Panama and the Canal Zone. The isthmus, as globalized commercial conduit and local polity, has long hosted debates over how (and whether) to enact legal sovereignty, decolonization, and nationhood amid intervening forces of transnational imperialism and capitalism. The end of the handover saw a prolongation, not an erasure, of these debates. Some Panamanians anticipated entering roles vacated by the US government, while others called for radical rupture and a wholesale rethinking of these roles and institutional structures. Amid a climate of uncertainty, the Handover Gala and Patria Entera invited audiences into the Canal Zone, linking past, present, and future through leisuring bodies. Despite their overarching goals to unify a public, both performances allowed for slippages, gaps, and acts of "viewing otherwise"—the emergence of uneasily assimilated narratives of the Canal's postsovereign future, alongside the potential for "utopian performatives." The interplay of site-specificity and subjunctivity illuminated possibilities of forming perspectival, partial views. As such, performance's "as if" allowed for multiple kinds of affective reception, from jubilation and hope to regret and fear, skepticism, and estrangement. In this multiplicity, the catachrestic concept of a sovereign demos was able to take flight.

CODA
After Sovereignty

Conditions in Panama and the former Canal Zone have changed dramatically since the Canal's handover in 1999. The Panama Canal Authority (ACP) manages the Canal as a for-profit industry.[1] Banking and real-estate booms have transformed the Panama City skyline into the so-called "Dubai of Latin America," and the isthmus's financial service economy has expanded, adding valences of tax haven and retirement destination for waves of international high-income migrants. The country's gaping income inequality is evident in a short trip from Panama City—a Pacific-side metropolis of gleaming skyscrapers and new highways—to the Atlantic terminus of Colón, where decrepit buildings house impoverished families, and some areas lack electricity and potable water. While national sovereignty has been "rescued," indigenous protesters continue to march, create blockades, and stage modes of public protest over increasing state and multinational intervention in their sovereign lands.

Amid changes and continuities, every year during Panama's independence celebrations people gather in the former Canal Zone to commemorate, in performance, the midcentury flag protests: Operation Sovereignty, the Flag-Sowing, and the 1964 flag conflict. The annual reperformance of the Flag-Sowing on November 3 symbolically plants hundreds of Panamanian flags in the former US military base Fort Clayton, now the City of Knowledge (Ciudad del Saber). In 2013, a local reporter journeyed to the City of Knowledge to report on the Flag-Sowing ceremony in progress. The reporter framed the conflict as resolved, a fait accompli, noting that "our flag now waves" just "below where that of the United States was raised for many years."[2] The idea of the nation-state as a sealed event emerged in the reporter's interview with Jorge Arosemena, executive president of the City of Knowledge Foundation. Arosemena acknowledged the site's military past, which lent the commemoration even greater significance: not only did the event "affirm our sovereignty," but, even more meaningfully, it did so at a former US military base transformed into "a center of study, of knowledge, investigation, and problem-solving" and given over to civilian uses.[3] Behind Arosemena, three hundred

Panamanian flags, each as tall as a person, waved in the central quad of the City of Knowledge. A youth marching band—a fixture of Panamanian parades—tested its drums and flutes, and *típico* musicians accompanied dancers in *polleras* and *montuno* dress whirling through *puntos* and *tamboritos*.

The ceremony's forest of flags evidenced performance's ability to narrow the gap between abstract concepts and concrete spatiotemporal sites. When used in their official capacities, flags are icons of sovereignty, marking out terrain as the jurisdiction of a sovereign power. Flags function like Andrew Sofer's idea of a prop, anchoring the scenography of sovereignty, providing a shape to the claim as well as displaying ornamental pomp and (re)animating narratives of conquest and self-determination.[4] But while a flag conventionally exerts a metonymic relationship to the terrain that it claims—standing in as shorthand for sovereignty—the three hundred flags that covered the City of Knowledge strained toward a literalization of the metonym, attempting a different sort of contact with the terrain. In this scene, the flags bridged ideological and materialized modes of staging sovereignty. Planting so many flags proliferated the normative effect of a flag, making it not just a symbol but also a walled barrier or even a cemetery: flags as grave-markers. This connection was not out of place in a ceremony honoring Panamanian "martyrs" of midcentury geopolitical conflict. The Flag-Sowing's mise-en-scène exaggerated the function of a flag almost to the point of parody, but parody touched tragedy in remembrance of the protests, eliciting a need to turn the flag into a verisimilitude that *claims territory*, something that a flag can conventionally only do through its symbolism.

In addition to celebrating Panama's reclamation of the Zone, the Flag-Sowing recalls the "sovereign ban" discussed by Giorgio Agamben—"ban" a root of flag (*bandera*) or banner, marking an enclosure from which the outlaw is banned, or abandoned.[5] In the sovereign "ban-structure" theorized by Carl Schmitt, that which is excluded is "included by its exclusion," mirroring the state of exception that defines the norm.[6] The excluded outlaw is an inverted mirror of the Schmittian sovereign, who stands outside the law, entering into law to determine the enclosure and "decide on the exception."[7] The idea of sovereign enclosure becomes momentarily visible and tangible in the mise-en-scène of the Flag-Sowing—a reminder to its participants that most Panamanians were excluded by the US government from Fort Clayton for the entirety of their lives, even though the Zone was said to be part of their country.[8] Hence, the flags' appearance as phalanx, forest, or fence does more than mark territory; it provides a material barrier that evokes the "fence of shame" that separated the Canal Zone from Panama in the mid-to-late twentieth century. The commemorative reperformance of the Flag-Sowing seeks to suture spectators into Panama's history by positioning them in the former Zone, now demarcated as "national space."

These annual commemorations are framed explicitly as *performance*—as re-presentations of past events, not the events themselves. Their subjunctivity allows for the momentary convergence of past, present, and future in reperformance. The ceremony highlights selective moments and omits others—namely, the violence that resulted from the actual events of November 3, 1959. The overarching goal is to evoke a sense of bounded (en)closure and a past that has "passed." There is no opponent here now: the Canal Zone has been reverted, so the Flag-Sowing can take place undeterred. Moreover, former military space has been pacified. Yet, as performance scholar Rebecca Schneider argues, "performing remains," in the bodies of participants, and in the "stickiness" of temporality, which does not cut neatly from past to present and future, but rather materializes in "live acts" as "*then* as well as *now*."⁹ While the Flag-Sowing reperformance seeks to materialize aspects of history—and to materialize this history subjunctively—I agree with Schneider's observation that the space between "history (composed in document) and memory (composed in body) is layered with anxiety about verity, authenticity, falsity, theatricality, truth, and claim."¹⁰ In performance, to paraphrase Richard Schechner, nothing is ever "for the first time"—or "for the last time."¹¹ The past is reperformed in the present as symbolic and reflexive "restored behavior," transmitted through and between bodies.

The Canal Zone's history, and the subjunctive sovereignty that characterized US imperialism, ghost the site of the former Zone in performance. Even as the Flag-Sowing seeks to stage a "passed" past, the site of its annual reperformance threatens to destabilize a neat dividing-line between past and present sovereignties, between national space and its "other(s)." This site, the former US military base Fort Clayton, is invested with an unruly history, still acutely visible in the architecture and landscaping of the former military base—a history that many spectators would be hard-pressed to disavow or ignore. After its reversion to Panama in 1999, Fort Clayton became the City of Knowledge, a nonprofit consortium of humanitarian and educational facilities, including the United Nations Development Programme (UNDP) and the International Red Cross. The City of Knowledge is one of the only sites where desires for the reverted military areas to serve a "public good" materialized; most of the bases have been given over to private and commercial uses. Yet for Panamanians, "Clayton" is imbued with multifaceted symbolic and affective connotations—of trespass and exclusion, or employment and allegiance.

The history of Clayton/City of Knowledge reminds us that ultimately, the meaning-making capacity of the Flag-Sowing depends on its spectators (who are also its performers). Most Panamanians know the Canal Zone's history of contested sovereignty, as this history has marked space and shaped what it means to be a citizen.¹² Yet this shared knowledge does not preclude the production,

in reception, of varied meanings and interpretations of sovereignty and citizenship. As in all performances, witnesses of this scene will come away with different senses of what they have observed—as a performance momentarily real, perhaps, or a citizen body momentarily fiction. Depending on their degree of awareness of and involvement in the events of the former Canal Zone's distant and recent past, some spectators might see progress, while others might (and do) view the site as "Clayton."

That many people still call the area "Clayton" and the "Zone" reveal telling lags in the uptake of renaming, and expose gaps in sovereign closure. These diverging, multilayered views intervene in official discourses of sovereignty and citizenship. In performances of national coherence, spectators are positioned as subjects or citizens in national space. Contained within the "scene of sovereignty" are multiple scenographies: one can choose to focus on the flags, or on the City of Knowledge—or one can attend to the site as (former) US military base. Fort Clayton (colonial space) has officially been relegated to the past, and the City of Knowledge (national space) occupies its present, but aesthetic and structural features remain consistent, rendering the distinction blurred. The blurring of present and past goes both ways: the flags may cordon off a new space or bring the formerly excluded into the center of power, but the conscious reperformance of the Flag-Sowing sheds different light on the event, depending on the views and memories of its celebrants.

Now that the former Canal Zone is Panamanian territory, many Panamanians are still barred from entering it—on the grounds that they are trespassing the private property of wealthy foreigners. Privatization of the Canal Zone, which commenced in 1979, exploded after 1999. The Flag-Sowing, in its spectacle of sovereign ban, effaces this other imposition on the Canal Zone's "national space." As such, the commemorations collapse past, present, and future iterations of sovereignty into the frame of the nation-state. Private property is another kind of sovereignty, one that has often preceded the claim of state sovereignty. In the Panama Canal Treaty negotiations in 1903, Philippe Bunau-Varilla proposed a sort of middle-ground between national sovereignty and real estate: the terms of a "lease" of the Canal Zone from Panama to the United States would make Panama the landlord, and the United States its tenant. But US Secretary of State John Hay changed this language from "lease" to "grant"—a move that historian John Major argues greatly weakened Panama's legal leverage.[13] While Panama's discourses of national sovereignty have not often adopted the language of real estate, ideas of usufruct, and of privatization of the reverted lands as eliciting the best national good, have been present in arguments about how to align capitalism with sovereign claims over the Zone's territory. In its fragmentation into gated communities, province of the rich, the Canal Area enacts other, distinctive kinds of sovereignty and settler colonialism.[14]

The Canal Area's postsovereign proliferation of boundaries is difficult to classify within geopolitical terms, harder to "see" (and represent) than the fence that separated Panama from the Canal Zone. Yet as critical theorists Mezzadra and Neilson note, "the nation-state . . . is really much more adaptable, sly, and fragmented than the limited and sovereign community identified by theorists who imagine it in these terms. It is capable of harboring a multiplicity of times, temporal zones, and temporal borders."[15] Indeed, Wendy Brown identifies sovereignty as "a peculiar border concept," whose primary function is to demarcate "the boundaries of an entity" and "through this demarcation se[t] terms and organiz[e] the space both inside and outside the entity."[16] What happens after sovereignty? Here "after sovereignty" could mean "after the attainment of sovereignty," or "after the liquidation of the concept's value and significance." The shading depends on one's view of the state of sovereignty more generally—as definitively on the wane, resurgent, or something in between.

Even as national borders become selectively permeable (to capital, not migration), performances of sovereignty like the Flag-Sowing reinforce boundaries of the nation-state—albeit in performance, as a troubling interpenetration of that which is, and that which is "as if." Throughout this book, I have sought to present multiple techniques whereby sovereignty has been, and continues to be, performed in and around the Panama Canal Zone. I have also sought to show how sovereignty as performance might matter for larger debates about waning (or reinvigorated) sovereignties, and the role of the nation-state in contemporary international relations. The Panama Canal Treaty proposed a style of subjunctive sovereignty that allowed for the simultaneous emergence of nation-state sovereignty and its absence—a style of sovereignty existing in relation to global capital and empire. In performances, groups and individuals living in and around the Canal Zone instantiated forms of collectivity and exclusion absent a firm definition of sovereignty—indeed, with knowledge of a 'crisis' of sovereignty having taken root in the soil on which they stood. Performances constitute sites where sovereign claims of differing scales can emerge and be represented—and contested—in ways that have mattered deeply for citizens, aliens, and *subjuncts* alike.

ACKNOWLEDGMENTS

So many people have had a hand in helping me develop this project over the past dozen years that it's hard to know where to begin. I would first like to thank my anonymous readers for their valuable insights, and Kimberly Guinta, Executive Editor at Rutgers University Press, who has been consistently supportive and helpful throughout the publishing process. Thanks are also in order to Carrie Hudak, Production Editor at Rutgers University Press; the Critical Caribbean studies Series Editors; and the entire production team. If not for the support and guidance of Sandra Richards, Tracy C. Davis, Jennifer DeVere Brody, D. Soyini Madison, Ana Puga, and Harvey Young in Northwestern University's graduate programs in theatre and performance studies, I would never have embarked on the journey. In graduate school and beyond, dear colleagues and friends Emily Sahakian, Adrian Curtin, Christina McMahon, Mario Lamothe, Gregory Mitchell, Jennifer Tyburczy, Pavithra Prasad, Gina Di Salvo, and Carla Della Gatta have helped me shape my ideas and offered continual comradeship. In Chicago, making theatre with Raúl Dorantes and Nancy García Loza was an unforgettable experience.

In Panama and in the field, my heartfelt thanks go out to: the brilliant Melva Lowe de Goodin, Veronica Forte, and fellow members of SAMAAP—who provide daily life lessons in leadership; Toni Williams-Sánchez and Enrique Sánchez; the late Marco Mason; Gale Cellucci and Carlos Williams; Bruce Quinn; Eric Jackson; José Ponce; Paul Anderer; Lucia Lasso; Rubén Blades; Alison Weinstock; Sebastián Calderón Bentín; Francisco Herrera; Lily Koster; Kevin Simmons; Adrienne Samos; Enrique Castro Ríos; Dalida Benfield; Rómulo Castro; Dino Nugent; Ela Spalding; Salome Larraín; Cristo Allende; and many, many others. The scholarship and mentorship of Aims McGuinness, Josef Barton, Sonja Stephenson Watson, Kaysha Corinealdi, and Peter Szok have shaped this work; Ifeoma Nwankwo in particular has provided brilliant guidance and incredibly generous support to a junior scholar. Renee Alexander-Craft has been a tremendous inspiration and a guiding light, leading the way. Michael Donoghue is great research company, with answers to all of my questions. Kara Andrade, Ariana Curtis, and Blake Scott have remained in close contact after our Fulbright years.

In Montréal, I have been fortunate to have colleagues who are also friends, and who have taken the time to give me detailed research feedback. I have had the

privilege to work closely with, among others: Geneviève Dorais, Cynthia Milton, Catherine LeGrand, Monica Popescu, Erin Hurley, Amelia Jones, Alanna Thain, Fiona Ritchie, Sandeep Banerjee, Maggie Kilgore, Denis Salter, Biella Coleman, Derek Nystrom, Allan Hepburn, and Trevor Ponech. I would also like to extend thanks to Selena Couture, Matt Hern, Cedric Tolliver, Geneviève Painter, VK Preston, Amy Blair, Joshua Chambers-Letson, Stephanie Leigh Batiste, Adair Rounthwaite, Christian DuComb, and Christine Mok, Yvonne Hung, and Arseli Dokumaci, for their insights, collaboration, and encouragement. Without the help of these communities, my work would be a shadow of what it is. Others in my support network include Sheetal Lodhia, Will Straw, Jonathan Sterne, Luís Alonso-Ovalle, Lynn Kozak, Aparna Nadig, Meghan Clayards, Tara Flanagan, Kris Onishi, and Sarah Woolley. The friendship and love of Rachel Ettling and Nick Wylie have buoyed me for what feels like forever, and I have benefited from the indispensable research assistance of Sarah Stunden, Amy Skjerseth, Laura Cameron, Sunita Nigam, and James Reath.

I would be remiss if I did not deeply thank my loving parents, Elizabeth Levins and Herbert Zien, my brother Charlie, and my grandmother Clara Levins, who have supported me in all that I've undertaken and "tiptoed around the subject" of the book for years. Finally, my partner Morgan makes me laugh (often), makes me breakfast (sometimes), and makes me happy every day, providing constant love and companionship through the tumultuous and sometimes bewildering processes of writing a book and living in the here-and-now.

NOTES

INTRODUCTION

1 Unnamed newspaper, quoted in Joseph C. Freehoff, *America and the Canal Title* (New York: The author, 1916), 77.

2 Charles D. Ameringer, "Philippe Bunau-Varilla: New Light on the Panama Canal Treaty," *The Hispanic American Historical Review* 46, no. 1 (1966): 32–33.

3 Philippe Bunau-Varilla, formerly an engineer with the failed French canal project, was self-designated broker of the transfer of French Canal assets to the US government, and he had successfully persuaded the junta to authorize his assumption of diplomatic responsibilities. See Walter LaFeber, *The Panama Canal: The Crisis in Historical Perspective* (New York: Oxford University Press, 1989), 29–34.

4 Jimmy Carter, "Giving Away the Canal: Jimmy Carter on Panama," *Time*, October 18, 1982; Ameringer, "Philippe Bunau-Varilla," 44–49.

5 Lawrence O. Ealy, *Yanqui Politics and the Isthmian Canal* (University Park: Pennsylvania State University Press, 1971), 62; LaFeber, *The Panama Canal*, 32.

6 John Major, "Who Wrote the Hay-Bunau-Varilla Convention?," *Diplomatic History* 8, no. 2 (1984): 115.

7 Ameringer, "Philippe Bunau-Varilla," 52.

8 For a discussion of the immediate conditions surrounding Panama's 1903 independence, see: Celestino Andrés Araúz and Patricia Pizzurno, *Relaciones Entre Panamá y los Estados Unidos* (Panamá: Autoridad del Canal de Panamá, 1999); Ameringer, "Philippe Bunau-Varilla"; Major, "Who Wrote the Hay-Bunau-Varilla Convention?"; LaFeber, *The Panama Canal*.

9 J. L. Austin, *How to Do Things with Words* (Cambridge, MA: Harvard University Press, 1962).

10 For the text of the Panama Canal (Hay-Bunau-Varilla) Treaty, see Yale Law School, "Convention for the Construction of a Ship Canal (Hay-Bunau Varilla Treaty), November 18, 1903," http://avalon.law.yale.edu/20th_century/pan001.asp, accessed May 1, 2016. See also "Convention between the United States of America and the Republic of Panama to Insure the Construction of a Ship Canal across the Isthmus of Panama to Connect the Atlantic and Pacific Oceans [. . .]," *American Society of International Law* 7, Special Issue on International Use of Straits and Canals (1913).

11 Panama's protectorate status was revoked in 1939 by the Alfaro-Hull Treaty.

12 "Convention between the United States of America and the Republic of Panama [. . .]," *American Society of International Law* (1913), 300–301. Emphasis added.

13 Björn Rothstein and Rolf Thieroff, *Mood in the Languages of Europe* (Philadelphia: John Benjamins, 2010), 441. *Irrealis*, while differing among languages, contains moods (e.g., conditional, optative, and subjunctive) conventionally expressing affective

positions of desire, doubt, utopia, and unreality. Linguists debate whether English has the "subjunctive" at all.

14 Joshua Chambers-Letson and Yves Winter, "Shipwrecked Sovereignty," *Political Theory* (2014): 5.

15 Leander T. Chamberlain, "A Chapter of National Dishonor," *The North American Review* 195, no. 675 (1912).

16 US critics of the Roosevelt administration's actions in Panama included the *New York World*, the *New York Times*, the New York Bar Association, the Yale Law School, US Senator John T. Morgan, James DuBois, Leander Chamberlain, Theodore Woolsey, and Joseph Freehoff. While some critics were opposed on moral grounds, others took up the events on the isthmus as a chance to criticize Roosevelt and his party.

17 See Araúz and Pizzurno, *Relaciones Entre Panamá y Los Estados Unidos*, Tomo I, 563–564, 584–585, 590–595; Freehoff, *America and the Canal Title*. The Mallarino-Bidlack Treaty obliged the US government to protect the neutrality of the Panama Railroad and defend the sovereignty of Nueva Granada, through whose isthmian territory the railroad passed, in the event of foreign aggression or local uprisings. In 1903, the US government strategically deployed the railroad as a means of enabling Panama's separation, preventing Colombia's soldiers from crossing the isthmus to stop the rebellion. This action was in clear violation of Colombia's sovereignty, although Philippe Bunau-Varilla and Theodore Roosevelt argued otherwise. The Hay-Bunau-Varilla Treaty was crafted in the wake of the Colombian Congress's rejection of the Hay-Herrán Treaty, which sought to give the US government similar rights and privileges in a future Canal Zone, in perpetuity, and for a sum that Colombia deemed insufficient. See Araúz and Pizzurno, 557–590.

18 US Department of War, Letter of the Secretary of War, Transmitting the First Annual Report of the Isthmian Canal Commission (Washington, DC, 1905), 4. See also Ameringer, "Philippe Bunau-Varilla," 43; Major, "Who Wrote the Hay-Bunau-Varilla Convention?," 121; Freehoff, *America and the Canal Title*, 54.

19 Cynthia Weber, "Performative States," *Millennium—Journal of International Studies* 27, no. 1 (1998): 92.

20 Wendy Brown, *Walled States, Waning Sovereignty* (New York: Zone Books, 2010), 22.

21 Freehoff, *America and the Canal Title*, 124.

22 Ibid., 123.

23 Chambers-Letson and Winter, "Shipwrecked Sovereignty," 5.

24 Diana Taylor, "The Politics of Passion," *e-misférica* 10, no. 2 (2013), http://hemisphericin stitute.org/hemi/en/e-misferica-102/taylor, accessed May 10, 2016.

25 Freehoff, *America and the Canal Title*, 92, 100, 138–213, 323.

26 On Panamanian nationalism before 1903, see Aims McGuinness, *Path of Empire: Panama and the California Gold Rush* (Ithaca, NY: Cornell University Press, 2008); Ricaurte Soler, *Formas Ideológicas de la Nación Panameña* (Panamá: Ediciones de la Revista Tareas, 1963); Ricardo J. Alfaro, *Vida del General Tomás Herrera* (Panamá: Universidad de Panamá, 1960); Pizzurno and Araúz, *Relaciones Entre Panamá y Los Estados Unidos*, Tomo I; Peter A. Szok, *La Última Gaviota: Liberalism and Nostalgia in Early Twentieth-Century Panamá* (Westport, CT: Greenwood Press, 2001).

27 Panamanian political theorist Justo Arosemena advocated for a confederation of semi-sovereign states, to allow for jurisdictional independence along with protection from US imperialism. See Aims McGuinness, "Sovereignty on the Isthmus: Federalism, U.S. Empire, and the Struggle for Panama During the California Gold Rush," in *The State of Sovereignty: Territories, Laws, Populations*, ed. Luise S. White and Douglas

Howland (Bloomington: Indiana University Press, 2008). This federalist schema—in which nation-state sovereignty is not the primary goal—is not entirely uncommon in the insular Caribbean, as Yarimar Bonilla shows. See Bonilla, "Ordinary Sovereignty," *Small Axe* 17, no. 3 (2013); *Non-Sovereign Futures: French Caribbean Politics in the Wake of Disenchantment* (Chicago: University of Chicago Press, 2015).

28 Secessionist attempts were made in 1826, 1830, 1831, 1840, and during the Thousand Days' War (1899–1902). Panama became a federal state of Nueva Granada in 1855, and a "sovereign state" in 1863.

29 Ameringer, "Philippe Bunau-Varilla," 43–44.

30 República de Panamá, Secretaría de Relaciones Exteriores, "Decreto Número 24 De 1903, de 2 de diciembre," *Gaceta Oficial* 1, no. 6 (1903). Emphasis added.

31 República de Panamá, Secretaría de Relaciones Exteriores, "Convención Celebrada Entre La República De Panamá y Los Estados Unidos De América Para La Construcción De Un Canal Para Buques a Través Del Istmo De Panamá [. . .]" (Panamá: Imprenta Nacional, 1927), 2. Emphasis added.

32 These include affects, regrets, etiquette, and futurity. The subjunctive mood is not only present under conditions of *irrealis*, but the subjunctive and conditional moods are used to express *irrealis*. Thanks to Luís Alonso-Ovalle for help with Spanish linguistics.

33 Jon Beasley-Murray, *Posthegemony: Political Theory and Latin America* (Minneapolis: University of Minnesota Press, 2010).

34 See Rebecca Schneider, *Performing Remains: Art and War in Times of Theatrical Reenactment* (New York: Routledge, 2011).

35 Anthony Anghie, "Finding the Peripheries: Sovereignty and Colonialism in Nineteenth Century International Law," *Harvard International Law Journal* 40, no. 1 (1990): 37.

36 Ibid.

37 Taiaiake Alfred, "Sovereignty," in Philip Joseph Deloria and Neal Salisbury, *A Companion to American Indian History* (Malden, MA: Blackwell Publishers, 2002), 460.

38 Ibid.

39 Anghie, "Finding the Peripheries," 39.

40 Ibid., 3.

41 Ibid., 5.

42 Critical indigenous studies scholars provide the best overview of sovereignty beyond the Westphalian nation-state. See, for example: N. Bruce Duthu, *Shadow Nations: Tribal Sovereignty and the Limits of Legal Pluralism* (New York: Oxford University Press, 2013); Scott Richard Lyons, *X-Marks: Native Signatures of Assent* (Minneapolis: University of Minnesota Press, 2010); Joanne Barker, *Sovereignty Matters: Locations of Contestation and Possibility in Indigenous Struggles for Self-Determination* (Lincoln: University of Nebraska Press, 2005); Audra Simpson, *Mohawk Interruptus: Political Life across the Borders of Settler States* (Durham, NC: Duke University Press, 2014); Audra Simpson and Andrea Smith, *Theorizing Native Studies* (Durham, NC: Duke University Press, 2014); Glen Sean Coulthard, *Red Skin, White Masks: Rejecting the Colonial Politics of Recognition* (Minneapolis: University of Minnesota Press, 2014); Kevin Bruyneel, *The Third Space of Sovereignty: The Postcolonial Politics of U.S.-Indigenous Relations* (Minneapolis: University of Minnesota Press, 2007); Patrick Wolfe, "Recuperating Binarism: A Heretical Introduction," *Settler Colonial Studies* 3, no. 3–4 (2013).

43 Alyosha Goldstein, *Formations of United States Colonialism* (Durham, NC: Duke University Press, 2014), 15.

44 Ibid., 17.

45 William Earl Weeks et al., *The New Cambridge History of American Foreign Relations* (New York: Cambridge University Press, 2013), 178–220.

46 See McGuinness, *Path of Empire*.

47 Ibid., 152–155.

48 Weeks et al., *The New Cambridge History of American Foreign Relations*, 205.

49 McGuinness, *Path of Empire*, 193.

50 Ibid., 158.

51 Ibid., 191.

52 Ibid., 180.

53 Aims McGuinness argues that the Panama Railroad Company created the "first of many 'enclaves' that would be made by US companies on Latin American soil." The Panama Canal Zone absorbed many of the Railroad Company's managerial techniques, in addition to those of the United Fruit Company enclave structure. Ibid., 82.

54 The Mallarino-Bidlack Treaty (1846) designated the United States "guarantor both of Colombia's continued sovereignty and of the international right of transit across the isthmus," marking a "significant step in the creation of both a hemispheric and a global American Empire." The United States signed the Clayton-Bulwer Treaty with Great Britain (1850) to ensure the neutrality of the route and "refrain from direct control over the Central American states in the region." This agreement, in keeping with the 1823 Monroe Doctrine's noncolonization clause, rebuked European imperial ambitions in the Western Hemisphere. Weeks et al., *The New Cambridge History of American Foreign Relations*, 204–206.

55 By the early twentieth century, "the US . . . consolidated its control of what are now the 'lower forty-eight' states, exercised jurisdiction over Alaska, Hawai'i, and numerous 'unincorporated' territories, and controlled the lives of more than ten million peoples held as 'subjects' rather than citizens." Natsu Taylor Saito, *Meeting the Enemy: American Exceptionalism and International Law* (New York: New York University Press, 2010), 159.

56 Christina Duffy Burnett, "Untied States: American Expansion and Territorial Deannexation," *University of Chicago Law Review* 72, no. 3 (2005): 806.

57 Ibid., 797.

58 Chambers-Letson, "Shipwrecked Sovereignty," 9.

59 Ibid.

60 For analysis of the postwar nation-state, see John D. Kelly and Martha Kaplan, "Legal Fictions after Empire," in *The State of Sovereignty: Territories, Laws, Populations*, ed. Douglas Howland and Luise S. White (Bloomington: Indiana University Press, 2009).

61 See, for example, James Howe, *A People Who Would Not Kneel: Panama, the United States, and the San Blas Kuna* (Washington, DC: Smithsonian Institution Press, 1998). Panamanian filmmaker Enrique Castro Ríos's documentary film, *Familia* (2007), includes an excellent and nuanced discussion of indigenous land and water rights in the Canal's expanding watershed. https://youtu.be/BAfmqzMBYOA, last accessed May 10, 2016. The Ngäbe-Buglé, Kuna, and other indigenous peoples on the isthmus have long protested mining, dams, and myriad forms of Panamanian state intervention in their respective *comarcas* (sovereign lands). The Ngäbe-Buglé continue to protest the Barro Blanco dam; see, for example, Óscar Sogandares, "Protestas masivas contra el Proyecto hidroeléctrico Barro Blanco en Panamá," https://www.international rivers.org/files/attached-files/cdm_article_28spanish29.pdf, last accessed May 10, 2016; Olmedo Beluche, "Panamá: La Lucha del Pueblo Ngäbe-Buglé contra mineras

e hidroelectricas," *Otramerica* (2012), http://otramerica.com/solo-texto/opinion/panama-la-lucha-del-pueblo-ngabebugle-contra-mineras-e-hidroelectricas/1513, last accessed May 10, 2016.

62 Quoted in Richard Schechner, *Between Theater and Anthropology* (Philadelphia: University of Pennsylvania Press, 1985), 102. See also Rhonda Blair, *The Actor, Image, and Action: Acting and Cognitive Neuroscience* (New York: Routledge, 2008).

63 Stanislavski emphasizes this in the anecdote of acting teacher Tortsov, who narrates his experience of having a fake surgical operation performed on his blindfolded body, then asks his students: "Were the experiences I then had really true, accompanied by real belief, or should what I felt more properly be called 'feelings that seem true'? Of course it wasn't real truth and belief. There was a constant switch between 'I believe' and 'I don't believe,' between real experience and an illusion of experience, between 'true' and 'true-seeming.'" Konstantin Stanislavsky and Jean Benedetti, *An Actor's Work: A Student's Diary* (New York: Routledge, 2008), 327. The feelings Tortsov recounts are both "moments of total experience during which I felt just as I would in reality" and illusions.

64 Schechner, *Between Theater and Anthropology*, 104.

65 Colin Counsell, *Signs of Performance: An Introduction to Twentieth-Century Theatre* (New York: Routledge, 1996), 17.

66 Schechner, *Between Theater and Anthropology*, 104.

67 Victor Turner, "Dewey, Dilthey, and Drama: An Essay in the Anthropology of Experience," in *The Anthropology of Experience*, ed. Victor W. Turner and Edward M. Bruner (Urbana-Champaign: University of Illinois Press, 1986), 295.

68 Victor Turner, *The Ritual Process: Structure and Anti-Structure* (Chicago: Aldine Pub., 1969).

69 Schechner, *Between Theater and Anthropology*, 3.

70 Ibid., 40.

71 Ibid., 37. "Negativity" indexes the "not-me, not-not-me" formulation that Schechner devises, after Winnicott. This is related to Stanislavski's idea of behaving "as if another" and "beside oneself."

72 Ibid., 6. Schechner locates subjunctivity in rehearsals and workshops, as well as in the "virtual, mythic, and fictional nonevents" (38) that inform theatre productions.

73 Ibid., 39.

74 Ibid., 104.

75 Ibid., 111.

76 Performance theorists and practitioners who uphold the empowering aspects of subjunctivity include Turner, Schechner, Augusto Boal, Jill Dolan, Diana Taylor, and Deborah Paredez. The work of Elin Diamond, Erika Fischer-Lichte, and Hans-Thies Lehmann also elevates concepts linked to subjunctivity and political and social change. Further, subjunctivity would seem a useful concept for philosopher Jacques Rancière's body of critique on aesthetics and politics. As Jon McKenzie points out, however, while many performance scholars focus on the "liminal" aspects of the ritual process, they tend to devote less attention to the "norm" that culminates the process, making rituals' attainment of *communitas* ultimately a conservative arc, as Turner himself concedes. See Jon McKenzie, *Perform or Else: From Discipline to Performance* (New York: Routledge, 2001), 51. By bringing Judith Butler's "performative normativity" together with Turner's "performative liminality" (166), McKenzie is able to trace the two-sided nature of the "liminal norm" in performance studies—an oscillation

between celebration of transgression and performativity's "normative and punitive force." (168) McKenzie states, tellingly: "the subjunctive mood of the 'as if,' used by Schechner and others to theorize liminality, must be understood not in opposition to an indicative mood of 'it is,' but as intimately related to an imperative mood which commands 'it must be'" (ibid.).

77 Quoted in Graham St. John, *Victor Turner and Contemporary Cultural Performance* (New York: Berghahn Books, 2008), 102.

78 Taylor, "The Politics of Passion."

79 Augusto Boal, *The Aesthetics of the Oppressed* (New York: Routledge, 2006), 39–40.

80 Ibid., 40.

81 Taylor, "The Politics of Passion."

82 Ibid.

83 Ibid.

84 Ibid.

85 Anne Anlin Cheng, *The Melancholy of Race* (New York: Oxford University Press, 2001), 57–58.

86 Ibid., 58. Judith Butler initially allowed for the possibility of agency in performativity's interruption by a subjunctivity that "repeats differently," but later scaled down the argument's more empowering implications. See Judith Butler, "Performative Acts and Gender Constitution," in *Performance: Critical Concepts in Literary and Cultural Studies*, ed. Philip Auslander (New York: Routledge, 2003). Discussed in McKenzie, *Perform or Else*, 168.

87 Elin Diamond is one of the most eloquent articulators of this relationship. See Diamond, *Unmaking Mimesis: Essays on Feminism and Theater* (New York: Routledge, 1997).

88 Taylor, "The Politics of Passion."

89 Ibid.

90 Ibid.

91 Thea Brejzek, "The Scenographic (Re-) Turn: Figures of Surface, Space and Spectator in Theatre and Architecture Theory, 1680–1980," *Theatre & Performance Design* 1, no. 1–2 (2015): 23.

92 Susan Manning, *Modern Dance, Negro Dance: Race in Motion* (Minneapolis: University of Minnesota Press, 2004), xvi–xvii.

93 Marvin Carlson, *Places of Performance: The Semiotics of Theatre Architecture* (Ithaca, NY: Cornell University Press, 1989), 137–141.

94 Henri Lefebvre, *The Production of Space* (Cambridge, MA: Blackwell, 1991); see also Joslin McKinney, "Scenography, Spectacle and the Body of the Spectator," *Performance Research* 18, no. 3 (2013).

95 For an expansion upon the act of "taking place," see Rachel Hann, "Blurred Architecture: Duration and Performance in the Work of Diller Scofidio + Renfro," *Performance Research* 17, no. 5 (2012).

96 Sandro Mezzadra and Brett Neilson, *Border as Method, or, the Multiplication of Labor* (Durham, NC: Duke University Press, 2013), 156–166.

97 Leti Volpp, "The Indigenous as Alien," *U.C. Irvine Law Review* 5, no. 289 (2015).

98 See the *Oxford English Dictionary*.

99 See http://panamaviejaescuela.com/operacion-soberania/, accessed March 9 2016; http://portal.critica.com.pa/archivo/historia/f11–39.html, accessed March 9, 2016;

Michael E. Donoghue, *Borderland on the Isthmus: Race, Culture, and the Struggle for the Canal Zone* (Durham, NC: Duke University Press, 2014), 17–18.

100 On Operation Friendship, see Donoghue, *Borderland on the Isthmus*, 184–185.

101 McGuinness, *Path of Empire*, 182.

102 See Mezzadra and Neilson, *Border as Method*.

CHAPTER 1 SOVEREIGNTY'S MISE-EN-SCÈNE

1 My thanks to Adair Rounthwaite for this suggestion.

2 Amy Kaplan, "Where Is Guantánamo?" *American Quarterly* 57, no. 3 (2005): 837.

3 Aims McGuinness, *Path of Empire: Panama and the California Gold Rush* (Ithaca, NY: Cornell University Press, 2008), 158, 182.

4 On the lived ramifications of legal decisions, see Joshua Takano Chambers-Letson, *A Race So Different: Performance and Law in Asian America* (New York: New York University Press, 2013), 5–6.

5 Alexander Missal, *Seaway to the Future: American Social Visions and the Construction of the Panama Canal* (Madison: University of Wisconsin Press, 2008), 154.

6 See Paul A. Kramer, "Empires, Exceptions, and Anglo-Saxons: Race and Rule between the British and United States Empires, 1880–1910," *Journal of American History* 88, no. 4 (2002).

7 Charles S. Maier, *Among Empires: American Ascendancy and Its Predecessors* (Cambridge, MA: Harvard University Press, 2006); Dane Kennedy, "Essay and Reflection: On the American Empire from a British Imperial Perspective," *The International History Review* 29, no. 1 (2007).

8 Kaplan, "Where Is Guantánamo?," 837.

9 Donald E. Pease, *The New American Exceptionalism* (Minneapolis: University of Minnesota Press, 2009), 7–23.

10 Richard Schechner, *Between Theater and Anthropology* (Philadelphia: University of Pennsylvania Press, 1985), 109–110.

11 The Canal Zone's large US government-funded bureaucracy came under scrutiny at midcentury, prompting the Panama Canal's reorganization in 1951.

12 For more information on the "Panama authors," see Missal, *Seaway to the Future*.

13 Ira E. Bennett, *History of the Panama Canal, Its Construction and Builders* (Washington, DC: Historical Pub. Co., 1915), 171. Emphasis added.

14 See, for example, Julian Go, "Imperial Power and Its Limits: America's Colonial Empire in the Early Twentieth Century," in *Lessons of Empire: Imperial Histories and American Power*, ed. Craig J. Calhoun, Frederick Cooper, and Kevin W. Moore (New York: New Press, 2006); Julian Go, *Patterns of Empire: The British and American Empires, 1688 to the Present* (New York: Cambridge University Press, 2011); Kramer, "Empires, Exceptions, and Anglo-Saxons"; Eric Tyrone Love, *Race over Empire: Racism and U.S. Imperialism, 1865–1900* (Chapel Hill: University of North Carolina Press, 2004).

15 Matthew Frye Jacobson, *Barbarian Virtues: The United States Encounters Foreign Peoples at Home and Abroad, 1876–1917* (New York: Hill and Wang, 2000), 42–43.

16 Christina Duffy Burnett, "Untied States: American Expansion and Territorial Deannexation," *University of Chicago Law Review* 72, no. 3 (2005): 806; Carl Russell Fish, *The Path of Empire: A Chronicle of the United States as a World Power* (New Haven, CT: Yale University Press, 1919).

17 Kennedy, "Essay and Reflection"; Kramer, "Empires, Exceptions, and Anglo-Saxons"; Love, *Race over Empire*.

18 Kramer, "Empires, Exceptions, and Anglo-Saxons," 1338; LaFeber, *The Panama Canal: The Crisis in Historical Perspective* (New York: Oxford University Press, 1989), 31; Love, *Race over Empire*, 150.

19 Theodore Roosevelt, *The Winning of the West* (New York: G. P. Putnam, 1889).

20 Maya Jasanoff, "What New Empires Inherit from Old Ones," *History News Network* (2005), http://historynewsnetwork.org/article/18853. Accessed September 2, 2015.

21 The paradox of "empire for liberty" continues to animate US international interventionism in the twentieth and twenty-first centuries. As Dane Kennedy, Maya Jasanoff, and the editors of *Lessons of Empire* note, neoconservative interventionists have recently revived the idea of US empire, with positive connotations.

22 Kramer, "Empires, Exceptions, and Anglo-Saxons," 1321–1322, 1331–1332; see also Walter Mignolo, *The Idea of Latin America* (Malden, MA: Blackwell, 2005), 79–80.

23 "What the President Will See When He Gets to Panama," *New York Times*, November 11, 1906.

24 Missal, *Seaway to the Future*.

25 Aims McGuinness, "Searching for 'Latin America': Race and Sovereignty in the Americas in the 1850s," in *Race and Nation in Modern Latin America*, ed. Anne S. Macpherson, Karin Alejandra Rosemblatt, and Nancy P. Appelbaum (Chapel Hill: University of North Carolina Press, 2003); Marisol de la Cadena, "Anterioridades y Externalidades: Más Allá De La Raza En América Latina," *e-misférica* 5.2 (2008), http://hemisphericinstitute.org/hemi/en/e-misferica-52/delacadena. Accessed September 10, 2015; Mignolo, *The Idea of Latin America*.

26 "What the President Will See," *New York Times*.

27 Kaplan, "Where Is Guantánamo?," 834–835; Love, *Race over Empire*; Thomas David Schoonover, *Uncle Sam's War of 1898 and the Origins of Globalization* (Lexington: University Press of Kentucky, 2003).

28 Roosevelt to Taft, quoted in LaFeber, *The Panama Canal*, 34–35. Emphasis added.

29 Joshua Chambers-Letson and Yves Winter distinguish sovereignty's material workings from its symbolic "marks"; see Joshua Chambers-Letson and Yves Winter, "Shipwrecked Sovereignty," *Political Theory* (2014): 9–10.

30 Between 1904 and 1914, inhabitants of the Canal Zone were allowed to remain, but after 1914 the Canal Zone was depopulated of all nonemployees. See Lawrence O. Ealy, *Yanqui Politics and the Isthmian Canal* (University Park: Pennsylvania State University Press, 1971), 94–105; Missal, *Seaway to the Future*, 123–124; Marixa Lasso, "From Citizens to 'Natives': Tropical Politics of Depopulation at the Panama Canal Zone," *Environmental History* 21 (April 2016): 240–249.

31 Theodore Roosevelt, *Excerpt of Theodore Roosevelt's Annual Message to Congress, December 6, 1904* (1904).

32 Quoted in LaFeber, *The Panama Canal*, 35. Emphasis added.

33 Ibid.

34 Patrick Anderson, "'Architecture Is Not Justice': Seeing Guantánamo Bay," in *Performance in the Borderlands*, ed. Ramón H. Rivera-Servera and Harvey Young (New York: Palgrave Macmillan, 2011), 95–96; Simon Reid-Henry, "Exceptional Sovereignty? Guantánamo Bay and the Re-Colonial Present," *Antipode* 39, no. 4 (2007).

35 Kaplan, "Where Is Guantánamo?," 837. Emphasis added.

36 Ibid.

37 Ibid., 838.

38 Ibid.

39 See William Jennings Bryan, *Republic or Empire? The Philippine Question* (Chicago: The Independence Company, 1899). On relationships between westward expansion and extraterritorial annexation, see Jacobson, *Barbarian Virtues*; Alyosha Goldstein, *Formations of United States Colonialism* (Durham, NC: Duke University Press, 2014); J. Kēhaulani Kauanui, *Hawaiian Blood: Colonialism and the Politics of Sovereignty and Indigeneity* (Durham, NC: Duke University Press, 2008); Michael J. Shapiro, "The Demise of 'International Relations': America's Western Palimpsest," *Geopolitics* 10, no. 22 (2005).

40 Frank Andre Guridy, *Forging Diaspora: Afro-Cubans and African Americans in a World of Empire and Jim Crow* (Chapel Hill: University of North Carolina Press, 2010), 7ff.

41 Kaplan, "Where Is Guantánamo?," 844.

42 Love, *Race Over Empire*, 200.

43 Conklin Mann, "Our Presidents on the Road," *Harper's Weekly*, November 6, 1909.

44 Julie Greene, *The Canal Builders: Making America's Empire at the Panama Canal* (New York: Penguin Press, 2009), 42–43. See also J. Michael Hogan, *The Panama Canal in American Politics: Domestic Advocacy and the Evolution of Policy* (Carbondale: Southern Illinois University Press, 1986), 40–41.

45 "The Panama Canal and the Presidency," *Harper's Weekly*, January 9, 1904, 44; see also Missal, *Seaway to the Future*, 92.

46 Thomas Dieuaide, "The President's Barge of State, the Battle-Ship Louisiana: How the Pride of the Navy Was Fitted for Mr. Roosevelt's Voyage to the Canal Zone," *Harper's Weekly*, November 24, 1906, 1671.

47 One could argue that the Canal Zone was also Panamanian territory, a point clarified in subsequent revisions of the 1903 treaty. The US press declared this Roosevelt's first official departure from US territory.

48 "Special Supplement," *Panama Star and Herald*, November 17, 1906.

49 Ibid., 3.

50 Mann, "Our Presidents on the Road"; Missal, *Seaway to the Future*, 92–95.

51 "What the President Will See," *New York Times*.

52 Greene, *The Canal Builders*, 199; Ralph Eldin Minger, "Panama, the Canal Zone, and Titular Sovereignty," *The Western Political Quarterly* 14, no. 2 (1961): 545; Gail Bederman, *Manliness & Civilization: A Cultural History of Gender and Race in the United States, 1880–1917* (Chicago: University of Chicago Press, 1995), 170; ibid.; Greene, *The Canal Builders*, 199; Minger, "Panama, the Canal Zone, and Titular Sovereignty," 545.

53 Bederman, *Manliness & Civilization*, 170.

54 Ibid.

55 Ibid., 180–191.

56 Mann, "Our Presidents on the Road." The phrase "one hundred and ten years" is an approximation of the time since George Washington became US president in 1789, maintaining the president within the territory of the United States while in office. TR was the first US president to break with this custom, Taft the second. Thanks to Sunita Nigam for the clarification.

57 Ibid.

58 Library of Congress, "Primary Documents in American History: Treaty of Guada-
 lupe Hidalgo," https://www.loc.gov/rr/program/bib/ourdocs/Guadalupe.html.
 Accessed March 25, 2016.

59 Richard Joyce and Peter Fitzpatrick, "The Normality of the Exception in Democracy's
 Empire," *Journal of Law and Society* 34, no. 1 (2007): 73–76.

60 "Roosevelt in Panama as Travelers Saw Him," *New York Times*, November 25, 1906.

61 William Inglis, "At Double-Quick Along the Canal with the President: The First of Two
 Articles Dealing with Actual Conditions in the Canal Zone, and the Recommenda-
 tions Made on the Ground by the Chief Executive after Seeing the Work and Work-
 men," *Harper's Weekly*, December 8, 1906.

62 Ibid.

63 Dieuaide, "The President's Barge of State."

64 "Roosevelt in Panama as Travelers Saw Him."

65 Dieuaide, "The President's Barge of State."

66 "Roosevelt in Panama as Travelers Saw Him"; Inglis, "At Double-Quick."

67 "What the President Will See," *New York Times*.

68 "Special Supplement," *Panama Star and Herald*.

69 "What the President Will See."

70 "At Double-Quick."

71 See Bill Brown, "Science Fiction, the World's Fair, and the Prosthetics of Empire, 1910–
 1915," in *Cultures of United States Imperialism*, ed. Amy Kaplan and Donald Pease (Dur-
 ham, NC: Duke University Press, 1993).

72 Michael Geyer in John R. Gillis, *The Militarization of the Western World* (New Brunswick:
 Rutgers University Press, 1989), 79; Laura McEnaney, *Civil Defense Begins at Home:
 Militarization Meets Everyday Life in the Fifties* (Princeton, NJ: Princeton University
 Press, 2000), 6.

73 "What the President Will See."

74 Michael E. Donoghue, *Borderland on the Isthmus: Race, Culture, and the Struggle for the
 Canal Zone* (Durham, NC: Duke University Press, 2014), 53.

75 Isthmian Canal Commission (hereafter ICC) Annual Report 1906 (Washington, DC:
 GPO, 1906).

76 "Roosevelt in Panama as Travelers Saw Him."

77 "At Double-Quick," 1742.

78 Suzanne P. Johnson, *An American Legacy in Panama: A Brief History of the Department of
 Defense Installations and Properties* (Fort Clayton, Panama: Directorate of Engineering
 and Housing, 1994).

79 For a discussion of Panama Canal construction as a form of war, see Missal, *Seaway to the
 Future*, 73–76.

80 Inglis, "At Double-Quick."

81 Johnson, *An American Legacy in Panama*, 58.

82 Ibid., 27–29.

83 Donoghue, *Borderland on the Isthmus*, 30–31.

84 Ronald Harpelle, "'White Zones': American Enclave Communities in Central America,"
 in *Blacks and Blackness in Central America and the Mainland Caribbean: Between Race
 and Place*, ed. Lowell Gudmunson and Justin Wolfe (Durham, NC: Duke University
 Press, 2010), 307–334.

85 "At Double-Quick"; "What the President Will See."

86 "What the President Will See."

87 Ibid.

88 Ibid.

89 Ibid.

90 Ibid.

91 Ibid.

92 "YMCA Buildings for the Canal Zone: Part of the Scheme to Make It a Model Colony," *New York Times*, November 9, 1906. See also "Panama Benefits by Our Example: President Amador, Here on a Vacation, Says Canal Work Is Good Object Lesson," *New York Times*, July 4, 1907.

93 W. C. Gorgas, "The Conquest of the Tropics for the White Race," *Journal of the American Medical Association* 52, no. 25 (1909); Stephen Frenkel, "Geography, Empire, and Environmental Determinism," *Geographical Review* 82, no. 2 (1992).

94 Stephen Frenkel, "Jungle Stories: North American Representations of Tropical Panama," *Geographical Review* 86, no. 3 (1996): 328.

95 A. Grenfell Price, "White Settlement in the Panama Canal Zone," *The Geographical Review* XXV, no. 1 (January 1935): 7–8.

96 Missal, *Seaway to the Future*, 154.

97 "What the President Will See," emphasis added. The moral mandate was not universally shared; many observers chafed at TR's conviction that the United States was morally obliged to build a canal (LaFeber, *The Panama Canal*, 32).

98 Bennett, *History of the Panama Canal*, 171.

99 Richard Guy Wilson, "Imperial American Identity at the Panama Canal," *Modulus: The University of Virginia School of Architecture Review* 14 (1981): 23.

100 Ibid., 26–27.

101 Missal, *Seaway to the Future*, 112.

102 Go, "Imperial Power and Its Limits," 204–205.

103 Missal, *Seaway to the Future*, 122.

104 Ornament has often been linked to excess, decadence, femininity, primitivism, and atavism, while the streamlined form, with its lack of ornament, has been construed as modern, male, and American. Reference points include Louis Sullivan, "The Tall Office Building Artistically Considered," *Lippincott's Magazine*, March 23, 1896; Adolf Loos, *Ornament and Crime: Selected Essays* (Riverside, CA: Ariadne Press, 1998); Naomi Schor, *Reading in Detail: Aesthetics and the Feminine* (New York: Methuen, 1987).

105 Sullivan, "The Tall Office Building Artistically Considered," 408–409.

106 Lewis Mumford, *Sticks and Stones: A Study of American Architecture and Civilization* (New York: Boni and Liveright, 1924), 128; David Brody, *Visualizing American Empire: Orientalism and Imperialism in the Philippines* (Chicago: University of Chicago Press, 2010).

107 Mumford, *Sticks and Stones*, 135.

108 Commission of Fine Arts, "Message from the President of the United States Transmitting a Report by the Commission of Fine Arts in Relation to the Artistic Structure of the Panama Canal" (Washington, DC, August 15, 1913), 2.

109 Ibid., 5.

110 Ibid.

111 Anonymous, "The Wonder of Work: Joseph Pennell's *Pictures of Panama*," *Current Literature* (November 1912): 579.

112 Ibid., 581.

113 Ibid.

114 Darcy Grimaldo Grigsby, *Colossal: The Suez Canal, Statue of Liberty, Eiffel Tower, and Panama Canal: Transcontinental Ambition in France and the United States During the Long Nineteenth Century* (Pittsburgh: Periscope Pub., 2011), 126.

115 Ibid.

116 Commission of Fine Arts, "Message from the President," 15. The Fine Arts Commission Report placed great emphasis on the aesthetics of lighthouses as symbols, in addition to their functional illumination. This focus accords with similar treatments at the Suez Canal and in New York, where the Statue of Liberty was meant to function as sculpture and beacon.

117 Carol McMichael Reese and Thomas F. Reese, *El Canal de Panamá y su Legado Arquitectónico, The Panama Canal and Its Architectural Legacy (1905–1920)* (Panamá, Panamá: Ciudad del Saber, 2013), 13.

118 Missal, *Seaway to the Future*, 97.

119 Reese and Reese, *El Canal De Panamá y su Legado Arquitectónico*, 155.

120 US architects' projects were not limited to the Canal Zone but transited US spheres of influence, connecting the United States and its military and commercial interests. Goodhue, for example, architect of the Hotel Washington in Colón, also designed structures for the 1915 Panama-Pacific International Exposition in San Francisco, USA, and several prominent structures in Cuba; Parsons followed his experience in Panama by assisting Daniel Burnham in the Philippines (Cody 37). See Jeffrey W. Cody, *Exporting American Architecture, 1870–2000* (New York: Routledge, 2003); José A. Gelabert-Navia, "American Architects in Cuba: 1900–1930," *The Journal of Decorative and Propaganda Arts* 22 (1996).

121 Reese and Reese, 196.

122 Susan I. Enscore, *Guarding the Gates: The Story of Fort Clayton—Its Setting, Its Architecture, and Its Role in the History of the Panama Canal* (Champaign, IL: U.S. Army Corps of Engineers, 2000), Sections 2–6 and 2–7.

123 Reese and Reese, *El Canal de Panamá y su Legado Arquitectónico*, 165.

124 "Aid Church in Canal Zone: The Administration Owns Twenty-Six Churches and Employs Chaplains," *New York Times*, August 6, 1910.

125 George W. Goethals, *Government of the Canal Zone* (Princeton, NJ: Princeton University Press, 1915), 50. It is noteworthy that Goethals identifies the truly unprecedented aspect of the Panama Canal as the Canal Zone's government. By contrast, Goethals notes that the Canal's engineering and disease eradication, which received greater publicity, employed preexisting technologies, only on a greater scale of magnitude.

126 Ibid.

127 Ibid., 91, 45–46.

128 Ibid., 90.

129 Reese and Reese, *El Canal de Panamá y su Legado Arquitectónico*, 162.

130 Ibid., 189.

131 Ibid., 190.

132 Vicki M. Boatwright, "Administration Building Unites Past, Present, and Future," *Panama Canal Review*, October 1, 1979.

133 Grigsby, *Colossal*, 130.

134 Ibid., 19.

135 Ibid., 127, 38.

136 Ibid., 130; Brown, "Science Fiction, the World's Fair, and the Prosthetics of Empire, 1910–1915."

137 Dennis Longwell, "Panama Canal Photographs by Ernest 'Red' Hallen," *Art Journal* 36, no. 2 (1976–1977); Missal, *Seaway to the Future*, Chapter 4.

138 *Seaway to the Future*, 81.

139 Ibid., 82.

140 Ibid., 88.

141 Donoghue, *Borderland on the Isthmus*, 89.

142 C. R. Vosburgh, June 2, 1965, quoted in Ealy, *Yanqui Politics and the Isthmian Canal*, 152–153.

CHAPTER 2 ENTERTAINING SOVEREIGNTY

1 Thomas Graham Grier, *On the Canal Zone* (Chicago: The Wagner & Hanson Company, 1908), 44.

2 Ira E. Bennett, *History of the Panama Canal, Its Construction and Builders* (Washington, DC: Historical Pub. Co., 1915), 169. See also Frederic J. Haskin, *The Panama Canal* (New York: Doubleday, 1913), 176–193.

3 Bennett, *History of the Panama Canal*, 169.

4 Secretary of War W. H. Taft to General Whitefield Davis, September 23, 1904. 28-A-31, NARA.

5 ICC, Annual Report [1905] (Washington, DC: GPO, 1905), 8.

6 Ibid., 8–9; ICC, Annual Report [1906], 4–5.

7 GPC, Annual Report [1921] (Washington, DC: GPO, 1921), 73.

8 George W. Goethals, *Government of the Canal Zone* (Princeton, NJ: Princeton University Press, 1915), 50–51.

9 Panama Canal Company (hereafter PCC) and Canal Zone Government (hereafter CZG), Annual Report [1958] (Balboa Heights, Canal Zone: PCC, 1958), 25.

10 Goethals, *Government of the Canal Zone*, 51.

11 Michael E. Donoghue, *Borderland on the Isthmus: Race, Culture, and the Struggle for the Canal Zone* (Durham, NC: Duke University Press, 2014), 65.

12 Miscellaneous Manuscripts 1806–1976. Organizations File. LOC.

13 Herbert and Mary Knapp, *Red, White, and Blue Paradise: The American Canal Zone in Panama* (San Diego: Harcourt Brace Jovanovich, 1984), 84–85, 104, 121–123.

14 ICC, Annual Report [1905], 8.

15 Shannon Jackson, *Lines of Activity: Performance, Historiography, Hull-House Domesticity* (Ann Arbor: University of Michigan Press, 2000), 8; see also Alfred W. McCoy and Francisco A. Scarano, *The Colonial Crucible: Empire in the Making of the Modern American State* (Madison: University of Wisconsin Press, 2009).

16 Julie Greene, *The Canal Builders: Making America's Empire at the Panama Canal* (New York: Penguin Press, 2009), 117.

17 Knapp and Knapp, *Red, White, and Blue Paradise*, 26.

18 David G. McCullough, *The Path between the Seas: The Creation of the Panama Canal, 1870–1914* (New York: Simon and Schuster, 1977), 578; Bennett, *History of the Panama Canal*, 169–170.

19 ICC and the Panama Canal, Annual Report [1914] (Washington, DC: GPO, 1914).

20 Miscellaneous Information Supplied to "World's Children" for Publication in International Year Book "Child Welfare Work and Care of Dependent Children," February

29, 1924. 95-D-1, NARA; Greene, *The Canal Builders*, 118. The YMCA also managed clubhouses in the Philippines at this time; see E. S. Turner, *Nation Building* (Manila, Philippines: Capitol Publishing House, 1965). Whereas in the Philippines the YMCA movement eventually incorporated Filipinos, the Canal's YMCA activity was largely confined to the Canal Zone, and Panamanians and nonwhite Canal workers were declared ineligible for membership.

21 ICC, Annual Report [1907] (Washington, DC: GPO, 1907), 34.

22 "Year with the Clubhouses," *Panama Canal Record*, October 6, 1909, 45.

23 See Miscellaneous Manuscripts 1806–1976, LOC.

24 Goethals, *Government of the Canal Zone*, 65–85.

25 Donoghue, *Borderland on the Isthmus*, 54–88.

26 Greene, "Spaniards on the Silver Roll: Labor Troubles and Liminality in the Panama Canal Zone, 1904–1914," *International Labor and Working-Class History* 66 (2004): 82.

27 Paul Woodrow Morgan, "The Role of North American Women in U.S. Cultural Chauvinism in the Panama Canal Zone, 1904–1945" (PhD diss., Florida State University, 2000), 21–63.

28 See Mildred White Wells, *Unity in Diversity: The History of the General Federation of Women's Clubs* (New York: General Federation of Women's Clubs, 1953), 39–41; "Women's Clubs in Canal Zone," *New York Times*, October 24, 1907.

29 "Social Life of the Zone," *Panama Canal Record*, January 22, 1908; "Nothing Decent to Eat," *Prensa*, January 8, 1907.

30 "Mrs. Amador's Message," *Prensa*, January 6, 1908.

31 Katherine Zien, "Minstrels of Empire: Blackface and Black Labor in Panama, 1850–1914," in *(Re)Positioning the Latina/o Americas: Theatrical Histories and Cartographies of Power*, ed. Jimmy Noriega and Analola Santana (Carbondale: Southern Illinois University Press, 2017).

32 ICC and PC, Annual Report [1914], 60. The YMCA retained clubs in the Canal Zone for US military officers.

33 Office of the Canal Zone Governor (hereafter "GPC," Governor of the Panama Canal), Annual Report [1924] (Washington, DC: GPO, 1924), 48.

34 GPC, Annual Report [1915] (Washington, DC: GPO, 1915), 420.

35 GPC, Annual Report [1926] (Washington, DC: GPO, 1926), 40.

36 GPC, Annual Report [1921] (Washington, DC: GPO, 1921), 73.

37 GPC, Annual Report [1929] (Washington, DC: GPO, 1929), 68–69.

38 GPC, Annual Report [1923] (Washington, DC: GPO, 1923), 45; GPC, Annual Report [1924] (Washington, DC: GPO, 1924), 48.

39 GPC, Annual Report [1926] (Washington, DC: GPO, 1926), 60–61.

40 Matthew Parker, *Panama Fever: The Epic Story of One of the Greatest Human Achievements of All Time, the Building of the Panama Canal* (New York: Doubleday, 2007), 49–60; Jason M. Colby, *The Business of Empire: United Fruit, Race, and U.S. Expansion in Central America* (Ithaca, NY: Cornell University Press, 2011); Noel Maurer and Carlos Yu, *The Big Ditch: How America Took, Built, Ran, and Ultimately Gave Away the Panama Canal* (Princeton, NJ: Princeton University Press, 2011), 108–110.

41 George W. Westerman, "Historical Notes on West Indians on the Isthmus of Panama," *Phylon* 22, no. 4 (1961): 340.

42 Michael L. Conniff, *Black Labor on a White Canal: Panama, 1904–1981*. Pitt Latin American Series (Pittsburgh: University of Pittsburgh Press, 1985), 25.

43 US Bureau of the Census, "Sixteenth Census of the United States, 1940," United States Department of Commerce (Washington, DC: Government Printing Office, 1941), 1217; "Reductions to Cease Soon: Bottom Force Level Expected by July 1," *Panama Canal Review*, May 5, 1950.

44 Velma Newton, *The Silver Men: West Indian Labour Migration to Panama, 1850–1914* (Mona, Kingston, Jamaica: Institute of Social and Economic Research, University of the West Indies, 1984), 46.

45 McCullough, *The Path between the Seas*, 575.

46 Goethals, *Government of the Canal Zone*, 64.

47 Maurer and Yu, *The Big Ditch*, 108–110.

48 Michael L. Conniff, *Black Labor*, 31–36. I prefer the terms "West Indian," "West Indian Panamanian," and criollo over "Caribbean" or "Antillean," following agreement that the greatest percentage of Afro-Caribbean workers hailed from the British West Indies. In Spanish, "antillano" or "afroantillano" are terms of reference.

49 Ibid., 91.

50 Ibid., 26.

51 Canal Zone Governor George Whitefield Davis to Secretary of Home Missions Benjamin Lyon Smith, September 21, 1904. 28-A-31, NARA.

52 Conniff, *Black Labor*, 49–52.

53 White US workers and families have received substantial scholarly coverage. See Donoghue, *Borderland on the Isthmus*; Greene, *The Canal Builders*; Paul Woodrow Morgan, "The Role of North American Women in U.S. Cultural Chauvinism in the Panama Canal Zone, 1904–1945" (PhD diss., Florida State University, 2000); West Indians' lives have been chronicled in Conniff, *Black Labor*; and Velma Newton, *The Silver Men*.

54 A. G. Coombs to A. Bruce Minear, August 30, 1907. 95-A-4, NARA.

55 A. G. Coombs to Theodore Roosevelt, August 7, 1907; A. G. Coombs to G. Goethals, August 15, 1909. 95-A-4, NARA.

56 General George W. Goethals to J. M. Dickinson, August 25, 1909. 95-A-1, NARA.

57 Newton, *The Silver Men*, 157.

58 Ibid.

59 A. Bruce Minear to Joseph Bucklin Bishop, September 11, 1907; A. Bruce Minear to G. Goethals, February 2, 1909. 95-A-4, NARA.

60 W.H.M. to George Goethals, February 4, 1909. 95-A-4, NARA.

61 Ibid.

62 D. Newton, E. Campbell to A. Bruce Minear, March 14, 1908. 95-A-4, NARA.

63 Ibid.

64 George Goethals to D.N.E. Campbell, April 10, 1908. 95-A-4, NARA.

65 James Harris to George Goethals, February 3, 1909. 95-A-4, NARA.

66 James Harris to George Goethals, February 25, 1909. 95-A-4, NARA.

67 A. G. Coombs to J. M. Dickinson and George Goethals, August 15, 1909. 95-A-4, NARA.

68 Colored Young Men's Christian League to Reverend Moss Loveridge, May 22, 1909. 95-A-4, NARA.

69 Reverend Moss Loveridge to C.Y.M.C.L., May 25, 1909; C.Y.M.C.L. to George Goethals, June 9, 1909. 95-A-4, NARA.

70 A. G. Coombs to George Goethals, August 15, 1909. 95-A-4, NARA.

71 Ibid.

72 Ibid.

73 George Goethals to J. M. Dickinson, August 25, 1909. 95-A-1, NARA.

74 J. M. Dickinson to Reverend A. G. Coombs, September 14, 1909. 95-A-4, NARA. See also George Goethals to Tom M. Cooke, Collector of Revenues and H. S. Blackburn, March 26, 1908. 95-H-503, NARA. Goethals allotted cricket field use with the understanding "that the space must be given up to the Commission at any time it may be needed."

75 The gold clubhouses were located in the townsites of Balboa, Cristóbal, Gatún, Pedro Miguel, and Ancón. Among the silver clubhouses, Cristóbal Silver was in operation at least since 1918, and La Boca existed since 1914. J. E. Waller to Canal Zone Bureau of Clubs and Playgrounds, August 15, 1919; E. F. Attaway to Auditor of Silver Clubhouses, May 26, 1919; A. B. Dickson to Jno. H. A. Davis, C. A. McIlvaine, and W. B. Shipp, June 23, 1914. 95-A-4, NARA.

76 Memorandum for Auditor Panama Canal Zone, May 26, 1919. 95-A-4, NARA.

77 ICC, Annual Report [1914] (Washington, DC: GPO, 1914), 405–406.

78 Memorandum Silver Secretary J. E. Waller, August 15, 1919. 95-A-4, NARA.

79 GPC, Annual Report [1927] (Washington, DC: GPO, 1927), 67.

80 GPC, Annual Report [1929] (Washington, DC: GPO, 1929), 68–69.

81 C. W. Omphroy to Bureau of Clubs and Playgrounds Business Secretary E. F. Attaway, July 8, 1919. 95-A-41/27, NARA. Other permitted groups between 1920 and 1932 included: the Colón Free Night School; the Silver school system; the Colored Girl Reserves; Silver City Boys Literary and Entertaining Society; Silver Clubhouse Baseball League; St. Paul's Friendly Society; Alliance Literary and Debating Society; Ideal Literary Club; and the Cristóbal Silver Clubhouse Junior Choir. For details, see entry 95-A-41/27, NARA.

82 Minutes of Silver Clubhouse Secretaries' Conference at La Boca Clubhouse, December 8, 1921. 95-A-41/27, NARA.

83 Silver Clubhouse Regulations, December 6, 1921. 95-A-41/27, NARA.

84 Memo to Secretaries of Clubhouses, October 22, 1924. 95-A-41/27, NARA.

85 J. E. Waller to E. F. Attaway, June 15, 1932. 95-A-41/27, NARA.

86 Ibid.

87 Correspondence to Director of the Panama American to Mr. Abilio Bellido, June 22, 1933. 95-A-41/27, NARA.

88 Kaysha Corinealdi, "Redefining Home: West Indian Panamanians and Transnational Politics of Race, Citizenship, and Diaspora, 1928–1970" (PhD diss., Yale University, 2011).

89 Silver Clubhouse Plan for Developing the Programming, October 10, 1919. 95-A-41/27, NARA.

90 GPC, Annual Report [1929] (Washington, DC: GPO, 1929), 68–69.

91 Conniff, Black Labor, 92–98.

92 Carla Burnett, "'Are We Slaves or Free Men?': Labor, Race, Garveyism, and the 1920 Panama Canal Strike" (PhD diss., University of Illinois at Chicago, 2004), 33.

93 General Secretary T. S. Booz to William Stoute, August 4, 1919. Use of the Panama Canal Clubhouses for Other than Clubhouse Activities, May 1, 1907–April 30, 1934. 95-A-40, NARA.

94 Memorandum to Bureau of Clubs and Playgrounds, "Uses of Cristóbal Silver Clubhouse by Labor Organization," July 12, 1919. 95-A-40, NARA. Gold-roll petitions to the Bureau of Clubs and Playgrounds from outside organizations appear in entries 95-E-6 and 95-E-7 in RG 185, NARA.

95 Carla Burnett, "'Are We Slaves or Free Men?,'" 36.

96 Ibid., 1–4. Panama boasted the third-highest number of UNIA branches in the world. Ronald Harpelle, "Cross Currents in the Western Caribbean: Marcus Garvey and the U.N.I.A. in Central America," *Caribbean Studies* 31, no. 1 (2003).

97 United Brotherhood of Maintenance of Way Employes [*sic*] and Railway Shop Laborers to General Secretary of Clubhouses T. Booz, July 28, 1919. 95-A-40, NARA.

98 Burnett, "'Are We Slaves or Free Men?,'" 2–3.

99 United Brotherhood to T. Booz, July 28, 1919. 95-A-40, NARA.

100 Memorandum to Secretary of Clubs and Playgrounds, July 12, 1919. 95-A-40, NARA.

101 United Brotherhood to T. Booz, July 29, 1919. 95-A-40, NARA.

102 J. E. Waller to Chester Harding, August 9, 1919. 95-A-40, NARA.

103 United Brotherhood to Chester Harding, August 9, 1919. 95-A-40, NARA.

104 Chester Harding to E. Bridgett, August 12, 1919. 95-A-40, NARA.

105 "'Are We Slaves or Free Men?,'" 138, 52–62.

106 Samuel H. Whyte, "West Indian Employees Association Was Formed in 1924," *Panama Star and Herald*, August 15, 1939.

107 PCWIEA to Executive Secretary of Clubs and Playgrounds C. A. McIlvaine, September 22, 1925. 95-A-40, NARA.

108 Executive Secretary C. A. McIlvaine to W. B. Ellis, November 6, 1925. 95-A-40, NARA.

109 Memorandum to Secretary of Clubs and Playgrounds, July 12, 1919. 95-A-40, NARA.

110 Charlotte Canning, *The Most American Thing in America: Circuit Chautauqua as Performance* (Iowa City: University of Iowa Press, 2005), 113–114. Whereas Canning notes that Chautauqua included lectures and performances by African American individuals and groups, ICC officials opposed bringing African American entertainers to the Canal Zone, claiming that audiences would object.

111 Alkahest Lyceum System to F. C. Freeman, General Secretary of the Y.M.C.A., May 14, 1910. Contracts with Traveling Entertainers; Entertainment Policy, 95-E-4, NARA.

112 "The Apollo Concert Company Scores a Triump [*sic*] on the Panama Canal Zone with Buescher Gold Instruments," *Lyceum Magazine*, October 1913, 84; Crawford Peffer of Redpath Lyceum Bureau to A. B. Dickson, May 22, 1913. 95-E-4, NARA.

113 Superintendent of Clubhouses to F. A. Morgan, August 2, 1910; George H. Glazier to A. Bruce Minear, January 13, 1910, 49 (95-E-4, NARA); "The Panama Singers," *Lyceum Magazine*, February 1914, 49.

114 Four Meryl Prince Girls to T. S. Booz, September 30, 1919. Box 1598, D-20, 3 (1) to 95-E-4 (1). NARA.

115 Charlotte Canning, *The Most American Thing in America*, 21–22.

116 Ibid., 160–164.

117 Thomas Postlewait, "The Hieroglyphic Stage," in *Cambridge History of American Theatre, 1870–1945*, Volume 2, ed. Don B. Wilmeth and Christopher Bigsby (New York: Cambridge University Press, 1999), 107–195.

118 General Secretary of the Bureau of Clubs and Playgrounds to George H. Glazier, Manager, Glazier Lyceum Bureau, January 28, 1910. 95-E-4, NARA.

119 ICC, Annual Report [1910] (Washington, DC: GPO, 1910), 437; ICC, Annual Report [1914] (Washington, DC: GPO, 1914), 407.

120 "Ancón Nurses Entertain," *Prensa*, January 14, 1908.

121 A. L. Flint to the Governor of the Panama Canal, February 26, 1921. 95-E-4, NARA.

122 F. M. M. Richardson to E. Tomlinson, c/o Y.M.C.A. Wilmerding, Pa, October 21, 1914. 95-E-4, NARA.

123 F. M. M. Richardson to Clyde Smith, January 21, 1915. 95-E-4, NARA.

124 Acting General Secretary of Clubhouses A. J. Scott to R. H. Cross Vaudeville Agency, December 15, 1919. 95-E-4, NARA.

125 F. M. M. Richardson to Dillon M. Deasy, September 24, 1915. 95-E-4, NARA.

126 Touring acts in the 1920s included: "Miss Evita Enireb, Queen of Illusionism"; "The Great Albert"; Spanish dancer La Marquesita; Princess Carnak; Dr. Saa de Waldemar, presenting hypnotism, magical and mysterious representations; Mr. Perisse (operatic tenor from Chicago), Mme. Augusta Pouget (soprano from the Colón theatre, Buenos Aires), Mlle. Sybil Florian, from the Lyric Gaiety theatre, Paris; Miss Elise de Grood, Dutch violinist; the "Fron Brown Animal Show"; Sra. Blanca del Campo, Chilean dramatic soprano; Nella Mazimova, classical dancer; Charles Vohnout, violinist; Mary Dvorak, pianist; the Odierno Opera Company; the Colombian National Orchestra; Ernesto Valdivia, "violin virtuoso"; Lady Thais, "noted Check Slavia [sic] violinist and singer"; Zeusi and Mecherini, novelty dancers; the Russian National Orchestra; "The Great Dalbeanie," comedian, trick cyclist, equilibrist; Hobo Jim, tramp cyclist; Sr. Roberto Saa Silva, lyric baritone of the Chilean National Opera; Alaida Zaza in classic dances and art poses; Nelson vaudeville acrobatic troupe; F. Tscheil, Viennese violinist, assisted by Prof. Alberto Galimany; the A. Graziani Opera Company; the Bragale Opera Company; and the Dunbar and Schneyer Circus. For details, see entry 95-E-6 in RG 185, NARA.

127 For information on the Canal's reductions in force, see GPC, Annual Report [1920] (Washington, DC: GPO, 1920), 59; GPC, Annual Report [1922] (Washington, DC: GPO, 1922), 42–43.

128 Invitees included Keith's Palace Theatre; The Art Drama Players; Associated Theatres; David Belasco; Broadway Booking Bureau; Broadway Varieties Company; Cohan & Harris; Globe Agency; B. F. Keith; Miss Frances R. King; Marcus Loews Booking Office; National Drama Corporation; and Orpheus Circuit Company.

129 Memorandum from C. A. McIlvaine to T. S. Booz, November 17, 1919. 95-E-4, NARA. Michael Conniff notes that McIlvaine was "a career administrator and the most powerful civilian in the Zone" (Black Labor, 77).

130 C. A. McIlvaine to Chief of Office, Washington DC, March 8, 1921. 95-E-4, NARA.

131 "List of Entertainers Recommended for a Repeat Engagement," February 18, 1920. 95-E-4, NARA; J. C. Searcy to T. S. Booz, June 14, 1921. 95-E-6, NARA.

132 Ray L. Smith, Acting Chief of Office to Hermann Fisher, Dramatic Stock and Repertory Departments, The Billboard [Magazine], August 7–16, 1920. 95-E-4, NARA.

133 A. L. Flint to Governor of the Panama Canal, May 31, 1921. 95-E-4, NARA.

134 C. A. McIlvaine to Chief of Office, Panama Canal, Washington DC, July 23, 1921. 95-E-4, NARA; Chief of Washington DC Office A. F. Flint to E. Walter Geisler, Business Manager Armour Institute Glee and Mandolin Club, September 15, 1921. 95-E-4, NARA.

135 A. L. Flint to the Governor of the Panama Canal, cc. A. J. Scott, September 1, 1921. 95-E-4, NARA.

136 Secretary Ancon Clubhouse L. R. McKenney to J. C. Searcy, July 8, 1921. 95-E-4, NARA.

137 "Financial Report for 'All American Sextette' from John H. Smith, Acting Executive Secretary, Bureau of Clubs and Playgrounds," May 24, 1921. 95-E-4, NARA.

138 A. L. Flint to the Governor of the Panama Canal, June 17, 1921. 95-E-4, NARA.

139 Canning, The Most American Thing, 219–223.

140 T. S. Booz to C. A. McIlvaine, October 12, 1921. 95-E-4, NARA.

141 Report on Community Night from Gatun Secretary, March 30, 1926. Entertainments at Individual Clubhouses, 95-E-6, NARA.
142 Clubs and Playgrounds Business Secretary E. F. Attaway to Gatun Clubhouse Secretary McGahhey, July 13, 1926; T. S. Booz to Gatún Clubhouse Secretary J. T. McGahhey, May 2, 1924. 95-E-6, NARA.
143 Gatun Silver Clubhouse Secretary J. E. Moore to T. S. Booz, May 6, 1925; Invitation from Pedro Miguel Secretary A. E. Cotton Re: "Old Time Program," May 18, 1927. 95-E-6, NARA.
144 R. L. Wilhite to T. S. Booz, October 19, 1926; Report on Cristobal Clubhouse Community Night, May 26, 1927; General Secretary of Clubhouses E. F. Attaway to Executive Secretary of Clubhouses C. A. McIlvaine, April 25, 1932. 95-E-6, NARA.
145 Gatun Clubhouse Community Night Report, September 8, 1931; Report on Community Night from A. E. Cotton to T. S. Booz, March 26, 1926; Cristobal Clubhouse Community Night Report, September 28, 1924; Pedro Miguel Clubhouse Community Night Program, May 25, 1927; Program for Community Night [Unknown Clubhouse], August 26, 1925; T. S. Booz to Chief Johannes, Police and Fire Division, March 28, 1927. 95-E-6, NARA.
146 Secretary Red Tank H. C. Williams to E. F. Attaway, May 9, 1928; Secretary Red Tank H. C. Williams to Acting General Secretary R. L. Dwelle, April 30, 1929; Community Night Report from H. C. Williams to R. L. Dwelle, May 13, 1929; Acting General Secretary R. L. Dwelle to Silver Clubhouses, December 10, 1929. 95-E-6, NARA.
147 Memo for Balboa Heights Superintendent of Schools Mr. B. N. Williams from Principal T. S. Johnston, March 1, 1933. 95-E-6, NARA.
148 J. E. Waller to T. S. Booz, November 13, 1926. 95-A-41/27, NARA; Report on Educational Show by Pedro Miguel Secretary C. H. Bradley for T. S. Booz, May 21, 1927. 95-E-6, NARA; J. E. Waller to E. F. Attaway, March 6, 1928. 95-A-41/27, NARA; H. C. Williams to E. F. Attaway, April 20, 1928. 95-E-6, NARA.
149 J. E. Moore to E. F. Attaway, January 18, 1928; Community Night Program Gatun Silver Clubhouse, February 28, 1928; Program from Gatun Silver Community Night, August 26, 1929; Request for Cristobal Silver Clubhouse Community Night from R. Hall, June 27, 1932. 95-E-6, NARA.
150 Report on Community Night at Gatun Silver Clubhouse by Acting Secretary A. L. Brandon, November 12, 1930; Report from C. H. Bradley on Paraiso "Educational Show and Community Night Program," March 12, 1934. 95-E-6, NARA.
151 Records on participation in silver Community Nights by nonwhite, non–West Indian workers are few, suggesting that these were isolated events. "The Spanish element" may refer to Latin American or Spanish labor migrants, who constituted an underrepresented minority in silver-roll labor at this time. In 1939, numbers of Latin American workers would rise with the Third Locks project. Report on Gatun Silver Community Night by J. E. Moore for E. F. Attaway, August 24, 1929. 95-E-6, NARA.
152 Silver City School Community Night Report, February 28, 1933. 95-E-6, NARA.
153 J. T. McGahhey to T. S. Booz, June 12, 1926. 95-E-6, NARA.
154 "Happenings in the Zone Towns," *Panama Tribune*, May 26, 1929.
155 "Joseph Raymond Writes a New Play," *Panama Tribune*, June 30, 1929; "'Neta' Acclaimed at Variedades: Star Scores Hit in Garvey's Play," *Panama Tribune*, July 14, 1929.
156 E. F. Attaway to J. E. Waller Approving Vaudeville Show and Dance with Syncopators Orchestra, January 13, 1927. 95-A-41/27, NARA.

157 "Advertisement, Teatro America," *Panama Tribune*, June 2, 1929.

158 W. W. Scarborough to Lew Ward, September 10, 1926 (95-E-6, NARA); T. S. Booz to Mr. McGahhey, March 5, 1927. 95-E-6, NARA. For information on the Isthmian Marching Band and Orchestra, see Box 24, LOC.

159 "Petition to Oust W. I. Musicians: Hint Campaign to Restrict Employment," *Panama Tribune*, June 9, 1929. This petition aligned with Panama's 1926 Law 13. See Conniff, *Black Labor*, 65.

160 Management Committee of Red Tank School in Pedro Miguel to R. L. Dwelle and Red Tank Secretary H. C. Williams, December 13, 1929. Clubhouses, Silver—Operation, Etc., 95-A-41/27, NARA.

161 Memo from E. F. Attaway to Cristobal Silver Clubhouse Acting Secretary, August 24, 1929. 95-A-41/27, NARA; E. F. Attaway to Cristobal Silver Clubhouse Acting Secretary A. L. Brandon, August 6, 1934. 95-E-6, NARA; R. L. Dwelle to J. E. Moore, December 7, 1929. 95-A-41/27, NARA.

162 J. E. Waller to R. L. Dwelle, July 1, 1929. 95-A-41/27, NARA; Memo from J. E. Waller to R. L. Dwelle, February 4, 1930. 95-E-6, NARA; Request to Rent Cristobal Silver Clubhouse Hall for Variety Concert, July 28, 1932. 95-A-41/27, NARA; E. F. Attaway to Red Tank Clubhouse Secretary H. C. Williams, April 25, 1934. 95-E-6, NARA; Request to Use Cristobal Silver Clubhouse for Conducting a Community Vitiphone [sic] Dance, October 24, 1932. 95-A-41/27, NARA; Request for Cristobal Silver Clubhouse for Initiation and Health Play by the Girls Reserve, October 24, 1932. 95-E-6, NARA.

163 Harpelle, "Cross Currents in the Western Caribbean," 45–46.

164 Colin Grant, *Negro with a Hat: The Rise and Fall of Marcus Garvey* (New York: Oxford University Press, 2008), 33; Céspedes Burke, "S.S. 'Saramacca' Docks at 11.35 with Pres. General Garvey Receiving U.N.I.A. Delegation of Divisions and Chapter[s]," *Panama Star and Herald*, December 8, 1927; Conniff, *Black Labor*, 71.

165 E. F. Attaway to Amy Ashwood Garvey c/o "the Rendezvous" in Colón, February 4, 1929. 95-E-4, NARA.

166 "Pack [sic] Houses Greet Manning," *Panama Tribune*, June 2, 1929.

167 Ibid.

168 "What Is the Status," *Panama Tribune*, June 2, 1929; "A Pernicious Theory," *Panama Tribune*, June 30, 1929.

169 "A Pernicious Theory."

170 "Seeking the Facts," *Panama Tribune*, June 2, 1929.

171 A. F. N., "The Silver Clubhouses," *Panama Star and Herald*, June 15, 1927.

172 Ibid.

173 I. I. Meyers, "Letter to the Editor, West Indian Section," *Panama Star and Herald*, June 19, 1927.

174 GPC, Annual Report [1940] (Washington, DC: GPO, 1940), 97.

175 "Clubhouse Debars Colon Cricketers," *Panama Star and Herald*, December 29, 1933.

176 GPC, Annual Report [1937] (Washington, DC: GPO, 1937), 80–81.

177 Ibid., 81.

178 GPC, Annual Report [1940] (Washington, DC: GPO, 1940), 46.

179 "Clubhouses Provide Variety in Services, Entertainment," *Panama Canal Review*, May 5, 1950.

180 PCC and CZG, Annual Report [1953], 25.

181 Ibid.

182 Donoghue, *Borderland on the Isthmus*, 59.

183 Ibid., 60.

184 A. C. Buchanan to Colonel F. H. Wang, July 18, 1946 (Box 16, Folder 35, George W. Westerman Papers, Manuscripts, Archives and Rare Books Division, Schomburg Centre for Research in Black Culture, The New York Public Library).

185 I.N.Y.C. Executive Secretary Roy Best to R. G. Taylor, Director of Panama Canal Clubhouses, October 6, 1944 (GWW, Box 16, Folder 35, Schomburg).

186 I.N.Y.C. to R. G. Taylor, May 16, 1946 (GWW, Box 16, Folder 35, Schomburg).

187 Ibid.

188 A. C. Buchanan to Colonel F. H. Wang, July 18, 1946 (GWW, Box 16, Folder 35, Schomburg).

189 I.N.Y.C. to Colonel F. H. Wang, May 17, 1945 (GWW, Box 16, Folder 35, Schomburg).

190 Conniff, Black Labor, 119–127.

191 Ibid., 106.

CHAPTER 3 BEYOND SOVEREIGNTY

1 "Marian Anderson Sings to 2000 in Panama Recital," Panama Tribune, June 24, 1951.

2 "Echoes of Marian Anderson's Visit," Panama Tribune, June 24, 1951.

3 George W. Westerman, "Leaves Vast Spiritual Heritage," Panama Tribune, April 24, 1965.

4 Archival evidence suggests that Westerman may have helped to organize the visits of Dizzy Gillespie in 1956 and Duke Ellington in 1971, but this is not confirmed.

5 Michael Conniff, Black Labor on a White Canal: Panama, 1904–1981. Pitt Latin American Series (Pittsburgh: University of Pittsburgh Press, 1985), 13. For biography of George W. Westerman, see Katherine Zien, "George Westerman," Dictionary of Caribbean and Afro-Latin American Biography, ed. Henry Louis Gates Jr. and Franklin W. Knight (New York: Oxford University Press, 2016).

6 Jacques Rancière, The Ignorant Schoolmaster: Five Lessons in Intellectual Emancipation (Stanford, CA: Stanford University Press, 1991), 137.

7 Lauren Berlant, The Queen of America Goes to Washington City: Essays on Sex and Citizenship (Durham, NC: Duke University Press, 1997), 228.

8 Ibid., 222–223.

9 See, for example, Conniff, Black Labor, 4.

10 George W. Westerman and Linda Samuels, "An Exhibit on the Races of Mankind" (Ancon, Canal Zone, Panama: Isthmian Negro Youth Congress Publishing Department, 1946), 6.

11 Trevor O'Reggio, Between Alienation and Citizenship: The Evolution of Black West Indian Society in Panama 1914–1964 (Lanham, MD: University Press of America, 2006), Appendix D.

12 Conniff, Black Labor, 65.

13 Ibid.

14 Ibid., 66.

15 Ibid. Panama was not alone in imposing harsh and punitive immigration laws. These measures echoed contemporaneous racial quotas and restrictions, such as the US Chinese Exclusion Act (1882), Canada's Chinese Immigration Act (1923), the US Johnson-Reed Act (1924), and Cuba's anti–West Indian immigration restrictions, as reported in the West Indian Panamanian newspaper the Workman in 1926.

16 George W. Westerman, "Westerman Speaks on Minorities" (Box 17, Folder 17, George W. Westerman Papers, Manuscripts, Archives and Rare Books Division, Schomburg Center for Research in Black Culture, The New York Public Library); Westerman, "Toward a Better Understanding" (Panama: n.p., 1946), v.

17 GWW, Box 17, Folder 12, Schomburg.

18 Janice Quinter, "Biographical Note," Finding Aid to the George W. Westerman Papers (Schomburg), 3. An online biography and finding aid are available at http://archives.nypl.org/scm/20916. Accessed April 11, 2016.

19 Westerman, "Toward a Better Understanding," v.

20 Ibid., 1.

21 Wendy Brown, *Walled States, Waning Sovereignty* (New York: Zone Books, 2010), 99.

22 These austerity measures were temporarily ameliorated by the Third Locks project (1939–1942). After the Canal expansion project ended unsuccessfully, West Indian workers were again pushed out of the Canal Zone.

23 Conniff, *Black Labor*, 91; Katherine Zien, "Race and Politics in Concert: Paul Robeson and William Warfield in Panama, 1947–1953," *The Global South* 6, no. 2 (2013).

24 "Now That They Are Hit," *Panama Tribune*, July 22, 1945; George W. Westerman, "The Passing Review," *I.N.Y.C. Bulletin*, The Passing Review, August 22, 1945, 2 (GWW, Box 17, Folder 2, Schomburg).

25 The 1950s witnessed a mass exodus of West Indian Panamanians to the United States. Westerman helped many to enter the United States for scholarships and internships. For information on West Indian descendants' immigration to the United States, see Conniff, *Black Labor*, and Kaysha Corinealdi, "Redefining Home: West Indian Panamanians and Transnational Politics of Race, Citizenship, and Diaspora, 1928–1970" (PhD diss., Yale University, 2011).

26 George W. Westerman, "The Passing Review," *I.N.Y.C. Bulletin*, November 22, 1942.

27 The "United Nations" referred at this time to the Allied nations.

28 Michael E. Donoghue, *Borderland on the Isthmus: Race, Culture, and the Struggle for the Canal Zone* (Durham, NC: Duke University Press, 2014), 14–16.

29 "Panama Defense: U.S. Gets Vital Air Bases," *Life*, March 17, 1941.

30 "Principal Dobbs Will Be Speaker on Colón Program," *The Nation*, October 10, 1946.

31 Westerman, "Toward a Better Understanding," vi.

32 Clare Croft, *Dancers as Diplomats: American Choreography in Cultural Exchange* (New York: Oxford University Press, 2015), 18–23, 142, 49–54. Croft discusses differences in funding and rhetoric around US cultural diplomacy from the mid-twentieth century to the present.

33 Ibid., 12–15.

34 Charlotte Canning, *On the Performance Front: US Theatre and Internationalism* (New York: Palgrave Macmillan, 2015), 14.

35 Fred Turner, *The Democratic Surround: Multimedia & American Liberalism from World War II to the Psychedelic Sixties* (Chicago: University of Chicago Press, 2013), 23–40. See also Ronald Radano, "Hot Fantasies: American Modernism and the Idea of Black Rhythm," in *Music and the Racial Imagination*, ed. Ronald Radano and Philip Vilas Bohlman (Chicago: University of Chicago Press, 2000).

36 Canning, *On the Performance Front*, 15; Danielle Fosler-Lussier, *Music in America's Cold War Diplomacy* (Oakland: University of California Press, 2015).

37 "Comments Relative to Photographic Collection of Fifty Outstanding Afro-Americans for Canal Zone Colored School" (GWW, Box 7, Folder 1, Schomburg); "Photographs

of 50 Outstanding American Negroes Presented to La Boca School by Goe. [*sic*] Westerman," *Panama Tribune*, May 24, 1942. See also GWW, Box 29, Folders 7–8, Schomburg.

38 Turner, *The Democratic Surround*, 10–11.

39 For more information on *The Family of Man*, see Fred Turner, "*The Family of Man* and the Politics of Attention in Cold War America," *Public Culture* 24, no. 1 (2012): 55–84. For details on "An Exhibit on the Races of Mankind," see GWW, Box 16, Folders 44 and 50, Schomburg.

40 Samuels, "An Exhibit on the Races of Mankind," 6.

41 Ibid.

42 Ibid.

43 Westerman, "The Passing Review," *I.N.Y.C. Bulletin*, November 22, 1942.

44 Michel-Rolph Trouillot, *Silencing the Past: Power and the Production of History* (Boston: Beacon Press, 1995), 88.

45 I.N.Y.C. to Eslanda Goode Robeson, May 26, 1945 (GWW, Box 16, Folder 41, Schomburg). Emphasis added.

46 Lloyd LeRoy Hogan, "Activities of the Isthmian Negro Youth Congress," *I.N.Y.C. Bulletin*, November 22, 1942 (GWW, Box 17, Folder 2, Schomburg).

47 George W. Westerman to I.N.Y.C. Executive Committee, March 10, 1947 (GWW, Box 16, Folder 35, Schomburg).

48 George W. Westerman, "The Passing Review," *I.N.Y.C. Bulletin* [Special Edition on "The Negro in Music"], January 31, 1943 (GWW, Box 17, Folder 2, Schomburg).

49 Fosler-Lussier, *Music in America's Cold War Diplomacy*, 37–38; Annegret Fauser, *Sounds of War: Music in the United States During World War II* (New York: Oxford University Press, 2013).

50 "Good-Will Ambassador Aubrey Pankey," *I.N.Y.C. Bulletin* [Special Edition on "The Negro in Music"], January 31, 1943, pp. 8, 17 (GWW, Box 17, Folder 2, Schomburg).

51 GWW, Box 16, Folder 40, Schomburg.

52 "Jamaican Artists Break Attendance Records to Give Recital Today at Gamboa," *Panama Tribune*, April 23, 1944; "Jamaican Artists Offer Fine Recital at La Boca Club," *Panama Star and Herald*, May 14, 1944.

53 George W. Westerman to Verna Arvey Still, October 12, 1943 (GWW, Box 16, Folder 42, Schomburg).

54 Program Notes, Todd Duncan and William Allen Concert, May 4, 1945 (GWW, Box 16, Folder 36, Schomburg).

55 Ibid.

56 "Cultural and Political History Made by Todd Duncan's Golden Voice," *I.N.Y.C. Bulletin*, August 22, 1945 (GWW, Box 17, Folder 2, Schomburg).

57 Ibid.

58 Ibid.

59 Ibid.

60 Ibid.

61 Westerman, "Toward a Better Understanding." Prologue by Gil Blas Tejeira, viii.

62 For scholarship on anti-Black racism in Latin America, see Conniff, *Black Labor*; Ifeoma Nwankwo, "The Art of Memory in Panamanian West Indian Discourse: Melva Lowe De Goodin's *De/from Barbados a/to Panamá*," *Publication of the Afro-Latin/American Research Association* 6 (2002); Sonja Stephenson Watson, "'Black Atlantic' Cultural Politics as Reflected in Panamanian Literature" (Diss., University of Tennessee,

Knoxville, 2005); Peter Wade, *Blackness and Race Mixture: The Dynamics of Racial Identity in Colombia* (Baltimore: Johns Hopkins University Press, 1993); Nancy P. Appelbaum, Anne S. Macpherson, and Karin Alejandra Rosemblatt, *Race and Nation in Modern Latin America* (Chapel Hill: University of North Carolina Press, 2003).

63 Herbert Thomas, "Statement to the I.N.Y.C.," October 10, 1944 (GWW, Box 16, Folder 35, Schomburg).

64 George Westerman to Barry Ulanov, March 6, 1946 (GWW, Box 16, Folder 46, Schomburg).

65 Ibid.

66 The reasons for Westerman's departure are unclear, but from internal correspondence with INYC officers it appears that he resented shouldering an outsized administrative burden and noticed accounting discrepancies that made him question the group's leadership.

67 George W. Westerman to Nelly Walter, October 11, 1947 (GWW, Box 30, Folder 13, Schomburg).

68 George W. Westerman to Johnnie Evans, October 7, 1949 (GWW, Box 30, Folder 13, Schomburg).

69 Matthew Smith, "Wanderers of Love: Touring and Tourism in the Jamaica-Haiti Musical Circuit of the 1950s," in *Sun, Sea, and Sound: Music and Tourism in the Circum-Caribbean*, ed. Timothy Romman and Daniel Neely (New York: Oxford University Press, 2014).

70 Stephen Hill to George W. Westerman, December 7, 1951 (GWW, Box 30, Folder 10, Schomburg).

71 George W. Westerman to Stephen Hill, August 27, 1951; George W. Westerman to Stephen Hill, October 21, 1951; George W. Westerman to Stephen Hill, October 30, 1951; Stephen Hill to George W. Westerman, November 3, 1951 (GWW, Box 29, Folder 38, Schomburg).

72 George W. Westerman to Sol Hurok Attractions, March 22, 1950; George W. Westerman to Herbert Decastro, April 13, 1951 (GWW, Box 29, Folder 28, Schomburg); Nelly Walter to George W. Westerman, August 14, 1947 (GWW, Box 30, Folder 2, Schomburg).

73 George W. Westerman to Johnnie Evans, November 7, 1949; George W. Westerman to Johnnie Evans, October 7, 1949 (GWW, Box 30, Folder 13, Schomburg).

74 GWW, Box 30, Folder 7, Schomburg.

75 "'Porgy and Bess' on McMechen Program: Gifted Lyric Soprano Sings Tonight with Symphony Orchestra," *Panama Star and Herald*, March 31, 1949.

76 George W. Westerman to Johnnie Evans, October 7, 1949 (GWW, Box 30, Folder 13, Schomburg).

77 "Ambassador and Mrs. Davis Honor Miss June McMechen with Reception," *The Nation*, March 30, 1949.

78 Jack Jamieson, "The Embassy Reception: Jamieson Considers It," *The Nation*, April 2, 1949.

79 "A New Tree in an Old Land for Singer," in "June McMechen Press Booklet" (GWW, Box 30, Folder 6, Schomburg).

80 "June McMechen Re-Writes U.S. History in Panama: Zone Wilts under Magic Spell of Vocal Excellency, Segregation Set up by U.S. Vanishes as All Panama Again Mingles on Equal Terms," *Washington Afro-American*, April 12, 1949.

81 Jamieson, "The Embassy Reception."

82 Jack Jamieson, "Smoldering Embers" (GWW, Box 30, Folder 7, Schomburg).

83 Columbia Concerts, "Camilla Williams Publicity Booklet," 10 (GWW, Box 30, Folder 22, Schomburg).

84 "Camilla Williams Publicity Booklet," 12.

85 *Time*, September 30, 1946, quoted in "Camilla Williams Publicity Booklet," 16.

86 "Camilla Williams Publicity Booklet," 15.

87 See George W. Westerman, Entertainment Career, Camilla Williams (New York, 1949) (GWW, Box 30, Folders 21–22, Schomburg).

88 George W. Westerman, Entertainment Career, Emily Butcher (New York: 1949) (GWW, Box 29, Folder 33, Schomburg).

89 Gladys Graham, "La Boca Teacher's Music Builds Morale Thro' Cz," *Panama American*, August 28, 1949.

90 "Receives Plaudits," *Panama Tribune*, October 9, 1949 (GWW, Box 29, Folder 34, Schomburg).

91 Jack Jamieson, "Says La Boca Townsite Can Be Very Proud of Miss Butcher's Success," "Drops and Turnovers," *Panama Tribune*, October 2, 1949 (GWW, Box 29, Folder 34, Schomburg).

92 Ibid.

93 Nelly Walter to George W. Westerman, October 29, 1947 (GWW, Box 30, Folder 13, Schomburg).

94 The designation "silver-roll" was changed to "local-rate" in 1948, although the meaning remained the same. See Conniff, *Black Labor*, 109. On Adam Clayton Powell Jr.'s visit to Panama, see "5 Congressmen, Hazel Scott Here on Visit [Fragment]," [Unnamed Newspaper], December 5, 1949; "Rev. Adam Clayton Powell and Wife of Congressional Group Arriving in Panama," *Associated Negro Press*, Entertainment Career, Hazel Scott (GWW, Box 30, Folders 13–15, Schomburg).

95 "Clayton Powell Reports to House on Canal Zone," *The Nation*, October 4, 1950 (GWW, Box 30, Folder 15, Schomburg).

96 "Powell Calls for Joint Efforts to Fight Hatred" [Unnamed Newspaper], December 16, 1949 (GWW, Box 30, Folder 15, Schomburg).

97 Hazel Scott, "Concert Program," December 15, 1949 (GWW, Box 30, Folder 14, Schomburg).

98 Minuet, "Hazel Scott Thrills Crowd at Concert: Noted Pianist Displays Art as Bach-Boogie Executant," [Unnamed Newspaper], December 11, 1949 (GWW, Box 30, Folder 15, Schomburg); "Hazel Takes a Bow," *The Nation*, December 7, 1949 (GWW, Box 30, Folder 15, Schomburg). Scott performed songs including passages from *South Pacific* and her film *Rhapsody in Blue*, "swung" Chopin, and played her compositions "Chicago Fire" and "Caribbean Fete," the latter a four-part work celebrating Trinidadian Carnival with calypso-infused melodies.

99 George W. Westerman, "Hazel Scott Press Booklet" (GWW, Box 30, Folder 14, Schomburg).

100 Ibid., 5.

101 Ibid.

102 "Biography of Concert Star Hazel Scott," "Hazel Scott Press Booklet."

103 George W. Westerman to Johnnie Evans, November 10, 1949 (GWW, Box 30, Folder 13, Schomburg).

104 Nelly Walter to George W. Westerman, July 21, 1947 (GWW, Box 30, Folder 2, Schomburg).

105 "Biographical Information for Dorothy Maynor," "Dorothy Maynor Press Booklet," 1950 (GWW, Box 30, Folder 3, Schomburg).

106 Ibid.

107 "Noted Soprano Sings Tonight at Lux Theatre," *Panama Star and Herald*, March 13, 1950 (GWW, Box 30, Folder 4, Schomburg).

108 "Critic's Corner," *Panama American*, n.d. (GWW, Box 30, Folder 5, Schomburg).

109 Dorremi II, "Dorothy Maynor En El Lux," *Panama American*, Musicalia column, March 14, 1950 (GWW, Box 30, Folder 5, Schomburg).

110 George W. Westerman to Nelly Walter, March 20, 1950 (GWW, Box 30, Folder 2, Schomburg).

111 Ibid.

112 Marian Anderson's visit was preceded by that of Carol Brice. Spatial constraints and a relative paucity of information prevent me from examining Brice's visit in depth. For more information, see GWW, Box 29, Folder 32, Schomburg.

113 "Celeste Aida," *Time*, July 29, 1946, quoted in "Critic's Corner," *Panama American*, October 3, 1951 (GWW, Box 29, Folder 32, Schomburg).

114 "Ellabelle Davis Appearance to Be Short in Colon," *Panama Star and Herald*, October 22, 1951.

115 "Ellabelle Davis Acclaimed in Latin America," *Panama Star and Herald*, October 1, 1951.

116 "Ellabelle Davis, La Gran Soprano de Color, Conquista a Europa," *La Nación*, October 3, 1951.

117 *The Daily Gleaner*, September 17, 1951 (GWW, Box 29, Folder 32, Schomburg).

118 "Colonites to Hear Ellabelle Davis in Open-Air Musicale," *The Nation*, October 13, 1951 (GWW, Box 29, Folder 32, Schomburg).

119 George W. Westerman to Stephen Hill, September 16, 1951 (GWW, Box 29, Folder 38, Schomburg).

120 Davis's Panama City concert garnered high praise from critics and audience members, who included US Ambassador John Wiley, US Army officials, local religious figures, and Panamanian politicians and intellectuals. "Ellabelle Davis Sings Tonight at National," *Panama Star and Herald*, October 26, 1951 (GWW, Box 29, Folder 32, Schomburg). Westerman suffered losses of over $500, however, and his relations with the Hills became strained. George W. Westerman to Stephen Hill, October 30, 1951 (GWW, Box 29, Folder 38, Schomburg).

121 Josephine Schuyler to George W. Westerman, July 21, 1952 (GWW, Box 30, Folder 10, Schomburg).

122 Raised in luxury and subjected to an unconventional diet and education, in later life Philippa Schuyler became acutely conscious of the politics of race and gender (and their influence on her upbringing).

123 After the 1952 tour, Philippa Schuyler would undertake a grand tour of Latin America, the Middle East, Africa, and Europe, sponsored by the US State Department. "Biographical Information for Philippa Duke Schuyler, Pianist," "Philippa Duke Schuyler Press Booklet" (GWW, Box 30, Folder 10, Schomburg). See also musicdiplomacy.org/database. Accessed April 12, 2016.

124 "En Magnífica Ceremonia Se Hizo Entrega De La Casa Del Periodista," *La Estrella de Panamá*, August 13, 1952 (GWW, Box 30, Folder 11, Schomburg). Schuyler also visited Canal Zone governor John Seybold, National University rector Octavio Méndez Pereira, and a Balboa school, among many other activities.

125 "Era ella un ejemplo para los racistas y los apóstoles de la discriminación racial que creen que la pigmentación de la piel otorga privilegios y superiores capacidades." Eleodoro Ventocilla, "Philippa Duke Schuyler: La Niña De Harlem Que Asombró El Mundo," *La Estrella de Panamá*, July 28, 1952.

126 "George Westerman, el dinámico e inteligente representante de Conciertos Westerman, el mismo que nos permitió escuchar a Marian Anderson y a las más altas figuras de su raza y de su estirpe, es el autor de esa fiesta grande e inolvidable para el espíritu." Ibid.

127 In his later career, Westerman was active in diplomatic affairs, as Panama's delegate to the United Nations General Assembly (1956–1960), and Panama's ambassador to Trinidad and Tobago (1967). After serving in these diplomatic posts, he traveled the world giving speeches on antiracism and Panama-US geopolitics, and reported to the United Nations on antiracism efforts. For more information, see Zien, "George Westerman," *Dictionary of Caribbean and Afro-Latin American Biography*.

128 "Warfield Wins over the Capital; Colon Next," *The Nation*, November 10, 1953; Eleodoro Ventocilla, "El Concierto De William Warfield," *La Estrella de Panamá*, November 11, 1953; Zien, "Race and Politics in Concert." See GWW, Box 30, Folder 18, Schomburg.

129 George W. Westerman to Nelly Walter, November 14, 1953 (GWW, Box 30, Folder 17, Schomburg).

130 H. L. Rose, "Westerman's Concert and Its Presentations for Cultural Elevation," *Panama Star and Herald*, September 27, 1949.

131 Homi K. Bhabha, *The Location of Culture* (London and New York: Routledge, 1994), 95.

132 Ibid.

133 Westerman was publicly anti-Communist, although his correspondence permits possible nuances: in a letter to Lester Granger, for example, he expresses doubts about HUAC and states that Paul Robeson is being unfairly targeted. George Westerman to Lester Granger, August 6, 1949 (GWW, Box 28, Folder 29, Schomburg). Arguably, one factor informing Westerman's anti-Communism—in addition to the risk of being an "out" Communist sympathizer or fellow traveler at midcentury—was the uneasy alliance, and then rupture, of West Indian Local Union 713 with the United Public Workers of America (UPWA) in 1947. From the pages of the *Panama Tribune*, culminating in a published pamphlet, Westerman crusaded against the UPWA, which he alleged (erroneously or not) to be a Communist interloper preying on the desires of West Indian Panamanians to unionize. George W. Westerman, *Blocking Them at the Canal: Failure of the Red Attempt to Control Workers in the Vital Panama Canal Area* (New York: Inter-American Association for Democracy and Freedom, 1952); Zien, "Race and Politics in Concert."

134 On Black female civil rights activists' performances of middle-class respectability and femininity, see Fosler-Lussier, *Music in America's Cold War Diplomacy*, 114; Steven F. Lawson, *Civil Rights Crossroads: Nation, Community, and the Black Freedom Struggle* (Lexington: University Press of Kentucky, 2003).

135 Daphne Brooks, *Bodies in Dissent: Spectacular Performances of Race and Freedom, 1850–1910* (Durham, NC: Duke University Press, 2006), 5.

136 On personal and bodily sovereignty, see Teresa Brennan, *The Transmission of Affect* (Ithaca, NY: Cornell University Press, 2004); Lauren Berlant, "Slow Death (Sovereignty, Obesity, Lateral Agency)," *Critical Inquiry* 33 (2007).

137 Croft, *Dancers as Diplomats*, 117.

138 A partial survey of the literature on Black cultural ambassadors must include: Thomas Borstelmann, *The Cold War and the Color Line: American Race Relations in the Global Arena* (Cambridge, MA: Harvard University Press, 2001); Canning, *On the Performance Front*; Croft, *Dancers as Diplomats*; Mary L. Dudziak, *Cold War Civil Rights: Race and the Image of American Democracy* (Princeton, NJ: Princeton University Press, 2000); Lisa E. Davenport, *Jazz Diplomacy: Promoting America in the Cold War Era* (Jackson: University Press of Mississippi, 2009); Fosler-Lussier, *Music in America's Cold War Diplomacy*; Penny M. Von Eschen, *Satchmo Blows up the World: Jazz Ambassadors Play the Cold War* (Cambridge, MA: Harvard University Press, 2004).

139 Tim Brooks and Richard K. Spottswood, *Lost Sounds: Blacks and the Birth of the Recording Industry, 1890–1919* (Urbana: University of Illinois Press, 2004), 436; Paul Allen Anderson, *Deep River: Music and Memory in Harlem Renaissance Thought* (Durham, NC: Duke University Press, 2001), 9; Canning, *On the Performance Front*, 218–219.

140 Christopher Antonio Brooks and Robert Sims, *Roland Hayes: The Legacy of an American Tenor* (Bloomington: Indiana University Press, 2015), 242–256.

141 In fact, Williams and Bazala became partners and lived together "in happy companionship" from 1969 to 2002. "Camilla Williams Obituary," *Telegraph*, February 1, 2012.

142 Jack Jamieson, "Saw Conception of Royalty in Bearing of Marian Anderson," *Panama Tribune*, Drops and Turnovers column, July 1, 1951 (GWW, Box 29, Folder 31, Schomburg).

143 Michelle Stephens highlights these links with regard to Paul Robeson's transnational performances. Stephens, "I'm the Everybody Who's Nobody: Genealogies of the New World Slave in Paul Robeson's Performances of the 1930s," in *Hemispheric American Studies*, ed. Caroline F. Levander and Robert S. Levine (New Brunswick, NJ: Rutgers University Press, 2008). In literature on Black transnationalism, African diaspora culture, and the Black Atlantic, some texts that shed light on Westerman Concerts are: Brent Hayes Edwards, "The Uses of Diaspora," *Social Text* 19, no. 1 (2001); Paul Gilroy, *The Black Atlantic: Modernity and Double Consciousness* (Cambridge, MA: Harvard University Press, 1993); Stephanie Leigh Batiste, *Darkening Mirrors: Imperial Representation in Depression-Era African American Performance* (Durham, NC: Duke University Press, 2011); Michelle Ann Stephens, *Black Empire: The Masculine Global Imaginary of Caribbean Intellectuals in the United States, 1914–1962* (Durham, NC: Duke University Press, 2005); Rinaldo Walcott, "The Problem of the Human: Black Ontologies and 'the Coloniality of Our Being,'" in *Postcoloniality—Decoloniality—Black Critique: Joints and Fissures*, ed. Sabine Broeck and Carsten Junker (Frankfurt-on-Main: Campus Verlag, 2014).

144 John D. Kelly and Martha Kaplan, "Legal Fictions after Empire," in *The State of Sovereignty: Territories, Laws, Populations*, ed. Douglas Howland and Luise S. White (Bloomington: Indiana University Press, 2009). In their revisionist historiography, Kelly and Kaplan trace liberal views of nation-state sovereignty to the postwar period.

145 On coloniality in the Americas, see, for example, Mabel Moraña, Enrique D. Dussel, and Carlos A. Jáuregui, *Coloniality at Large: Latin America and the Postcolonial Debate* (Durham, NC: Duke University Press, 2008); Walter Mignolo, *The Darker Side of Western Modernity: Global Futures, Decolonial Options* (Durham, NC: Duke University Press, 2011); Anibal Quijano, "Coloniality of Power, Eurocentrism, and Latin America," *Nepantla: Views from the South* 1, no. 3 (2000); Kiran Asher, "Latin American

Decolonial Thought, or Making the Subaltern Speak," *Geography Compass* 7, no. 12 (2013); Nelson Maldonaldo-Torres, "On the Coloniality of Being," *Cultural Studies* 21, no. 2–3 (2007). In *Coloniality of Diasporas*, Yolanda Martínez-San Miguel links coloniality to the Caribbean, which exhibits a relationship to the nation-state distinct from those of Latin American republics. See Martínez-San Miguel, *Coloniality of Diasporas: Rethinking Intra-Colonial Migrations in a Pan-Caribbean Context* (New York: Palgrave Macmillan, 2014). On diasporic blackness and coloniality, see Rinaldo Walcott, "Caribbean Pop Culture in Canada: Or, the Impossibility of Belonging to the Nation," *Small Axe: A Caribbean Journal of Criticism* 5, no. 1 (2001); Sylvia Wynter, "Unsettling the Coloniality of Being/Power/Truth/Freedom: Towards the Human, after Man, Its Overrepresentation—an Argument," *C.R.: The New Centennial Review* 3, no. 3 (2003). Theorists of coloniality like Mignolo stress the need for a "decolonial option," a creation or refashioning of existing ontological and epistemological counter-paradigms to undo Enlightenment modernity.

146 Michael Hanchard, "Afro-Modernity: Temporality, Politics, and the African Diaspora," *Public Culture* 11, no. 1 (1999).

147 Ibid., 267.

148 Ibid., 247.

149 Ibid.

150 Ibid., 246.

151 Quoted in Jack Jamieson, "Ellabelle Davis Rates with Greatest Singers Produced by Her Race," *Panama Tribune*, Drops and Turnovers, n.d. (GWW, Box 29, Folder 32, Schomburg).

152 Nina Sun Eidsheim, "Marian Anderson and 'Sonic Blackness' in American Opera," *American Quarterly* 63, no. 3 (2011).

153 Grant Olwage, "Listening B(l)ack: Paul Robeson after Roland Hayes," *The Journal of Musicology* 32, no. 4 (2015): 556.

154 Anderson, *Deep River*, 97.

155 See, for example, Concha Peña, "La Emoción De Los Spirituals," *Estrella de Panamá*, June 10, 1951; "Marian Anderson: La Gloria De Una Mujer Singular," *Mundo Gráfico*, June 16, 1951; Esplandián, "Conciertos Westerman," *El País*, Simpatías y Diferencias column, June 22, 1951.

156 "Todo el dolor de su raza la hubiera elegido para regar por el mundo su llanto de milagro sonoro." Matilde Espinoza de Pérez, "Todo El Dolor De Una Raza," *El Tiempo*, June 14, 1951.

157 "En los negro-espirituales, esas delicadas melodías tan nostálgicas, quizá furtivas en ocasiones pero siempre vitales, Marian Anderson se colocó a la altura artística que ocupan aquellas. Cuanta lástima da el que sus ignotos ancestros no hubieron sabido que estas tiernas canciones llegarían a ser expandidas por alguien de su raza, con tan inquebrantable fe, con la convicción y con tanto encanto." "Marian Anderson Juzgada Por La Crítica Mundial," *La Nación*, June 15, 1951 (GWW, Box 29, Folder 30, Schomburg).

158 Olwage, "Listening B(l)ack," 547.

159 Ibid., 533–534.

160 Jon Cruz, *Culture on the Margins: The Black Spiritual and the Rise of American Cultural Interpretation* (Princeton, NJ: Princeton University Press, 1999), 1–18; Olwage, "Listening B(l)ack," 526–527.

161 On spirituals in US cultural diplomacy, see Fosler-Lussier, *Music in America's Cold War Diplomacy*, 125–133.

162 "El arte magnífico de Marian Anderson no le pertenece a una raza, a una nación o a un hemisferio. Le pertenece al Universo entero y nosotros, los panameños, nos sentimos orgullos y felices de poder compartir la emoción de [. . .] vida que siente toda persona al sentarse bajo la influjo mágico de la Primera Dama de la Canción de América." George W. Westerman, "Marian Anderson, La Más Grande Artista Actual," *Panamá América*, suplemento dominical, June 10, 1951 (GWW, Box 29, Folder 31, Schomburg).

163 A. Bell, *The Nation*, Jingles column, June 24, 1951 (GWW, Box 29, Folder 30, Schomburg).

164 "A Welcome to Marian Anderson," *Panama Tribune*, editor's note, June 17, 1951 (GWW, Box 29, Folder 30, Schomburg).

165 Many scholars have highlighted coloniality's exclusion of African-descended peoples from full incorporation in the nation-state. Walcott calls Black Canadians "not-quite-citizens," and Hanchard distinguishes among "qualitatively superior" and inferior degrees within citizenship, regardless of its formal conferrals. See Walcott, "Caribbean Pop Culture in Canada," 127; Hanchard, "Afro-Modernity," 266.

166 Gilroy, *The Black Atlantic*, 117.

167 Walcott, "The Problem of the Human," 103.

168 See, for example, Westerman's pamphlet on "under-developed nations" and the United Nations General Assembly: George W. Westerman, *Non-Self-Governing Territories and the United Nations* (Panama: Imprenta de La Academia, 1958).

169 Westerman's professed faith in liberalism wavered momentarily after the United States bombed Hiroshima and Nagasaki. He wrote a moving column that condemned the "indiscriminate and wholesale slaughtering of Japanese" and questioned the legitimacy of the US government's self-declared values after such a horrific act. Westerman, "The Passing Review," *I.N.Y.C. Bulletin*, Passing Review, August 22, 1945 (GWW, Box 17, Folder 2, Schomburg).

170 Westerman, "Leaves Vast Spiritual Heritage," *Panama Tribune*, Passing Review, April 24, 1965.

171 Ibid.

172 Donoghue, *Borderland on the Isthmus*, 18.

173 Conniff, *Black Labor*, 146–150.

174 For example, Westerman worked on the presidential campaign of José Antonio Remón Cantera, former chief of Panama's National Police/Guard, and a "king-maker." Ibid., 130.

175 George Priestley, "Antillean-Panamanians or Afro-Panamanians?: Political Participation and the Politics of Identity During the Carter-Torrijos Treaty Negotiations," *Transforming Anthropology* 12, no. 1–2 (2004): 52; Conniff, *Black Labor*, 137.

176 Priestley, "Antillean-Panamanians or Afro-Panamanians?"

CHAPTER 4 NATIONAL THEATRE AND POPULAR SOVEREIGNTY

1 Quoted in Walter LaFeber, *The Panama Canal: The Crisis in Historical Perspective* (New York: Oxford University Press, 1989), 40. As Peter Szok notes, many Latin American critics viewed Panama as a "sham" nation but blamed the United States rather than Panamanians for this condition of artificiality (and theatricality). See Peter A. Szok, *La Última Gaviota: Liberalism and Nostalgia in Early Twentieth-Century Panamá* (Westport, CT: Greenwood Press, 2001), 42.

2 Szok, *La Última Gaviota*, 7, 19, 106–108.
3 "La 'Cucarachita Mandinga' Subirá al Nacional," *Estrella de Panamá*, November 27, 1937.
4 "Estrénase Mañana La 'Cucarachita Mandinga,'" *Estrella de Panamá*, December 5, 1937; "Por la Presentación de La Cucarachita Mandinga Existe un Enorme Entusiasmo," *Panamá América*, December 1, 1937.
5 "Por demás nos parece subrayar el justo interés que esta nueva revelación de nuestra cultura ha despertado en todo los sectores del pueblo y sociedad panameña." "La 'Cucarachita Mandinga' Subirá al Nacional."
6 Many Panamanians still consider the interior—particularly the province of Los Santos—to be Panama's heartland and primary source of national cultural identity.
7 "La posición del puente del mundo nos va creando, sin darnos cuenta, una psicología de pueblo tránsito . . . psicología ligera, despreocupada, sin sentido de tradiciones, de constancia, ni aún de nacionalismo bien entendido." Quoted in Jesús Alemancia and Raúl Leis, *Reversión Canalera: Informe de un Desafío* (Panamá: Centro de Estudios y Acción Social Panameña (CEASPA), 1995), 7.
8 Szok, *La Última Gaviota*, 61. During the Panama Canal's construction (1904–1914), US officials commandeered Panama's immigration policy. Michael Conniff estimates that roughly 150,000 West Indians traveled to Panama for Canal labor. See Michael L. Conniff, *Black Labor on a White Canal: Panama, 1904–1981*. Pitt Latin American Series (Pittsburgh: University of Pittsburgh Press, 1985), 4. After the Canal opened in 1914, many foreign workers—the majority from the West Indies—remained in Panama, joined by dependents.
9 "Por la Presentación de La Cucarachita Mandinga Existe un Enorme Entusiasmo," *Panamá América*. The reviewer noted as highlights "*tunas* from Las Tablas, *mejoranas*, *salomas*."
10 Narciso Garay, *Tradiciones Y Cantares: Ensayo Folklórico* (Brussels, Belgium: Presses de l'Expansion Belge, 1930), 129–149.
11 Ibid., 81; "Todo Listo Para el Estreno de La Cucarachita Mandinga," *Panamá América*, December 5, 1937.
12 "La orquesta estará formada por más de veinte alumnos con instrumentos típicos o nacionalizados: pitos orgánicos, ukeleles, acordeones, guitarras, violines, mejoranas, maracas, claves, *bongoes*, tambores, etc." "Por la Presentación de La Cucarachita Mandinga Existe un Enorme Entusiasmo."
13 "Al Margen de una Representación," *Panamá América*, December 9, 1937.
14 See Blanca Korsi de Ripoll, "Un Ensayo Sobre un Estudio Folklórico Global," *Panamá América*, October 31, 1965.
15 "¿Cómo harías por las noches?" Rogelio Sinán, *La Cucarachita Mandinga: Farsa Musical Para Teatro De Niños* (Panamá: Instituto Nacional de Cultura, 1992), 20.
16 LaFeber, *The Panama Canal*, 178. Rural separation from the Canal persisted throughout the twentieth century and to the present, although improvements in communication have occurred.
17 "Si en el estreno de aquella joya, colocada con candorosa levedad en el pecho de infantes y adultos, se consultaron elementos de modernización del cuento bisabuelo: con su coro de grillos, radios, altoparlantes, silbido de sirenas, automóviles, etc., que daban a la historieta rural un tono urbano, las nuevas exhibiciones mostrarán que el Teatro Mínimo de Sinán y Brenes ha crecido por dentro, y el público panameño presenciará un Ballet nacional: representación lírica y coreográfica de su significado telúrico."

Federico Tuñon, "A Propósito de La Cucarachita Mandinga" (Panamá, Panamá: Ministerio de Educación, 1965).

18 This is not to say that people of color only resided in urban areas in Panama. Although nationalists often portrayed the residents of the rural interior as racially "whitened," Panama's oldest citizens may well be the sizable African-descended population called *afrocoloniales* (afro-colonials), whose presence in Panama can be traced to their arrival as slaves during the Spanish Conquest. As Renee Alexander-Craft and Sonja Watson show, this population has often been ignored in representations of Panamanianness, as it contradicts the popular connotation of blackness with foreignness, as linked to West Indian descendants (or *afroantillanos*, Afro-Antilleans). *Afrocoloniales* have consequently been socially and economically marginalized for centuries. See Renee Alexander, "Art as Survival: The Congo Tradition of Portobelo, Panama" (PhD diss., Northwestern University, 2005); Sonja Stephenson Watson, *The Politics of Race in Panama: Afro-Hispanic and West Indian Literary Discourses of Contention* (Gainesville: University Press of Florida, 2014).

19 Boris Armando Gómez, "El Legado De Gonzalo Brenes," *La Prensa*, November 18, 2001.

20 Watson, "'Black Atlantic' Cultural Politics as Reflected in Panamanian Literature" (Diss., University of Tennessee, Knoxville, 2005), 86–93.

21 Rogelio Sinán, "Divagaciones Sobre La Fábula De La Cucarachita Mandinga Y Sobre Una Posible Resurrección De Ratón Pérez," *Revista Cultural la Lotería* 221 (1974): 21–22; "Vivencia de la India," *Revista Lotería* 370 (1988): 114–117.

22 The narrator may be a commentary on the geopolitics of broadcasting. Two years after the play's premiere, the Alfaro-Hull Treaty enabled Panamanians to operate radio stations. Until then, the US government controlled radio communications and roads on the isthmus. Michael L. Conniff, *Panama and the United States: The Forced Alliance* (Athens: University of Georgia Press, 2001), 91; LaFeber, *The Panama Canal*, 87–88.

23 Studying in Italy from 1926 to 1930, Sinán observed the cultural effects of futurism and fascism. He witnessed artistic production both as a tool of violence, as in Mussolini's spectacular processions, and as a means of protesting the barbarity of war and oppression. Personal interview with Delia Cortés, June 20, 2010; Rogelio Sinán, "Mi Poesía: Una Ojeada Retrospectiva," *Revista Cultural de la Lotería* 370 (1988): 105–107.

24 The play critiques Hollywood and Disney with the pre-show mise-en-scène of a lowered curtain flanked by posters depicting Cockroach and Mouse as Hollywood celebrities. The cartoonish characters critique the cultural saturation of Panama, and Latin America more generally, by Disney and Hollywood. The play also gestures to Disney's interest in Latin America. A few years after the play's premiere, Walt Disney's studios produced animated films featuring Donald Duck in Latin America and Latin American characters such as "Los Tres Caballeros" and the parrot "Zé Carioca." See Julianne Burton, "Don (Juanito) Duck and the Imperial-Patriarchal Unconscious: Disney Studios, the Good Neighbor Policy, and the Packaging of Latin America," in *Nationalisms and Sexualities*, ed. Andrew Parker (New York: Routledge, 1992); Robert Siegel, "'Walt & El Grupo' Documents Disney Diplomacy," in *All Things Considered* (National Public Radio, 2009); "What Walt Disney Learned from South America" (National Public Radio, 2009); Ariel Dorfman and Armand Mattelart, *How to Read Donald Duck: Imperialist Ideology in the Disney Comic* (New York: International General, 1975).

25 Guillermo Márquez, "Comentario a La Cucarachita Mandinga," *Panamá América*, December 9, 1937.

26 Rogelio Sinán, *La Cucarachita Mandinga, Farsa Infantil* (Panamá, Panamá: Benedetti Hermanos, 1937), 8.

27 Márquez, "Comentario a La Cucarachita Mandinga."

28 Ibid.

29 Sinán, "Divagaciones," 23. The original essay is not available, but the 1974 edition identifies itself as a reprint of an essay published in 1937, and data contained within the essay's text confirm this earlier publication date.

30 Variations of the tale appear in Puerto Rico, Cuba, Costa Rica, and Brazil, among other locales. Sinán cites the publication of Puerto Rican scholar Pura Belpré's version of the tale. Pura Belpré, *Perez and Marina: A Portorican Folk Tale* (Eau Claire, WI: E. M. Hale and Co., 1932). For a contemporary satire of the fable, see performance artist Carmelita Tropicana (Alina Troyano)'s 2004 piece, *With What Ass Does the Cockroach Sit?*, reviewed in the *New York Times*. Margo Jefferson, "On the Home Front, the Personal Becomes Theatrical (and Political, Too)," *New York Times*, December 11, 2004.

31 See Carmen Lyra, *Los Cuentos de Mi Tía Panchita* (San José, Costa Rica: Soley & Valverde, 1936). As a teacher in northern Costa Rica, Lyra likely encountered many Afro-Costa Ricans. Carmen Lyra and Elizabeth Horan, *The Subversive Voice of Carmen Lyra: Selected Works* (Gainesville: University Press of Florida, 2000), 7–9. Spatial constraints prevent me from reprising debates over whether "creole" linguistic forms exist in Spanish as in French and English, and what is meant by the ideologically loaded term "creole." Therefore, I note that the *cucarachita* speaks with a local accent, but I cannot deduce from the few examples given by Lyra whether this is a distinct dialect, and I would suspect that Lyra's emphasis is on phonemic differences.

32 For a distinction between "abstract" and "representational" traits, see Eric Lott, "Blackface and Blackness: The Minstrel Show in American Culture," in *Inside the Minstrel Mask: Readings in Nineteenth-Century Blackface Minstrelsy*, ed. Annemarie Bean, James Vernon Hatch, and Brooks McNamara (Hanover, NH: Wesleyan University Press, 1996), 16.

33 Sinán, "Divagaciones"; Fernando Ortiz, *Glosario de Afronegrismos* (La Habana: Editorial de Ciencias Sociales, 1991), 304; Angel Rosenblat, *Buenas y Malas Palabras en el Castellano de Venezuela* (Caracas: Ediciones Edime, 1960), 374; see also Jean-Pierre Tardieu, *De Diablo Mandingo al Muntu Mesiánico: el Negro en la Literatura Hispanoamericana Del Siglo XX.* (Madrid: Editorial Pliegos, 2001).

34 Rosenblat, *Buenas y Malas Palabras*, 378.

35 "Además, todo mandinga—era cosa sabida—ocultaba un cimarrón en potencia. Decir mandinga, era decir díscolo, revoltoso, demonio. Por eso los de ese reino se cotizaban tan mal en los mercados de negros. Todos soñaban con el salto al monte." Alejo Carpentier, *El Reino de este mundo: relato* (México: Edición y Distribución Ibero Americana de Publicaciones, 1949), 38.

36 Many sources examine the fugitive or insurgent slave as symbol of anticolonialism across the Americas. These include: Raúl Leis, *Mundunción* (Panamá: Arosemena Inst. Nacional de Cultura, 1988); Alexander, "Art as Survival"; Susan Gillman, "The Epistemology of Slave Conspiracy," *Modern Fiction Studies* 49, no. 1 (2003); Ada Ferrer, *Insurgent Cuba: Race, Nation, and Revolution, 1868–1898* (Chapel Hill: University of North Carolina Press, 1999); Jane Landers and Barry Robinson, *Slaves, Subjects, and Subversives: Blacks in Colonial Latin America* (Albuquerque: University of New Mexico Press, 2006); Norman E. Whitten and Arlene Torres, *Blackness in Latin America*

and the Caribbean: Social Dynamics and Cultural Transformations (Bloomington: Indiana University Press, 1998).

37 "Cucarachita y mujer con gracia y coquetería. Mandinga y Diablo, son maneras de decir que amalgama el pueblo. La Cucarachita Mandinga es la mujer diabólica." Ofelia Hooper, "La Cucarachita Mandinga," Panamá América, December 16, 1937.

38 Jill Lane, Blackface Cuba, 1840–1895 (Philadelphia: University of Pennsylvania Press, 2005), 4.

39 Vera M. Kutzinski, Sugar's Secrets: Race and the Erotics of Cuban Nationalism (Charlottesville: University Press of Virginia, 1993), 5.

40 Richard Graham et al., The Idea of Race in Latin America, 1870–1940 (Austin: University of Texas Press, 1990), 37–38.

41 In a Colombian context, see Peter Wade, Race and Sex in Latin America (New York: Palgrave Macmillan, 2009), 114–115; Alicia Arrizón argues that mestizaje can be reclaimed and "queered" as a radical methodology: Alicia Arrizón, Queering Mestizaje: Transculturation and Performance (Ann Arbor: University of Michigan Press, 2006).

42 See Gilberto Freyre in Brazil, José Vasconcelos in Cuba, and José Mariátegui in Peru, who valorized mestizaje and/or racial democracy. Freyre, Casa Grande & Senzala: Formação Da Família Brasileira Sob O Regime Da Economia Patriarcal (Rio de Janeiro: J. Olympio, 1973); Hermilo Borba Filho and Gilberto Freyre, Sobrados E Mocambos (Rio de Janeiro: Civilização brasileira, 1972); Peter Wade, Race and Ethnicity in Latin America (Chicago: Pluto Press, 1997), 34, 49–50; Graham et al., The Idea of Race in Latin America, 1870–1940, 21–22; Jorge Coronado, The Andes Imagined: Indigenismo, Society, and Modernity (Pittsburgh: University of Pittsburgh Press, 2009); José Vasconcelos, La Raza Cosmica: Mision De La Raza Iberoamericana, Argentina Y Brasil (Mexico: Espasa-Calpe, 1966).

43 Graham et al., The Idea of Race in Latin America, 1870–1940, 4.

44 Sonja Stephenson Watson, "Poetic Negrism and the National Sentiment of Anti-West Indianism and Anti-Imperialism in Panamanian Literature," Callaloo 35, no. 2 (2012): 459–461.

45 West Indian labor migration for Panama Canal construction irrevocably transformed Panama's population demographics. Michael Conniff estimates that West Indians and their descendants numbered 100,000 in 1940, composing at least one-sixth of Panama's national population. Black Labor, 106.

46 Ibid., 459.

47 "Aquí Viene El Toro ... Toro, Toronjil," Panamá América, October 24, 1965.

48 Frances Aparicio, "Ethnifying Rhythms, Feminizing Cultures," in Music and the Racial Imagination, ed. Ronald Michael Radano and Philip Vilas Bohlman (Chicago: University of Chicago Press, 2000), 97.

49 On women's symbolic roles in figuring nationhood, or what Erin Hurley calls their "representational labor," see Hurley, National Performance: Representing Quebec from Expo 67 to Céline Dion (Toronto: University of Toronto Press, 2011), 27–28; Floya Anthias, Nira Yuval-Davis, and Harriet Cain, Racialized Boundaries: Race, Nation, Gender, Colour and Class and the Anti-Racist Struggle (New York: Routledge, 1992), 28, 113–114; Anne McClintock, "'No Longer in a Future Heaven': Nationalism, Gender, and Race," in Becoming National: A Reader, ed. Geoff Eley and Ronald Grigor Suny (New York: Oxford University Press, 1996).

50 Kutzinski, Sugar's Secrets, 172–173.

51 Ibid., 7.

52 Aparicio, "Ethnifying Rhythms, Feminizing Cultures," 96.

53 Julia Kristeva, *Powers of Horror: An Essay on Abjection* (New York: Columbia University Press, 1982).

54 Mary J. Russo, *The Female Grotesque: Risk, Excess, and Modernity* (New York: Routledge, 1995), 62–63; Alicia Arrizón, *Latina Performance: Traversing the Stage* (Bloomington: Indiana University Press, 1999), 90–94.

55 Sinán, *La Cucarachita Mandinga, Farsa Infantil*, 1.

56 "Vida de una Obra Inmortal," *La Prensa*, February 19, 2006.

57 Edilia Camargo, "La Cucarachita Mandinga, Versión 1976: Teatro y Ballet," *Panamá América*, June 27, 1976.

58 Correspondence with Delia Cortés, June 19, 2010.

59 Octavio Arosemena, "Reseña, Orquesta Sinfónica Nacional," *La Prensa*, Talingo column, October 26, 2000.

60 Personal interview with Josefina Nicoletti, July 6, 2010.

61 E.R.V., "El Primer Ballet Integralmente Nacional," *Panamá América*, November 29, 1953.

62 *La Cucarachita Mandinga* was the longest-running ballet in Panama at the time.

63 "Séptima Presentación de una Obra," *Siete*, December 12, 1953; LaFeber, *The Panama Canal*, 113–120.

64 Remón's limited program of economic reforms marked an early attempt by a Panamanian presidential administration to correct Panama's economic disparities and address rural/urban divides.

65 "Ni millones ni limosnas: queremos justicia." Kaysha Corinealdi, "Redefining Home: West Indian Panamanians and Transnational Politics of Race, Citizenship, and Diaspora, 1928–1970" (PhD diss., Yale University, 2011), 77.

66 On US-Panama conflict, see Richard Baxter et al., *The Panama Canal: Background Papers and Proceedings* (Dobbs Ferry, NY: Oceana Publications, 1965); Alan L. McPherson, *Yankee No! Anti-Americanism in U.S.–Latin American Relations* (Cambridge, MA: Harvard University Press, 2003), 77–116; McPherson, "From 'Punks' to Geopoliticians," U.S. and Panamanian Teenagers and the 1964 Canal Zone Riots," *The Americas* 58, no. 3 (2002); Roberto N. Méndez, *Panamá, 9 de Enero de 1964: Qué Pasó y Por Qué* (Panama: Universidad de Panamá, 2000); "Inside an Ugly Fight in Panama," *Life*, January 24, 1964; "Panama: Crisis over the Canal," *Time*, January 17, 1964; "Panama: Semantics, Politics, & Passion," *Time*, January 24, 1964; Trevor Armbrister, "Panama: Why They Hate Us," *Saturday Evening Post*, March 7, 1964.

67 "Aquí Viene el Toro . . . Toro, Toronjil." The Robles-Johnson treaty, had it passed Panama's National Assembly, would have laid the groundwork for the Canal Zone's reversion to Panamanian sovereignty. See LaFeber, *The Panama Canal*, 115–116.

68 Panama's artists have often held administrative posts. For example, in 1965 Sinán was appointed director of the National Department of Culture, precursor to Panama's National Institute of Culture (INAC). For Sinán's biography and bibliography, see Monchi Torrijos, "La Patria Rinde Homenaje a Sinán," *Revista Lotería* 370 (1988): 173–180.

69 "La Cucarachita Mandinga Se Estrena el 22 de Octubre," *Estrella de Panamá*, October 14, 1965.

70 "Gonzalo Brenes: Maestro de las Notas Panameñas," *Panamá América*, June 27, 1976.

71 Rogelio Sinán, *Teatro Infantil: Lobo Go Home, Fuenteovejuna, La Cucarachita Mandinga* (Panamá: Impresora Géminis, 1976), 5.

72 "Hacia un Teatro Genuinamente Panameño," *Estrella de Panamá*, October 21, 1965.

73 Peralta, "Aquí Viene el Toro…Toro, Toronjil," *Panamá América*; "La Cucarachita Mandinga Se Estrena el 22 de Octubre."

74 "La Cucarachita Mandinga Se Estrena el 22 de Octubre."

75 Ripoll, "Un Ensayo Sobre un Estudio Folklórico Global."

76 Manuel F. Zárate and Dora P. de Zárate, *Tambor y Socavón: Un Estudio Comprensivo de los Temas del Folklore Panameño y de sus Implicaciones Históricas y Culturales* (Panamá: Ministerio de Educación, Dirección Nacional de Cultura, 1962), 43. The text is influenced by Fernando Ortiz's *Contrapunteo cubano de tabaco y azúcar*, which delineates cultural and social valences of agricultural products tobacco and sugar (gendered, raced, and classed).

77 Ibid., 23–24.

78 Ibid., 30–34; Armando Fortune, "Estudio Sobre la Insurrección de los Negros Esclavos: Los Cimarrones de Panamá," *Revista Cultural de la Lotería* (1956).

79 "El hecho de que los tambores sean hoy patrimonio de todo panameño, de uno a otro confín del país; el más conspicuo aún, de que se ostente como nacional, en un país de origen hispánico, un baile de franco antecedente negro, prueba toda la eficacia de la transculturación, operada en su ambiente sin coerciones inhibitorias y propio para que se formara una personalidad independiente y espiritualmente autónoma. Obsérvese que ningún otro país del Continente, con predominante cepa peninsular, posee generalizado y con sentido típico-nacional, un baile con origen y elemento negro predominante." Zárate and de Zárate, *Tambor y Socavón*, 34–35.

80 Ibid., 177.

81 Ibid., 19–22.

82 Ibid., 44–45.

83 "A pesar de que el mismo Sinán ha demostrado el origen africano de 'La Cucarachita Mandinga,' como apólogo, ha enraizado su farsa en lo más hondo de nuestro humus istmeño, nutriéndola de nuestras mejores savias y caracterizándola con los más altos símbolos de nuestra historia." "Hacia Un Teatro Genuinamente Panameño." Emphasis added.

84 Ibid.

85 Ripoll, "Un Ensayo Sobre un Estudio Folklórico Global."

86 Conniff, *Panama and the United States*, 125–128.

87 On Torrijos's legacy, see LaFeber, *The Panama Canal*, 125–187.

88 On the United Nations' official recognition of the Congress, see Ministerio de Relaciones Exteriores de Venezuela, *Bolívar En La ONU: La Asamblea General de Las Naciones Unidas Rinde Homenaje al Libertador Simón Bolívar, con Motivo del Sesquicentenario del Congreso Anfictiónico de Panamá, New York, Diciembre de 1976* (Caracas: Ministerio de Relaciones Exteriores, 1978).

89 Pedro J. Mérida, "La Cucarachita Mandinga," *Panamá América*, June 24, 1976.

90 Personal interview with Aurea "Baby" Torrijos, June 26, 2010. Viewing musical theatre as a populist form, Baby Torrijos stated her desire to present the play as a Broadway-style musical to engage audiences from a variety of socioeconomic sectors in Panama.

91 Personal interview with Miguel Moreno, June 26, 2010.

92 Ibid.

93 Personal interview with Bruce Quinn, June 21, 2010. Despite this incident, Bruce Quinn and Baby Torrijos remained friends and collaborators.

94 Euclides Meléndez, "Realizaciones de Cultura Popular: Del INAC al DEXA," *Matutino*, August 10, 1978. Torrijos either created or expanded the Conjunto Nacional (National

Folkloric Dance Troupe), Coro Polifónico, National Ballet and Symphony, National Theatre, and National Schools of Music, Dance, Theatre, and Visual Arts. State support for artists gave the impression that the cultural boom was backed by economic largesse derived from national development projects. In fact, the administration's domestic spending depended on international lenders, increasing debt. See LaFeber, *The Panama Canal*, 174–178.

95 On the range of performing arts initiated under Torrijos, see Héctor Rodríguez, *Primera Historia del Teatro en Panamá* (Panamá: n.p., 1984), 44–73.

96 Interview with Aurea Torrijos, June 26, 2010.

97 Sinán, *Teatro Infantil*, 5.

98 Moreno, interview, June 26, 2010.

99 "Cucarachita Mandinga Opens Tonight at Javier," *Panama American*, June 25, 1976.

100 Sinán, *Teatro Infantil*, 4.

101 "Es el vil sapo istmeño de las chicanas y los paquetazos. Es el político bribón que, en esta tierra, vive y muere sapeando, adulando y lambisqueando." Ibid., 29–30.

102 Scenery depicting the National Lottery both acknowledged the prominence of the Lotería in Panamanian national life and nodded to one of the play's sponsors. Camargo, "La Cucarachita Mandinga," *Panamá América*.

103 "Casitas brujas escalonadas en diversos niveles. En lo más alto de la loma. Una iglesia. En la penumbra inicial variadas luces multicolores dan la ilusión de un enorme pesebre navideño, pero al iluminarse el escenario nos damos cuenta de que en verdad se trata de un miserable caserío. Debe ser una bella y atractiva escenografía, que al mismo tiempo produzca la absoluta sensación de miseria." Sinán, *Teatro Infantil*, 9; For information on "*casas brujas*," see Álvaro Uribe, "Travesía Urbana: Tomas Aéreas de la Ciudad de Panamá" (Panamá, Panamá: Museo de Arte Contemporáneo, 2008), 2.

104 See LaFeber, *The Panama Canal*, 160–178; George Priestley, *Military Government and Popular Participation in Panama: The Torrijos Regime, 1968–75* (Boulder: Westview Press, 1986), 55–96.

105 "Pero ese cobre es nada menos que cobre colorado." [. . .] "Es la señal de una riqueza que la Cucarachita ignoraba y que ahora debe explotar, aprovechar, usufructuar . . ." Sinán, *Teatro Infantil*, 13.

106 "Es el medio de que ella ha de valerse para saber administrarse, para empezar a conocerse y liberarse de la opresión foránea." Ibid. In fact, the Cerro Colorado project was a joint effort involving Panamanian and multinational interests. LaFeber, *The Panama Canal*, 197–198.

107 Sinán, *Teatro Infantil*, 15–16.

108 "Cuando ella entre, trajeada con mayor esplendor, la escenografía dará un vuelco y las casas brujas quedarán convertidas en casas nuevas, algunas con letras individuales que dicen: Escuela, Fábrica, Hospital, Biblioteca, Colegio, Teatro, Librería, Cultura, Universidad . . ." Ibid., 16–17.

109 "Luces resplandecientes alumbran un nuevo mundo de rascacielos, chimeneas y altos postes con múltiples alambres e hilos conductores de energía y luz eléctrica . . ." Ibid., 34.

110 "Sólo quien no se esfuerza en el trabajo supone que Dios debe arreglarle sus problemas, sin acordarse de que Él ha dicho: Ayúdate, que yo te ayudaré. Nadie debiera presentarse ante el Señor sin hacer antes un acto de purificación: limpiar la casa y el

espíritu; poner en orden nuestras cosas, analizar, investigar, tomar conciencia de lo que somos, de lo que en suma deseamos ser." Ibid., 11.

111 Ibid., 23.

112 Ibid., 3–4.

113 While one might be tempted to attribute the 1976 production's non-Black protagonist to a dearth of actors of color in Panama, contemporaneous theatrical works such as playwright Raúl Leis's *Viaje a la salvación y otros paises* and *Nido de macuá* were presented at the National Theatre starring West Indian Panamanian actors Danny Calden and Leslie George, respectively.

114 Camargo, "La Cucarachita Mandinga," *Panamá América*.

115 Ibid. "Lo que le queda a 'la cucarachita' de 'mandinga' es sólo su apellido. [...] El símbolo de la 'cucaracha,' aparece, paradójicamente 'limpio,' a pesar de todas las proyecciones repugnantes que el mismo texto va construyendo a su alrededor."

116 Pedro J. Mérida, "La Cucarachita Mandinga."

117 Interviews with Torrijos, June 26, 2010; Moreno, June 26, 2010.

118 Leslie George, interviewed by K. Zien, May 15, 2010.

119 Panameño, "Crítica De Arte—Presentación De La 'Cucarachita Mandinga,'" *Panamá América*, July 4, 1976.

120 Sinán, "Divagaciones," 24.

121 (Dialogue spoken by several *vecinas*): "¡Es el gran toro español de la Conquista! Aventurero y voraz, viene dispuesto a enriquecerse con el oro de la Cucarachita Mandinga. Es el famoso toro de lidia hispano. ¡El toro brutal, bravo y feroz! Su codicia avanzará a sangre y fuego. Cruel y ambicioso, pisoteará vidas humanas con tal de hacerse rico. [...] Esperemos que la Cucarachita Mandinga sepa torearlo diestramente, y consiga liberarse de sus cuernos." Sinán, *Teatro Infantil*, 19.

122 Ibid., 23.

123 Sinán, *La Cucarachita Mandinga, Farsa Infantil* (1937), 6–7.

124 Sinán, *Teatro Infantil*, 26.

125 Ibid., 27.

126 Ibid.

127 "¿Cómo vas a invadirnos por las noches?" Ibid., 28–29.

128 "No me gustan los discriminadores, que menosprecian a las razas morenas. Creo que eres uno de ellos. Lo que a ti te interesa es mi fortuna. Lo que te atrae es el brillo de la plata y el oro. Me desprecias, pero deseas enriquecerte a mi costa. Demuéstrame que vas a ser ecuánime. Quiero saber si en vez de relinchar de codicia serás un noble enamorado. ¿Cómo harías por las noches?" Ibid., 23.

129 This may refer to the betrayal of English pirate Sir Francis Drake in 1571 by his guide, "Pedro Mandinga," who alerted the Spanish to Drake's impending assault. Harry Kelsey, *Sir Francis Drake: The Queen's Pirate* (New Haven: Yale University Press, 1998), 46–47.

130 Sinán, *Teatro Infantil*, 38.

131 Camargo, "La Cucarachita Mandinga."

132 "Y tampoco olvidemos trabajar. Sólo así lograremos progresar. Y el progreso nos puede liberar. Con riqueza y cultura de verdad, seguiremos andando más y más. Caminemos, señores, y haya paz. Seguiremos felices, sí señor. Y este cuento, señores, se acabó." Sinán, *Teatro Infantil*, 42.

133 Critical reception is complicated by the fact that most of the positive reviews came from the state-censored press.

134 "Mundo en Busca de Justicia Hace Suya la Lucha de Panamá," *Panamá América* Special Edition: La Verdad de Panamá Ante el Mundo. January 12, 1976; "El Peregrinaje Diplomático de Omar Consolida la Nueva Política Exterior," *Panamá América*, La Verdad de Panamá Ante el Mundo, January 12, 1976; Omar Torrijos Herrera, *La Quinta Frontera: Partes de la Batalla Diplomática Sobre el Canal de Panamá* (Ciudad Universitaria Rodrigo Facio, Costa Rica: Editorial Universitaria Centroamericana, 1978).

135 "Programa de la Reunión del Consejo de Seguridad de las Naciones Unidas en Panamá"; "Panama: A Historic No," *Time*, April 2, 1973.

136 "Ayer Gráfico: Yo No Quiero Entrar a La Historia; Quiero Entrar a La Zona Del Canal," *Crítica en Línea*, Opinión. 1995–2000, http://portal.critica.com.pa/archivo/090799/opiayer.html. Accessed May 5, 2015.

137 "Popular Mechanics: Administration Building of Panama Canal," *Canal Record*, December 30, 1914.

138 Daniel Dominguez, "El Teatro Te Hace Sentir: Artistas y Directores Buscan Mejorar la Calidad de las Producciones y Garantizar su Rentabilidad," *La Prensa*, April 1, 2006.

139 Eric Jackson, "La Cucarachita Mandinga on the Admin. Building Steps," *Panama News* 12 (2006), http://www.thepanamanews.com/pn/v_12/issue_04/review_03.html. Accessed July 14, 2014.

140 The Panama Canal Authority (ACP) currently operates and maintains the Panama Canal.

141 "Vida de una Obra Inmortal," *La Prensa*; Autoridad del Canal de Panamá (ACP), "Noches Culturales de Verano: La Cucarachita Mandinga," in *El Canal al Día*, SERTV [Canal 11] (Panamá, 2006).

142 Omar Jaén Suárez, *El Canal de Panamá* (Autoridad del Canal de Panamá [ACP], 2007), 187.

143 The expansion was plagued by problems, running over budget and behind schedule. See "Your Money or Your Locks: Trouble at the Panama Canal," *The Economist*, January 3, 2014; "The New Panama Canal: A Risky Bet," *New York Times*, June 22, 2016; http://www.nytimes.com/interactive/2016/06/22/world/americas/panama-canal.html?_r=0. Accessed June 22, 2016.

144 The Program of Community Development (PRODEC) funds development projects financed through Canal revenues.

145 *Panama Maritime Review* (2009–2010), 11.

146 Delia Cortés, correspondence. June 21, 2010.

147 ACP, "Noches Culturales De Verano: La Cucarachita Mandinga."

148 "Vida de una Obra Inmortal," *La Prensa*.

149 Personal interview with Dino Nugent, June 23, 2010.

150 "Vida de una Obra Inmortal."

151 The band's instruments included accordions, keyboards, and bass guitar, the *pujador*, *repicador*, and *caja* drums (staples of *típico* music), maracas, and the *guáchara* or *churuca* (a Panamanian *güira*, a corrugated metal washboard or gourd, strummed with a stylus).

152 Zárate, *Tambor y Socavón*, 145.

153 On race in performance see, for example, Harvey Young, *Theatre & Race* (New York: Palgrave Macmillan, 2013); Shannon Jackson, *Professing Performance: Theatre in the Academy from Philology to Performativity* (New York: Cambridge University Press, 2004).

154 "Vida de una Obra Inmortal"; César Young Nuñez, "Hasta Que las Lágrimas Nos Separen," *La Prensa*. March 5, 2006.

155 News articles employing *La cucarachita mandinga* as a central metaphor include: Betty Brannan Jaén, "Gehry Deploró el Oportunismo que Hasta Ahora Ha Caracterizado Algunas Obras de las Áreas Revertidas," *La Prensa*, August 9, 2000; Rafael Candanedo, "La Cucarachita y su Cinta," *La Prensa*, October 11, 2009; Magela Cabrera Arias, "La Cucarachita Mandinga y el FFD," *La Prensa*, March 27, 2002; Roberto Brenes, "Ampliación del Canal de Panamá: La Ilusión del Desarrollo Planificado," *La Prensa*, July 17, 2006.

156 Boris Armando Gómez, "El Legado de Gonzalo Brenes," *La Prensa*, November 18, 2001.

157 Personal Interview with Delia Cortés, June 20, 2010.

158 Douglas Howland and Luise White, *The State of Sovereignty*, 1–2.

159 Ibid.

160 "*La Cucarachita Mandinga . . . Chiquilinga y Lobo Go Home* [son] piezas que acusan y confrontan la nacionalidad y la identidad y la búsqueda de los poderes a través de aparentes juegos infantiles, pero con duras verdades de fondo." Quoted in Daniel Domínguez, "Un Nuevo Sinán," *La Prensa*, March 21, 2004.

CHAPTER 5 STAGING SOVEREIGNTY AND MEMORY IN THE PANAMA CANAL HANDOVER

1 Charles S. McElroy, "USARSO Departs Panama," *Tropic Times*, July 30, 1999; Ariyuri H. de Mantovani, "Countdown Clock Starts Ticking toward Canal Transfer," *Panama Canal Spillway*, June 18, 1999.

2 "End of an Era at Panama Canal," *British Broadcasting Corporation*, December 14, 1999.

3 The civilian Canal Zone was officially dissolved and renamed the "área canalera" (Canal Area) in 1979. Throughout the chapter I refer to the site as "Canal Area" and "former Canal Zone." Ana Patricia Rodríguez refers to the "Canal (Zone)" as conjoined but separate entities. I note the usage here, although it differs from my own. See Rodríguez, "Encrucijadas: Rubén Blades at the Transnational Crossroads," in *Latino/a Popular Culture*, ed. Michelle Habell-Pallán and Mary Romero (New York: New York University Press, 2002), 85–101.

4 Joseph R. Roach, *Cities of the Dead: Circum-Atlantic Performance* (New York: Columbia University Press, 1996), 2.

5 Ibid., 37–38.

6 Ibid., 74. Even in a liberal democracy, the sovereign figurehead and the political theology that underpins it do not disappear. Supreme Court justices and the commander-in-chief are invested with sovereign powers, argues Paul Kahn in his US-oriented reinterpretation of Carl Schmitt's classic text. See Kahn, *Political Theology: Four New Chapters on the Concept of Sovereignty* (New York: Columbia University Press, 2011).

7 The 1999 Siembra de Banderas (Flag Sowing) recalled the Panamanian protest in 1959. See Arnulfo Barroso, "Panamá 2000: Al Fin El Canal!," in *Servicio Informativo Iberoamericano*, Organization of Ibero-American States, November 2000.

8 For a discussion of the patronymics (and matronymics), and imperialist and patriarchal logics, of "la madre patria," see Yolanda Martínez-San Miguel, *Coloniality of Diasporas: Rethinking Intra-Colonial Migrations in a Pan-Caribbean Context*. New Caribbean Studies, 1st ed. (New York: Palgrave Macmillan, 2014), 121–124, 189–191.

9 Peggy Phelan, *Unmarked: The Politics of Performance* (New York: Routledge, 1993), 6.

10 Noel Maurer and Carlos Yu, *The Big Ditch: How America Took, Built, Ran, and Ultimately Gave Away the Panama Canal* (Princeton, NJ: Princeton University Press, 2011), 260; Michael E. Donoghue, *Borderland on the Isthmus: Race, Culture, and the Struggle for the Canal Zone* (Durham, NC: Duke University Press, 2014), 21–22.

11 Jesús Alemancia and Raúl Leis, *Reversión Canalera: Informe De Un Desafío*. Panamá Hoy, vol. 6 (Panamá, Panamá: Centro de Estudios y Acción Social Panameña, 1995), 36–57.

12 The Panama Canal Commission seemed like a binational entity, but the United States controlled it. As Maurer and Yu note: "The Panama Canal Treaty stipulated that until the 1999 handover, the United States would appoint five members of the board of the new Panama Canal Commission. The United States would select the remaining four members from a list provided by the Panamanian government." Maurer and Yu, *The Big Ditch*, 260.

13 Roxana Cain, "The End of an Era: A Personal View," *Panama Canal Spillway*, December 30, 1999.

14 Michael L. Conniff, *Panama and the United States: The Forced Alliance*, 2nd ed. (Athens: University of Georgia Press, 2001), 141–146.

15 Maurer and Yu, *The Big Ditch*, 284–298.

16 Peter Michael Sánchez, *Panama Lost? U.S. Hegemony, Democracy, and the Canal* (Gainesville: University Press of Florida, 2007), 171.

17 Marco A. Gandásegui, "XX Aniversario de la Invasión," *Estrella de Panamá*, December 17, 2009; Maurer and Yu, *The Big Ditch*, 297–298.

18 On sovereignty and international relations in the US invasion of Panama, see Cynthia Weber, *Simulating Sovereignty: Intervention, the State, and Symbolic Exchange* (New York: Cambridge University Press, 1995), 92–129.

19 Although spatial constraints prevent me from covering the Noriega years in depth, the following texts provide an overview: Conniff, *Panama and the United States*, 154–167; Andrew S. Zimbalist and John Weeks, *Panama at the Crossroads: Economic Development and Political Change in the Twentieth Century* (Berkeley: University of California Press, 1991); Mark Falcoff and Richard Millett, *Searching for Panama: The U.S.-Panama Relationship and Democratization* (Washington, DC: Center for Strategic and International Studies, 1993); Orlando J. Pérez, *Political Culture in Panama: Democracy after Invasion* (New York: Palgrave Macmillan, 2011).

20 Personal interview with Raúl Leis, April 28, 2010.

21 Personal interview with Rómulo Castro, April 20, 2010.

22 "El Presidente Guillermo Endara heredó un país en ruinas, aislado internacionalmente, con una extraordinaria deuda externa, una elevadísima tasa de desempleo, masiva pobreza, concentración del ingreso en pocas manos y ocupado por el ejército de los Estados Unidos." Patricia Pizzurno and Celestino Andrés Araúz, "Los Retos de la Nueva Etapa Democrática (1990–1999): Panamá Resurge de las Cenizas de la Invasión," Panamá América, *Panamá en el Siglo XX* (1995–2000), http://www.critica.com.pa/archivo/historia/f14-50.html. Accessed September 1, 2014.

23 See John Lindsay-Poland, *Emperors in the Jungle: The Hidden History of the U.S. in Panama* (Durham, NC: Duke University Press, 2003).

24 These talks ended on September 24, 1998. Jorge Turner Morales and Alexis Rodríguez Mójica, "On the Eve of Great Change," *Revista Envío*, March 1999.

25 Alemancia and Leis, *Reversión Canalera*, 6, 23–24; Jesús Q. Alemancia and Herasto Reyes, "Qué Es el Centro Multilateral de Lucha Contra el Narcotráfico?," in *El Canal de*

Panamá en el Siglo XXI: Encuentro Académico Internacional Sobre el Canal de Panamá (Universidad de Panamá, 1998); Maurice Lemoine, "Panama Gets Its Canal Back," *Le Monde Diplomatique*, August 6, 1999.

26 "El Parlamento Panameño Aprueba La Abolición Del Ejército," *El País*, December 28, 1991.

27 Maurer and Yu note: "the American public greeted the Panama Canal agreements with a mixture of apathy and disappointment," while "the Panamanian reaction to the two treaties was the polar opposite. . . . The treaties were immensely popular, winning two-thirds of the vote in a national plebiscite on October 23, 1977." *The Big Ditch*, 264–265.

28 Jon Lee Anderson, "Letter from Panama: 233,000 Acres, Ocean Views," *New Yorker*, November 29, 1999, 51.

29 See Herbert Knapp and Mary Knapp, *Red, White, and Blue Paradise* (San Diego: Harcourt, Brace, Jovanovich, 1984), 119.

30 Gregorio A. Urriola Candanedo, "Construyendo el Futuro: Prospectiva Tecnológica, la Reversión Canalera y el Desarrollo Nacional, Elementos de una Política de Inovación para Panamá," in *El Canal de Panamá en el Siglo XXI*, 187–195.

31 These proposals considered civic benefits from the reverted lands, civilian uses of military bases, environmental protections, and the Canal's revenue as government funding sources. Various studies, like that published by the Ministerio de Planificación y Política Económica (MIPPE) in June 1980, laid out plans for uses of the Canal Area's grounds and watershed (see Alemancia and Leis, 15). Panama's National Guard, the business elite, and representatives of the middle classes weighed in on visions for the post-1979 Canal Area. Whereas Torrijos had sought "the greatest social use possible" ("el mayor uso social possible") of the lands, citing nationalization, collectivism, and redistribution, the business sector ultimately won out, arguing that privatization and development of the reverted areas, with the possibility for the Panamanian government to collect rents, would be the best way to make profitable use of the lands for all Panamanians (Alemancia and Leis, 18–19). Today, public-private partnerships govern some areas; the former US Howard Air Force Base, for example, has become Panamá Pacífico, a "special economic area" governed by a government agency that derives benefits from private development. See http://www.app.gob.pa/index.php?p=estructura. Accessed April 22, 2016.

32 When the Canal Zone was dissolved, many Zonian Canal employees transferred their careers to the Department of Defense (DoD) and Commission, remaining in the area until 1999. Many Zonians and West Indian Panamanians were skeptical of the ACP's management capabilities (Donoghue, *Borderland on the Isthmus*, 90–91). For Zonians coping with the loss of their livelihoods and communities, the DoD offered trauma counseling services (personal interview with Toni Williams Sánchez, August 10, 2010).

33 Alemancia and Leis, *Reversión Canalera*, 6, 29–30. Maurer and Yu explain that this fear turned out to be largely unfounded (*The Big Ditch*, 305–312).

34 "Anniversary Celebrations," in Miscellaneous Manuscripts, 1806–1976, Folder 32 and Oversize Folder 15 (LOC).

35 Castro interview, April 20, 2010.

36 Castro interview; personal interview with Luís Arteaga, April 20, 2010.

37 Donoghue, *Borderland on the Isthmus*, 18–21.

38 Ibid., 90.

39 Mantovani, "Countdown Clock Starts Ticking toward Canal Transfer."

40 Personal interview with Gale Cellucci, August 20, 2008.

41 Roosevelt Medal Descendants, "Roosevelt Medal Facts" (personal archive of Patricia Quinn, 1999); personal interview with Bruce Quinn, August 22, 2008.

42 On changing US attitudes toward Panama, see Knapp and Knapp, *Red, White, and Blue Paradise*, 141–143. Although the TGA mandated English-language productions, its actors belonged to diverse groups in Panama and the Zone, and its membership was unrestricted. Nevertheless, several Panamanian interviewees saw the TGA as a "Zonian" pastime.

43 Bruce Quinn interview, August 22, 2008.

44 Personal interview with Sarah Knapp, April 22, 2010. Rehearsals took place in the Canal Area. Several interviewees recounted that military bases were the only places in the Canal Area where access was completely restricted. While access to nonmilitary spaces in the Zone was not closed, Panamanians' presence in the Zone was often construed as "loitering without a reason" and invited racial profiling and intimidation by the Canal Zone police force.

45 Quinn interview, August 22, 2008.

46 Personal interview with Aurea Torrijos, June 26, 2010. As I noted in the preceding chapter, Aurea "Baby" Torrijos hired Quinn to direct *La Cucarachita mandinga* in 1976, but the contract was revoked due to Quinn's dual citizenship.

47 The program for *Maestra Vida* is held at the Rubén Blades Collection, Loeb Music Library, Harvard University, Series 3, "Publicity and Promotional Materials." Video footage and posters are also available in Series 5 and 8.

48 Personal interview with Dino Nugent, May 24, 2010.

49 Raúl Bernal, "Se Prepara Gran Gala del Canal de Panamá," *Panamá América*, July 18, 1999.

50 "Con este acto se rendirá tributo a todos aquellos que tuvieron la visión de construir una vía interamericana por el Istmo, a los constructores del Canal y a la futura administración panameña de la vía acuática." "Canal de Panamá Celebra su 85 Aniversario con Gran Gala Artística y Musical," *Panamá América*, August 13, 1999.

51 "Con esta Gala del Canal, en el año de la transición, hemos querido conmemorar los aportes de sudor, sangre, visión, y esperanza de miles de personas que hicieron posible esta grandiosa obra de ingeniería y a la vez proyectamos al futuro." Ibid.

52 "Se Prepara Gran Gala del Canal de Panamá."

53 Ibid.

54 Nugent interview, May 24, 2010.

55 Quinn interview, August 1, 2008.

56 Personal interview with Orlando Hernández Ying, April 22, 2010.

57 Ibid.

58 Blades performed the song on one night; Luís Arteaga sang it on other nights. "Canal Anniversary Gala Performers," *Panama Canal Spillway*, July 30, 1999.

59 "Se Inician Celebraciones de 85 Aniversario del Canal de Panamá," *La Nación*, August 13, 1999.

60 See Aims McGuinness, *Path of Empire: Panama and the California Gold Rush*. The United States in the World (Ithaca, NY: Cornell University Press, 2008), 80.

61 For example, Condassin stated in the second interlude: "Hoy celebramos el júbilo de Panamá y la esperanza de un continente, que hace casi cien años fue dividido por la visión . . . y la fuerza humana en beneficio del mundo entero."

62 "La transferencia del canal de Panamá ocurrirá el 31 de diciembre de 1999, y será una celebración tanto panameña como de la humanidad." Panama Canal Authority (ACP), "Pietajes: 85 Aniversario Del Canal De Panamá" (videorecording, 1999).

63 Candanedo, "Construyendo el Futuro."

64 "Building the Stage," *Panama Canal Spillway*, August 13, 1999.

65 "Buenas noches, damas y caballeros. Para celebrar el 85º aniversario de la apertura del canal y el cuarto año de transición de la era estadounidense a la era panameña, haremos un viaje a través del tiempo y espacio para recordar los miles y miles de personas que dieron su juventud, y hasta sus vidas, para lograr el sueño de dividir la tierra para unir al mundo." ACP, "Pietajes."

66 Other topics discussed by the narrators included the California Gold Rush and Panama Railroad; the influence of North American jazz in Panama; the French era of Canal construction; Panama's National Theatre; and conservation of the Canal's watershed.

67 See "Entertainment and Culture; Cynthia Franklin Brown, 1975–1980" in GWW Papers, Box 30, Folder 32, Schomburg.

68 Anton Rajer, *París en Panamá: Roberto Lewis y la Historia de sus Obras Restauradas en el Teatro Nacional de Panamá* (Madison, WI: Fine Arts Conservation Services, 2005); Naomi Adele André, Karen M. Bryan, and Eric Saylor, *Blackness in Opera* (Urbana: University of Illinois Press, 2012), 55–77.

69 Daphne Brooks, *Bodies in Dissent: Spectacular Performances of Race and Freedom, 1850–1910* (Durham, NC: Duke University Press, 2006), 328.

70 Katherine Zien, "Toward a Pedagogy of Redress: Staging West Indian Panamanian History in *De/from Barbados a/to Panamá*," *Latin American and Caribbean Ethnic Studies* 4, no. 3 (2009); Sonja Stephenson Watson, "The Use of Language in Melva Lowe De Goodin's *De/from Barbados a/to Panamá*: A Construction of Panamanian West Indian Identity," *College Language Association Journal* (2005); Ifeoma Nwankwo, "The Art of Memory in Panamanian West Indian Discourse: Melva Lowe De Goodin's *De/from Barbados a/to Panamá*," *Publication of the Afro-Latin/American Research Association* 6 (2002).

71 Personal interview with Ela Spalding, February 17, 2010.

72 Knapp interview, April 22, 2010.

73 "Latin America: Collision Course on the Canal," *Time*, July 28, 1975.

74 Rómulo Castro composed several songs for Rubén Blades, including "La Rosa de los Vientos" and "Encrucijadas."

75 See Robin Moore, *Music and Revolution: Cultural Change in Socialist Cuba* (Berkeley: University of California Press, 2006); Peter Lamarche Manuel, Kenneth M. Bilby, and Michael D. Largey, *Caribbean Currents: Caribbean Music from Rumba to Reggae* (Philadelphia: Temple University Press, 2006), 56–57.

76 Castro, April 20, 2010.

77 "Pa' cuando tú crezcas, pela'o, pa' cuando me muera, mucha plata no te dejaré, se me fue en quimeras, te dejo esta tierra pa' que la quieras."

78 Blades featured "La Rosa de los Vientos" on his 1996 album of the same name, winning a Latin Grammy in 1997.

79 On Blades's album, which Castro produced, the song is given a multi-instrumental arrangement including flutes and drums.

80 "Cada hombre lleva encima la huella de su tiempo." The lyrics in the version on Blades's album are different: "cada uno lleva encima la huella de sus sueños."

81 See Ana Patricia Rodríguez, "Encrucijadas."

82 "¿Quién dijo que la risa tuvo que emigrar?"

83 "Puedes negar un nombre / o un *ghetto* desecar, decir que el Polo Norte / está en el Sur...
 ¿y delirar?"

84 "Yo soy de donde nace / la rosa de los vientos."

85 Rodríguez, "Encrucijadas," 96.

86 On the clave rhythm, see Manuel et al., *Caribbean Currents*, 46–52.

87 Lisa Sánchez-González, "Reclaiming Salsa," *Cultural Studies* 13, no. 2 (1999).

88 Lise Waxer, *Situating Salsa: Global Markets and Local Meanings in Latin Popular Music*
 (New York: Routledge, 2002), 7–22.

89 See Frances R. Aparicio, *Listening to Salsa: Gender, Latin Popular Music, and Puerto
 Rican Cultures* (Hanover, NH: University Press of New England, 1998), 65–70.

90 Ángel G. Quintero Rivera, "Salsa y Democracia: Prácticas Musicales y Visiones
 Sociales En La América Mulata," *Íconos* (Ecuador) 18 (2004): 23.

91 Ibid.

92 Ibid., 22.

93 "Que no habrá más tutela, ni espontaneidad; que ahora tendrás la culpa . . . y la
 oportunidad."

94 "Navega tu propio barco, enfrenta tu temporal, sortea piratas y riscos: a buen puerto has
 de llegar."

95 "De ti depende, mi raza, y nadie te va ayudar: serás parte de la Historia o serás historia y no
 más."

96 "Si hasta ahora sólo has visto las cosas pasar, ya tienes cinco siglos y unos años más, y ya
 eres suficientemente mayor de edad."

97 "Un Panamá solidario, como el que a tí no te dieron, pa' nuestros hijos y nietos. La 'Gen-
 eración del 2,000' eres tú, y tú no quieres ni 'rosca,' ni 'revolú.' [. . .] Que no te vengan
 con cuentos, que no te tiren la toalla; la función es toda tuya, el teatro es tu propia casa.
 El futuro ya llegó, y está contigo, a tu vera; Ascanio lo pregonó: ¡Bandera! ¡Bandera!"

98 Castro interview, April 20, 2010.

99 Ibid.

100 In Castro's view, the ACP's separation from the national government had benefits and
 drawbacks; the ACP was rendered somewhat immune from "politiqueros" (politick-
 ing, corruption), but its relationship to the public sector and the Ministry of Finance
 was not sufficiently transparent.

101 Rodríguez, "Encrucijadas," 91–97.

102 I use this term to evoke the "disaggregated musical," which informed Quinn's
 dramaturgy.

103 Maurer and Yu, *The Big Ditch*, 329.

104 In *Music and Revolution* (2006), Robin Moore defines a *peña* as "an informal artistic
 gathering" (143). In the 1960s and 1970s, many *peñas* engaged social justice and other
 left/progressive topics.

105 Frank M. Figueroa, "Rubén Blades and His Cast of Characters," *Latin Beat*, June 1997.

106 Personal interview with Rubén Blades, December 8, 2009.

107 Calypsonian Leslie George, for example, also initially emulated Lymon and other
 North American musicians. Personal interview with Leslie George, May 15, 2010.

108 Blades interview, December 8, 2009.

109 Quinn interview, August 22, 2008.

110 Blades interview, December 8, 2009.

111 Ibid.

112 José David Saldívar, *The Dialectics of Our America: Genealogy, Cultural Critique, and Literary History* (Durham, NC: Duke University Press, 1991), 152.

113 "La salsa es un folklore internacional a nivel urbano, el cual refleja el sentir de Hispanoamérica en busca de su unificación e identidad." Quoted in María Elvira Azúa, "Rubén Blades: ¡Se Retira Pronto!" *Artistas*, May 14, 1979.

114 Saldívar, *The Dialectics of Our America*, 152.

115 Ibid., 153. Emphasis added?

116 "'Pedro Navaja' es una composición naturalista porque expresa una realidad tal y como es, sin disimulos. Es por este motivo que admiro al escritor Kafka, porque presenta un problema pero no da la solución. He llevado una vida de observación y he compartido con todo tipo de personas. Creo que mis temas sirven para demostrar que las vidas que se desarrollan en la 'oscuridad' terminan de igual manera. Pero no creo en la crítica, porque veo que hay belleza dentro de lo morboso . . ." Quoted in Azúa, "Rubén Blades."

117 "Rubén Blades' Crowning Glory," *New York Daily News*, August 21, 1985.

118 While US media coverage of Blades's presidential campaign was infused with a skeptical and bemused tone (the *Los Angeles Times* calling a salsa artist president "outlandish," for example), there are many examples of performing artists serving as politicians (not least Ronald Reagan). Tracy Wilkinson, "Ruben Blades' Panamanian Pipe Dream: The Singer-Actor Finds the Spotlight Is Hotter When You're Running for President," *Los Angeles Times*, April 24, 1994; Peter Manuel, "The Soul of the Barrio: 30 Years of Salsa," *N.A.C.L.A. Report on the Americas* 28, no. 2 (1994).

119 Ray Sánchez, "Rubén Blades Faces His Toughest Audience Yet," *New York Newsday*, May 3, 1994.

120 Papa Egoró means "Mother Earth" in the language of the indigenous Emberá people. Meg Grant, "Panama's Favorite Son," *People*, May 9, 1994; "Ruben Blades' Panamanian Pipe Dream."

121 Pérez, *Political Culture in Panama*, 75–85.

122 Ibid., 71. The Civilistas' ties to the United States are still only partly known. Since the group included businessmen with US interests, some members may have helped lay the groundwork for "Operation Just Cause."

123 Blades interview, December 8, 2009.

124 Ibid.

125 Ibid.

126 After the 1989 invasion, Guillermo Endara was elected president under the Alianza Democrática de Oposición Civilista (ADOC), which combined the National Civil Crusade with members from the Arnulfistas and other parties. Despite technically winning the 1989 election, Endara, who was reinstated with US military aid, did not satisfy many Panamanians' desires for dramatic overhaul of the political system. See Margaret Scranton, "Consolidation after Imposition: Panama's 1992 Referendum," *Journal of Interamerican Studies and World Affairs* 35, no. 3 (1993); Richard L. Millett, "Panama: Transactional Democracy," in *Constructing Democratic Governance: Latin America and the Caribbean in the 1990s*, ed. Jorge I. Domínguez and Abraham F. Lowenthal (Baltimore: Johns Hopkins University Press, 1996). As Maurer and Yu note, in 1999 Mireya Moscoso, Arnulfo Arias's widow, won the election under the Unión por Panamá, an Arnulfista coalition. Maurer and Yu, *The Big Ditch*, 304. The Arnulfista party became the Panameñistas in 2005 (personal communication with Carlos Guevara Mann, December 10, 2012).

127 Other members included Bernabé Pérez, Gloria Young, and Mariela Jiménez. Leis, a prominent Panamanian sociologist and playwright, was secretary general. "Muere Sociólogo Panameño Raúl Leis, Líder de la Sociedad Civil Organizada," *Panamá América*, May 1, 2011; Katherine Zien, "Panamanian Theatre for Social Change: Notes from an Interview with Playwright Raúl Leis," *Latin American Theatre Review* 47, no. 2 (2014).

128 "Ruben Blades' Panamanian Pipe Dream."

129 Movimiento Papa Egoró (MPE), "Una Sola Casa: Aportes Para un Programa Nacional del Gobierno del Acuerdo y el Compromiso entre Panameños" (Panamá, 1992). In RBC, Loeb Library, Harvard. Series 4, Political Campaign Materials.

130 "Rubén Blades Faces His Toughest Audience Yet"; reportage by Eric Jackson, *The Panama News*, February 21, 2012.

131 MPE, "Una Sola Casa," 3.

132 Ibid., 4.

133 "Panamá está perdida en el laberinto de una crisis económica, política, moral y social. CRISIS . . . tiene dos componentes: peligro y oportunidad. El peligro de sucumbir para siempre; la oportunidad de aprovechar la situación para construir algo mejor." Ibid., 3–4.

134 "Nuestro lema, PRO MUNDI BENEFICIO, es entendido por nuestro Movimiento como PRO PANAMA. Panamá primero, nuestro interés por delante." Ibid., 10.

135 Ibid., 12.

136 Ibid., 9.

137 "Consideramos que el criterio que debe imperar en cuanto al uso de esas áreas no debe exclusivamente limitarse al factor económico. Tenemos que considerar las posibilidades culturales, de recreación y de conservación ambiental, e integrar estas necesidades dentro de la respuesta. Es imperativo el que se produzca la utilización económica que integre a ese sector de la nación. . . . Pero no olvidemos también la función social que debe cumplir el área revertida." Ibid.

138 Spalding, February 17, 2010.

139 Pérez, *Political Culture in Panama*, xx; Marco A. Gandásegui, "Panamá: Años Decisivos," *Nueva Sociedad* 132 (1994).

140 Eric Jackson, "Central America: Voters Reverse Panama Invasion Verdict," Zmag.org (1994); George Priestley, "Elections: The Opposition Returns to Power," *N.A.C.L.A Report on the Americas* 28, no. 2 (1994).

141 Manolo Álvarez, "Partido de Rubén Blades le da Sorpresas a los Panameños," *Nuevo Herald*, January 20, 1999.

142 See Howard French, "Panama Likes Rubén Blades but Not, It Seems, as Leader," *New York Times*, March 17, 1994.

143 Anti-Blades sentiment intensified when Blades was named minister of tourism by Martín Torrijos's PRD administration in 2004; however, few would question Blades's assertion that he does not support the PRD's corruption.

144 "Representantes del cantante, compositor, actor y político . . . han advertido que ninguno de los dos espectáculos persigue fines políticos, sino de unidad nacional, de paz, optimismo y sana diversión, aunque su música, más que de escape, sirve para enfrentar las realidades." Martha Vanessa Concepción, "Rubén Blades en Doble Concierto este 31 de Diciembre," *Panamá América*, December 29, 1999.

145 Castro interview, April 20, 2010.

146 Concepción, "Rubén Blades En Doble Concierto Este 31 De Diciembre."

147 Ibid.

148 Ibid.

149 "Se celebra la transferencia del Canal de Panamá y la reversión total de las tierras que durante 96 años fueron administradas por el gobierno de Estados Unidos." "Rubén Blades Estará en Evento de Reversión de la Alcaldía: Será Gratis Para Todo el Pueblo," *La Crítica*, November 30, 1999.

150 "Transmitirán Concierto de Blades en Internet," *Panamá América*, December 15, 1999; "Cuatrocientos Mil Ciudadanos Disfrutaron Concierto con Blades," *Panamá América*, January 4, 2000.

151 "Se anunció que ochenta por ciento del repertorio de Rubén Blades estará basado en sus temas viejos, que le han dado tanta gloria, como 'Decisiones,' 'Buscando América,' y especialmente 'Patria,' que se presume prácticamente será el himno del momento en un ambiente donde de seguro ondearán las banderitas panameñas." "Rubén Blades en Doble Concierto este 31 de Diciembre."

152 "El alcalde del distrito capital Juan Carlos Navarro, gestor de la actividad, felicitó a los panameños por el hecho histórico de la recuperación del Canal, ya que esta es una conquista nacional que une a todos y permite entrar al nuevo siglo como una 'patria entera' con una esperanza de desarrollo y progreso para el país. Destacó que todos los panameños debemos trabajar juntos y comprometidos en honrar el legado de todos los grandes hombres y mujeres de esta tierra." "Cuatrocientos Mil Ciudadanos Disfrutaron Concierto con Blades." Navarro had been a political independent but joined the PRD in 1999.

153 The label "national artist," which I apply to Sammy y Sandra Sandoval, Manuel de Jesús Abrego, and Osvaldo Ayala, is significant due to Panama's law requiring the participation of one "national artist" per touring international artist, and the inclusion in the event of "national" repertoire like *pindín*. Dino Nugent suggested that these laws came into being in the late twentieth century. Nugent interview, May 24, 2010.

154 Rubén Blades with Editus, "Patria Entera," concert footage. Broadcast on SERTV, Canal 11 (Panamá, 1999).

155 Ibid.; personal Interview with Osvaldo Jordan, August 20, 2008.

156 Erika Fischer-Lichte examines performance's power to transform subject-object relations and hermeneutic/phenomenological dynamics, rendering an aesthetic and social event (rather than a fixed artwork separate from its creator) whose outcomes are codetermined by the intersubjective relations of participants. See Fischer-Lichte, *The Transformative Power of Performance: A New Aesthetics* (New York: Routledge, 2008).

157 All of Blades's comments were in Spanish; all translations are mine. No transcripts are available.

158 Rubén Blades with Editus, "Patria Entera," Concert footage.

159 Ibid.

160 The patio is customarily an open terrace in a rural cottage in Panama's interior. More generally, the phrase "[X] de patio" designates the entity in question as intrinsic to Panama's "folk."

161 See McGuinness, *Path of Empire*, 123–151.

162 "Cuatrocientos Mil Ciudadanos Disfrutaron Concierto Con Blades."

163 See Benedict Anderson, *Imagined Communities: Reflections on the Origin and Spread of Nationalism* (London: Verso, 1983). I do not mean to praise nationalism, but I do seek to understand how discussions of nationalism have been and can be more nuanced

than a simple dismissal. As Partha Chatterjee notes, after the 1970s nationalism was reviled as "the reason why people in the Third World killed each other" but was previously regarded as a positive attribute, "a feature of the victorious anticolonial struggles in Asia and Africa." Chatterjee goes on to state that "nationalism is now viewed as a dark, elemental, unpredictable force of primordial nature threatening the orderly calm of civilized life." Yet "not many years ago nationalism was generally considered one of Europe's most magnificent gifts to the rest of the world." Chatterjee, *The Nation and Its Fragments: Colonial and Postcolonial Histories* (Princeton, NJ: Princeton University Press, 1993), 3–4. Transformations of nationalism, its continual irruption into international relations, and its strategic uses merit further study, rather than dismissal.

164 Anderson, *Imagined Communities*, 9–12.

165 "Patria, son tantas cosas bellas/ Como aquel viejo árbol del que nos habla aquel poema, Como el cariño que aun guardas después de muerta abuela. [. . .] Son las paredes de un barrio y en su esperanza morena / Es lo que lleva en el alma todo aquél cuando se aleja . . . Patria es un sentimiento en la mirada de un viejo / Sol de eterna primavera, risa de hermanita nueva."

166 Erika Fischer-Lichte distinguishes "space" from "spatiality." "Spatiality" is created by the convergence of the performer's body with audience reception and the performance space, elaborated in an interactive and unstable process of exchange between performer and audience. Spatiality is a particularly fascinating aspect of performances in nontheatre venues, as at the Administration Building; here the venues create spatiality as a convergence of performers' embodied acting, spectators' interpretation, and the extratheatrical functions and significance of the venues themselves. Fischer-Lichte, *The Transformative Power of Performance*, 94–107.

167 Descriptions of the Canal Zone as utopia and paradise are too many to list in full. Examples include Alexander Missal, *Seaway to the Future: American Social Visions and the Construction of the Panama Canal*. Studies in American Thought and Culture (Madison: University of Wisconsin Press, 2008), 9–13, 122–161; Knapp and Knapp, *Red, White, and Blue Paradise*.

168 "The Nation: Panic in a Tropical Playground," *Time*, August 22, 1977; "Latin America: Collision Course on the Canal."

169 Eduardo Tejeira Davis, "Taking Back the Canal Zone: A Challenge for Panama City," in *Ciudad Multiple City: Urban Art and Global Cities, an Experiment in Context*, ed. Gerardo Mosquera and Adrienne Samos (Amsterdam, Neth.: K.I.T. Publishers, 2004), 8–9.

170 Alan McPherson, "Myths of Anti-Americanism: The Case of Latin America," *Brown Journal of World Affairs* x, no. 2 (2004): 148.

171 Nugent, May 24, 2010.

172 Ying, April 22, 2010.

173 Jill Dolan, *Utopia in Performance: Finding Hope at the Theater* (Ann Arbor: University of Michigan Press, 2005), 7.

174 Elin Diamond, quoted in ibid., 6.

175 Roach, *Cities of the Dead*, 74.

176 Ibid., 76.

177 Paul Connerton, *How Societies Remember* (New York: Cambridge University Press, 1989), 4–5.

178 Ibid., 6.

179 Ibid., 8.

180 Ibid., 10, 72–73.
181 Ibid., 72.
182 Roach, *Cities of the Dead*, 76.
183 Wendy Brown, *Walled States, Waning Sovereignty* (New York: Zone Books, 2010), 49.
184 Ibid.
185 Amid sovereignty's many paradoxes, which Wendy Brown enumerates, sovereign democracy stands out as a particular "absurdity," paraphrasing Immanuel Kant (*Walled States, Waning Sovereignty*, 53–54).
186 Ibid., 49.
187 Ibid., 50. For a fuller critique of sovereign democracy, see 49–52.
188 Josh D. Kun, "The Aural Border," *Theatre Journal* 52, no. 1 (2000).

CODA AFTER SOVEREIGNTY

1 Noel Maurer and Carlos Yu, *The Big Ditch: How America Took, Built, Ran, and Ultimately Gave Away the Panama Canal* (Princeton, NJ: Princeton University Press, 2011).
2 TVN, "Siembran 300 banderas en la Ciudad del Saber," November 6, 2013. https://youtu.be/hjCAVCAE_PE. Accessed May 10, 2016.
3 Ibid.
4 Andrew Sofer, *The Stage Life of Props* (Ann Arbor: University of Michigan Press, 2003).
5 Giorgio Agamben and Daniel Heller-Roazen, *Homo Sacer: Sovereign Power and Bare Life* (Stanford, CA: Stanford University Press, 1998), 28, 41.
6 Stewart Motha, "The Sovereign Event in a Nation's Law," *Law and Critique* 13, no. 3 (2002): 327.
7 Carl Schmitt, *Political Theology: Four Chapters on the Concept of Sovereignty* (Cambridge, MA: MIT Press, 1985).
8 Thousands of Panamanians were employed by the US military bases in service sector roles, however. These histories are indeed part of Panama's past, even though they might not be welcomed into the national sovereignty narrative.
9 Rebecca Schneider, *Performing Remains: Art and War in Times of Theatrical Reenactment* (New York: Routledge, 2011), 37.
10 Ibid., 38.
11 "Performance means: never for the first time." Richard Schechner, *Between Theater and Anthropology* (Philadelphia: University of Pennsylvania Press, 1985), 36.
12 Panama's accumulation and preponderance of sovereignty discourses have even (to entertain levity) resulted in a national beverage called "Cerveza Soberana" (Sovereign Beer).
13 John Major, "Who Wrote the Hay-Bunau-Varilla Convention?" *Diplomatic History* 8, no. 2 (1984): 122–123.
14 On nuances and similarities of gentrification and sovereignty discourses, see Matt Hern, *What a City Is For* (Cambridge, MA: MIT Press, 2016). My thanks to Matt for sharing his thoughts.
15 Sandro Mezzadra and Brett Neilson, *Border as Method, or, the Multiplication of Labor* (Durham, NC: Duke University Press, 2013), 165.
16 Wendy Brown, *Walled States, Waning Sovereignty* (New York: Zone Books, 2010), 52.

BIBLIOGRAPHY

ARCHIVES

Canal Zone Library-Museum Collection. Library of Congress, Washington, DC.
Panama Canal Company Records, RG 185, National Archives and Records Administration, College Park, Maryland.
George W. Westerman Papers, Sc M G505. Manuscripts, Archives, and Rare Books Division, Schomburg Center for Research in Black Culture, the New York Public Library.
Rubén Blades Collection, Loeb Music Library, Harvard University.

PERSONAL INTERVIEWS

Arteaga, Luís. April 20, 2010, Panama City, Panama.
Blades, Rubén. December 8, 2009, Panama City, Panama.
Castro, Rómulo. April 20, 2010, El Cangrejo, Panamá.
Cellucci, Gale. August 20, 2008, La Cresta, Panama.
Cortés, Delia. June 20, 2010, Panama City, Panama.
George, Leslie. May 15, 2010, Río Abajo, Panama.
Jordan, Osvaldo. August 20, 2008, Panama City, Panama.
Knapp, Sarah. April 22, 2010, Emailed Questionnaire.
Leis, Raúl. April 28, 2010, Coco del Mar, Panama.
Moreno, Miguel. June 26, 2010, Panama City, Panama.
Nicoletti, Josefina. July 6, 2010, Panama City, Panama.
Nugent, Dino. May 24, 2010, Panama City, Panama.
Quinn, Bruce. August 1, 2008, Panama City, Panama.
Quinn, Bruce. August 22, 2008, Panama City, Panama.
Sánchez, Toni Williams. August 10, 2010, Panama City, Panama.
Spalding, Ela. February 17, 2010, Panama City, Panama.
Torrijos, Aurea. June 26, 2010, El Dorado, Panama.
Ying, Orlando Hernández. April 22, 2010, Telephone.

NEWSPAPERS IN PANAMA

Crítica en Línea
La Estrella de Panamá (Panama Star and Herald)
La Hora
El Matutino
El Mundo Gráfico
The Nation / La Nación

Panamá América
Panama American
Panama Canal Record
Panama Canal Review
Panama Canal Spillway
Panama Tribune
Siete

SELECTED SECONDARY SOURCES

Agamben, Giorgio, and Daniel Heller-Roazen. *Homo Sacer: Sovereign Power and Bare Life.* Meridian. Stanford, CA: Stanford University Press, 1998.

Alemancia, Jesús, and Raúl Leis. *Reversión Canalera: Informe De Un Desafío.* Panamá Hoy. Vol. 6. Panamá: Centro de Estudios y Acción Social Panameña (CEASPA), 1995.

Alexander, Renee. "Art as Survival: The Congo Tradition of Portobelo, Panama." PhD diss., Northwestern University, 2005.

Alfaro, Ricardo J. *Vida Del General Tomás Herrera.* Ed. conmemorativa del XXV aniversario. Panamá: Universidad de Panamá, 1960.

Ameringer, Charles D. "Philippe Bunau-Varilla: New Light on the Panama Canal Treaty." *The Hispanic American Historical Review* 46, no. 1 (1966): 28–52.

Anderson, Benedict R. *Imagined Communities: Reflections on the Origin and Spread of Nationalism.* London: Verso, 1983.

Anderson, Patrick. "'Architecture Is Not Justice': Seeing Guantánamo Bay." In *Performance in the Borderlands*, edited by Ramón H. Rivera-Servera and Harvey Young, 82–96. New York: Palgrave Macmillan, 2011.

Anderson, Paul Allen. *Deep River: Music and Memory in Harlem Renaissance Thought.* New Americanists. Durham, NC: Duke University Press, 2001.

André, Naomi Adele, Karen M. Bryan, and Eric Saylor. *Blackness in Opera.* Urbana: University of Illinois Press, 2012.

Anghie, Anthony. "Finding the Peripheries: Sovereignty and Colonialism in Nineteenth Century International Law." *Harvard International Law Journal* 40, no. 1 (1990).

Anthias, Floya, Nira Yuval-Davis, and Harriet Cain. *Racialized Boundaries: Race, Nation, Gender, Colour and Class and the Anti-Racist Struggle.* New York: Routledge, 1992.

Aparicio, Frances. "Ethnifying Rhythms, Feminizing Cultures." In *Music and the Racial Imagination*, edited by Ronald Michael Radano and Philip Vilas Bohlman, 95–112. Chicago: University of Chicago Press, 2000.

———. *Listening to Salsa: Gender, Latin Popular Music, and Puerto Rican Cultures.* Music/Culture. Hanover, NH: Published by University Press of New England [for] Wesleyan University Press, 1998.

Appelbaum, Nancy P., Anne S. Macpherson, and Karin Alejandra Rosemblatt. *Race and Nation in Modern Latin America.* Chapel Hill: University of North Carolina Press, 2003.

Araúz, Celestino Andrés, and Patricia Pizzurno. *Relaciones entre Panamá y los Estados Unidos.* Tomo I. Panama: Autoridad del Canal de Panamá, Biblioteca de la Nacionalidad. 1999.

———. "Los Retos de la Nueva Etapa Democrática (1990–1999): Panamá Resurge de las Cenizas de la Invasión." In *Panamá en el Siglo XX.* Edited by Panamá América 1995–2000. http://www.critica.com.pa/archivo/historia/f14–50.html.

Arrizón, Alicia. *Latina Performance: Traversing the Stage.* Unnatural Acts. Bloomington: Indiana University Press, 1999.

———. *Queering Mestizaje: Transculturation and Performance*. Triangulations. Ann Arbor: University of Michigan Press, 2006.

Asher, Kiran. "Latin American Decolonial Thought, or Making the Subaltern Speak." *Geography Compass* 7, no. 12 (December 2013): 832–842.

Austin, J. L. *How to Do Things with Words*. The William James Lectures. Cambridge, MA: Harvard University Press, 1962.

Barker, Joanne. *Sovereignty Matters: Locations of Contestation and Possibility in Indigenous Struggles for Self-Determination*. Contemporary Indigenous Issues. Lincoln: University of Nebraska Press, 2005.

Batiste, Stephanie Leigh. *Darkening Mirrors: Imperial Representation in Depression-Era African American Performance*. Durham, NC: Duke University Press, 2011.

Beasley-Murray, Jon. *Posthegemony: Political Theory and Latin America*. Minneapolis: University of Minnesota Press, 2010.

Bederman, Gail. *Manliness & Civilization: A Cultural History of Gender and Race in the United States, 1880–1917*. Women in Culture and Society. Chicago: University of Chicago Press, 1995.

Beluche, Olmedo. "Panamá: La Lucha Del Pueblo Ngäbe-Buglé Contra Mineras E Hidroelectricas." *Otramerica*. Published electronically February 7, 2012. http://otramerica.com/solo-texto/opinion/panama-la-lucha-del-pueblo-ngabebugle-contra-mineras-e-hidroelectricas/1513.

Bennett, Ira E. *History of the Panama Canal, Its Construction and Builders*. Builders' ed. Washington, DC: Historical Pub. Co., 1915.

Berlant, Lauren. *The Queen of America Goes to Washington City: Essays on Sex and Citizenship*. Series Q. Durham, NC: Duke University Press, 1997.

———. "Slow Death (Sovereignty, Obesity, Lateral Agency)." *Critical Inquiry* 33 (Summer 2007): 754–780.

Bhabha, Homi K. *The Location of Culture*. New York: Routledge, 1994.

Blair, Rhonda. *The Actor, Image, and Action: Acting and Cognitive Neuroscience*. New York: Routledge, 2008.

Boal, Augusto. *The Aesthetics of the Oppressed*. New York: Routledge, 2006.

Boatwright, Vicki M. "Administration Building Unites Past, Present, and Future." *Panama Canal Review*, October 1, 1979.

Bonilla, Yarimar. *Non-Sovereign Futures: French Caribbean Politics in the Wake of Disenchantment*. Chicago: University of Chicago Press, 2015.

———. "Ordinary Sovereignty." *Small Axe* 17, no. 3 (November 1, 2013): 152–165.

Borba Filho, Hermilo, and Gilberto Freyre. *Sobrados e Mocambos*. Rio de Janeiro: Civilização brasileira, 1972.

Borstelmann, Thomas. *The Cold War and the Color Line: American Race Relations in the Global Arena*. Cambridge, MA: Harvard University Press, 2001.

Brejzek, Thea. "The Scenographic (Re-) Turn: Figures of Surface, Space and Spectator in Theatre and Architecture Theory, 1680–1980." *Theatre & Performance Design* 1, no. 1–2 (2015): 17–30.

Brennan, Teresa. *The Transmission of Affect*. Ithaca, NY: Cornell University Press, 2004.

Brody, David. *Visualizing American Empire: Orientalism and Imperialism in the Philippines*. Chicago: University of Chicago Press, 2010.

Brooks, Christopher Antonio, and Robert Sims. *Roland Hayes: The Legacy of an American Tenor*. Bloomington and Indianapolis: Indiana University Press, 2015.

Brooks, Daphne. *Bodies in Dissent: Spectacular Performances of Race and Freedom, 1850–1910*. Durham, NC: Duke University Press, 2006.

Brooks, Tim, and Richard K. Spottswood. *Lost Sounds: Blacks and the Birth of the Recording Industry, 1890–1919*. Music in American Life. Urbana: University of Illinois Press, 2004.

Brown, Bill. "Science Fiction, the World's Fair, and the Prosthetics of Empire, 1910–1915." In *Cultures of United States Imperialism*, edited by Amy Kaplan and Donald Pease, 129–163. Durham, NC: Duke University Press, 1993.

Brown, Wendy. *Walled States, Waning Sovereignty*. New York: Zone Books, 2010.

Bruyneel, Kevin. *The Third Space of Sovereignty: The Postcolonial Politics of U.S.-Indigenous Relations*. Indigenous Americas. Minneapolis: University of Minnesota Press, 2007.

Burnett, Carla. "'Are We Slaves or Free Men?': Labor, Race, Garveyism, and the 1920 Panama Canal Strike." PhD diss., University of Illinois at Chicago, 2004.

Burnett, Christina Duffy. "Untied States: American Expansion and Territorial Deannexation." *University of Chicago Law Review* 72, no. 3 (2005): 797–879.

Burton, Julianne. "Don (Juanito) Duck and the Imperial-Patriarchal Unconscious: Disney Studios, the Good Neighbor Policy, and the Packaging of Latin America." In *Nationalisms and Sexualities*, edited by Andrew Parker, 21–41. New York: Routledge, 1992.

Butler, Judith. "Performative Acts and Gender Constitution." In *Performance: Critical Concepts in Literary and Cultural Studies*, edited by Philip Auslander, 97–110. New York: Routledge, 2003.

Candanedo, Gregorio A. Urriola. "Construyendo el Futuro: Prospectiva Tecnológica, la Reversión Canalera y el Desarrollo Nacional, Elementos de una Política de Inovación para Panamá." In *El Canal de Panamá en el Siglo XXI: Encuentro Académico Internacional Sobre el Canal de Panamá*. Panama City, Panamá: Universidad de Panamá, 1998.

Canning, Charlotte. *The Most American Thing in America: Circuit Chautauqua as Performance*. Studies in Theatre History and Culture. Iowa City: University of Iowa Press, 2005.

———. *On the Performance Front: US Theatre and Internationalism*. Studies in International Performance. New York: Palgrave Macmillan, 2015.

Carlson, Marvin. *Places of Performance: The Semiotics of Theatre Architecture*. Ithaca, NY: Cornell University Press, 1989.

Chamberlain, Leander T. "A Chapter of National Dishonor." *The North American Review* 195, no. 675 (1912): 145–174.

Chambers-Letson, Joshua. *A Race So Different: Performance and Law in Asian America*. Postmillennial Pop Series. New York: New York University Press, 2013.

Chambers-Letson, Joshua, and Yves Winter. "Shipwrecked Sovereignty." *Political Theory* (2014): 1–25.

Chatterjee, Partha. *The Nation and Its Fragments: Colonial and Postcolonial Histories*. Princeton Studies in Culture/Power/History. Princeton, NJ: Princeton University Press, 1993.

Cheng, Anne Anlin. *The Melancholy of Race*. Race and American Culture. New York: Oxford University Press, 2001.

Cody, Jeffrey W. *Exporting American Architecture, 1870–2000*. Planning, History and the Environment Series. New York: Routledge, 2003.

Colby, Jason M. *The Business of Empire: United Fruit, Race, and U.S. Expansion in Central America*. The United States in the World. Ithaca, NY: Cornell University Press, 2011.

Connerton, Paul. *How Societies Remember*. Themes in the Social Sciences. New York: Cambridge University Press, 1989.

Conniff, Michael L. *Black Labor on a White Canal: Panama, 1904–1981*. Pitt Latin American Series. Pittsburgh: University of Pittsburgh Press, 1985.

———. *Panama and the United States: The Forced Alliance*. 2nd ed. Athens: University of Georgia Press, 2001.

Corinealdi, Kaysha. "Redefining Home: West Indian Panamanians and Transnational Politics of Race, Citizenship, and Diaspora, 1928–1970." PhD diss., Yale University, 2011.

Coronado, Jorge. *The Andes Imagined: Indigenismo, Society, and Modernity*. Pittsburgh: University of Pittsburgh Press, 2009.

Coulthard, Glen S. *Red Skin, White Masks: Rejecting the Colonial Politics of Recognition*. Indigenous Americas. Minneapolis: University of Minnesota Press, 2014.

Counsell, Colin. *Signs of Performance: An Introduction to Twentieth-Century Theatre*. New York: Routledge, 1996.

Croft, Clare. *Dancers as Diplomats: American Choreography in Cultural Exchange*. Oxford and New York: Oxford University Press, 2015.

Cruz, Jon. *Culture on the Margins: The Black Spiritual and the Rise of American Cultural Interpretation*. Princeton, NJ: Princeton University Press, 1999.

Davenport, Lisa E. *Jazz Diplomacy: Promoting America in the Cold War Era*. American Made Music Series. Jackson: University Press of Mississippi, 2009.

Davis, Eduardo Tejeira. "Taking Back the Canal Zone: A Challenge for Panama City." In *Ciudad Multiple City: Urban Art and Global Cities; an Experiment in Context*. Edited by Gerardo Mosquera and Adrienne Samos. Amsterdam, Neth.: K.I.T. Publishers, 2004.

Deloria, Philip Joseph, and Neal Salisbury. *A Companion to American Indian History*. Malden, MA: Blackwell, 2002.

Diamond, Elin. *Unmaking Mimesis: Essays on Feminism and Theater*. New York: Routledge, 1997.

Dolan, Jill. *Utopia in Performance: Finding Hope at the Theater*. Ann Arbor: University of Michigan Press, 2005.

Donoghue, Michael E. *Borderland on the Isthmus: Race, Culture, and the Struggle for the Canal Zone*. Durham, NC: Duke University Press, 2014.

Dorfman, Ariel, and Armand Mattelart. *How to Read Donald Duck: Imperialist Ideology in the Disney Comic*. New York: International General, 1975.

Dudziak, Mary L. *Cold War Civil Rights: Race and the Image of American Democracy*. Politics and Society in Twentieth-Century America. Princeton, NJ: Princeton University Press, 2000.

Duthu, N. Bruce. *Shadow Nations: Tribal Sovereignty and the Limits of Legal Pluralism*. New York: Oxford University Press, 2013.

Ealy, Lawrence O. *Yanqui Politics and the Isthmian Canal*. University Park: Pennsylvania State University Press, 1971.

Edwards, Brent Hayes. "The Uses of Diaspora." *Social Text* 19, no. 1 (2001).

Eidsheim, Nina Sun. "Marian Anderson and 'Sonic Blackness' in American Opera." *American Quarterly* 63, no. 3 (2011): 641–671.

Enscore, Susan I., and Construction Engineering Research Laboratory. *Guarding the Gates: The Story of Fort Clayton—Its Setting, Its Architecture, and Its Role in the History of the Panama Canal*. ERDC/CERL Monograph. Champaign, IL: U.S. Army Corps of Engineers, 2000.

Falcoff, Mark, and Richard Millett. *Searching for Panama: The U.S.-Panama Relationship and Democratization*. Significant Issues Series vol. 15, no. 6. Washington, DC: Center for Strategic and International Studies, 1993.

Fauser, Annegret. *Sounds of War: Music in the United States During World War II*. New York: Oxford University Press, 2013.

Ferrer, Ada. *Insurgent Cuba: Race, Nation, and Revolution, 1868–1898*. Chapel Hill: University of North Carolina Press, 1999.

Fischer-Lichte, Erika. *The Transformative Power of Performance: A New Aesthetics*. New York: Routledge, 2008.

Fish, Carl Russell. *The Path of Empire: A Chronicle of the United States as a World Power*. New Haven, CT: Yale University Press, 1919.

Fortune, Armando. "Estudio Sobre la Insurrección de los Negros Esclavos: los Cimarrones de Panamá." *Revista Cultural de la Lotería* (Panama: April 1956).

Fosler-Lussier, Danielle. *Music in America's Cold War Diplomacy*. California Studies in 20th-Century Music. Oakland: University of California Press, 2015.

Frenkel, Stephen. "Geography, Empire, and Environmental Determinism." *Geographical Review* 82, no. 2 (1992).

———. "Jungle Stories: North American Representations of Tropical Panama." *Geographical Review* 86, no. 3 (1996).

Freyre, Gilberto. *Casa Grande & Senzala: Formação da família brasileira sob o regime da economia patriarcal*. 16th ed. Rio de Janeiro: J. Olympio, 1973.

Gandásegui, Marco A. "Panamá: Años Decisivos." *Nueva Sociedad* 132 (July–August 1994).

Gelabert-Navia, José A. "American Architects in Cuba: 1900–1930." *The Journal of Decorative and Propaganda Arts* 22 (1996): 132–149.

Gillis, John R. *The Militarization of the Western World*. New Brunswick: Rutgers University Press, 1989.

Gillman, Susan. "The Epistemology of Slave Conspiracy." *Modern Fiction Studies* 49, no. 1 (2003): 101–123.

Gilroy, Paul. *The Black Atlantic: Modernity and Double Consciousness*. Cambridge, MA: Harvard University Press, 1993.

Go, Julian. "Imperial Power and Its Limits: America's Colonial Empire in the Early Twentieth Century." In *Lessons of Empire: Imperial Histories and American Power*. Edited by Craig J. Calhoun, Frederick Cooper, and Kevin W. Moore. New York: New Press, 2006.

———. *Patterns of Empire: The British and American Empires, 1688 to the Present*. New York: Cambridge University Press, 2011.

Goldstein, Alyosha. *Formations of United States Colonialism*. Durham, NC: Duke University Press, 2014.

Graham, Richard, Thomas E. Skidmore, Aline Helg, and Alan Knight. *The Idea of Race in Latin America, 1870–1940*. Critical Reflections on Latin America Series. Austin: University of Texas Press, 1990.

Grant, Colin. *Negro with a Hat: The Rise and Fall of Marcus Garvey*. Oxford and New York: Oxford University Press, 2008.

Greene, Julie. *The Canal Builders: Making America's Empire at the Panama Canal*. The Penguin History of American Life. New York: Penguin Press, 2009.

Grigsby, Darcy Grimaldo. *Colossal: The Suez Canal, Statue of Liberty, Eiffel Tower, and Panama Canal; Transcontinental Ambition in France and the United States During the Long Nineteenth Century*. 1st ed. Pittsburgh: Periscope Pub., 2011.

Guridy, Frank Andre. *Forging Diaspora: Afro-Cubans and African Americans in a World of Empire and Jim Crow*. Chapel Hill: University of North Carolina Press, 2010.

Hanchard, Michael. "Afro-Modernity: Temporality, Politics, and the African Diaspora." *Public Culture* 11, no. 1 (1999): 245–268.

Hann, Rachel. "Blurred Architecture: Duration and Performance in the Work of Diller Scofidio + Renfro." *Performance Research* 17, no. 5 (October 2012): 9–18.

Harpelle, Ronald. "Cross Currents in the Western Caribbean: Marcus Garvey and the U.N.I.A. In Central America." *Caribbean Studies* 31, no. 1 (2003).

———. "'White Zones': American Enclave Communities in Central America." In *Blacks and Blackness in Central America and the Mainland Caribbean: Between Race and Place*, edited by Lowell Gudmunson and Justin Wolfe, 307–334. Durham, NC: Duke University Press, 2010.

Hern, Matt. *What a City Is For*. Cambridge, MA: MIT Press, 2016.

Hogan, J. Michael. *The Panama Canal in American Politics: Domestic Advocacy and the Evolution of Policy*. Carbondale: Southern Illinois University Press, 1986.

Howe, James. *A People Who Would Not Kneel: Panama, the United States, and the San Blas Kuna*. Washington, DC: Smithsonian Institution Press, 1998.

Howland, Douglas, and Luise White. *The State of Sovereignty: Territories, Laws, Populations*. Bloomington: Indiana University Press, 2008.

Hurley, Erin. *National Performance: Representing Quebec from Expo 67 to Céline Dion*. Cultural Spaces. Toronto: University of Toronto Press, 2011.

Jackson, Eric. "Central America: Voters Reverse Panama Invasion Verdict." *Zmag.org* (July 1994).

———. "La Cucarachita Mandinga on the Admin Building Steps." *Panama News* 12 (2006). Published electronically February 19–March 4.

Jackson, Shannon. *Lines of Activity: Performance, Historiography, Hull-House Domesticity*. Ann Arbor: University of Michigan Press, 2000.

———. *Professing Performance: Theatre in the Academy from Philololgy to Performativity*. Theatre and Performance Theory. New York: Cambridge University Press, 2004.

Jacobson, Matthew Frye. *Barbarian Virtues: The United States Encounters Foreign Peoples at Home and Abroad, 1876–1917*. New York: Hill and Wang, 2000.

Jasanoff, Maya. "What New Empires Inherit from Old Ones." *History News Network* (2005). Published electronically December 12, 2005. http://historynewsnetwork.org/article/18853.

Johnson, Suzanne P. *An American Legacy in Panama: A Brief History of the Department of Defense Installations and Properties*. Edited by United States. Dept. of Defense. Legacy Resources Management Program, Fort Clayton, Panama: Directorate of Engineering and Housing, 1994.

Joyce, Richard, and Peter Fitzpatrick. "The Normality of the Exception in Democracy's Empire." *Journal of Law and Society* 34, no. 1 (March 2007): 65–76.

Kahn, Paul W. *Political Theology: Four New Chapters on the Concept of Sovereignty*. Columbia Studies in Political Thought / Political History. New York: Columbia University Press, 2011.

Kaplan, Amy. "Where Is Guantánamo?" *American Quarterly* 57, no. 3 (September 2005): 831–858.

Kaplan, Martha, and John D. Kelly. "Legal Fictions after Empire." In *The State of Sovereignty: Territories, Laws, Populations*. Edited by Douglas Howland and Luise S. White. Bloomington: Indiana University Press, 2009.

Kauanui, J. Kēhaulani. *Hawaiian Blood: Colonialism and the Politics of Sovereignty and Indigeneity*. Narrating Native Histories. Durham, NC: Duke University Press, 2008.

Kennedy, Dane. "Essay and Reflection: On the American Empire from a British Imperial Perspective." *The International History Review* 29, no. 1 (2007): 83–108.

Kramer, Paul A. "Empires, Exceptions, and Anglo-Saxons: Race and Rule between the British and United States Empires, 1880–1910." *Journal of American History* 88, no. 4 (March 2002): 1315–1353.

Kristeva, Julia. *Powers of Horror: An Essay on Abjection*. European Perspectives. New York: Columbia University Press, 1982.

Kun, Josh D. "The Aural Border." *Theatre Journal* 52, no. 1 (March 2000): 1–21.

Kutzinski, Vera M. *Sugar's Secrets: Race and the Erotics of Cuban Nationalism*. New World Studies. Charlottesville: University Press of Virginia, 1993.

LaFeber, Walter. *The Panama Canal: The Crisis in Historical Perspective*. New York: Oxford University Press, 1989.

Landers, Jane, and Barry Robinson. *Slaves, Subjects, and Subversives: Blacks in Colonial Latin America*. Diálogos. Albuquerque: University of New Mexico Press, 2006.

Lane, Jill. *Blackface Cuba, 1840–1895*. Rethinking the Americas. Philadelphia: University of Pennsylvania Press, 2005.

Lasso, Marixa. "From Citizens to 'Natives': Tropical Politics of Depopulation at the Panam Canal Zone." *Environmental History* 21 (April 2016).

Lawson, Steven F. *Civil Rights Crossroads: Nation, Community, and the Black Freedom Struggle*. Lexington: University Press of Kentucky, 2003.

Lefebvre, Henri. *The Production of Space*. Cambridge, MA: Blackwell, 1991.

Leis, Raúl Alberto. *Mundunción*. Colección Ricardo Miró. 1st ed. Panamá: Arosemena Inst. Nacional de Cultura, 1988.

Lindsay-Poland, John. *Emperors in the Jungle: The Hidden History of the U.S. in Panama*. American Encounters/Global Interactions. Durham, NC: Duke University Press, 2003.

Longwell, Dennis. "Panama Canal Photographs by Ernest 'Red' Hallen." *Art Journal* 36, no. 2 (Winter 1976–1977): 123–125.

Lott, Eric. "Blackface and Blackness: The Minstrel Show in American Culture." In *Inside the Minstrel Mask: Readings in Nineteenth-Century Blackface Minstrelsy*, edited by Annemarie Bean, James Vernon Hatch, and Brooks McNamara, xiv. Hanover, NH: Wesleyan University Press, 1996.

Love, Eric Tyrone Lowery. *Race over Empire: Racism and U.S. Imperialism, 1865–1900*. Chapel Hill: University of North Carolina Press, 2004.

Lyons, Scott Richard. *X-Marks: Native Signatures of Assent*. Indigenous Americas. Minneapolis: University of Minnesota Press, 2010.

Lyra, Carmen. *Los Cuentos De Mi Tía Panchita*. San José, Costa Rica: Impr. española, Soley & Valverde, 1936.

Lyra, Carmen, and Elizabeth Horan. *The Subversive Voice of Carmen Lyra: Selected Works*. Gainesville: University Press of Florida, 2000.

Maier, Charles S. *Among Empires: American Ascendancy and Its Predecessors*. Cambridge, MA: Harvard University Press, 2006.

Major, John. "Who Wrote the Hay-Bunau-Varilla Convention?" *Diplomatic History* 8, no. 2 (1984): 115–123.

Maldonado-Torres, Nelson. "On the Coloniality of Being." *Cultural Studies* 21, no. 2–3 (2007).

Manning, Susan. *Modern Dance, Negro Dance: Race in Motion*. Minneapolis: University of Minnesota Press, 2004.

Manuel, Peter, Kenneth M. Bilby, and Michael D. Largey. *Caribbean Currents: Caribbean Music from Rumba to Reggae*. Philadelphia: Temple University Press, 2006.

Martínez-San Miguel, Yolanda. *Coloniality of Diasporas: Rethinking Intra-Colonial Migrations in a Pan-Caribbean Context*. New Caribbean Studies. 1st ed. New York: Palgrave Macmillan, 2014.

Maurer, Noel, and Carlos Yu. *The Big Ditch: How America Took, Built, Ran, and Ultimately Gave Away the Panama Canal*. Princeton, NJ: Princeton University Press, 2011.

McClintock, Anne. "'No Longer in a Future Heaven': Nationalism, Gender, and Race." In *Becoming National: A Reader*. Edited by Geoff Eley and Ronald Grigor Suny. New York: Oxford University Press, 1996.

McCoy, Alfred, and Francisco A. Scarano. *The Colonial Crucible: Empire in the Making of the Modern American State*. Madison: University of Wisconsin Press, 2009.

McCullough, David G. *The Path between the Seas: The Creation of the Panama Canal, 1870–1914*. New York: Simon and Schuster, 1977.

McEnaney, Laura. *Civil Defense Begins at Home: Militarization Meets Everyday Life in the Fifties*. Politics and Society in Twentieth-Century America. Princeton, NJ: Princeton University Press, 2000.

McGuinness, Aims. *Path of Empire: Panama and the California Gold Rush*. The United States in the World. Ithaca, NY: Cornell University Press, 2008.

———. "Searching for 'Latin America': Race and Sovereignty in the Americas in the 1850s." In *Race and Nation in Modern Latin America*. Edited by Anne S. Macpherson, Karin Alejandra Rosemblatt, and Nancy P. Appelbaum. Chapel Hill: University of North Carolina Press, 2003.

———. "Sovereignty on the Isthmus: Federalism, U.S. Empire, and the Struggle for Panama During the California Gold Rush." In *The State of Sovereignty: Territories, Laws, Populations*, edited by Luise S. White and Douglas Howland, 19–34. Bloomington: Indiana University Press, 2008.

McKenzie, Jon. *Perform or Else: From Discipline to Performance*. New York: Routledge, 2001.

McKinney, Joslin. "Scenography, Spectacle and the Body of the Spectator." *Performance Research* 18, no. 3 (September 24, 2013): 63–74.

McPherson, Alan. "From 'Punks' to Geopoliticians: U.S. And Panamanian Teenagers and the 1964 Canal Zone Riots." *The Americas* 58, no. 3 (January 2002): 395–418.

———. "Myths of Anti-Americanism: The Case of Latin America." *Brown Journal of World Affairs* X, no. 2 (Winter–Spring 2004): 148.

———. *Yankee No! Anti-Americanism in U.S.–Latin American Relations*. Cambridge, MA: Harvard University Press, 2003.

Méndez, Roberto N. *Panamá, 9 de Enero de 1964: Qué Pasó y Por Qué*. Panama: Universidad de Panamá, 2000.

Mezzadra, Sandro, and Brett Neilson. *Border as Method, or, the Multiplication of Labor*. Durham, NC: Duke University Press, 2013.

Mignolo, Walter. *The Darker Side of Western Modernity: Global Futures, Decolonial Options*. Latin America Otherwise: Languages, Empires, Nations. Durham, NC: Duke University Press, 2011.

———. *The Idea of Latin America*. Blackwell Manifestos. Malden, MA, and Oxford: Blackwell, 2005.

Millett, Richard L. "Panama: Transactional Democracy." In *Constructing Democratic Governance: Latin America and the Caribbean in the 1990s*, edited by Jorge I. Domínguez and Abraham F. Lowenthal, 92–103: Baltimore: Johns Hopkins University Press, 1996.

Missal, Alexander. *Seaway to the Future: American Social Visions and the Construction of the Panama Canal*. Studies in American Thought and Culture. Madison: University of Wisconsin Press, 2008.

Moore, Robin. *Music and Revolution: Cultural Change in Socialist Cuba*. Berkeley: University of California Press, 2006.

Moraña, Mabel, Enrique D. Dussel, and Carlos A. Jáuregui. *Coloniality at Large: Latin America and the Postcolonial Debate*. Latin America Otherwise. Durham, NC: Duke University Press, 2008.

Motha, Stewart. "The Sovereign Event in a Nation's Law." *Law and Critique* 13, no. 3 (2002): 311–338.

Newton, Velma. *The Silver Men: West Indian Labour Migration to Panama, 1850–1914*. Mona, Kingston, Jamaica: Institute of Social and Economic Research, University of the West Indies, 1984.

Nwankwo, Ifeoma. "The Art of Memory in Panamanian West Indian Discourse: Melva Lowe De Goodin's *De/from Barbados a/to Panamá*." *Publication of the Afro-Latin/American Research Association* 6 (Fall 2002): 3–17.

Olwage, Grant. "Listening B(l)ack: Paul Robeson after Roland Hayes." *The Journal of Musicology* 32, no. 4 (Fall 2015): 524–557.

O'Reggio, Trevor. *Between Alienation and Citizenship: The Evolution of Black West Indian Society in Panama 1914–1964*. Lanham, MD: University Press of America, 2006.

Ortiz, Fernando. *Glosario de Afronegrismos*. Pensamiento Cubano. 2nd ed. La Habana: Editorial de Ciencias Sociales, 1991.

Pease, Donald E. *The New American Exceptionalism*. Critical American Studies Series. Minneapolis: University of Minnesota Press, 2009.

Peña, Elaine. "De-Politicizing Border Space." *E-misférica* 3, no. 2 (November 2006).

Pérez, Orlando J. *Political Culture in Panama: Democracy after Invasion*. 1st ed. New York: Palgrave Macmillan, 2011.

Phelan, Peggy. *Unmarked: The Politics of Performance*. New York: Routledge, 1993.

Postlewait, Thomas. "The Hieroglyphic Stage." In *Cambridge History of American Theatre, 1870–1945*, Volume 2, edited by Don B. Wilmeth and Christopher Bigsby, 1998–2000.

Priestley, George. "Antillean-Panamanians or Afro-Panamanians? Political Participation and the Politics of Identity During the Carter-Torrijos Treaty Negotiations." *Transforming Anthropology* 12, no. 1–2 (2004): 50–67.

———. "Elections: The Opposition Returns to Power." *N.A.C.L.A. Report on the Americas* 28, no. 2 (September–October 1994): 11–14.

———. *Military Government and Popular Participation in Panama: The Torrijos Regime, 1968–75*. Westview Special Studies on Latin America and the Caribbean. Boulder, CO: Westview Press, 1986.

Quijano, Anibal. "Coloniality of Power, Eurocentrism, and Latin America." *Nepantla: Views from the South* 1, no. 3 (2000): 533–578.

Radano, Ronald. "Hot Fantasies: American Modernism and the Idea of Black Rhythm." In *Music and the Racial Imagination*, edited by Ronald Michael Radano and Philip Vilas Bohlman, 459–465. Chicago: University of Chicago Press, 2000.

Rajer, Anton. *París en Panamá: Roberto Lewis y la Historia de sus Obras Restauradas en el Teatro Nacional de Panamá*. Madison: Fine Arts Conservation Services; University of Wisconsin Press distributor, 2005.

Rancière, Jacques. *The Ignorant Schoolmaster: Five Lessons in Intellectual Emancipation*. Stanford, CA: Stanford University Press, 1991.

Reese, Carol McMichael, and Thomas F. Reese. *The Panama Canal and Its Architectural Legacy (1905–1920)*. Panama: Ciudad del Saber, 2013.

Reid-Henry, Simon. "Exceptional Sovereignty? Guantánamo Bay and the Re-Colonial Present." *Antipode* 39, no. 4 (2007): 627–648.

Reyes, Herasto, and Jesús Q. Alemancia. "Qué Es el Centro Multilateral de Lucha Contra el Narcotráfico?" In *El Canal de Panamá en el Siglo XXI: Encuentro Académico Internacional Sobre el Canal de Panamá*, 251–296: Universidad de Panamá, 1998.

Rivera, Ángel G. Quintero. "Salsa y Democracia: Prácticas Musicales y Visiones Sociales en la América Mulata." *Íconos (Ecuador)* 18 (2004): 20–23.

Roach, Joseph R. *Cities of the Dead: Circum-Atlantic Performance*. The Social Foundations of Aesthetic Forms. New York: Columbia University Press, 1996.

Rodríguez, Ana Patricia. "Encrucijadas: Rubén Blades at the Transnational Crossroads." In *Latino/a Popular Culture*. Edited by Michelle Habell-Pallán and Mary Romero. New York: New York University Press, 2002.

Rosenblat, Angel. *Buenas y Malas Palabras en el Castellano de Venezuela*. Grandes Libros Vene-zolanos. 2nd ed. Caracas and Madrid: Ediciones Edime, 1960.

Rosenthal, Cindy, and James Harding,. *The Rise of Performance Studies: Rethinking Richard Schechner's Broad Spectrum*. New York: Palgrave Macmillan, 2011.

Rothstein, Björn, and Rolf Thieroff. *Mood in the Languages of Europe*. Studies in Language Companion Series. Amsterdam and Philadelphia: John Benjamins, 2010.

Russo, Mary J. *The Female Grotesque: Risk, Excess, and Modernity*. New York: Routledge, 1995.

Saito, Natsu Taylor. *Meeting the Enemy: American Exceptionalism and International Law*. Critical America. New York: New York University Press, 2010.

Saldívar, José David. *The Dialectics of Our America: Genealogy, Cultural Critique, and Literary History*. Post-Contemporary Interventions. Durham, NC: Duke University Press, 1991.

Sánchez, Peter Michael. *Panama Lost? U.S. Hegemony, Democracy, and the Canal*. Gainesville: University Press of Florida, 2007.

Sánchez-González, Lisa. "Reclaiming Salsa." *Cultural Studies* 13, no. 2 (1999): 237–250.

Schechner, Richard. *Between Theater and Anthropology*. Philadelphia: University of Pennsylvania Press, 1985.

———. *Performance Theory*. Rev. and expanded ed. New York: Routledge, 1988.

Schlor, Naomi. *Reading in Detail: Aesthetics and the Feminine*. New York: Methuen, 1987.

Schmitt, Carl. *Political Theology: Four Chapters on the Concept of Sovereignty*. Studies in Contemporary German Social Thought. Cambridge, MA: MIT Press, 1985.

Schneider, Rebecca. *Performing Remains: Art and War in Times of Theatrical Reenactment*. New York: Routledge, 2011.

Schoonover, Thomas David. *Uncle Sam's War of 1898 and the Origins of Globalization*. Lexington: University Press of Kentucky, 2003.

Scranton, Margaret. "Consolidation after Imposition: Panama's 1992 Referendum." *Journal of Interamerican Studies and World Affairs* 35, no. 3 (Autumn 1993): 65–102.

Shapiro, Michael J. "The Demise of 'International Relations': America's Western Palimpsest." *Geopolitics* 10, no. 22 (2005): 222–243.

Siegel, Robert. "'Walt & El Grupo' Documents Disney Diplomacy." *All Things Considered*. National Public Radio, 2009.

Simpson, Audra. *Mohawk Interruptus: Political Life across the Borders of Settler States*. Durham, NC: Duke University Press, 2014.

Simpson, Audra, and Andrea Smith. *Theorizing Native Studies*. Durham, NC: Duke University Press, 2014.

Sinán, Rogelio. "Divagaciones Sobre La Fábula De La Cucarachita Mandinga Y Sobre Una Posible Resurrección De Ratón Pérez." *Revista Cultural la Lotería* 221 (July 10, 1974): 21–26.

———. "Mi Poesía: Una Ojeada Retrospectiva." *Revista Cultural de la Lotería* 370 (January–February 1988).

———. "Vivencia De La India." *Revista Lotería* 370 (enero–febrero 1988).

Smith, Matthew. "Wanderers of Love: Touring and Tourism in the Jamaica-Haiti Musical Circuit of the 1950s." In *Sun, Sea, and Sound: Music and Tourism in the Circum-Caribbean*. Edited by Timothy Romman and Daniel Neely. New York: Oxford University Press, 2014.

Sofer, Andrew. *The Stage Life of Props*. Theory/Text/Performance. Ann Arbor: University of Michigan Press, 2003.

Soler, Ricaurte. *Formas Ideológicas de la Nación Panameña*. Panamá: Ediciones de la Revista Tareas, 1963.

Stanislavsky, Konstantin, and Jean Benedetti. *An Actor's Work: A Student's Diary*. New York: Routledge, 2008.

Stephens, Michelle Ann. *Black Empire: The Masculine Global Imaginary of Caribbean Intellectuals in the United States, 1914–1962.* New Americanists. Durham, NC: Duke University Press, 2005.

———. "I'm the Everybody Who's Nobody: Genealogies of the New World Slave in Paul Robeson's Performances of the 1930s." In *Hemispheric American Studies*, edited by Caroline F. Levander and Robert S. Levine, 166–186. New Brunswick, NJ: Rutgers University Press, 2008.

St. John, Graham. *Victor Turner and Contemporary Cultural Performance.* New York: Berghahn Books, 2008.

Suárez, Omar Jaén. *El Canal De Panamá.* Edited by Ediciones Balboa: Autoridad del Canal de Panamá (A.C.P.), 2007.

Szok, Peter A. *La Última Gaviota: Liberalism and Nostalgia in Early Twentieth-Century Panamá.* Westport, CT: Greenwood Press, 2001.

Tardieu, Jean-Pierre. *De Diablo Mandingo al Muntu Mesiánico: el Negro en la Literatura Hispanoamericana del Siglo XX.* Madrid: Editorial Pliegos, 2001.

Taylor, Diana. "The Politics of Passion." *e-misférica* 10, no. 2 (2013). http://hemisphericinstitute.org/hemi/en/e-misferica-102/taylor.

Torrijos, Monchi. "La Patria Rinde Homenaje a Sinán." *Revista Lotería* 370 (January–February 1988): 173–180.

Trouillot, Michel-Rolph. *Silencing the Past: Power and the Production of History.* Boston: Beacon Press, 1995.

Turner, Fred. *The Democratic Surround: Multimedia & American Liberalism from World War II to the Psychedelic Sixties.* Chicago: University of Chicago Press, 2013.

———. "*The Family of Man* and the Politics of Attention in Cold War America." *Public Culture* 24, no. 1 (2012): 55–84.

Turner, Victor W. "Dewey, Dilthey, and Drama: An Essay in the Anthropology of Experience." In *The Anthropology of Experience.* Edited by Victor W. Turner and Edward M. Bruner. Urbana-Champaign: University of Illinois Press, 1986.

———. *The Ritual Process: Structure and Anti-Structure.* The Lewis Henry Morgan Lectures, 1966. Chicago: Aldine Pub., 1969.

Uribe, Álvaro. "Travesía Urbana: Tomas Aéreas de la Ciudad de Panamá." Edited by Museo de Arte Contemporáneo. Panamá: Museo de Arte Contemporáneo, 2008.

Vasconcelos, José. *La Raza Cosmica: Mision De La Raza Iberoamericana, Argentina Y Brasil.* Colección Austral. 3rd ed. Mexico: Espasa-Calpe, 1966.

Volpp, Leti. "The Indigenous as Alien." *U.C. Irvine Law Review* 5, no. 289 (June 2015): 289–326.

Von Eschen, Penny M. *Satchmo Blows up the World: Jazz Ambassadors Play the Cold War.* Cambridge, MA: Harvard University Press, 2004.

Wade, Peter. *Blackness and Race Mixture: The Dynamics of Racial Identity in Colombia.* Johns Hopkins Studies in Atlantic History and Culture. Baltimore: Johns Hopkins University Press, 1993.

———. *Race and Ethnicity in Latin America.* Critical Studies on Latin America. Chicago: Pluto Press, 1997.

———. *Race and Sex in Latin America.* Anthropology, Culture and Society. New York: Palgrave Macmillan, 2009.

Walcott, Rinaldo. "Caribbean Pop Culture in Canada: Or, the Impossibility of Belonging to the Nation." *Small Axe: A Caribbean Journal of Criticism* 5, no. 1 (March 2001): 123–139.

———. "The Problem of the Human: Black Ontologies and 'the Coloniality of Our Being.'" In *Postcoloniality—Decoloniality—Black Critique: Joints and Fissures*, edited by Sabine Broeck and Carsten Junker, 93–105. Frankfurt-on-Main: Campus Verlag, 2014.

Watson, Sonja Stephenson. "'Black Atlantic' Cultural Politics as Reflected in Panamanian Literature." Diss., University of Tennessee, Knoxville, 2005.

———. "Poetic Negrism and the National Sentiment of Anti-West Indianism and Anti-Imperialism in Panamanian Literature." *Callaloo* 35, no. 2 (Spring 2012): 459–477.

———. *The Politics of Race in Panama: Afro-Hispanic and West Indian Literary Discourses of Contention.* Gainesville: University Press of Florida, 2014.

———. "The Use of Language in Melva Lowe De Goodin's *De/from Barbados a/to Panamá*: A Construction of Panamanian West Indian Identity." *College Language Association Journal* (2005).

Waxer, Lise. *Situating Salsa: Global Markets and Local Meanings in Latin Popular Music.* New York: Routledge, 2002.

Weber, Cynthia. "Performative States." *Millennium—Journal of International Studies* 27, no. 1 (March 1, 1998): 77–95.

———. *Simulating Sovereignty: Intervention, the State, and Symbolic Exchange.* New York: Cambridge University Press, 1995.

Weeks, William Earl, Walter LaFeber, Akira Iriye, and Warren I. Cohen. *The New Cambridge History of American Foreign Relations.* 4 vols. Cambridge and New York: Cambridge University Press, 2013.

Westerman, George W. "Historical Notes on West Indians on the Isthmus of Panama." *Phylon* 22, no. 4 (1961).

"What Walt Disney Learned from South America." In *Tell Me More.* National Public Radio, 2009.

Whitten, Norman E., and Arlene Torres. *Blackness in Latin America and the Caribbean: Social Dynamics and Cultural Transformations.* Blacks in the Diaspora. Bloomington: Indiana University Press, 1998.

Wilson, Richard Guy. "Imperial American Identity at the Panama Canal." *Modulus: The University of Virginia School of Architecture Review* 14 (1981): 22–29.

Wolfe, Patrick. "Recuperating Binarism: A Heretical Introduction." *Settler Colonial Studies* 3, no. 3–4 (November 2013): 257–279.

Wynter, Sylvia. "Unsettling the Coloniality of Being/Power/Truth/Freedom: Towards the Human, after Man, Its Overrepresentation—an Argument." *C.R.: The New Centennial Review* 3, no. 3 (Fall 2003): 257–337.

Young, Harvey. *Theatre & Race.* Theatre &. New York: Palgrave Macmillan, 2013.

Zárate, Manuel F., and Dora P. de Zárate. *Tambor y Socavón: un Estudio Comprensivo de los Temas del Folklore Panameño y de sus Implicaciones Históricas y Culturales.* Panamá: Ministerio de Educación, Dirección Nacional de Cultura, 1962.

Zien, Katherine. "Minstrels of Empire: Blackface and Black Labor in Panama, 1850–1914." In *(Re)Positioning the Latina/o Americas: Theatrical Histories and Cartographies of Power.* Edited by Jimmy Noriega and Analola Santana. Carbondale: Southern Illinois University Press, 2017.

———. "Panamanian Theatre for Social Change: Notes from an Interview with Playwright Raúl Leis." *Latin American Theatre Review* 47, no. 2 (Spring 2014): 109–115.

———. "Race and Politics in Concert: Paul Robeson and William Warfield in Panama, 1947–1953." *The Global South* 6, no. 2 (Fall 2013): 107–129.

———. "Toward a Pedagogy of Redress: Staging West Indian Panamanian History in *De/from Barbados a/to Panamá.*" *Latin American and Caribbean Ethnic Studies* 4, no. 3 (November 2009): 293–317.

Zimbalist, Andrew S., and John Weeks. *Panama at the Crossroads: Economic Development and Political Change in the Twentieth Century.* Berkeley: University of California Press, 1991.

INDEX

Page numbers in italics refer to illustrations.

ABOUT THE AUTHOR

KATHERINE A. ZIEN is Assistant Professor in the Department of English at McGill University. Zien's pedagogy and research focus on theatre and performance in the Americas, with emphasis on transnational mobility, cultural management, and frameworks of racialization. Zien's writing may be found, among other places, in *Theatre Survey*, *Women and Performance*, *e-misférica*, *Theatre Research in Canada*, *Global South*, *Identities*, and *Latin American Theatre Review*.

Printed in the United States
By Bookmasters